S0-ADB-362

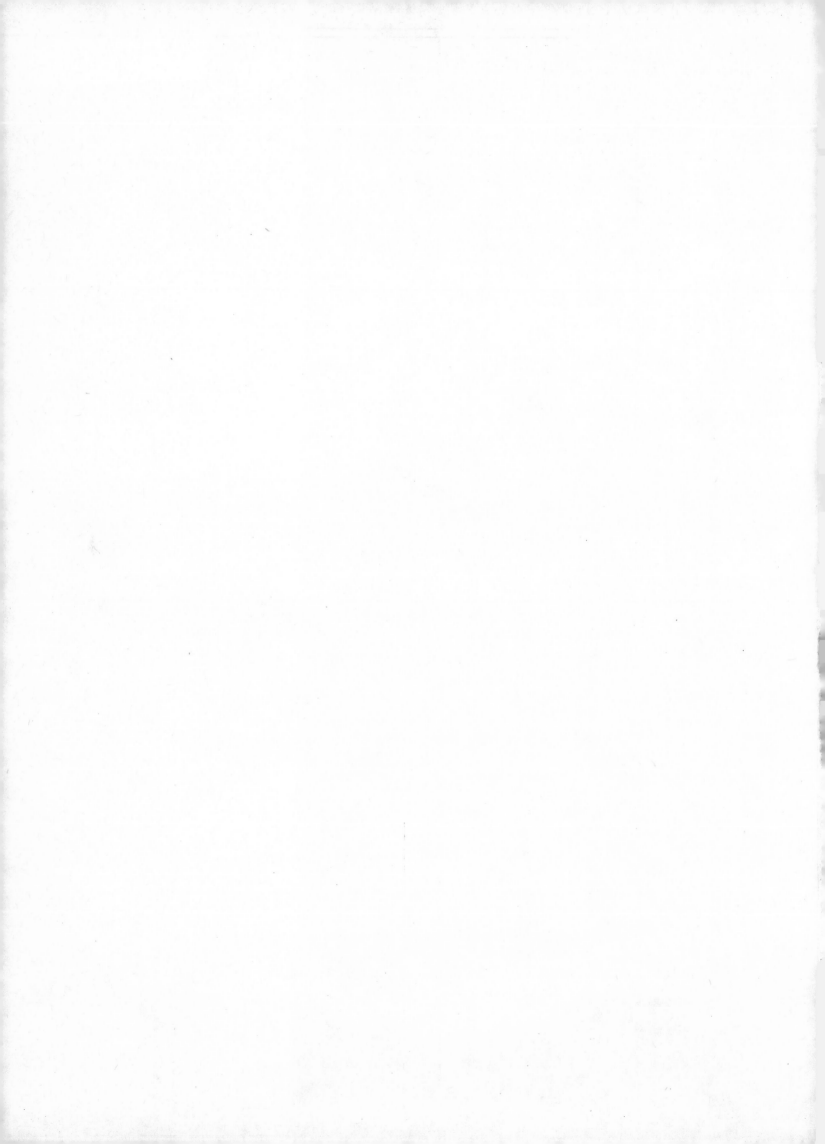

JOHN QUINCY ADAMS WARD
Dean of American Sculpture

The American Art Journal/University of Delaware Press Books

Editorial Committee

John I. H. Baur, General Editor
Wayne Craven
Lawrence A. Fleischman
E. P. Richardson
Thomas Yoseloff

THE INLANDER: *Life and Work of Charles Burchfield, 1893–1967*
 By John I. H. Baur

EDWARD HICKS: *His* Peaceable Kingdoms *and Other Paintings*
 By Eleanore Price Mather and Dorothy Canning Miller

ERASTUS D. PALMER
 By J. Carson Webster

J. ALDEN WEIR: *An American Impressionist*
 By Doreen Burke

SCULPTURE IN AMERICA
 By Wayne Craven

ARTHUR DOVE: *Life and Work*
 By Ann Lee Morgan

JOHN QUINCY ADAMS WARD: *Dean of American Sculpture*
 By Lewis I. Sharp

ARTHUR FITZWILLIAM TAIT: *Artist in the Adirondacks*
 By Warder H. Cadbury and Henry F. Marsh

JOHN LEWIS KRIMMEL: *An Artist in Federal America*
 By Milo M. Naeve

ARTHUR B. DAVIES: *A Catalogue Raisonné of the Prints*
 By Joseph S. Czestochowski

John Quincy Adams Ward, *The James Abram Garfield Monument,* **1887. Washington, D.C.**

JOHN QUINCY ADAMS WARD
Dean of American Sculpture

WITH A CATALOGUE RAISONNÉ

LEWIS I. SHARP

An American Art Journal/Kennedy Galleries Book

NEWARK: UNIVERSITY OF DELAWARE PRESS
LONDON AND TORONTO: ASSOCIATED UNIVERSITY PRESSES

© 1985 by Associated University Presses Inc.

Associated University Presses
440 Forsgate Drive
Cranbury, N.J. 08512

Associated University Presses
25 Sicilian Avenue
London WC1A 2QH, England

Associated University Presses
2133 Royal Windsor Drive
Unit 1
Mississauga, Ontario, Canada, L5J 1K5

Library of Congress Cataloging in Publication Data

Sharp, Lewis I.
 John Quincy Adams Ward, dean of American sculpture.

 (An American art journal/Kennedy Galleries book)
 Bibliography: p.
 Includes index.
 1. Ward, John Quincy Adams, 1830–1910—Catalogs.
2. Ward, John Quincy Adams, 1830–1910. 3. Sculptors—
United States—Biography. I. Ward, John Quincy Adams,
1830–1910. II. Title. III. Series.
 NB237.W2A4 1985 730'.92'4 84-8664
 ISBN 0-87413-253-3

Jerry L. Thompson's photographs in the Album were made
possible by a grant from the Clevepak Corporation.

Printed in the United States of America

PHOTO CREDITS

Albany Institute of History and Art, McKinney Library, Albany, New York: cat. nos. 11, 15; figs. 4, 15, 25, 50, 51, 52, 79, 83

American Academy of Arts and Letters, New York City: cat. no. 62; figs. 2, 9, 38, 60, 62, 63, 69, 74, 90

The American Institute of Architects Foundation, Washington, D.C.: cat. nos. 66, 77, 80; figs. 5, 29, 34, 35, 37, 45, 76, 77, 78, 80, 81, 87, 88, 91

American Paintings and Sculpture Department, The Metropolitan Museum of Art, New York City: cat. nos. 7.3, 14.1, 32.3, 39, 47, 60, 68, 71, 73, 83, 109, 112, 115, 122, 123; figs. 1, 10, 20, 31, 36, 39, 40, 42, 46, 47, 49, 55, 58, 59, 68, 86, 92

The Art Commission of the City of New York, New York City: cat. nos. 48, 50, 68.1, 69.2, 72

Art Resources, New York City: figs. 17 (Alinari 1219), 19 (Alinari 22625), 23 (Alinari 1456), 44 (Giraudon LAC 84008), 61 (Giraudon 661), 70 (Alinari 22756)

Boston Public Library, Boston, Massachusetts: cat. no. 44

The Brooklyn Museum, Brooklyn, New York: cat. no. 76

Deborah Bryk, Albany, New York: fig. 85

Chesterwood National Trust for Historic Preservation, Stockbridge, Massachusetts: fig. 75

Cooper-Hewitt Museum, The Smithsonian Institution's National Museum of Design, New York City: cat. no. 125

The Corcoran Gallery, Washington, D.C.: cat. no. 70

The Equitable Life Assurance Society, New York City: figs. 33, 82

Frick Art Reference Library, New York City: cat. no. 100

Edward Gallob: fig. 73

Hirschl & Adler Galleries, New York City: cat. no. 106.1

Peter A. Juley & Son Collection, National Museum of American Art, Smithsonian Institution, Washington, D.C.: cat. no. 104 (J0113504); figs. 24 (J0113507), 64 (J0113506), 65 (J0113511), 71 (J0113508), 72 (J0113510), 89 (J0113505)

Library of Congress, Washington, D.C.: cat. no. 103; figs. 11, 66

Man at Arms Publications, Providence, Rhode Island: cat. nos. 23, 24

The Metropolitan Museum of Art, New York City: cat. nos. 12.7, 54; fig. 56

The Museum of the Confederacy, Richmond, Virginia: cat. no. 8

National Academy of Design, New York City: figs. 14, 27

National Museum of American History, Smithsonian Institution, Washington, D.C.: cat. no. 22; fig. 21

National Portrait Gallery, Smithsonian Institution, Washington, D.C.: cat. nos. 18, 90.1

The Newark Museum, Newark, New Jersey: cat. no. 104.1

The New-York Historical Society, New York City: cat. nos. 34, 82.1, 85, 88, 107.2; figs. 28, 32, 67

Nancy Scott, New Haven, Connecticut: fig. 57

Barea L. Seeley, Tenafly, New Jersey: cat. no. 108; fig. 93

Mr. and Mrs. Oliver E. Shipp, Newburgh, New York: opposite Foreword; figs. 3, 8, 41, 48, 53, 54, 84

Jerry L. Thompson: frontispiece; cat. nos. 4, 5, 10, 21.7, 36, 38, 45, 46, 50.7, 53, 55, 55.1, 58, 58.1, 58.2, 59, 61, 61.2, 63.1, 67, 67.1, 68.3, 69, 75, 78, 79, 89, 89.1, 91, 91.3, 94, 95, 95 detail, 96.1, 97.2, 99, 110, 110.2, 114, 117, 118, 121; figs. 12, 13, 16, 18, 22, 26, 30, 43; Plates I-LX

United States Capitol, Washington, D.C.: fig. 6

Mr. and Mrs. Erving Wolf, New York City: cat. nos. 3, 69.4

For my parents and for Susan, Lewis, Sam, and Amy

CONTENTS

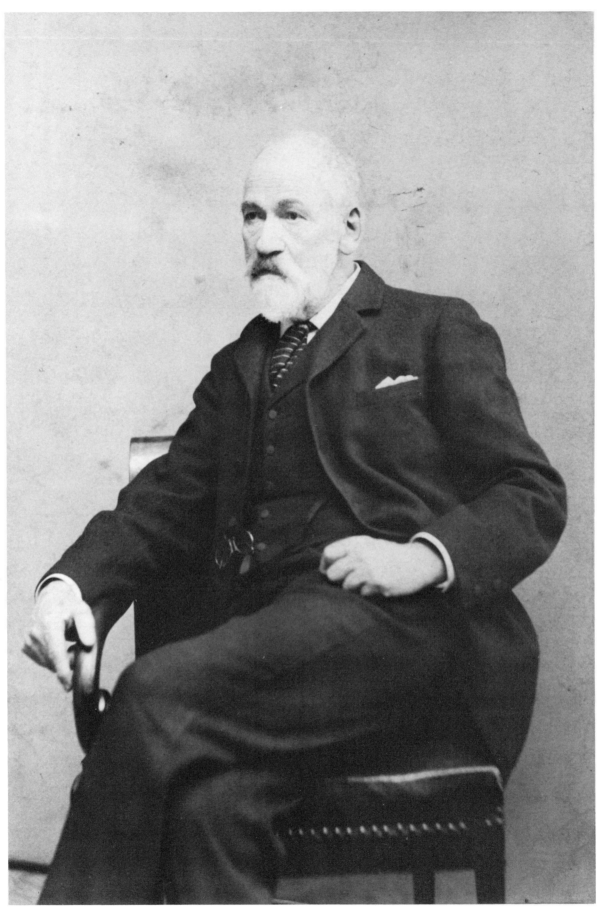

John Quincy Adams Ward at approximately seventy years of age. Photograph. Collection of Mr. and Mrs. Oliver E. Shipp, Newburgh, New York.

FOREWORD

JOHN QUINCY ADAMS WARD WAS RECOGNIZED DURING THE SECOND HALF OF THE nineteenth century as one of America's leading sculptors. *The Indian Hunter,* first exhibited as a model in 1859, later installed permanently as a full-size bronze statue in Central Park, won him his reputation. His excellent work, mostly large-scale monuments, became nationally known, establishing him as a teacher and art-world personality of great influence. Because Ward's artistic and personal importance has been largely overlooked in the many years since his death, it is timely and appropriate for The Metropolitan Museum of Art to sponsor the publication of Lewis Sharp's *John Quincy Adams Ward: Dean of American Sculpture,* and to present with it a selective exhibition of Ward's best work. The sculptor's connections with the Museum were significant from its inception, since he was not only one of its founding Trustees but also a member of its Executive Committee until 1901, a span of over thirty years. Moreover, the Metropolitan is fortunate to have in its collection nine of Ward's works.

This book and the accompanying exhibition belong to a concentrated series of publications and exhibitions, sponsored by the Metropolitan and overseen by Mr. Sharp, which are devoted to the study and presentation of American sculpture of the nineteenth and early twentieth centuries. When completed, the exhibition series will have presented a comprehensive view of the work of Erastus Dow Palmer, John Quincy Adams Ward, and Augustus Saint-Gaudens. From its beginnings in 1980, this project and others within the Museum have been supported by a generous grant from the Clevepak Corporation, which has consistently demonstrated a great understanding of their importance. Clevepak Corporation's contributions, linked with a grant from the Henry Luce Foundation, have enabled Jerry L. Thompson to produce the sensitive and precise photographs of Ward's sculpture seen in this book. The William Cullen Bryant Fellows of the American Wing have also provided substantial funds to underwrite the production of the incorporated photograph album, as well as additional editorial costs.

Until recent years, American sculpture of the nineteenth and early twentieth centuries has suffered considerable and undeserved neglect on the part of collectors, dealers, curators, scholars, and museums. Books such as this one, the product of years of scholarship and care, are presented to help address that situation.

John K. Howat
The Lawrence A. Fleischman
 Chairman of the Departments
 of American Art
The Metropolitan Museum of Art

A GUIDE TO THE CATALOGUE

THE CATALOGUE ENTRIES ARE ARRANGED CHRONOLOGICALLY. THE DATES ASSIGNED TO THE individual pieces have been determined by when they were inscribed by the artist or, if they were not inscribed, by documented information on the date Ward completed work on them. For example, because he inscribed the bust of William H. Vanderbilt with the date 1886 next to his signature, the work appears in the catalogue under that date although it was not cast by the Henry-Bonnard foundry until 1888.

All related works and references to works that have yielded to a thorough search have been included, even though some have not yet been located.

The works have been separated into distinct categories: preparatory model, statuette, statue, reduction, replica, or proposed design.

There are three types of illustration in the book. Figure numbers are assigned to all illustrations in the introductory and biographical essays, and to related works in the catalogue. Catalogue numbers are used to denote illustrations of works at that entry. Plate numbers refer to the photographs in the album.

Information on the lives of Ward's subjects is derived from the *Dictionary of American Biography*. Additional biographies are recorded only if they contain references to Ward or to the sculpture.

The terms "naturalism" and "realism" are herein used in their literal sense: that reproduction which is arrived at according to direct observation of a subject.

Preceding the catalogue proper is a chronological list of Ward's work.

For explanation of the abbreviations used throughout the notes, see pages 280–88.

ACKNOWLEDGMENTS

I MUST FIRST ACKNOWLEDGE THE INSTITUTION OF THE METROPOLITAN MUSEUM OF ART and my many colleagues there who during the past twelve years have assisted me with this book in their individual ways. I would particularly like to thank James Pilgrim, the museum's Deputy Director, for his steadfast support of the curatorial staff's scholarly aspirations. I am grateful to my colleagues in the Departments of American Art, especially to John K. Howat, who has unfailingly encouraged my work on Ward. Natalie Spassky and Doreen B. Burke have over the years fed me a steady diet of information that they uncovered in the course of their own work; Kathryn Greenthal has been a helpful touchstone for many of my comparisons between Ward's work and contemporary French sculpture; Donna Hassler has looked after many time-consuming details; and Kathleen Luhrs, Kristine Schassler, Ellin Rosenzweig, and Nancy Gillette have offered cheerful assistance. Zackary Karabell, an intern, did some admirable sleuthing in the city's libraries, and Susan Ebner was extremely helpful in her conscientious preparation of the manuscript and in checking many of the references. Others at the museum who have helped me in the project include William B. Walker and his staff in the Thomas J. Watson Library; Patricia F. Pellegrini, of Archives; Stuart W. Pyhrr, of Arms and Armor; David W. Kiehl and Weston J. Naef, of Prints and Photographs; and Kjeld Tidemand-Johannessen, Shinichi Doi, Hermes Knauer, and William Hickman, of Objects Conservation.

John Quincy Adams Ward: Dean of American Sculpture grew out of a doctoral dissertation done at the University of Delaware under the direction of Wayne Craven, surely the dean of scholarship in the field of American sculpture. Three of my fellow graduate students have given me much valuable information and assistance over the years: Michael T. Richman, who initially fostered my interest in sculpture and who throughout our continuing friendship has been the intelligent critic of many of my ideas on the subject as well as a guide to the Daniel Chester French papers and source materials in Washington, D.C.; George Gurney, who selflessly shared his information on Olin Levi Warner; and Grant Holcomb, who brought to my attention many informative references.

A special acknowledgment must be accorded three organizations for their generous support. The Henry Luce Foundation, which is sponsoring the catalogue now in preparation of the Metropolitan Museum's collection of American sculpture, underwrote the expenses for Jerry L. Thompson's photographs of Ward's works that are housed in the museum. The Clevepack Corporation, in their far-reaching endowment for the creation of programs featuring American sculpture, have funded Mr. Thompson's album of photographs in the book and also the Ward exhibition that accompanies it. The Metropolitan Museum's Bryant Fellows, who are dedicated to the American Wing's publication of books on American art, have

contributed funds that covered special editorial expenses and the production of the photograph album. Mr. Thompson's photographs of Ward's sculpture, an invaluable addition to the book, would not have been possible without the participation of these organizations.

Strangely, almost none of Ward's personal correspondence survives, but the rich manuscript and photographic collections here listed permit a broad portrait of the sculptor and his work to be painted. Two Ward family descendants have been most helpful: the late Mrs. R. Ostrander Smith, the sculptor's stepdaughter-in-law, and Mrs. Oliver E. Shipp, Newburgh, New York, great-granddaughter of Ward's eldest sister, Eliza Thomas. The following institutions and members of their staffs have been of great assistance: the Archives of American Art, its former director William E. Woolfenden and his staff; the National Museum of American Art, William H. Treuttner and Robert Johnston; the National Museum of American History, Henry Hunter; the National Portrait Gallery, Robert G. Stewart, Monroe Fabian, Ellen Miles, Linda Neumaier, and Susan C. Jenkins; all part of the Smithsonian Institution, Washington, D.C.; the American Academy of Arts and Letters, New York City, Margaret Mills; The American Institute of Architects Foundation, Washington, D.C., Susan Stein and Sherry C. Birk; the Albany Institute of History and Art, Norman S. Rice, Suzanne Roberson, and Daryl Severson; The Art Commission of the City of New York, Frances McGuire; The Brooklyn Museum, Dianne Pilgrim; the Chamber of Commerce of the State of New York, New York City; Chesterwood, Stockbridge, Massachusetts, Paul Ivory; The Equitable Life Assurance Society, New York City; the Indiana Historical Society, Indianapolis, Caroline Dunn; the Library of Congress, Washington, D.C.; the National Academy of Design, New York City, Abigail Gerdts; the National Archives, Washington, D.C., Charles A. Shaughnessy; the National Sculpture Society, New York City, Thea Morgan; The Newark Museum, Newark, New Jersey; The New-York Historical Society, New York City, Thomas J. Dunnings, Wendy J. Shadwell, and Helena Zinkham; the New York Public Library, New York City; the New York Stock Exchange, New York City; the Union Theological Seminary, New York City, Glenn Loomis.

A number of individuals brought helpful material to my attention: Gary Arnold, Raymond Auyang, Robert Bahssin, August Belmont, Russell E. Burke III, Alice E. L. Duncan, William Gerdts, James Graham, Virginia S. Halstead, John D. Hamilton, James Haskett, H. Draper Hunt, Brock W. Jobe, Harold Jonas, Frank H. Kehoe, David Labarre, Louis Marder, Susan Menconi, Grete Meilman, Andrew Mowbray, Glenn Opitz, Howard and Dorothy Pack, Edward Pawlin, Caroline Pitts, Peter B. Rathbone, Richard and Sheila Schwartz, Nancy Scott, Barea L. Seeley, Barbara Sevy, Michael Shapiro, John F. I. Sharp, Hildegarde Smith, Countess Anthony Szápáry, Doug Thompson, Donald D. Webster, Patricia Windels, and Erving and Joyce Wolf.

I express my sincere gratitude to John H. I. Baur, General Editor of the American Art Journal Books, for selecting this book to be part of their series on American art. I thank Thomas Yoseloff of the Associated University Presses for his support of this project and for his and his staff's commitment to publishing books of superior quality. I am grateful to Howard I. Gralla for coordinating and overseeing the production of the book's photographic album at the Meriden Gravure Company.

Finally, I express my deepest appreciation to two persons who have cared as much about the book as I have and who have tried to make it as close to perfect as possible: Emely Bramson, who has coordinated all my research efforts, and Mary-Alice Rogers, who has edited the book with infinite skill and with sensitivity to both subject and author.

because of Ward's preeminent position in the sculptural transition from neoclassicism to naturalism in the third quarter of the nineteenth century, because of his own rejection of a European training and career, and because of the sheer force of the realism of his work. But to view Ward's sculpture only as a native art form misrepresents his basic attitudes and prevents the recognition of the breadth of his accomplishment. Ward was always receptive to the sculptors of both the past and the present. "I want to see every statue that has ever been made," he told an interviewer in 1878.[23] Though Ward himself avoided a European training, he was not opposed to others' studying abroad. He merely felt a young sculptor must

> . . . know the grammar of his art before he can take advantage of the great book of art in the olden countries; then, when prepared to go to higher schools than our country affords, let him go to the great art centers of the world and learn how to do, then come back to his native country and try to do that which he understands best.[24]

His only fear of exposure to European art was that an immature artist might be completely overwhelmed; he felt Rome to be especially dangerous, because the attraction of its antique sculpture was so strong that it could draw "a sculptor's manhood out of him."[25] That fear and Ward's desire for the development of a distinctly indigenous style was what undoubtedly caused critics to overlook or to underestimate the historical influences on his work.

Of all the styles of the past, classical art affected Ward the most. "In sculpture," he asserted,

> No man can ignore the grandeur and the beauty of the antique. Adhere to nature, by all means, but assist your intelligence and correct your taste by the study of the best Greek works. If one is faithful and conscientious, he will find that every good Greek work is verified in nature. After years of observation, I have found things in nature that I once doubted, and the joy of the discovery was intense. It is scarcely worth while to study intermediate schools of art; go directly to the Greeks; they are the masters. Michael Angelo, Thorwaldsen, Canova, Flaxman—why should you stop to talk with them when you can listen to Phidias and Praxiteles? . . . Why not study at once such works as the pediments of the Parthenon, the 'Venus of Milo,' and the 'Fighting Gladiators'. Begin by drawing from good casts of those sculptures. They will educate your sense of form.[26]

That conviction of Ward's is evidenced by his serving on the Special Committee on Casts at The Metropolitan Museum of Art between 1891 and 1895,[27] and by his purchase of plaster casts for the art faculty at the National Academy of Design on each of his two trips to Europe.[28] His own sketchbooks also contain numerous drawings of classical subjects (fig. 4),[29] and he kept in his studio a plaster cast of the *Borghese Gladiator* (fig. 3) and a student cast he had made of the *Farnese Hercules* (cat. no. 4).[30] Ward's esteem for the antique should not, however, be confused with his disdain for neoclassical sculpture, for he felt that the smoothly modeled, stylized statues of the neoclassical sculptors from the days of Thorvaldsen on were "weak and namby-pamby" compared to the glorious works they imitated.[31]

The influence of classical art on Ward is most clearly evident in his early works, which, for all their naturalistic qualities, are derived compositionally from antiquity. As Ward matured, though he borrowed less directly from classical sources, his sculpture continued to show restraint and repose. In essence, a number of his statues (his early works in particular), though dressed in modern attire and imbued with a vigorous naturalism, are Praxitelean figures that stand quiescently on an engaged leg, the other slightly bent, giving the figure a graceful contrapposto learned from the sculpture of antiquity.

The force that Renaissance art exerted on Ward's oeuvre is less pronounced than is that of the antique, and is in fact limited to Michelangelo. Even Michelangelo's influence is clearly discernible in only a few of Ward's pieces. In comparing the great sixteenth-century artist with the Greek sculptors, Ward seemed to dismiss him: "Michael Angelo, indeed, was a mighty intellectual force, who emancipated art from some of its harder and more timid conditions; but he was not true enough to nature, and he was not the founder of a school.[32] Ward nevertheless is reported to have read eagerly about Michelangelo in his father's "Cy-

Fig. 4. John Quincy Adams Ward, classical study, 1849–56. Pencil on paper. Albany Institute of History and Art, Albany, New York.

clopedia Britannica."[33] Moreover, a photograph taken about 1874 of Ward's studio (fig. 38) shows that he owned plaster casts of the Renaissance master's *Moses,* and his figures of *Day* and *Night* and *Dawn* and *Dusk* from the Medici Chapel in the Church of San Lorenzo in Florence.

The third influence on Ward's art, and by far the greatest, was the sculpture of nineteenth-century France. Though somewhat skeptical of French art and claiming that "a Frenchman doesn't care what he does, but how he does it," Ward regarded the Parisian ateliers as the

best system of teaching, "training the eye to the movement of figures and to accuracy of representation."[34] Because of his respect for that discipline, he advised Henry Kirke Bush-Brown, nephew of Henry Kirke Brown, to go to France for his training.[35] It is also logical to assume that Daniel Chester French, Paul Wayland Bartlett, and Charles Albert Lopez, close friends of Ward's who had worked or studied with him, probably went to Paris on his advice, or at least with his blessing. Ward's full approval of the work of the Beaux-Arts-schooled sculptors was dramatically illustrated in 1876, when he refused the *Farragut Memorial* commission in New York City and used his influence to have the work given instead to the Paris-trained sculptor Augustus Saint-Gaudens.[36]

In the 1860s, Ward was completely indoctrinated into the principles of the Beaux-Arts movement by the architect Richard Morris Hunt, who, after studying in Paris at the École des Beaux-Arts, set up a studio in New York in 1856 and quickly became a leading force in American art circles.[37] Ward and Hunt first worked together on the statue of Commodore Matthew Calbraith Perry for Newport in 1868 (fig. 5), and during the next quarter-century they collaborated on thirteen public monuments and were associates in numerous civic and

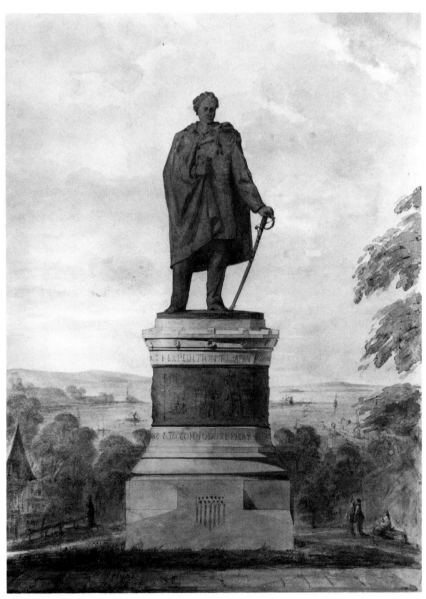

Fig. 5. Richard Morris Hunt, *Commodore Matthew Calbraith Perry*, about 1868. Watercolor. The American Institute of Architects Foundation, Washington, D.C.

artistic organizations.[38] Of their collaboration, Hunt's wife reported that "R____ planned out the general idea of the monument, Ward did the sculpture and R____ furnished drawings for the pedestal and studied up the inscriptions."[39] How much of that is fact and how much is wifely devotion is a matter of conjecture, but there is a ring of truth about it. Hunt also designed for Ward a house with a studio in New York in 1868, a studio and stable in Urbana, Ohio, in 1881, and a combination house and studio in New York in 1882.[40] The working relationship between the two men was a primary influence on the sculptor's work, and their artistic collaboration was responsible for a major chapter in the history of the Beaux-Arts movement in America.

Ward never mentioned the French Troubadour style of the 1830s or the work of David d'Angers, but since both exerted a profound effect on nineteenth-century portraiture in general, they tangentially helped to shape Ward's work. The standing portrait that remained firmly rooted throughout the nineteenth century has been noted as "in the tradition defined by David d'Angers for both historical and contemporary personalities."[41] David's statue of the *Grande Condé* in Paris (completed in 1827 for the Pont Louis XVI, now the Pont de la Concorde, and destroyed during the Second World War) is accepted as the turning point in

Fig. 6. David d'Angers, *Thomas Jefferson*, 1832/33. Bronze. United States Capitol, Washington, D.C.

the history of French sculpture. That one work, representing the dramatic action of Condé, dressed in the costume of his time, leading his men into battle, was such a dazzling departure from the norms of Napoleonic neoclassicism that everything that came after could not fail to bear some evidence of its influence.[42] David's greatest contribution to the realm of American sculpture, however, was probably the statue of Thomas Jefferson (fig. 6) that he did for the United States Capitol between 1832 and 1833, and the plaster replica of it that is still exhibited at City Hall in New York. The importance of David's *Jefferson* in America has been perceptively summed up by James Holderbaum:

> The monumental bronze statue . . . is the first and most characteristic of a type invented by David: the naturalistic but noble figure worthy of public veneration and emulation, in modern costume and with readily intelligible, commonsense attributes rather than abstruse allegorical adjuncts, conceived for bronze and taking full aesthetic advantage of the medium. Today it is difficult to understand the extraordinary originality of this invention in 1830; countless later derivations from it dull our response to the freshness and force of David's prototypes in their own time. The seminality of this type is clear if we compare the *Jefferson* with the still Neoclassical contemporary portrait monuments by Thorvaldsen, and then with characteristic examples of half a century later, such as Saint-Gaudens' *Farragut* or J. Q. A. Ward's *Beecher* in New York.[43]

Fig. 7. David d'Angers, *Ludwig Tieck*, 1834. Bronze. Spencer Museum of Art, University of Kansas, Lawrence, Kansas.

David's 1834 statuette of a seated Ludwig Tieck (fig. 7) is less influential only because the majority of nineteenth-century public portrait statues were of standing figures. The *Tieck*, widely distributed in small plaster and bronze casts, was undoubtedly known by artists on this side of the Atlantic.[44] If David's was the single most important source for the nineteenth-century sculptural portrait style, the characteristics of the Troubadour school undoubtedly also affected the portrayal of historical statues. For Ward, though his works were largely of American subjects (rather than the medieval themes presented by the Troubadours), they nevertheless reveal the Troubadours' preoccupation with historical accuracy both in the presentation of events celebrated and in the likenesses and costumes of their subjects.[45]

Through his friendship with Richard Morris Hunt and the younger American men trained in Paris, and on his two trips abroad, Ward was directly exposed to the excitement of the emerging neo-baroque style of the Beaux-Arts movement. Although he was proudly independent and chauvinistic in his own work and in his desire to aid the development of an American school of sculpture (which kept him apart from the movement), he found much scope in the style for the expansion of his ideas. He took it to himself and used it well. As president of the National Sculpture Society, he championed the cause of large public art programs and was responsible for some of the most imaginative Beaux-Arts projects ever to integrate successfully the forms of architecture and sculpture in this country. His mature portraiture similarly reflects his total understanding and mastery of the Beaux-Arts principles, evident in the realism of his likenesses, his richly textured surfaces, and the natural, candid manner in which he posed his subjects. Ward's interpretation of the Beaux-Arts style is not as flamboyant as that of some of the younger, Paris-trained men, but in his truthful, psychologically penetrating portraits are a vigor and verve equalled during that period only in the work of Thomas Eakins and Augustus Saint-Gaudens.

Ward, though influenced to varying degrees by classical, Renaissance, and nineteenth-century French art, was nevertheless first and foremost an American artist. Because he always insisted on working directly from nature, the deep, unswerving, constant, and fundamental quality of his sculpture is naturalism. He examined other movements: he fused the poses, gestures, and stylistic characteristics of other schools into his work, but he never allowed them to overwhelm it. In his art, then, as in every other facet of his life, he was his own man.

Ward's career must be assessed within that broad context. He was a pioneer in his field and a leader in it for fifty years. During the eighteen-sixties and seventies he was correctly recognized as one of the foremost of a group of post–Civil War realist artists, but his work and his position in American sculpture reached their apex during the last quarter of the nineteenth century largely because of his espousal of the rejuvenated naturalism practised by his French contemporaries. His association with the progressive tendencies in American art was recognized by artists and critics alike, while his stature as "dean" of American sculpture was acknowledged by Homer Saint-Gaudens in 1913:

> The Italian school had nearly vanished, together with the smug neatness or uncontrolled abandon of the amateur age. Instead the Paris-trained men had arrived to govern American feeling with a true sense of form and sculptural ideas. Three of these artists in especial, J. Q. A. Ward, Olin Warner, and Daniel Chester French, joined with my father in discovering the path that led out from the forest of petrified heroes and galvanized athletes of the early days. Ward had become unquestionably the dean of sculptors.[46]

The Beginnings, 1830–49

John Quincy Adams Ward, affectionately known to his family and friends as "Quincy,"[47] was born on June 29, 1830, in the small rural town of Urbana in Champaign County, Ohio. There was little in his background to suggest his future success as a sculptor. The family proudly traced its lineage back to John Ward, who had settled in Jamestown, Virginia, in the seven-

teenth century, but in young Quincy's mind his principal ancestor was undoubtedly his grandfather Colonel William Ward, who had founded Urbana in 1805.[48] A stern, patriarchal figure, Colonel Ward was born in Greenbriar County, Virginia, on December 14, 1752.[49] After serving in the revolutionary war he moved his family to Kentucky, but was then drawn on to the Ohio Territory, where his younger brother John had been taken in 1758 after his capture by Shawnee Indians.[50] In 1866, recounting events in Colonel Ward's life, one of Quincy's uncles wrote:

> [Colonel] Ward and [Simon] Kenton were the pioneers of this part of Ohio. They were both Virginians by birth—Kenton had been a pioneer with [Daniel] Boone in Kentucky, and in the frequent encounters with the Indians had been taken prisoner and carried to the Mackechack and Broad River town, where he found the family of a brother of Ward who had been carried away captive from Virginia during childhood and adopted and reared by the Indians, among whom he married and raised up a family. He remembered his family name, and often tried to visit his friends, but never got to see any of them, and finally lost his life in trying to make his way back to his family in hopes of making peace through them between the Whites and Indians.[51]

In 1802, Colonel Ward finally settled in Springfield, Ohio, where he continued to maintain some ties with his deceased brother's Indian family. That Quincy had Indian relatives could explain his later sensitive renderings both of Indian subjects and of members of other minority groups.

Colonel Ward achieved economic security for his family and its future generations in 1805, when Champaign County was legally formed. He acquired a hundred and sixty acres of land that he foresaw as the most logical site for the new county seat, and he was able to convince the county commissioners of the wisdom of his point of view. Thus he became the proprietor of what would become the town of Urbana.[52] His speculative success was matched by his agricultural achievements. His farm had been from the start one of the most profitable in the new area: his orchard was one of the first to bear fruit, and his livestock was regarded as the best in the country.[53] Now affluent and the father of a large family, he built a handsome farmhouse that still stands on College Street in Urbana (fig. 8). That was the birthplace of John Quincy Adams Ward.

Fig. 8. Ward homestead, Urbana, Ohio. Photograph. Collection of Mr. and Mrs. Oliver E. Shipp, Newburgh, New York.

When Colonel Ward died on December 24, 1822,[54] his son John Anderson Ward inherited the family homestead and six hundred acres of land.[55] John, with his new-found financial security, married Eleanor Macbeth (cat. no. 3),[56] whose parents had come from Cumberland County, Pennsylvania, with their nine children. In 1807 they had settled on a farm about six miles south of Urbana.[57] The Wards and the Macbeths had been on friendly terms from the beginning, for Colonel Ward had given the new homesteaders the necessary supplies to get through the first hard year in their new surroundings. Eleanor's brother J. R. Macbeth gave a telling account of his family's initial encounter with Colonel Ward:

> When our family moved into Ohio the country was new and produce scarce—but few farmers had any surplus to spare—and it was a matter of importance to secure something to eat until a crop could be raised. After inquiring for potatoes in various places without success, my mother stopped the Colonel when he was riding by and asked him if he had any potatoes to sell. The prompt reply was: "No, Madam—none to sell—but plenty to give away to new settlers."[58]

John and Eleanor continued to work the farm and to oversee the land they had inherited. They were kept equally busy with the rearing of their family of eight children. Quincy, so named because of his father's deep admiration for the country's sixth president, was the fourth child of this marriage, coming after Eliza, William, and Jane, and before Eleanor, Mary, Rachel, and Edgar.[59] As the son of a prosperous farmer Quincy had all the advantages that Urbana could offer. He received his instruction first from teachers in the family and then in the village schools,[60] which were run by a Miss Lazure and one "Bunty" Robinson.[61] He later studied with John Ogden, "a good scholar and worthy lawyer," who lived in Urbana.[62] Quincy, however, by reading a set of the *Encyclopedia Britannica* that was in his father's library, acquired much of his education by himself. In 1871, in one of the first major articles written about him, it was said that there the young boy initially read of drawing and modeling and "had his first revelation of the possibilities of Art" that kindled his desire to become a sculptor.[63]

Even as a boy Ward was obsessed with the idea of expressing himself in three-dimensional form. As he said in an 1899 interview with Theodore Dreiser:

> I cannot remember the time when I did not want to express myself in form. During my first year at school, which was my sixth in age, I had got so far with my natural instinct as to fashion crude figures out of mud. So strong and satisfying was this taste in me that I had much rather sit down by the creek-bed trying to make the head of a man than go a-fishing. On Saturdays I would work all day long on my hobby. I had a little crevice in a mill-dam where I hid my tools and things before I went home.[64]

Preoccupied with modeling, he formed small animals, figures on horseback, sawmills, and completely populated villages. His father was apprehensive about the ramifications of this hobby, but as Ward later told Dreiser:

> I think he was rather proud of my remarkable diversion, altho he was not the sort of father who would have said so in my presence. He was a quiet, reserved Presbyterian, and said little at any time. Still he must have talked of the matter, for altho I said nothing, the fact that I modelled heads and figures out of clay got around our little town. People came down to our house at the end of the village "to see the queer things Mr. Ward's boy had been making."[65]

The youth's interest in modeling was encouraged by a neighbor, a local potter named Miles Chatfield. Ward, eleven at the time, was given the run of Chatfield's workshop, where he acquired a knowledge of the craftsman's tools and learned to turn a pot and to decorate it with bas-reliefs.[66] At fifteen he was reportedly working on a three-dimensional figure, using an engraving as his model.[67] The most complete account of Ward's early efforts was given by his good friend William Dean Howells:

> His earliest attempt was a figure modeled in wax which one of his sisters used in making wax

flowers, and which he clandestinely borrowed. Then he made a bas-relief of the first train of cars he ever saw, but this he did in clay at the village potter's; and he also modeled in clay the head of a Negro, well-known in the place, which we neighbors recognized.[68]

His parents, while interested in their sixteen-year-old son's sculptural efforts and perhaps proud of him, felt it was time he applied himself to something more constructive—something with a more promising future. As a result, Ward spent several years working on his father's farm.[69] It was during this period that Ward encountered Hiram Powers' statue of *The Greek Slave* when it was exhibited in Cincinnati in 1847.[70] He must have been overwhelmed and discouraged by that most celebrated piece of contemporary sculpture. Unfamiliar with the production techniques of marble statuary, he could not have realized that a sculptor did not merely sit in front of a block of stone and let the chips fly,[71] nor could he have known that nineteenth-century sculptors hired professional stonecutters rather than do their own carving. Speaking later to Dreiser of his naiveté, he said:

> I was sure that beautiful work was not done that way, and that my poor slow-modeled clay images were but an evidence of my dullness. I felt a deep, bitter resentment in my heart because my fingers were slow and my sense of accuracy uncertain. That made me think of abandoning the struggle and taking up any chance business opportunity that offered, and often in my heart I gave up with an agonizing sense of separation and loss my dreamed-of career and turned to home affairs.[72]

Ward, completely disheartened regarding a career as a sculptor, was discontented with the routine of farm life, and his family proposed that he study medicine.[73] After only a short time he contracted malaria and was forced to abandon his studies.[74] His time had not been wasted. The anatomical knowledge he would have acquired during that period was undoubtedly invaluable when, eventually, he turned to sculpture.

The Apprentice, 1849–56

While Ward was recuperating from his illness, his sister Eliza, who had married Jonathan Wheelock Thomas, a successful Brooklyn merchant, arrived in Urbana to visit her parents. Eliza was sympathetic to her brother's interest in sculpture, and when she returned home, she approached Henry Kirke Brown, a Brooklyn sculptor, about the possibility of his accepting her brother as a student.[75] Brown offered little encouragement, warning of the hardships of such a pursuit and pointing out the slim chance of success at the end of the struggle. Eliza wrote to her brother, "If you think you have genius of the highest order, then you may come on and study."[76]

Ward was willing to accept the hardships and the risk of failure, but he shrank from the demand that he admit to "genius of the highest order." He therefore did not go to Brown's studio until later, when at the age of nineteen and recuperating from a second illness, he decided to visit his sister in Brooklyn.[77] While there he carved an alabaster figurine of an old Irish workman (cat. no. 1) with "patches in his trousers, the vent in his coat, and the creases in his narrow-brim stove-pipe hat."[78] Eliza was so taken with the small statuette that she reportedly took it to Brown, who announced, "This boy has something in him."[79] It was only then that Ward mustered up his courage and accepted an invitation to meet with Brown. When he reached the sculptor's studio, as he later told Dreiser:

> Some statuary was being moved out and the door was open. I walked in unheeded. The great place was barn-like, but full of the bits of figure-work that I had long craved to see. No one seemed to be or to have been hewing anything. A few barrels of clay were in the corner, some revolving stands in another. A young man, stretched prone upon the floor, was diligently studying an anatomical chart. As I waited and gazed about the truth dawned upon me. There was no invariable need of hewing and making the chips fly. Artists modeled as I had tried to do. A great load lifted from me instantly, and I faced the master of the place with a light heart.[80]

During their initial encounter, in order to judge if the youth had sufficient talent to pursue a sculptor's career, Brown asked Ward to model something. With enthusiasm derived from his new realization and from at last being given the chance to prove his capabilities, Ward left the studio to acquire some clay and a plaster cast of the *Venus de Medici*.[81] He modeled a small statue after the *Venus* at his sister's home, and took his figure to Brown's studio, leaving it for the sculptor to inspect. When Ward returned several days later, Brown said "some flattering things, and ended by offering to take Quincy as a pupil."[82] Within a year, Ward had been engaged as one of Brown's assistants, and was receiving wages for his modeling.[83]

Ward spent seven years—from 1849 to 1856—in Brown's studio,[84] during which time the master exerted a profound influence on him, helping to shape not only his sculptural style and technical proficiency but also his attitudes toward art in general. In his youth in rural Ohio, far removed from any knowledge of the aesthetics of neoclassicism, Ward had turned to the natural world around him for inspiration in fashioning his "crude figures out of mud." During his apprenticeship, his naturalistic predilection was reinforced by Brown, who had rejected a secure career as a neoclassical sculptor in Italy in order to devote his artistic energy in his native country to the portrayal of American themes. Ward adopted Brown's credo as his own, employing in his work his mentor's simple, direct naturalism.

With the opportunity to work in clay, plaster, marble, and bronze, Ward learned the basic elements of the sculptor's craft. Brown was a good craftsman—a master stonecutter—and one of the first American sculptors to work in bronze. Ward's introduction to that metal at an early age and his almost continuous use of it during his apprenticeship might partly explain his later success in working it. Brown, a skillful draftsman, had Ward copy faithfully a sixteenth-century anatomical drawing by Albrecht Dürer (fig. 9),[85] and provided Ward and his other studio assistants with the advantage of live models at regular evening drawing classes.[86] Brown's home in Brooklyn was always open to his assistants, and Mrs. Brown took a motherly interest in each of the young men.[87] Larkin Mead, who had been a studio assistant along with Ward, wrote lightheartedly to him in 1856: "When we used to room together in the studio we did not allow anyone to eat more cookies & gingerbread etc. than we."[88] During this considerate and invaluable apprenticeship, Ward found himself in the midst of

Fig. 9. Anatomical drawing with caption "Alberto Durero 1532." Pencil on paper. Inscribed on reverse: "Mr. Ward copied from H. K. Brown's study of proportions." American Academy of Arts and Letters, New York City.

one of the country's major artistic circles, which, as William Dean Howells later reported, included:

> Mr. [Sanford R.] Gifford, the painter, and such artists and connoisseurs as Mr. Daniel Huntington, Mr. Henry Gurdon Marquand, Mr. Richard Willis, Mr. Bromley Brown, Mr. Henry Peters Gray, Mr. Samuel Colman, Mr. William Page, Mr. Asher Brown Durand, Mr. William James Stillman, Mr. William Cullen Bryant and his family, Mr. William Ames, and the young Quincy Ward and Larkin Mead, and a host of others.[89]

The years of Ward's studies with Brown coincided with what were probably the most important and productive ones of the older sculptor's career. When Ward entered the studio, in 1849, Brown was working on a seven-foot-high statue, *Indian and Panther* (fig. 10)—a manifestation of his advocacy of native themes realistically depicted. (The *Indian and Panther* must have made a great impression on the young Ward, undoubtedly influencing his choice of subject and the rendering of it several years later in his first major work, *The Indian Hunter.*) In 1850 Brown began work on the statue of DeWitt Clinton (fig. 11) for Greenwood Cemetery in Brooklyn, a statue that provided Ward with his first real experience in bronze

Fig. 10. Henry Kirke Brown, *Indian and Panther*, about 1849. Bronze (?). Location unknown. Photograph. The Metropolitan Museum of Art, New York City.

Fig. 11. Henry Kirke Brown, *DeWitt Clinton*, 1850–52. Bronze. Green-wood Cemetery, Brooklyn, New York.

casting. Intoxicated by the sight of the first important piece of sculpture he had actually worked on and deeply impressed by Brown's clothing the figure in contemporary garb, draped with a great mantle—so solving the conflict between historical accuracy in the attire and the traditional manner of representing a heroic figure—Ward wrote to a friend: "I wish you could see it, so grand, so full of power, & feeling yet in perfect repose. The modern costume in which he has treated it [is] so beautifully adroitly managed that the strictest classic could not object, or the most fastidious historian, find an error."[90]

The *Clinton* was completed in 1852, and Ward returned to Urbana to visit his father, who was ailing.[91] Brown remained in Brooklyn working on a number of busts and bas-reliefs, but also preoccupied with contractual problems that had developed regarding an equestrian statue of George Washington that he and the sculptor Horatio Greenough had been commis-

sioned to execute for New York City. In a letter he wrote to Ward on July 17, Brown, in obvious frustration, told his assistant: "The farce about the statue of Washington is finished and the contract broken. When you return I will tell you the rest that you may understand how too many cooks spoil the broth."[92] Several months later Brown was given a new contract, this one calling for the completion of the statue in two years for a fee of $22,500.[93] With Ward again at his side, Brown launched into one of the most outstanding works to be executed in that era by an American sculptor (fig. 12). Ward would have been by then a participant in the careful preparatory work that included procuring the general's uniform from the Capitol and the decision to use a copy of Houdon's 1785 bust of Washington, taken from life, as the source of Brown's portrait.[94] Ward was probably also concerned with the technical problems of building a temporary studio to house the fourteen-foot-high statue; with the decision to work the statue in plaster rather than in clay; and with the selection of the famous classical equestrian statue of Marcus Aurelius on the Capitoline Hill, in Rome, to serve as the basic model. The statue was cast in the winter of 1854/55 by the Ames Manufacturing Company in Chicopee, Massachusetts, and Brown and Ward spent much of their time there supervising the work.[95] When the casting was finally completed, in May, the pieces were sent to the Brooklyn studio, where the laborious task of assembling and chasing the statue continued for the following year.[96]

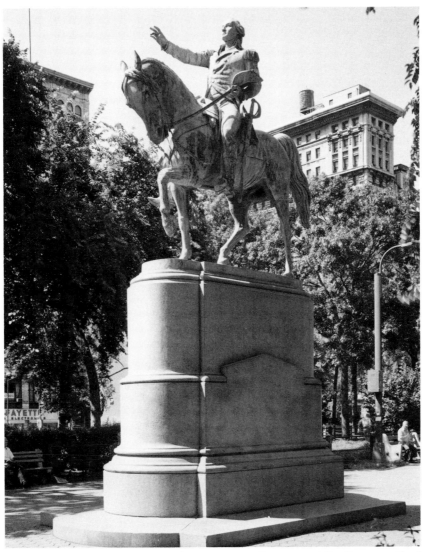

Fig. 12. *Equestrian Statue of George Washington*, 1852–56. Inscribed "H. K. Brown/Sculptor/JQA Ward Ast." Bronze. Union Square Park, New York City.

In 1856 Brown was spending a great deal of time in Washington, D.C., pursuing his ambition to secure a major commission in the capital. (His proposed design for the decoration of the Senate Pediment was rejected that March.)[97] Ward, left in charge at the Brooklyn studio, did much of the final work on the *Washington*. Dreiser wrote sagely when he said, "The apprentice toiled harder than the master and gave the work a strong smack of his genius."[98] Toward the end of the work there was a falling-out over some question of trade privileges between Brown and the French workmen who were assembling and chasing the statue, and the workmen went on strike. Dreiser reported the dramatic sequel:

> When the sculptor stood appalled at the delay the apprentice threw off his coat, and, seizing some tools, said he would finish placing it. No objection was offered, and like a workman he entered the body of the statue and hammered and filed away, bolting and riveting the work until in three days it was done.[99]

Ward later said that he had spent "more days inside that horse than Jonah did inside the whale."[100] Brown, in an unprecedented gesture of appreciation for Ward's contribution, inscribed on the finished statue, "JQA Ward Ast.," along with his own signature. His part in the project completed, Ward wrote to a friend in the summer of 1856 about watching the figure of Washington being put in place: "I was surprised at the coolness and unconcern he manifested while being hoisted in his awkward and stiff action in the presence of a large multitude—we account for it from the quality of brass in his face."[101]

To evaluate the total effect that Brown had on Ward is impossible, but the young sculptor's deep admiration and respect for his mentor is revealed in a letter he wrote in 1852:

> I find in the companionship of Mr. Brown a purer, nobler, & more exalting influence than it is possible for young persons to impart. When he speaks of art 'tis no boyish thought, it leaves an impression, & I always try to keep at such a distance from him as may give respect to his words. He is my Master in art & as such I will ever regard him. Nor does that prevent him from being pleasant and agreeable.[102]

The master–student relationship developed in time into a lasting friendship. The two became constant companions, hunting and fishing together and spending endless hours in philosophical discussions of life and the pursuit of artistic ideals. Reflecting later on Ward's apprenticeship, Dreiser revealed that Brown had publicly declared:

> [Ward] is a sculptor of great originality, accuracy, and power. He was seven years in my studio, closely applied to study, devoted to severe routine work—the discipline of which is the basis and stepping-stone to great achievement. When he left me he did not comprehend his powers, nor anticipate their result. I did not perceive his gifts fully until one day he placed before me a little model of the Indian and Dog. I remember well that on occasion of converse with other and less laboriously drilled art students Ward would speak impatiently of the lack of knowledge on their part, not seeing that such observation as a result of comparison of acquirements was due to his superior knowledge, rather than to their lack of it. Once, when he was most impatient, I reminded him of the [value of routine lesson and study practice]. After that Ward was content to practice and not originate in my service, and the value of his training has been exemplified.[103]

While a member of Brown's studio, Ward executed a marble relief of his mother, Eleanor Macbeth Ward (cat. no. 3), and a marble bust of his brother-in-law Jonathan Wheelock Thomas (cat. no. 5; fig. 13). These are among Ward's earliest extant works. The obvious influence of Brown's sculpture is revealed in both Ward portraits: they are conceived in sharply drawn lines and in broad planes with smoothly polished surfaces; their hair and drapery have a stylized quality. There is a strong stylistic similarity between Ward's bust of *Thomas* and the one Brown did in 1847 of Asher B. Durand (fig. 14), exemplifying the master's effect on the student's work. More fundamental, however, is the proficiency that young Ward demonstrated in modeling and executing literal, realistic portraits infused with a psychological sensitivity. This humanistic naturalism was already in the 1850s the essence of his sculpture.

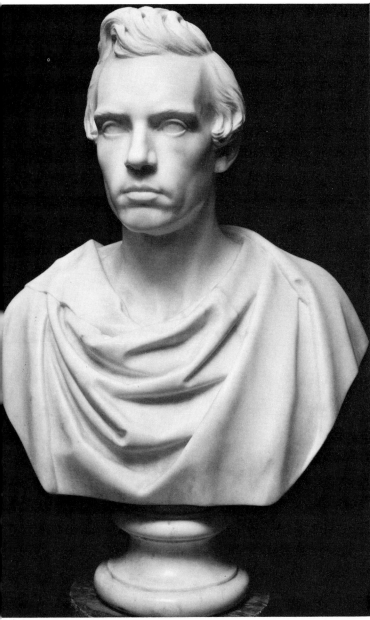

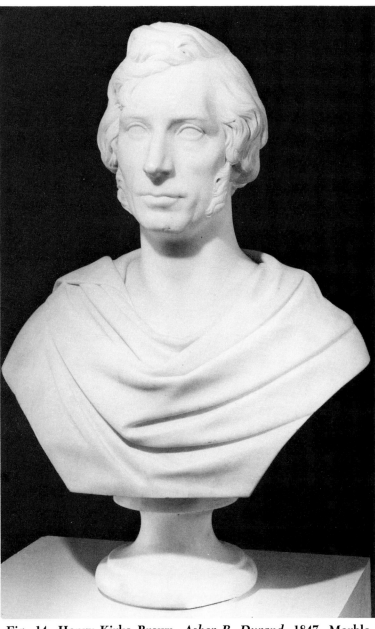

Fig. 14. Henry Kirke Brown, *Asher B. Durand*, 1847. Marble. National Academy of Design, New York City.

Fig. 13. John Quincy Adams Ward, *Jonathan Wheelock Thomas*, about 1855. Marble. Collection of Edward Pawlin, Old Lyme, Connecticut.

The Early Career, 1856–64

About the time the *Washington* was erected, in July 1856, Ward's apprenticeship was concluded. Now twenty-six years old, he was undoubtedly eager to begin his own career, and since Brown at the moment had no large projects on hand, it was a natural time for the young sculptor to leave his master. After a brief trip to New England[104] and a visit to Ohio[105] he returned to Brooklyn. Brown had moved to Newburgh, New York, and Ward took over the sculptor's Brooklyn studio (fig. 15).[106] In 1857, from Newburgh, Brown wrote a fatherly letter to Ward:

I have a peculiar superstition about your going west. Not that it is not all right but that you are wandering away from the old hive! I just begin to realize that you are no longer a boy. God knows what others feel when their own sons grow up and go away but I know this that I have a feeling as

Fig. 15. John Quincy Adams Ward's drawing of the back entrance to Henry Kirke Brown's studio on Pacific Street, Brooklyn, New York, 1854. Pencil on paper. Albany Institute of History and Art, Albany, New York.

tho' my right half had caved in, but go where you will you cannot escape my good will! Your good judgment will direct you towards your highest best interest always I trust—and I cannot but hope you may bring back your arms full of commissions to the old hole where we have worked together so long.[107]

It was a difficult time to establish a career as a sculptor. After a period of great financial prosperity the country was experiencing an economic slump that lasted for several years. The depression was caused by the drop in agricultural prices resulting from the abrupt end to overseas demand for American farm products at the end of the Crimean War (1854–56). Ward nonetheless received commissions for portrait busts and for other work, apparently, and also embarked on his first studies for what would be *The Indian Hunter* and the *Simon Kenton*, as well as other compositions.

On February 10, 1858, Ward married Anna Bannan, an intelligent and devoted woman who was to exert a profoundly beneficent influence on Ward and his art during their years together.[108] Sometime after that the Wards moved to Washington, where Ward set up a studio in the Capitol.[109] Commissions were not plentiful, however, as Brown referred to in a letter he wrote to Ward in the spring of 1859:

> Yours of the 5 inst has just reached me and I am very glad to hear from you altho I could wish that you were more occupied in your art to your liking. But for God's sake don't be discouraged. You are passing through a sad ordeal to be sure but it is fortunate that it happened early in life. When you once get commenced the sky will clear up to you and the world will seem fair.[110]

The Wards must have been encouraged by President Buchanan's appointment in 1859 of Henry Kirke Brown, James R. Lamdin, and John F. Kensett to a newly established Federal Art Commission. The commission proposed an expenditure of $166,900 for the decoration of the Capitol, but Congress refused to appropriate such a large sum. Without funds, the commission was abolished in 1860,[111] and with its demise Ward's hope of obtaining a major sculptural project in Washington faded.

Ward nonetheless continued to work on several compositions and to support himself and his wife by doing busts of prominent political figures. In 1859 he had exhibited a statuette of *The Indian Hunter* (cat. no. 12; Pls. II, IV; fig. 18) at the Washington Art Association and statuettes of *The Indian Hunter* and the Ohio pioneer Simon Kenton (cat. no. 7; fig. 16) at the Pennsylvania Academy of the Fine Arts. The popular New York portrait painter Henry Peters Gray was probably referring to these two works when on January 22, 1859, he wrote to Ward:

> I left Wash. so suddenly that it escaped my mind to say anything further to you about your works, which as I told you sincerely, made a great impression on me.
> I confess candidly to a partiality to the Indian (without disparaging the woodsman) probably on account of the figure being nude. But I desire to have the pleasure to present it to the Century Club as I said to you, or *perhaps both of them* if you would prefer, I really hope you will permit me as soon as possible.[112]

Fig. 16. **John Quincy Adams Ward, *Simon Kenton,* 1857. Painted plaster. Collection of Mr. and Mrs. Oliver E. Shipp, Newburgh, New York.**

Fig. 17. *Apollo Belvedere.* **Marble. The Vatican Museums.**

Fig. 18. John Quincy Adams Ward, *The Indian Hunter*, 1860. Bronze. The Metropolitan Museum of Art, New York City.

Ward's statuettes of *The Indian Hunter* and the *Simon Kenton*, praised at the time for their naturalism, are nevertheless both derived from influential pieces of antique sculpture. The *Kenton* exhibits the same graceful contrapposto found in the *Apollo Belvedere* (fig. 17), and while it may seem incongruous to think of the *Apollo Belvedere* in frontier dress, it should be remembered that when Benjamin West first saw the classical piece in Rome, he commented, "My God, how like it is to a young Mohawk warrior!"[113] *The Indian Hunter* (fig. 18) bears a striking resemblance in pose to the *Borghese Gladiator* (fig. 19), a cast of which Larkin Mead in 1856 referred to as being in Brown's studio;[114] a similar cast appears in a later photograph of Ward's studio (fig. 3). The powerful legs of the young Indian, frozen in the midst of a long stride, correspond to those of the fighting gladiator, and though the Indian's torso and head turn to the right and the gladiator's to the left, the two figures have the same strong diagonal carried down the back through the disengaged leg.

Ward, coming to the realization that no government commission was forthcoming, thought seriously of going to Europe for a period of travel and study.[115] He abandoned his plans when

Fig. 19. *Borghese Gladiator.* Marble. Musée du Louvre, Paris.

the possibility arose that he would be asked to convert his *Kenton* statuette into a public monument for Columbus, Ohio, and the Wards spent the winter and spring of 1860/61 in Columbus. William Dean Howells, then a reporter for the *Columbus Journal,* later gave an account of that period:

> The great sculptor, J.Q.A. Ward . . . had come to the capital of his native state in the hope of a legislative commission for a statue of Simon Kenton. It was a hope rather than a scheme, but we were near enough to the pioneer period for the members to be moved by the sight of the old Indian Fighter in his hunting-shirt and squirrel-skin cap, whom every Ohio boy had heard of, and Ward was provisionally given a handsome room with a good light, in the State House. . . . But the "Kenton" was never to be eternized in bronze or marble for that niche in the rotunda of the capitol where Ward may have imagined it finding itself. The cloud thickened over us, and burst at last in the shot fired on Fort Sumter; the legislature appropriated a million dollars as the contribution of the state to the expenses of the war, and Ward's hopes vanished as utterly as if the bolt had smitten his plaster model into dust.[116]

In Columbus, Ward modeled a bust of William Dennison (cat. no. 17; fig. 20), the gover-

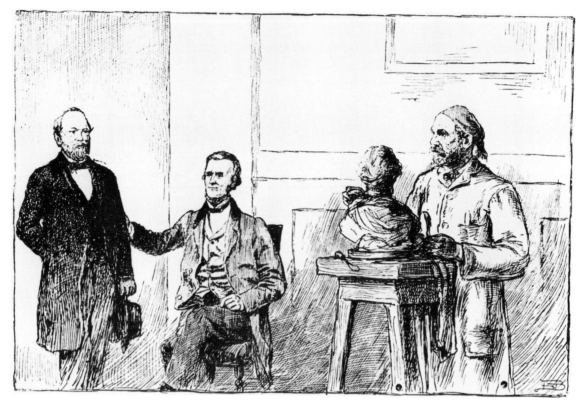

Fig. 20. John Quincy Adams Ward modeling the bust of *Governor William Dennison*, about 1861. Reproduced from Alexander Black, *The Story of Ohio*, 1888, p. 293.

nor of Ohio who would later serve as chairman of the Republican National Convention and then be appointed postmaster general by Abraham Lincoln. With this his only known commission, Ward and his wife left Columbus for New York. He must have been in low spirits. His hopes of being awarded a contract to execute the *Kenton* had been dashed by the outbreak of war; he was faced with the decision of whether or not to enlist in the army; and his departure also meant the end of a number of stimulating associations. Though he lived "much to himself in Columbus,"[117] he had become friendly with such future notables as Howells and Whitelaw Reid, who would one day be editor of the *New York Tribune*. The friendship between Howells and Ward was especially warm. Howells often visited the sculptor in his studio, where the two men discussed literature, art, aesthetic life in New York City, and, when nothing else, themselves, their convictions, and their ambitions. They frequently dined together, took long walks in a local park, and vied in athletic feats which, Howells admitted, Ward won easily.[118] Before he left Columbus, Ward modeled a relief portrait of Howells (cat. no. 18).

Back in New York, Ward decided not to enlist in the army but to continue his work in sculpture. Howells, on hearing of the struggling artist's decision, wrote to him: "I'm glad you're not going into the army. It would have been the end of you as a sculptor, and I don't think this beastly ungrateful world can really spare you, though it makes no great provision for keeping you."[119]

A nation plunged into war had little interest or money to expend on the arts, but Ward nevertheless rented space in the Dodsworth, a popular studio building for New York artists,[120] and earned much of his living during the next few years by modeling small art objects and the military presentation pieces that were then much in demand. The Ames Manufacturing Company, which had cast the *DeWitt Clinton* and the equestrian *Washington* for Brown, employed Ward to model, among other objects, a small table bell (cat. no. 20), tops for canes (cat. no. 31), and elaborate presentation swords for the Union officers Admiral Andrew Hull Foote (cat. no. 23), General Richard James Oglesby (cat. no. 24), and General Ulysses S.

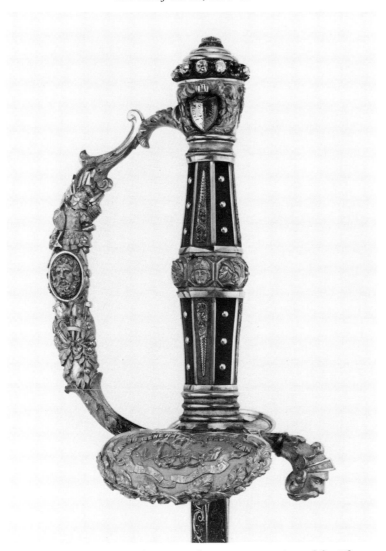

Fig. 21. John Quincy Adams Ward, *Presentation Sword for Ulysses S. Grant*, 1863. Steel, goldplate, diamonds, and tortoise shell. National Museum of American History, Smithsonian Institution, Washington, D.C.

Grant (cat. no. 22; fig. 21). Though Ward is generally believed to have worked exclusively for the Ames company during this period, the New York founder L.A. Amouroux also cast for him a number of small commissions—a bronze box (cat. no. 26), a matchbox (cat. no. 25), a small vase (cat. no 33). For the State Department, Ward made official presentation pieces including two swords for the kings of Siam (cat. no. 28) and a pair of pistol handles "cast in silver, covered with figures, and the barrels inlaid with gold"[121] for a Turkish governor (cat. no. 30). Through the architect Calvert Vaux he received a commission in March 1863 to model a "relief design for a medal" (cat. no. 27) for the Sanitary Commission (a forerunner of the Red Cross) in Washington, D.C.

During the war he also executed several busts and statuettes. In 1862, he displayed the bust of Henry Peters Gray (cat. no. 19) and a bronze statuette of *The Indian Hunter* at the annual spring exhibition of the National Academy of Design. The two works were enthusiastically received, and Ward was elected an Associate of the academy.[122] It was probably in the fall of 1862 that Ward began work on *The Freedman* (cat. no. 21; Pl. V; fig. 22), a statuette of a seminude Negro from whose wrists hang the remnants of the chains that once bound him. An interpretation in sculptural form of the Emancipation Proclamation issued on September 22,

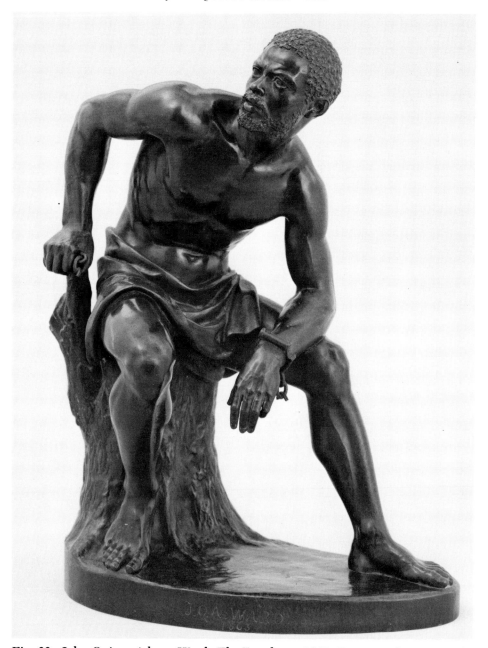

Fig. 22. John Quincy Adams Ward, *The Freedman*, 1863. Bronze. The Metropolitan Museum of Art, New York City.

1862, by President Lincoln, the work reflects not only Ward's abolitionist sentiments but, more important, his profound desire to create through his work relevant statements on the political and moral issues of the day. It may have been that desire that influenced his decision to remain out of the army, possibly in the belief that patriotism expressed through art was for him a more potent weapon than a rifle. Ward completed the work in plaster in time for the annual academy exhibition in May 1863. Modeled from life, *The Freedman* was one of the first and most accurate sculptural representations of an American black. Ward's composition shows his obvious acquaintance with its prototype, the antique sculpture of the *Belvedere Torso* (fig. 23),[123] but the overriding quality of the work is, as always, naturalism. The statuette was poorly displayed at the National Academy, yet it was widely acclaimed, and in recognition of its merits Ward was elected an Academician.[124] An article praising *The Freedman* appeared in a *New York Times* review of the academy exhibition,[125] and in 1864 James Jackson Jarves, a prominent American art critic, described the work:

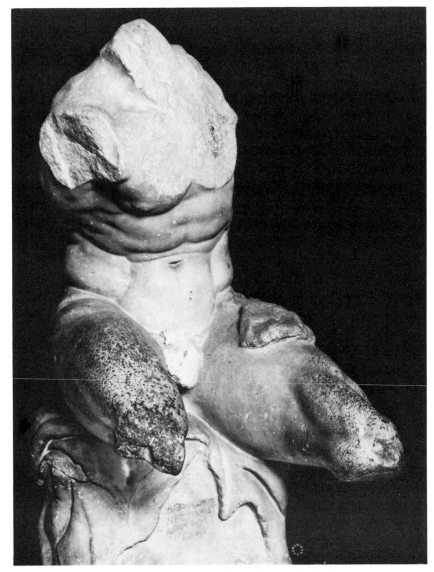

Fig. 23. *Belvedere Torso.* Marble. The Vatican Museums.

A genuine inspiration of American history, noble in thought and lofty in sentiment. It is a simple statuette, to us the work of an unknown name, and the sole one we have had the good fortune to see. We refer to the African Freedman, of the New York Academy Exhibition, 1863, by Ward. A naked slave has burst his shackles, and, with uplifted face, thanks God for freedom. It symbolizes the African race of America,—the birthday of the new people. . . . We have seen nothing in our sculpture more soul-lifting, or more comprehensively eloquent. It tells in one word the whole sad tale of slavery and the bright story of emancipation. In spiritual significance and heroic design it partakes of the character of Blake's unique drawing of Death's Door, in his illustration of the Grave. The negro is true to his type, of naturalistic fidelity of limbs, in form and strength suggesting the colossal, and yet of an ideal beauty, made divine by the divinity of art. . . . It is the hint of a great work, which, put into heroic size, should become the companion of the Washington of our nation's Capitol, to commemorate the crowning virtue of democratic institutions in the final liberty of the slave.[126]

Between 1863 and 1864 Ward modeled a small equestrian relief of the popular Union general George B. McClellan (cat. no. 32) from a design drawn by F. O. C. Darley, a well-known illustrator. A patent for the relief was issued on January 14, 1864, to James F. Drummond, a man whose portrait Ward also modeled (cat. no. 34). The McClellan relief, cast in bronze or silver and only eighteen and three-quarters inches high, marked the only occasion in Ward's career that he produced a work for commercial distribution.

Although a commission for a major public monument had eluded Ward in the eight years since leaving Brown's studio, he had created half a dozen busts. As with that of Alexander Stephens (fig. 24), which is the only dated portrait located from this period, he intended them all to be carved in marble. While the *Stephens* is a naturalistic likeness, Ward, by his stylized treatment of the hair and the drapery and by his rendering the surface smooth and completely untextured, continues to evince an Italianate quality. By contrast, in the statuettes of *The Indian Hunter,* the *Simon Kenton,* and *The Freedman,* which were modeled in the hope that they would be enlarged, the naturalism is more radical: they were intended to be executed in bronze, and while the composition of each is derived from antique sculpture, all are realistically observed, and with a naturalistic detail never before attained by an American sculptor. The *Kenton* and *The Freedman* were destined never to be enlarged, but when *The Indian Hunter* was, its success established Ward as one of the leading proponents of post–Civil War realism.

The Post–Civil War Realist, 1865–72

The income Ward derived from modeling busts, presentation pieces, and small art objects enabled him to undertake the enlargement of *The Indian Hunter* statuette into a life-size plaster cast. Before he began work on the project, Ward traveled to the Dakotas in order to make additional studies of the American Indian in his native habitat, there carefully recording his observations in a number of pencil (fig. 25) and small red wax sketches (fig. 26). In

**Fig. 24. John Quincy Adams Ward, *Alexander Hamilton Stephens,* 1858.
Plaster. The Museum of the Confederacy, Richmond, Virginia.**

Fig. 25. John Quincy Adams Ward, study for *The Indian Hunter*, 1857–64. Pencil on paper. Albany Institute of History and Art, Albany, New York.

Fig. 26. John Quincy Adams Ward, studies for *The Indian Hunter*, 1857–64. Wax American Academy of Arts and Letters, New York City.

1867, the wax images were said to be "amongst the most authentic aboriginal physiognomical types extant in plastic art, so careful in detail are they executed."[127]

The life-size cast of *The Indian Hunter* was displayed in a Broadway building in New York in the fall of 1865 (cat. no. 38; fig. 27). A newspaper article reported:

> The gallery where this work is exhibited is in the rear of Mr. Snedicor's Picture Frame Store. No price is charged for admission. Besides The Indian Hunter, there are a large number of fine paintings on exhibition there, among which are Cropsey's "October," Coleman's "Alhambra," and some excellent work of our friend Tait of Woodstock.[128]

Ward made only a few minor changes in the enlarged version—the aboriginal quality of the facial features was intensified, the bow arm was raised, and the size of the animal skin worn around the figure's waist was reduced. In that era of public preoccupation with the romance of Indian life, the statue was enthusiastically praised not only for the American theme it portrayed but also for its noble but realistic representation. On June 21, 1866, after having received financial support from a group of some twenty-three private citizens, Ward signed a contract with the founder L. A. Amouroux to have the statue cast in bronze for $10,000. He then sent the finished work and a statuette of *The Freedman* to the Paris Exposition of 1867. When *The Indian Hunter* returned to the United States in 1868, it was exhibited at the National Academy of Design in New York along with the other American entries to the Exposition. On December 28, 1868, the statue was officially presented by its subscribers to

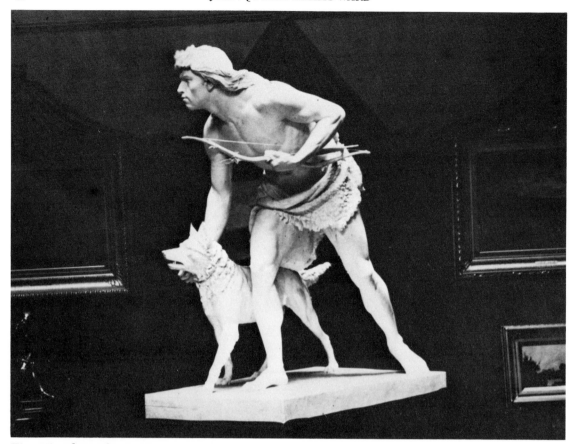

Fig. 27. *The Indian Hunter*, Snedicor's Gallery, 1865. Photograph by Mathew Brady. National Academy of Design, New York City.

the city of New York for permanent display in Central Park, the first work by an American sculptor to be erected there (fig. 28; Pl. III). It has been one of the most admired and popular works in the park ever since.

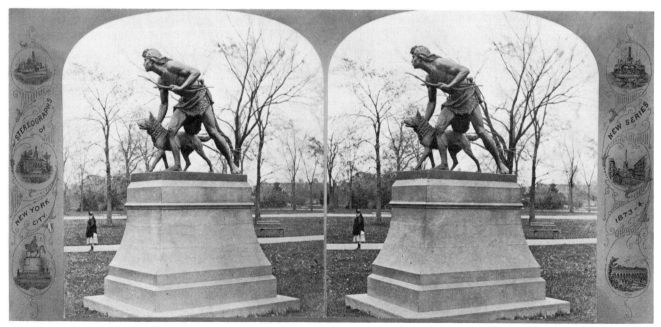

Fig. 28. John Quincy Adams Ward, *The Indian Hunter*, about 1874. Bronze. Central Park, New York City. Stereograph. The New-York Historical Society, New York City.

Ward had demonstrated with *The Indian Hunter* his ability to handle an ideal subject, but, as he wrote in 1895: "[There was no] bread and butter in it. About the time that I finished the "Indian Hunter" the craze for making statues of departed heroes and statesmen arrived. I was caught in the flood with the rest of the sculptors of the day."[129]

The effect *The Indian Hunter* had on American sculpture in 1865 cannot be overemphasized. Augustus Saint-Gaudens wrote of Ward in 1907: "His work and career, his virility and sincerity, have been a great incentive to me, from the day when he exhibited his *Indian Hunter* in an art store on the east side of Broadway. It was a revelation, and I know of nothing that had so powerful an influence on those early years."[130] The critical acclaim *The Indian Hunter* received marked the turning point in Ward's career. After seeing the plaster cast, the New York banker August Belmont contracted with Ward to model a statue of his father-in-law, Commodore Matthew C. Perry (cat. no. 46; Pl. VI; fig. 29), for the city of Newport, Rhode Island. The *Perry* commission began Ward's long and illustrious career as a sculptor of

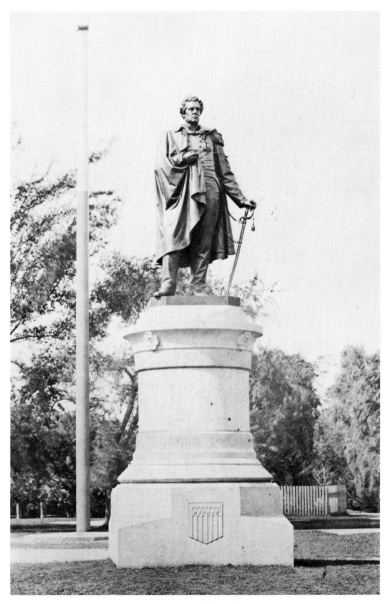

Fig. 29. *Commodore Matthew Calbraith Perry.* Bronze statue by John Quincy Adams Ward; granite pedestal by Richard Morris Hunt, 1868. Newport, Rhode Island. Photograph, before the 1870s, when Ward's relief panels were fitted onto the pedestal. The American Institute of Architects Foundation, Washington, D.C.

public monuments. As Ward told Montgomery Schuyler, the well-known art critic, in 1909, "From that day to this, I have never been without a commission."[131] (The Belmonts, one of the wealthiest families in America and generous patrons of the arts, commissioned Ward during the next quarter-century to do a number of sculptural projects.)[132] The *Perry*, the likeness derived from Erastus Dow Palmer's 1859 bust of the commodore (fig. 30), was erected on a pedestal designed by Richard Morris Hunt. Ward later encircled the cylindrical base with a bronze bas-relief frieze that portrayed the major events in Perry's naval career. The statue's pose, the use of a robe to simplify the details of the contemporary attire, and the frieze on the pedestal are reminiscent of the *DeWitt Clinton* (fig. 11), which Ward had worked on in Brown's studio.

At around the same time, Ward was approached by the architectural firm of Ware & van Brunt to create the sculpture for a monument they were designing. The work had been commissioned by a wealthy Boston philanthropist named Thomas Lee to commemorate the discovery of the anesthetic ether at the Massachusetts General Hospital on October 16, 1864. *The Ether Monument* (cat. no. 44) was to be erected in the Boston Public Garden, and Ward was asked to model the crowning work of the group, *The Good Samaritan*. He was also to provide for the monument's base four bas-reliefs: two to show the administration of ether

Fig. 30. Erastus Dow Palmer, *Commodore Matthew Calbraith Perry*, 1859. Memorial Museum of the United States Navy, Washington Naval Yard, Washington, D.C.

to patients, and the other two to be representations of the Triumph of Science and the Descent of the Angel of Mercy. The quasi-Gothic-revival monument that resulted, unveiled on September 25, 1868, represents one of the first collaborations between an American architect and a sculptor in which their individual skills are completely integrated, each element complementing the other in the overall conception and realization of a work of art.

In 1866, the City of New York invited "all the principal American sculptors" to submit a model for a proposed statue of William Shakespeare, in celebration of the tricentennial of the poet's birth. Ward's model, which won him the commission, was illustrated in *Harper's Weekly* (fig. 31).[133] The *Shakespeare* (cat. no. 50), Ward's second statue to be placed in Central Park (fig. 32), illustrates the basic ingredients of Ward's early work: a composition classically inspired and a subject realistically depicted. It was a basic formula that Ward was to employ in much of his sculpture until the end of his life, and it resulted in the accurate, objective, and naturalistic kind of portrait that was his unparalleled achievement. Ward wrote of his sources for the likeness:

> The Stratford bust I took as the most authoritative of all the representations of Shakespeare. It must, in my judgment, be regarded as better established than any of the others, notwithstanding the slip of the sculptor's chisel about the nostril, which compelled the shortening of the nose. Next to this in authenticity . . . I considered the Droeshout etching. . . . I was in possession . . . of the then recent volume "Life Portraits of Shakespeare" by J. Hain Friswell (London, 1864) and had also woodcuts of the Kesselstadt death-mask. But I attached little importance to any of the speculative material. The Stratford bust and the Droeshout print were the sources upon which I relied.[134]

For clothing the figure, Ward conferred with the noted Shakespearean actor Edwin Booth, who invited Ward to a play to see the kind of attire that the poet would have worn:

> I will obtain you as good seats as I can that you may have a full view of the stage . . . and among the costumes worn in the play you will observe the short slashed trunks, full cloak and doublet of Elizabeth's times, which did not go out of fashion entirely until during Chas. 1st. of England and Louis XIII of France. You will note the change in the occasional long trunks or breeches, falling below the knee, as worn by some characters. The slashed green and white—worn by A———(or the brown and pearl worn by him early in the play) with a full cloak, is the costume Shakespeare doubtless wore in "dress." The long *houberk* I think was worn as "undress" easy costume. I will see how I can manage the matter—for I am as anxious that Shakespeare should be properly clothed.[135]

Combined with Ward's careful researching of his subject and greatly augmenting the realism of his figure was his method of building up and modeling a statue, which he described in the following manner:

> Take an iron rod long enough to reach to the neck of the figure, and fasten it securely in a perpendicular position. The upper end must be directly under the pit of the throat, else the body will not stand well. Put some cross-pieces near the pelvis to support the clay, and see that the clay is thick enough. If not thick enough, it will have a tendency to roll down. For the bent leg and arm use pieces of lead pipe, which will bend easily, and can be adjusted at the proper angle after being covered with the clay. Iron pipe would be liable to oxidize, and besides, would be more or less brittle and unmanageable. All over the skeleton thus made put little iron crosses, still further to support the clay. The nearer the clay is to the skeleton and crosses, the stiffer it must be. This will make the figure more compact, and enable you to use softer clay in modelling the exterior. Then build up the body, putting on the large masses of clay at the waist, the head, foot, leg, and so on; the order is not important. It is important only to keep all the parts of the figure at about the same stage of completion, so that you can judge intelligently of their relation to one another. It wouldn't do, for instance, to finish the head before beginning to model the bust, for when the bust was done, the head might require a good deal of changing. No matter how the figure is to be draped, always model it in the nude first, so as to feel the masses and the movement of the figure.[136]

Though Ward devoted most of his career to portraiture, he also accepted a number of architectural sculpture commissions, most of which were done in a decorative, classical revival style. The first of these was a statue group titled *The Protector* (cat. no. 54), which he

Fig. 31. John Quincy Adams Ward, *William Shakespeare,* **1886. Plaster. Reproduced from** *Harper's Weekly* **11 (April 27, 1867), p. 269.**

agreed to do in 1868 at the request of Henry B. Hyde, the founder of the Equitable Life Assurance Society. Ward's sculpture, based on a vignette designed by the American Bank Note Company, was described in *The Insurance Monitor:*

> The stricken widow and her orphan child are posed, the one in an attitude of sorrow and submission, the other in innocent hopefulness, while over them stands the genius of life insurance with its guardian shield outspread to protect them from the sad effects of their dire calamity, which would reach them but for the provision afforded them through its beneficent instrumentality.[137]

The model of the statue was sent to Carrara late in 1868 to be put into marble by a group of Italian stonecutters supervised by Robert Cushing, whom Ward had hired as his agent. After

Fig. 32. John Quincy Adams Ward, *William Shakespeare.* Unveiling ceremony in Central Park, New York City, May 23, 1872. Stereograph. The New-York Historical Society, New York City.

two and a half years the eleven-foot-high *Protector* was shipped back to America and installed in the fall of 1871, but it was left wrapped in canvas until a suitable occasion arose for the unveiling ceremony. This came when Grand Duke Alexis, grandson of Emperor Alexander II of Russia, visited New York (fig. 33). As the Grand Duke's procession moved down Broadway on November 21, the bells of Trinity Church rang out the Russian national anthem. When the Grand Duke's carriage reached the Equitable building, his attention was drawn to the canvas, whereupon it fell away to reveal the sculpture. The Grand Duke saluted, and as his carriage moved on, he turned to gaze back at the statuary. The life of *The Protector* was short: when the building was remodeled in 1886/87, the statue was found to be so badly weathered that it had to be removed. Although *The Protector* was one of Ward's largest architectural sculpture commissions, it is rarely listed as part of his oeuvre: the group was not regarded as fine art because of its commercial association and it survived for only fifteen years.

In the late 1860s the country was caught up in a fever to erect bronze monuments to the military heroes of the Civil War, and Ward and Hunt once again worked together, this time on memorials to the Seventh Regiment (cat. no. 48), for New York City, and to Major General John F. Reynolds (cat. no. 53; Pl. VII), for Gettysburg, Pennsylvania. *The Seventh Regiment Memorial* was Ward's third statue to be placed in Central Park. Fifty-eight men from the New York regiment had died in the Civil War, and soon after the war ended the regiment formed a Monument Association to see to the erection of an appropriate memorial to their fallen brothers. In May 1868, members of the group approached Ward to execute a statue ten feet in height, offering him a fee of $23,000. Ward's concept for the statue—a solitary soldier, who stands leaning on his rifle—was suggested to him in an undated letter from the architectural firm of Olmsted and Vaux, the landscape architects to the Central Park commissioners:

> The typical idea represented by the Regt seems to have been "Vigilance"—When the war commenced it was found to be on Guard, prepared for immediate action and ready to take its place as a watchful Sentinel in front of the Picketline and it may probably be more fairly and honorably represented in this character than in any other.
>
> A bronze Statue seven or eight feet high of a private soldier in the uniform of the regiment and with the heavy army overcoat on would it seems to us make a good subject for the principal statue.[138]

Fig. 33. John Quincy Adams Ward, *The Protector*, 1871. Reproduced from *Frank Leslie's Illustrated Newspaper*, December 9, 1871, p. 1.

Although the statue was intended as a general representation of a Seventh Regiment soldier, Ward chose to work from a live model. Steele MacKaye, a well-known actor, "posed in his regimental uniform for his friend, Ward, and the statue bears in its features and form a remarkable personal resemblance."[139] The bronze statue was inscribed "1869," but was not unveiled until June 22, 1874, a delay that seems to have resulted from problems to do with the choice of its site and the treatment of its pedestal. From the large number of Richard Morris Hunt drawings that survive it is clear that Hunt and Ward envisioned a fully developed Beaux-Arts style monument, which would have predated by twelve years the monument to Admiral David Farragut created by Stanford White and Augustus Saint-Gaudens for Madison Park in New York. One of Hunt's drawings (fig. 34) reveals a complex circular scheme that skillfully combines architecture and sculpture in a monument carefully sited in the park's landscape. Three sets of stairs—one at the front, one on either side, each flanked at the bottom by bronze eagles—provide access to a circular walk at the memorial's base. Surrounding the walk and leading up each stairway is a richly decorated balustrade. At the center of the monument is a graduated pedestal surmounted by Ward's Seventh Regiment soldier standing in eternal vigilance. Probably in an effort to placate the park architects and commissioners, Hunt and Ward abandoned this opulent Beaux-Arts plan and developed a less complex, nonarchitectural one (fig. 35). That monument was to have been flanked by two sculptural groups—at the left, two soldiers relaxing in camp; at the right, a soldier caring for a wounded comrade. The second version was developed far enough that Ward actually made models of the two groups (figs. 76, 77), but again the monument's design and its placement in

Fig. 34. Richard Morris Hunt, design for *The Seventh Regiment Memorial*, about 1870. Watercolor. The American Institute of Architects Foundation, Washington, D.C.

Fig. 35. Richard Morris Hunt, design for *The Seventh Regiment Memorial*, about 1870. Watercolor. The American Institute of Architects Foundation. Washington, D.C.

the park could not be resolved. The final statue—the soldier that was to have stood atop the pedestal in the original scheme—was ultimately located not at its intended place, the Warrior's Gate at 110th Street and Seventh Avenue, but on the West Walk, opposite 69th Street (fig. 36). The pedestal was reduced to a simple base that Hunt had designed two years earlier for another proposed statue. Although Hunt and Ward's efforts were thwarted, the drawings for the Seventh Regiment Memorial reveal that the two men were working successfully in a fully developed Beaux-Arts style by the early 1870s.

Ward was now devoting most of his time to large public commissions, but he still managed to produce a number of lesser works. In October 1865, at Schaus's Gallery in New York City, he exhibited a marble bust of the Reverend Orville Dewey (cat. no. 37), who had been pastor of the Church of the Messiah in New York. Around the same time he made a bust of Valentine Mott (cat. no. 41), internationally respected as an innovative surgeon and teacher. In 1867, at the forty-second annual exhibition of the National Academy of Design, he exhibited a marble bust of Horace Webster (cat. no. 42), a distinguished member of the

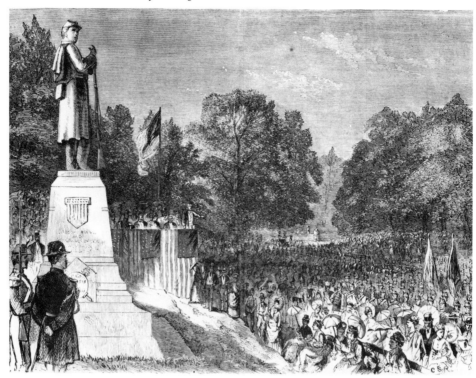

**Fig. 36. John Quincy Adams Ward, unveiling of *The Seventh Regiment Memorial,*
June 22, 1874. Reproduced from *Harper's Weekly* 18 (July 11, 1874), p. 577.**

faculty of the City College of New York. In the academy's exhibition the following year
he entered a "Marble Portrait Bust," which was of a man known only as W. J. Gordon (cat.
no. 43).

It is interesting to note that while Ward executed the majority of his public monuments in
bronze, he continued to do all his busts of that period in marble. A perfectionist in every
aspect of his work, Ward must have been unhappy to have his portraits carved abroad and to
be unable to take a direct hand in them. Probably in an effort to remedy that situation, he
wrote in 1867 to a broker in Florence:

> In accordance with your proposition, I should like to order from you five . . . blocks of first quality
> statuary marble . . . free from color.
> The blocks to average not more than six (6) cubic feet and to be in such shape as to work into busts
> advantageously. For which I will pay you $10 per cubic foot on delivery of the marble in N Y
> provided it is delivered within 6 months of this date.[140]

His attempts must have proved unsuccessful, for in 1868 he had his bust of General
George B. McClellan (cat. no. 45) carved in Rome, and in 1870, his bust of Erastus Fairbanks
(cat. no. 51) carved in Carrara under the supervision of Robert Cushing, his agent in charge
of *The Protector.*

The New York City directories beginning in 1863 reveal that after Ward established
himself there he moved his residence four times and his studio three, and that the two had
never been at the same address.[141] Now, in 1869, he moved into a stylish new twin town
house, designed by Richard Morris Hunt, at 7 and 9 West Forty-ninth Street (fig. 37).
According to Paul R. Baker, Hunt's biographer, the two adjoining houses were tall and
narrow,

> . . . rising sixty-nine feet but extending only thirteen and one-half feet in width. Faced with Ohio
> ashlar and decorated with Neo-Grec linear incised panels and small rosettes, the houses were
> topped by a slate and tin mansard roof. To the rear, a large studio for the sculptor extended the full
> width of both houses.[142]

Fig. 37. John Quincy Adams Ward's house and studio, 1869–82, designed by Richard Morris Hunt, at 7 and 9 West 49th Street, New York City. Photograph. The American Institute of Architects Foundation, Washington, D.C.

The studio, illustrated in a photograph taken about 1874 (fig. 38), was described in a 1871 newspaper article:

> The other day, I attended a private view given by Mr. Ward at his studio of the completed statue of Shakespeare in plaster. It is a very pleasant room, paneled with dark wood, which makes the white statuary stand out in fine relief. On shelfs about the sides are arranged the various portrait busts which Ward has executed, while his large works are grouped about the floor or placed on a sort of platform at one side. . . . About the walls of the studio are fencing materials, weapons of the chase, spurs, pipes, and Indian relics brought from the West.[143]

By the early 1870s Ward had attained a noteworthy position in American sculpture. He was also active in other pursuits—in 1869, in plans to establish The Metropolitan Museum of Art in New York City;[144] the following year, in accepting the vice presidency of the National Academy of Design.[145] That same year a young aspiring sculptor named Daniel Chester French came to consult with Ward about the possibility of studying with him. Ward, hard at work on the *Shakespeare,* the *Reynolds,* and the *Fairbanks,* must have been apprehensive about the additional responsibility of taking on a student, but after seeing several pieces by the twenty-year-old artist, he agreed to accept him as a pupil for a fee of $50 a month.[146] In April 1870 French wrote to his friend William Brewster:

Fig. 38. John Quincy Adams Ward's studio, West 49th Street, New York City, about 1874. Photograph. American Academy of Arts and Letters, New York City.

A week ago yesterday I went up to talk with Mr. Ward the best sculptor in the country to see if he would be willing to take me into his studio, and let me work under his instruction for a month or more. He said he was very much pressed for room, but finally concluded to take me for a month, and try it. . . . I have been for the whole of the first week, except one day, modelling a foot from a plaster cast, and haven't finished it yet. I find that I never knew what good modelling was before. I have to put in every vein, every little depression or elevation, in fact every thing. Mr. W. says he should want me to work on that foot about three weeks if I were going to remain with him a long time. As it is I shall probably begin something else tomorrow. Ward is one of the pleasantest men, I ever saw; always full of fun, fond of gunning and fishing and everything that pertains to the country; so we have a very pleasant time, and I learn a great deal. He is from the West and amuses me with his stories of shooting wild pigeons, and turkeys.[147]

A week later French wrote to his sister Sarah Bartlett:

I have about finished my anatomical figure at Ward's and shall begin copying [Clytie] in a day or two. Copying is not the most interesting thing in the world, but it is excellent practice. . . . I like him better and better, and he is a good instructor in modelling.[148]

French studied with Ward only a month, but the two men developed a deep mutual respect that would culminate forty years later with French's supervision of the casting and erecting of several of Ward's works.

On May 6, 1870, Ward's wife, Anna, died after a brief illness.[149] She had been a good helpmate, making many sacrifices to advance her husband's work during their twelve years of marriage. It was ironic that with fame and wealth finally at hand she did not live to share

them. Ward's only prospective work at the moment was a statue of Israel Putnam for Hartford, Connecticut. Taking advantage of the temporary lull in his activities and perhaps still unsettled after the loss of his wife, Ward resigned from the Board of Trustees of The Metropolitan Museum of Art[150] and took a long-delayed trip to Europe.

The Mature Years, 1872–92

Ward wrote an outline of his 1872 itinerary in Europe in one of his sketchbooks. His trip started in Paris and proceeded to Strasbourg, Frankfurt, Cologne, Düsseldorf, Berlin, Dresden, Munich, "Venice or Florence," as he put it, Rome, and then Naples.[151] In Paris he met the sculptor Frédéric-Auguste Bartholdi, who helped him select the plaster casts he bought for the National Academy of Design.[152] When he was in Venice he is known to have called on the American sculptors Larkin Mead, his old friend, and Joel T. Hart and the painter Edwin White.[153] Though Ward by 1872 was a mature artist, he must have been deeply impressed by the rich sculpture tradition he encountered, and would probably have been particularly affected by the richly textured surfaces, complex compositions, and intense realism of the Beaux-Arts sculpture he was introduced to in France. After his return to the United States he incorporated certain of these stylistic innovations into his sculpture. By these, Wayne Craven, the noted scholar of American sculpture, wrote, "his portraiture was strengthened immeasurably."[154]

The first statue Ward executed after his trip to Europe was a standing figure of Israel Putnam (cat. no. 55; Pls. VIII, IX), the legendary Connecticut militiaman, Indian-fighter, and staunch patriot who left his plow and hastened to Massachusetts when he heard there was fighting in Lexington. The statue was unveiled on June 17, 1874, in Bushnell Park, on the grounds of the Connecticut state Capitol in Hartford. In the *Putnam*, Ward's reliance on the antique for his composition and his usual painstaking research into likeness and attire can still be found. There is, however, a difference—a step forward. The *Putnam* is derived from the *Apollo Belvedere* (fig. 17), but it is no longer a static figure frozen in time. Rather, it is a candid portrait that captures the self-assured general in a fleeting moment as he strides forth, his sword under his arm. The candid quality of the pose introduced a new concept into Ward's portraits, heightening their natural and spontaneous character and, by extension, the realism of his sculpture. An advancement undoubtedly absorbed from the contemporary work he saw in France, it was a radical departure from Ward's sculpture of the post–Civil War period, and it marked a new and important dimension in his artistic growth.

The commission from the Society of the Army of the Cumberland in 1874 to execute an equestrian statue of Major General George H. Thomas, the Union Civil War officer (cat. no. 61; Pl. X), in Washington, D. C., was undoubtedly the crowning achievement of Ward's career to date. It presented him with a paramount opportunity, for not only was an equestrian monument a highly prized commission, but this one was to be erected in the nation's capital—a signal honor, and one that would pave the way for future government patronage. After signing a contract for $35,000 with the society in February 1874, Ward requested from the general's widow photographs of her husband, one of his uniforms, and other of his personal effects. He then set to work (fig. 39). The finished statue, on an ornate pedestal designed by J. L. Smithmeyer, a Washington architect, was unveiled on November 19, 1879 (fig. 1). Imposingly situated in a circle at the intersection of Massachusetts and Vermont avenues and 14th and M streets, the *Thomas*, one of the most innovative works of Ward's entire oeuvre, reveals the degree to which he had absorbed the neo-baroque style of French Beaux-Arts sculpture (fig. 40). The lightly textured surface of the *Thomas* produces an impressionistic play of light and shadow, and though the work is devoid of any complicated action, Ward has endowed it with a dynamic quality by placing the horse on a slight incline. The long legs of the powerful stallion convey an air of liveliness; his wind-blown mane and tail, a sense of movement. The statue is imbued with a dramatic immediacy. Writing in 1913

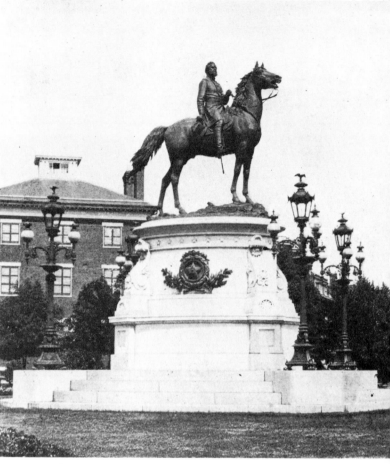

Fig. 39. John Quincy Adams Ward modeling the horse for the *Major General George Henry Thomas*, about 1878. Reproduced from *Harper's New Monthly Magazine* 57 (June 1878), p. 65.

Fig. 40. John Quincy Adams Ward, *Major General George Henry Tho* 1879. Bronze. Washington, D.C. Reproduced from *Scribner's Magazin* (October 1902), p. 390.

of the *Thomas*'s spirited and revolutionary design, Augustus Lukeman, one of Ward's fellow American sculptors, called it "the finest example of the equestrian art in Washington."[155] A decade later, Homer Saint-Gaudens wrote that it "struck the American note with special accuracy because of its lack of ostentation and yet power of easy, unstinted modeling."[156]

In addition to the unveiling of the *Putnam* and the securing of the commission for the *Thomas*, the year 1874 saw *The Seventh Regiment Memorial* finally erected in Central Park, and a bust of James T. Brady (cat. no. 56), a successful New York lawyer, exhibited at the National Academy of Design. Further evidence of the acclaim Ward had earned from his peers was his reelection to the Board of Trustees of The Metropolitan Museum of Art in 1873,[157] and his election as president of the National Academy of Design,[158] the first sculptor to be so honored. In 1875 he was commissioned to execute a bust of the noted Southern writer William Gilmore Simms (cat. no. 60), a work not dedicated until June 11, 1879, in White Point Garden in Charleston, South Carolina. The number of commissions being offered him was steadily increasing, but Ward was forced to refuse some because he lacked the time to do them. In 1876, in an unprecedented gesture, he declined the opportunity to do the important *Farragut Memorial*, which was to be placed Madison Square Park in New York. Homer Saint-Gaudens, in a celebrated account of Ward's withdrawal in favor of Augustus Saint-Gaudens, a younger and then relatively untried sculptor, paid tribute to his unselfishness:

I am glad of the opportunity to record the fact that the Farragut Commission ultimately came to Saint-Gaudens through the aid of Mr. J. Q. A. Ward. When the time for the final decision arrived, in December, 1876, I understand that, upon the committee first voting six for Ward and five for Saint-Gaudens, Ward declined to accept the offer and most generously used all his influence towards having the work given to his rival.[159]

In 1878 and 1879 Ward was also busy with decorative sculptural projects for the state Capitols of Connecticut and New York. For Connecticut (cat. no. 58), he was commissioned to provide twelve allegorical figures for the base of the dome-tower of the eclectic, high-Victorian building that Richard M. Upjohn had designed for Hartford. The statues, personifications of Agriculture, Law, Commerce, Science, Music, and Equity, were carved in duplicate by Hartford stone contractor J. G. Batterson. Set in place in the spring of 1879, high above the ground, Ward's figures appear only as decorative silhouettes against the gold dome. In contrast, the proposed project for New York (cat. no. 64) was to be one of the most auspicious artistic collaborations of the late nineteenth century, bringing Ward into contact with three of the nation's most prominent architects—Leopold Eidlitz, Henry Hobson Richardson, Frederick Law Olmsted—who in 1876 had assumed the responsibility for finishing the New York state Capitol. Eidlitz, who was designing the Assembly Chamber, commissioned William Morris Hunt to paint two great allegorical frescoes in the lunettes of the ceiling vaults and invited Ward to do a frieze showing a series of historical subjects between the chamber's two banks of windows (fig. 85). Of these projects, only Hunt's murals were actually completed (they have all since been covered over); the other decorative schemes for the Capitol interior had to be abandoned because of the tightening of appropriations in 1879. All that survives of Ward's frieze is a photograph of the section called *Peace Pledge* (fig. 86).

Ward participated in another ill-fated project around the same time. Thomas Gold Appleton, a Boston philanthropist, had approached him in 1872 about doing a statue of the Norseman Leif Ericson (cat. no. 63). The project was financially insecure from the outset, but Appleton was confident that necessary funds would be forthcoming once people saw Ward's model for the proposed statue. His confidence proved unjustified. The model was in hand by January 1880, but Appleton was forced to write to the sculptor the following year to tell him to abandon work on the monument until enough money was raised. The commission ultimately went to Anne Whitney, whose *Leif the Norseman* was unveiled on Commonwealth Avenue in Boston in 1887.

On June 19, 1877, Ward married for a second time.[160] Now affluent and much in demand as a sculptor, he was ready to seek the companionship he had so sorely missed since Anna's death. While Ward continued to work at the Forty-ninth Street studio, he and his new wife, Julia Devens Valentine (fig. 41), took up residence at 140 East Thirty-eighth Street.[161] Their dining room was remodeled in the "aesthetic style" by the architects Kimball and Wisedell (fig. 42),[162] and they acquired a new suite of furniture in the "Bombay" style.[163] Ward's future seemed bright and assured, but once more his hopes were dashed, for his second marriage ended with Julia's death in childbirth on January 31, 1879.[164] The baby did not survive. Ward, again bereft, commissioned Thomas Wisedell to design and Ellin Kitson to execute a memorial to Julia in Greenwood Cemetery, in Brooklyn, where she is buried.[165]

The celebration of the nation's centennial in 1876 had generated great excitement, causing a large number of historical monuments to be erected across the country. Of these commissions Ward had his fair share. Between 1874 and 1883 he executed ten statues, all of which display a strong French influence. The *Putnam* (cat. no. 55; Pls. VIII, IX), erected in 1874 on the grounds of the Connecticut state Capitol, was the first. Three years later Ward was commissioned to do a statue of George Washington (cat. no. 59; Pl. XI) for Newburyport, Massachusetts. Unveiled on February 21, 1879, the statue portrays Washington as commander in chief addressing his troops. Like the *Putnam*, the pose is based on that of the *Apollo Belvedere* (fig. 17). As for historical accuracy, Ward was on secure ground. He was

Fig. 41. Julia Devens Valentine Ward, about 1878. Photograph.
Collection of Mr. and Mrs. Oliver E. Shipp, Newburgh, New York.

Fig. 42. Kimball & Wisedell, architectural drawing for John Quincy Adams Ward's
aesthetic-style dining room, 1878. Reproduced from *The American Architect and
Building News* 8 (August 28, 1880), no. 244.

already completely familiar with Washington's physiognomy and dress from the experience he had gained in assisting Henry Kirke Brown on the equestrian Washington monument for Union Square in New York City.

For Spartanburg, South Carolina, Ward did a standing portrait of General Daniel Morgan for the *Centennial Memorial to the Victors of Cowpens* (cat. no. 67; Pls. XII, XIII; fig. 43). The monument commemorates the event of January 17, 1781, when a small force led by Morgan dealt a decisive blow to the British forces in the South. Represented in the midst of battle, the general's figure is related to François Rude's statue of *Marshal Ney* (fig. 44), executed between 1852 and 1853 and situated on the Avenue de l'Observatoire in Paris. The two works are similar in composition; Ward, like Rude, has succeeded in evoking the essence of a historical drama through the portrayal of a naturalistic image. The portraits of Ney and Morgan are exuberantly staged statues that re-create the patriotism and excitement of past action. They celebrate legendary events. Ward himself described his own highly charged work:

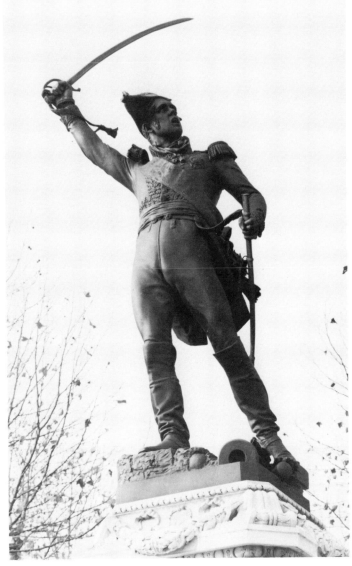

Fig. 43. John Quincy Adams Ward, *Daniel Morgan,* **1881. Bronze. Spartanburg, South Carolina.**

Fig. 44. François Rude, *Marshal Ney,* **1852/53. Bronze. Paris.**

After reading the biography of General Morgan, and studying the history of his military career, I felt it essential to a proper portrayal of his character that the statue should represent a man of action—intrepid, aggressive, alert—at the same time I wished to indicate, by certain movements of the head and left arm, that there was a sympathetic quality, even a tenderness, in the nature of the daring General.

I represented him with drawn sword, advancing with his troops, his attention for the moment attracted by some movement of the enemy on his left.[166]

Ward's fourth centennial project was the *Alliance and Victory Monument* (cat. no. 66; fig. 45) for Yorktown, Virginia, an elaborate column recalling Cornwallis's surrender of the British forces on October 19, 1781. The monument was done in collaboration with the architects Richard Morris Hunt and Henry van Brunt, who adapted their design from one French architects had submitted just previously for a *Constitutional Assembly Memorial* to be built at Versailles (fig. 46). For the Yorktown monument Ward designed the emblems on the base, the classical figures of thirteen maidens that encircle the foot of the column, and

Fig. 45. Richard Morris Hunt, *Alliance and Victory Monument,* 1881. Watercolor. The American Institute of Architects Foundation, Washington, D.C.

Fig. 46. Designs for the *Constitutional Assembly Memorial,* 188 Versailles. Reproduced from *The American Architect and Buildi News* 10 (October 15, 1881), no. 303.

the figure of Liberty that surmounts the sixty-foot-high shaft. The work was well received when it was completed in 1885, but it did not arouse much enthusiasm because of its somewhat remote geographical location. Again, because the monument is primarily an architectural work, it is seldom included in lists of Ward's oeuvre.

Ward's remaining two centennial statues—the *Lafayette,* in Burlington, Vermont, and the *Washington,* in New York City—reveal no further exploration of his recent, European-derived inspiration but instead revert to his earlier formula: a classical pose combined with a naturalistic portrait derived from well-known historical likenesses of the subjects. Both statues were unveiled in 1883. The *Lafayette* (cat. no. 68), based on the David d'Angers bust at Mount Vernon, portrays the sixty-four-year-old marquis in 1824, on the occasion of his second triumphal tour of the United States.

The *Washington* (cat. no. 69; Pls. XV, XVI), situated high on the steps of the old Sub-Treasury Building (now Federal Hall), dominates the plaza formed by the junction of Wall and Broad streets—the spot where Washington took his oath of office as first president of the United States. He is portrayed as he lifts his hand from the Bible at the end of the swearing-in ceremony. For historical accuracy Ward relied extensively on two of the most famous life portraits of Washington: Gilbert Stuart's Athenaeum painting and a standing statue by Antoine Houdon at the Virginia state Capitol in Richmond. Though the strong influence on Ward of Houdon's work is shown in the two statues' similarity of dress and composition, Ward's *Washington* has a simplicity of detail that the other lacks. In his drama-infused rendering of the historical event Ward has produced a statue of complete creative integrity. The dedication of the *Washington* (fig. 47) took place on November 26, 1883—the centennial anniversary of the evacuation of British troops from New York. The popularity of these unveiling ceremonies is attested by the crowd of six thousand people, including Chester A. Arthur, president of the United States, and Grover Cleveland, governor of the state of New York, that attended the events, even though the day was cold and rainy. The *Washington* was the first of Ward's works to be cast by the Henry-Bonnard Bronze Foundry of New York, which had just been established in February 1883[167] and was to do most of Ward's foundry work for the next twenty years.

Much of Ward's time was now being spent on monumental public statues, but he was also undertaking a number of smaller commissions. In 1880 he modeled a posthumous portrait medallion of the noted publisher Fletcher Harper (cat. no. 65), who had died in 1877. Three years later he completed a bust, modeled from life, of William W. Corcoran (cat. no. 70), an influential Washington banker and philanthropist and the founder of the Corcoran Gallery of Art. Also modeled from life was his bust of Dr. Joseph M. Toner (cat. no. 71), a Washington physician who had donated his impressive collection of medical books to the newly formed Library of Congress.

In 1882, just as Ward was finishing work on the *Lafayette* and the *Washington,* Richard Morris Hunt was completing a new studio/residence (fig. 48) for him at 119 West Fifty-second Street in New York.[168] Ward needed more working space for his large public commissions, and the new studio also had an elaborate reception area richly decorated in the Pompeian manner (fig. 49). During the 1880s Ward, a great sportsman, began spending his summers at the bucolic house he had built at Peekamoose, in the Catskills (fig. 50), where he belonged to a fishing club whose ten members shared an interest in the arts and in outdoor activities (fig. 51).[169] Among the members was Anthony W. Dimock, a financier, writer, and naturalist for whom Ward carved an elaborate chair in 1886 (cat. no. 76). At his country retreat Ward could divide his time between his sculpture projects, which he worked on in a studio he also built at Peekamoose, and fishing and horseback-riding (fig. 52).[170] William Ames wrote about the Catskills house in 1886:

> You have given yourself something of a vacation this summer I hope? You need to surely. That mountain cabin of yours is a 'saving clause' for you - and the oftener you get away, and build bridges - or do other work there, in the intervals of hunting and fishing, (and smoking) the better for you. I

Fig. 47. The unveiling of John Quincy Adams Ward's statue of *George Washington*, November 26, 1883, New York City. Photograph. The Metropolitan Museum of Art, New York City.

would like to see that engineering feat, but really nothing that you would do in this or any mechanical way would surprise me.[171]

Soon after he moved into his new studio in New York Ward was ready to begin work on two large statues for the city: *The Pilgrim* (cat. no. 72) and the *Dodge* (cat. no. 73). *The Pilgrim*, on a rusticated pedestal designed by Richard Morris Hunt, was unveiled on June 6, 1885,

In 1883 the Society of the Army of the Cumberland commissioned Ward to execute a memorial to President James A. Garfield (cat. no. 78; Pls. XIX–XXI; fig. 54). The president had been assassinated two years before by a deranged office-seeker whose government appointment had been blocked by Garfield's reform policies. The *Garfield* was the second statue Ward did for the society, and his second to be placed in the nation's capital. Ward's most ambitious public monument, it bears fresh evidence of his expertise in the French Beaux-Arts mode. Garfield had been a member of the Society of the Army of the Cumberland, and when the society adopted a resolution to erect a statue in his honor at their annual reunion in 1881, they decided not to hold an open competition for the commission but to choose Ward, undoubtedly because of the success of his *Thomas.* Ward's apparent friendship with Garfield, who was only a year younger and who had also grown up on the Ohio frontier, would also probably have influenced their decision. A member of the society referred to the friendship when he wrote Ward in April 1883: "As far as I am concerned—I am for you first last and all the time—as I happen to know something of General Garfield's feelings towards

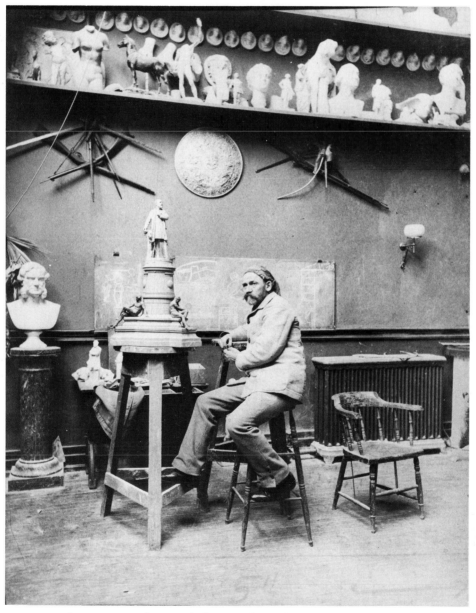

Fig. 54. John Quincy Adams Ward at work on the *James Abram Garfield Monument,* about 1885. Photograph. Collection of Mr. and Mrs. Oliver E. Shipp, Newburgh, New York.

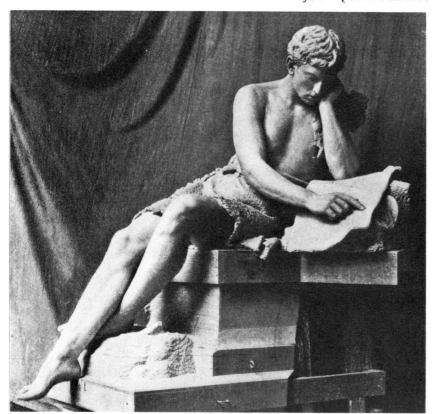

Fig. 55. John Quincy Adams Ward, study for *The Student*, about 1885. Plaster. Reproduced from *Scribner's Magazine* 32 (October 1902), p. 397.

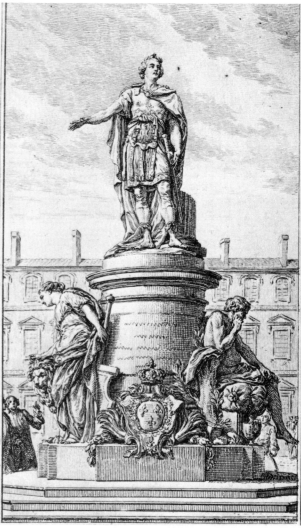

Fig. 56. Jean-Baptiste Pigalle, *Monument to Louis XV*, 1765. Rheims, France. Engraving. The Metropolitan Museum of Art, New York City.

you."[172] Two years after securing the commission for the standing figure of the president, Ward, with Richard Morris Hunt, was selected to execute the pedestal and base sculpture to represent, in Ward's words, the "three important phases in Garfield's life: the *Student*, the *Warrior* and the *Statesman*." To complement Ward's sculpture, Hunt designed a pedestal composed of a tapered cylinder superimposed on a triangular base whose corners form rectangular seats for the three figures (fig. 55). The cylinder is divided by decorative moldings into horizontal sections, a series of graduated architectural masses and lines. A rich movement of receding and projecting elements with attendant play of light and shadow is thus created, transporting the viewer's eye to the dramatic figure of Garfield, who is shown as he pauses in an address, holding the text of his speech against his chest and looking emphatically out at his audience. Of his intended effect Ward wrote:

> It was the general desire of those interested in the work that I should represent Garfield in the act of speaking. This I have endeavored to do, or rather, to represent him at the close of a period, while delivering a speech. From personal observation and from information, I have chosen one of his characteristic attitudes and gestures. There has been no attempt to represent any particular incident or moment in his oratorical career, but the statue is meant to broadly suggest to each spectator such interpretation as his memory or imagination may allow.[173]

The *Garfield* was unveiled in Washington on May 12, 1887, at the foot of the Capitol, in a ceremony attended by President Grover Cleveland, justices of the Supreme Court, members of Congress, officers of the Society of the Army of the Cumberland, and both Ward and

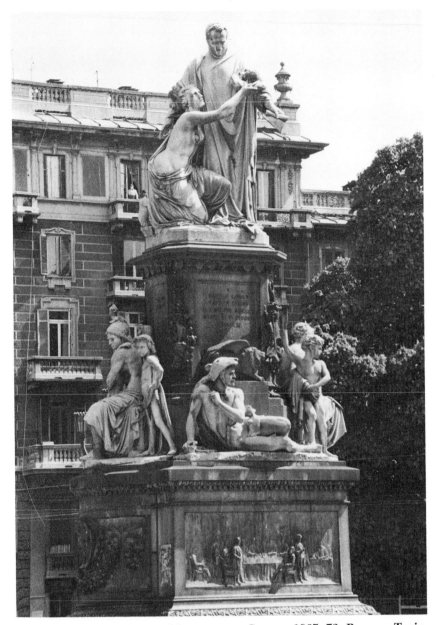

Fig. 57. Giovanni Dupré, *Monument to Cavour,* 1865–73. Bronze. Turin.

Hunt. The ornate neo-baroque pedestal bears a striking similarity to Jean-Baptiste Pigalle's 1765 *Monument to Louis XV* (fig. 56), in Rheims; in the *Student* is a strong resemblance to Pigalle's seated base figure of *The Citizen;* and in the *Warrior* is a strong affinity to a reclining figure clad in an animal skin on the base of the *Monument to Cavour* (fig. 57) that Giovanni Dupré executed in Turin, Italy (1865–73). Though Ward's base figures are related to these examples of European sculpture, his ultimate source (and, possibly, that of the other men) was undoubtedly Michelangelo's figures of *Day* and *Night* and *Dawn* and *Dusk* in the Medici Chapel. The derivation is most evident when Ward's *Warrior* is compared with Michelangelo's *Day.* The figure of the *Warrior,* like *Day,* is reclining cross-legged, his head turned to look over his shoulder—elements that produce a powerful reversed movement in the torso and give the overall figure a sweeping S curve. This splendidly conceived and finely crafted monument, one of the outstanding achievements of the American Beaux-Arts movement, is the result of Ward's successful use of allegorical figures to personify the different stages of Garfield's life, the animated poses and vibrant realism with which he presents them, and, finally, the remarkable collaboration between Ward and Hunt.

In 1887 Ward made a second trip to Europe, armed with a letter of introduction from Samuel P. Avery, the noted connoisseur and art dealer, to Albert P. Lucas, requesting him "to assist Mr. Ward in seeing some of the leading sculptors, with the view of getting a sight of such fine monuments as may not be at once accessible to a stranger."[174] Avery also wrote letters of introduction to Leon-Joseph Florentin Bonnat,[175] and a Mr. Moreau-Vauthier.[176] Felix Aucaigne, father of Eugene, the superintendent of the Henry-Bonnard Bronze Foundry, wrote letters of introduction to Henry Vignaud[177] and Adolph Chabard.[178] Ward again spent time purchasing plaster casts to give to the National Academy of Design. In acknowledgment, Thomas Addison Richards, corresponding secretary of the academy, wrote Ward in the fall of 1887: "I had the pleasure to present in your behalf the gift to the school of the valuable collection of casts which have recently come, by your order, from Paris. The Council have accepted your kind present and desire me to send you their hearty thanks."[179]

After returning from Europe, Ward began work on two busts for public memorials. The first, for Columbus, Ohio, was to Lincoln Goodale (cat. no. 83), a wealthy Ohio merchant and physician who had given the city a large tract of land for a park that still bears his name. The bronze portrait bust, on its tall elaborate pedestal designed in the fully realized Beaux-Arts manner by Richard Morris Hunt, was commissioned in 1887 and completed the following year. The second memorial honored Alexander Lyman Holley (cat. no. 85), whose adaptation for American use of the Bessemer steel process, which had been developed in England, revolutionized steel manufacturing in this country. The *Holley* was commissioned in 1886 by the Institute of Mining Engineers, but was not completed until three years later. The likeness, true to Ward's tenets, is convincing and realistic. Holley's wavy hair, represented as gently blown by the wind, contributes to the subtly textured surface that gives the work a lively, spontaneous quality. A wreath encircling the base of the bust produces a subtle transition from the portrait to architect Thomas Hasting's tall, eclectic, Beaux-Arts pedestal. The bust is situated in Washington Square Park in New York, where both bust and pedestal have now badly weathered.

Ward's position in American sculpture in the mid-1880s assured him a steady stream of new commissions, but since his studio was relatively small and his staff limited, he was forced to turn many of them away. In 1887, responding to an invitation to compete for the commission of a statue for Cincinnati, Ward said that he "declined to submit a model in competition."[180] An artist's position, however, is ever tenuous. Even at the height of Ward's career, a commission that he seemed to covet—the statue of Peter Cooper for the city of New York—was awarded instead to Augustus Saint-Gaudens.[181]

Ward's time was now mainly devoted to large public commissions, but he continued to do a number of private portraits. For the first time he used bronze in the execution of several of his nonpublic works. In 1888 he had his bust of financier and railroad tycoon William H. Vanderbilt cast in bronze (cat. no. 75), and he did a marble portrait of William H. Fogg (cat. no. 74; Pls. XVII, XVIII), a New York China-trade merchant; in 1889 he made a marble bust of Joseph Drexel (cat. no. 86), a Philadelphia financier and philanthropist; in 1890 he did a bronze portrait of Silas Packard (cat. no. 88), president of a well-known adult educational college; and in 1891 he modeled a bust, to be cast in bronze, of August Belmont (cat. no. 90), New York banker, diplomat, and art patron. Ward's use of bronze during this period radically heightened the realism of his work. Not only did his surfaces become livelier and more spontaneous because of it, but its darker patina also imparted a greater warmth and afforded subtle modulations to his color tones.

In the early 1890s Ward completed two of his finest public portrait statues, those of Horace Greeley and Henry Ward Beecher, both for New York City. The statue to Greeley (cat. no. 89; Pls. XXIV, XXV), the founder of the *New York Tribune* and one of America's greatest (if most controversial) editors, was unveiled on September 20, 1890, on a pedestal designed by Richard Morris Hunt. In the *Greeley* Ward was confronted at the outset with two basic problems: he had to create an imposing portrait statue even though his subject was an eccentric looking man with a small round head, his face somewhat absurdly framed by

unkempt throat whiskers; and the figure had to be seated, in order to fit into its destined site—a sidewalk niche in front of the *Tribune* building (fig. 58). The informally posed portrait of Greeley is kindred to David d'Angers's *Ludwig Tieck* (fig. 7), and, its challenges met and conquered, has a realism and a psychological presence that make it one of Ward's finest portrait statues.

Ward's participation in the *Beecher Monument* (cat. no. 91; Pls. XXVI–XXIX; fig. 59) began during the popular preacher's last days. As Beecher's life began to ebb, arrangements were made for Ward to take the death mask. On March 8, 1887, Ward received a telegram: "Beecher died nine-thirty. Dr. Seele says mask should be taken within four hours."[182] Having taken the death mask, Ward was the logical choice to execute the statue. On April 6, 1888, he

Fig. 58. John Quincy Adams Ward's statue of *Horace Greeley*, at its original site in front of the New York Tribune building. Reproduced from *Scribner's Magazine* 32 (October 1902), p. 398.

Fig. 59. John Quincy Adams Ward's *Henry Ward Beecher Monument,* at its original site in Borough Hall Park, Brooklyn. Photograph. The Metropolitan Museum of Art, New York City.

signed a contract for $35,000 with the Beecher Statue Fund Committee to "design, model, execute and complete in fine bronze a statue . . . eight feet in height" as well as two or three figures "representing some phase of Beecher's character of public service."[183] Working from photographs of the clergyman and from the death mask, Ward completed his final model of the *Beecher Monument* by the winter of 1889; the pedestal figures, by the following year. Although Beecher's family and close friends criticized to varying degrees the accuracy of Ward's sculptural likeness, the statue was widely acclaimed as one of the finest in the country. Its progress was reported on almost daily by the press, and when it was cast on May 10, 1890, the event was attended by two hundred elegantly dressed men and women. When the finished monument was unveiled a year later, on June 24, 1891, it was a major civic event, attracting over fifteen thousand people to Borough Hall Park in Brooklyn. The *Beecher Monument*, on a black granite pedestal designed by Richard Morris Hunt, is the epitome of the best nineteenth-century American public statuary. In it can be seen Ward's method of dealing with problems to do both with the portraiture and with the fundamental sculpture. The statue is one of prodigious monumentality, yet Ward has modeled a convinc-

Fig. 60. Plaster models for the base figures from the *Beecher Monument*, about 1890. Photograph. American Academy of Arts and Letters, New York City.

Fig. 61. Henri Chapu. *Youth,* for the *Monument to Regnault,* 1876. Marble. École des Beaux-Arts, Paris.

ing, realistic image of Beecher the man, who stands before a crowd he is about to address. The statue is a massive triangular shape and its volumes are broadly treated, but Ward has simplified the surface details by clothing the figure in a knee-length Inverness cape. In contrast to the almost austere quality of the work are the small, intimately represented genre figures on its base. On the right, a small boy supports a young girl (fig. 60; Pls. XXVIII, XXIX) who reaches up to place a wreath at Beecher's feet—an expression of Beecher's love for children. On the left, a young black woman (Pl. XXVI) places a palm leaf before him—a gesture of gratitude for the role he played in the abolitionist movement. Base statuary of this type was widely used in nineteenth-century French sculpture, and in this instance Ward's conception, particularly in the pose of the young black woman, is distinctly related to Henri Chapu's figure of *Youth* for the 1876 *Monument to Regnault* at the École des Beaux-Arts in Paris (fig. 61).[184]

The dedication of the *Beecher Monument* in 1891 marked the culmination of Ward's mature period that had begun in 1872 with his first trip to Europe. His sculpture now

exhibited a successful combining of the literal naturalism of his work of the Civil War era with the tangible, energy-infused naturalism that reflects the influence on him of the French École des Beaux-Arts. He continued to model American themes, but they were posed in a more candid, animated attitude; their surfaces were treated in a more impressionistic fashion; and their pedestals had become a more integral part of the monuments. Reflecting on Ward's position in American sculpture between 1875 and 1893, Homer Saint-Gaudens wrote:

> He alone bridged with his mature work the entire period between the Philadelphia Centennial and the Chicago World's Fair, showing through such of his statues as the "Horace Greeley," unveiled in 1890, and the "Henry Ward Beecher," set before the public the following year, that he had attained an ability hitherto unreached to grasp the external and transitory details of the day, and through his art to make them both permanent and noble in bronze.[185]

The Final Years, 1892–1910

At the time of the unveiling of the *Beecher Monument*, in 1891, Ward was sixty-one years old, yet during the next ten years his productivity and the quality of his work continued undiminished. In the next decade he executed two public monuments. The first was to Roscoe Conkling (cat. no. 94), a successful lawyer and, later, as United States senator from New York, the Republican "boss" of the state. After his death in 1888, a group of his friends, including Clarence A. Seward, Cornelius Bliss, and former vice president Levi P. Morton, commissioned the statue for Madison Square Park. The *Conkling* head was derived from a bust (cat. no. 93; Pls. XXX, XXXI) that Ward had done the year before. The naturalism of the head, as Wayne Craven has perceptively written:

> . . . rivals Italian Renaissance portraiture of the 15th century in its incisive portrayal, its feeling for the sculptural form, and its exquisite sense of design. The last is especially evident in the wiry hair and beard, which are splendidly contrasted to the solid structure of the head and flesh. But Ward was not imitating the style of Verrocchio or of Donatello . . . and if there is any trace of a foreign style in his work, it is in the enlivened surfaces that come from contemporary French sculpture.[186]

The delicately modeled surface of the *Conkling*, combined with the realistic rendering of the subject, is characteristic of the deeply intuitive portrait style of Ward's mature years. His subjects are now more than just finely crafted likenesses; as the *Conkling* demonstrates, they are shrewd psychological portraits. Ward has captured the dynamism and charisma of the senator from New York whose career had embraced both triumph and controversy.

Ward's second public monument of the decade was a bust of Abraham Coles (cat. no. 104), a New Jersey physician and writer. Ward was commissioned to execute the posthumous portrait in 1894 by J. Ackerman Coles, the doctor's son. The bust was unveiled in Washington Park in Newark on July 5, 1897, its base resting on a stack of books and, like the *Holley* (cat. no. 85), encircled with a foliate wreath.

In between work on large sculpture projects, Ward continued to execute a number of smaller, private commissions. In 1893 he did a marble bust of Horace Fairbanks (cat. no. 95; Pl. XXXII), former Vermont state senator and governor and the president of his family's platform-scale company in St. Johnsbury. In the next year Ward executed two more portrait busts. The first, in bronze, was of Stephen Wilcox (cat. no. 96; Pl. XXXIII), an inventor and engineer who had developed a steam generator that was distributed all over the world by his company, the firm of Babcock & Wilcox. The second bust, done in both marble and bronze, was a portrait of Elliot F. Shepard (cat. no. 97), prominent New York lawyer, newspaper editor, and Civil War officer. The work was commissioned by Shepard's widow, the former Margaret Louisa Vanderbilt, daughter of the William H. Vanderbilt whose bust Ward had done in 1886 (cat. no. 75). In 1895 Ward executed a bronze relief of James Hazen Hyde (cat. no. 99), heir-apparent to the presidency of the Equitable Life Assurance Society founded by

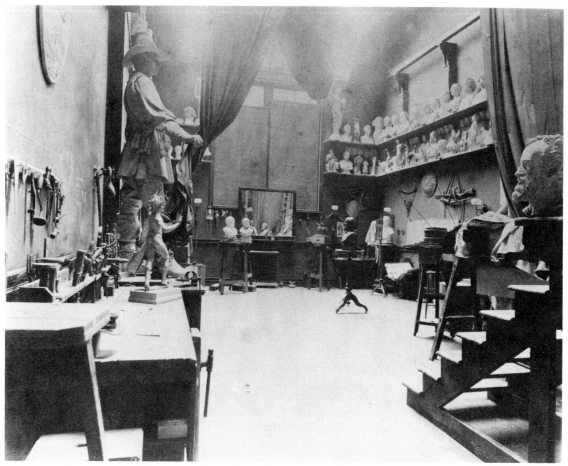

Fig. 62. John Quincy Adams Ward's studio, about 1892. Photograph. American Academy of Arts and Letters, New York City.

his father. The realistic image of the junior Hyde shows his head in right profile, the ripple of light and shadow emanating from the subtly modeled bronze surface bringing each feature of the nineteen-year-old man to life. Ward added an inscription to the plaque, undoubtedly influenced by the decorative calligraphy employed by Augustus Saint-Gaudens on all his relief portraits. Though Ward successfully integrated the name and birthdate of his subject, his inscription lacks the symbolic expression and decorative merit that Saint-Gaudens so exquisitely imparted to his.

During the 1890s Ward received private commissions for two full-length standing portraits. The first was of William H. Fogg (cat. no. 100; fig. 63), whose bust Ward had done in 1886 (cat. no. 74; Pls. XVII, XVIII). Some years later, his widow left a bequest of $30,000 to the National Academy of Design with the provision that the institution "receive and permanently keep in the building a statue of William H. Fogg."[187] As a member of the academy, and having modeled Fogg's bust, Ward was the obvious choice to carry out Mrs. Fogg's wishes. He signed a contract in April 1894 to model the statue, which was cast a year later and placed at the entrance to the academy. The second portrait was that of Henry B. Hyde (cat. no. 110; Pls. XXXIV, XXXV; figs. 64, 65). In 1899, Hyde, founder and president of the Equitable Life Assurance Society—the man who had commissioned Ward in 1868 to do *The Protector* (cat. no. 54)—had just died, and James Hazen Hyde, his son, engaged Ward to do a statue of him to be installed in the lobby of the Equitable building in New York. The statue was unveiled there, in the arcade at 120 Broadway, on May 2, 1901, the second anniversary of Hyde's death. In the *Hyde* can be sensed the forceful will and energy of the man who founded an insurance company and built it into one of the largest in the world. The *Fogg* and the *Hyde* are life-size statues that in their modern attire and casual poses have a genre quality. Fogg,

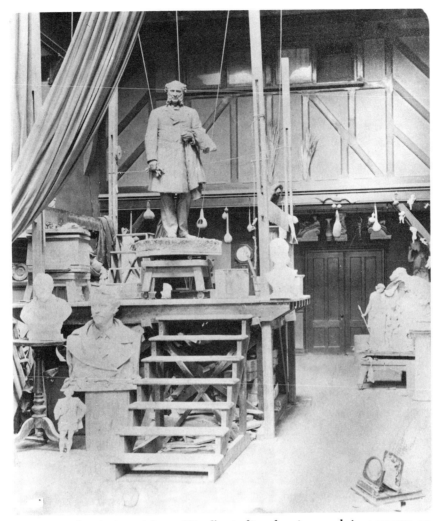

Fig. 63. John Quincy Adams Ward's studio, showing work in progress on the statue of *William Hayes Fogg*, about 1895. Photograph. American Academy of Arts and Letters, New York City.

overcoat draped over an arm and gloves in hand, stands at the threshold of an oft-visited institution, and the contemplative figure of Hyde, in the lobby of the Equitable building, oversees to this day the comings and goings of his company's employees.

Ward was an individual of consistently strong ideals and convictions, especially where quality of design and craftsmanship were concerned. In keeping with his beliefs, he devoted a generous part of his time during the last twenty years of his life to a number of public and private organizations that promoted the commissioning of public art projects and policed their progress. He maintained his close relationship with Richard Morris Hunt and developed a warm friendship with Charles R. Lamb, architect and enthusiastic advocate of the visionary City Beautiful movement. That idealistic movement was a reaction to both the decay and the chaotic growth of nineteenth-century America's urban centers. The City Beautiful movement provided the background for the development of city planning, although much of its actual time was spent on large municipal art projects.[188] Ward's energy and dedication to the artistic community and to the quality of public art are captured in one of his exhortations to his colleagues on the Art Commission of the City of New York:

Thus far we have progressed, but the ideal is still ahead of us! This Art Commission has only judicial power, and the artists are in too small a minority. This Commission should have power to initiate schemes, to establish a general system of adornment for the city, and to direct all that pertains to its artistic appearance.[189]

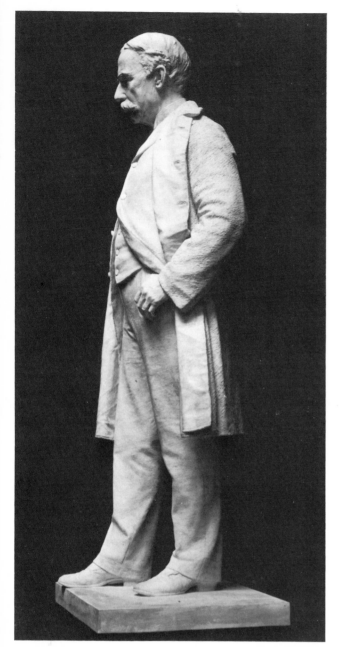

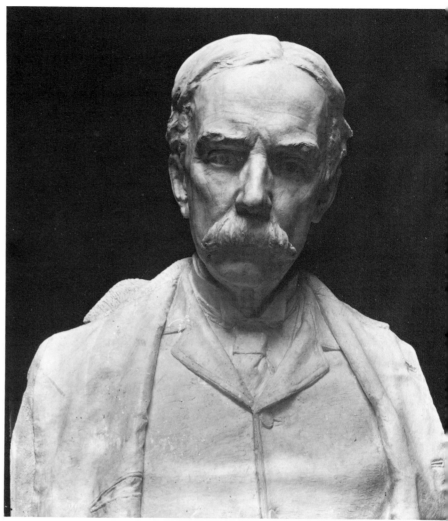

Fig. 65. John Quincy Adams Ward, study for the *Henry Baldwin Hyde*, about 1*
Photograph. National Museum of American Art, Smithsonian Institution, Wash
ton, D.C.

Fig. 64. John Quincy Adams Ward, preliminary model of the
Henry Baldwin Hyde, about 1900. Photograph. National Museum
of American Art, Smithsonian Institution, Washington, D.C.

Ward's most significant contribution to the implementation of these proposals—and the one
that had the greatest effect on American sculpture of the period—was his commitment to the
formation of the National Sculpture Society, established in 1893 in part to promote an
educated awareness of sculpture and in part to foster its commissioning. Charles de Kay, art
editor of the *New York Times* and one of the principal organizers of the society, wrote to
invite Ward to its initial meeting, saying, "Annual exhibitions neither provide properly for
sculpture nor secure a fair showing thereof. Moreover the people who buy art objects rarely
buy sculpture, not being educated to understand it."[190] The primary objectives of the society,
as reported in the *New York Times*, were:

> To spread the knowledge of good sculpture, foster the taste for, and encourage the production of,
> ideal sculpture for the house-hold, to promote the decoration of public buildings, squares, and
> parks with sculpture of high class, improve the quality of the sculptor's art as applied to industries,
> and provide from time to time for exhibitions of sculpture and objects of industrial art.[191]

Ward was elected president of the new society, a position he held for eleven years, a period in which it developed into one of the most powerful artistic organizations in the country. Under its auspices some magnificent projects were undertaken, including those constructed at the Pan-American Exposition in Buffalo in 1901 and the Louisiana Purchase Exposition in St. Louis in 1904, as well as the embellishment between 1894 and 1896 of the Reading Room of the Library of Congress in Washington, D.C., and, in 1899, the construction of the Dewey Arch and the Appellate Court House in New York City.

These great neo-baroque projects undertaken at the turn of the century were an outgrowth of the influence of contemporary French art on American sculpture. The École des Beaux-Arts emphasized the integration of the arts for the creating of a total artistic environment; the Beaux-Arts style, therefore, incorporated architecture, sculpture, painting, and landscape gardening to achieve a total effect that subordinated the individual elements.

Ward's role in two of these projects was a major one: he was the chairman of the Sculpture Society committees that oversaw both the decoration of the Reading Room (fig. 66) and the building and decorating of the Dewey Arch (fig. 67). In January 1894, only six months after the National Sculpture Society's formation, General Thomas L. Casey, chief engineer of the United States Army, wrote Ward to express his wish that the society undertake the sculptural decoration of the Library of Congress. A committee composed of Ward, Augustus Saint-Gaudens, and Olin Warner devised with Casey an elaborate decorative scheme for the dome of the Reading Room: it consisted of an ornate sculpture clock and a series of eight emblematic female figures to be placed on piers at the base of the dome in relation to sixteen bronze

Fig. 66. Reading Room, Library of Congress, Washington, D.C., 1894–96.

statues of men of illustrious achievement, which were to be arranged below, around the balustrades of the gallery. Ward himself did the statue of *Poetry* (cat. no. 103), a majestic classical maiden whose outstretched right hand gestures emphatically, whose left arm holds an open scroll. Although *Poetry*, like the other figures, is noble and monumental, the beauty of the Reading Room is found not in the artistic qualities of the individual statues but in the room's total spatial scheme.

Two years after the decoration of the Reading Room, the National Sculpture Society undertook the construction and decoration of a memorial to Admiral George Dewey's victory over the Spanish forces at Manila Bay in 1898 (fig. 67). As Dewey's fleet steamed toward New York in the summer of 1899, the society appointed a special committee to suggest to the city the idea of erecting a triumphal arch to celebrate his visit. The committee members were Karl Bitter, Charles R. Lamb, John De Witt Warner, Frederick W. Ruckstull, and Ward. On the basis of a plan quickly prepared by Lamb, the city appropriated $30,000 for the arch, and the members of the society agreed to donate their services. A triumphal form based on the design of the Arch of Titus was selected as the architectural model. The sculptural decoration on the arch and on the colonnades that were to flank Fifth Avenue north and south of Twenty-third Street honored the naval attributes of a nation peaceful yet, when threatened, capable of heroic deeds. Twenty-eight sculptors in all contributed to the project. Ward's group, *Victory Upon the Sea* (cat. no. 108; figs. 68, 69), was the keynote of the whole celebration. In place atop the arch, it produced a spectacular silhouette that could be seen up and down the avenue. Ward's noble winged *Victory* stood in the bow of a barge being borne through the water by five spirited sea-horses ridden by Tritons and mermans. In her raised right hand she held a laurel wreath, symbolic of her triumphs; her left hand, at her side, held a branch of

Fig. 67. ***The Dewey Arch,*** **1898. Fifth Avenue at 23rd Street, New York City. Photograph. The New-York Historical Society, New York City.**

Fig. 68. John Quincy Adams Ward modeling *Victory Upon the Sea* for *The Dewey Arch*, 1899. Photograph. The Metropolitan Museum of Art, New York City.

palm leaves. The dramatic image is derived from the *Victory of Samothrace* (fig. 70)—another example of Ward's ability to adapt an antique sculpture to a modern idiom. Ward's sculpture also bears a striking similarity to two French statues: Lambert-Sigisbert Adam's *Fountain of Neptune* (1735–40) at Versailles, and Alexandre Falguière's *Quadriga* (1882) for the Arc de Triomphe at the Place de l'Étoile in Paris.[192] The Dewey Arch was constructed of "staff," a material made of plaster mixed with fiber, but it was the Sculpture Society's hope that the work would later be rendered in some more permanent medium. The necessary funds were not forthcoming, however, and the arch was dismantled a year later. The Dewey Arch, though demolished, was a testament in heroic form to the ideas and capabilities of the members of the society and of Ward, its president. One of the most lavish Beaux-Arts memorials of the nineteenth century, it was designed and constructed in a period of only six weeks.

Since the exhibition of *The Indian Hunter* in 1865 Ward's reputation had ridden the crest of a long and swelling wave, but in the late 1890s he suffered his first major professional

Fig. 69. Model for John Quincy Adams Ward's *Victory Upon the Sea*, 1899. Photograph. American Academy of Arts and Letters, New York City.

Fig. 70. *Victory of Samothrace.* Marble. Musée du Louvre, Paris.

setbacks: he was unable to complete to his own satisfaction the models for equestrian statues of generals Philip Henry Sheridan (cat. no. 114; Pl. XXXVI) and Winfield Scott Hancock (cat. no. 115). Ward regarded the works as his swan song, and he devoted the labor of sixteen years to one and twelve to the other. In the end, because of his delay in completing the models and because he had taken on additional commissions that sapped his energy, the contracts for both statues were voided, and the works were finally brought into being only after Daniel Chester French assumed complete responsibility for their enlargement, casting, and erection. While the circumstances surrounding the realization of the works mark a sad episode in Ward's long career, the finished statues nonetheless stand with his finest work—a fitting end to his artistic life.

"Little Phil" Sheridan was one of the most popular and daring of the Union generals of the Civil War. Sheridan was an influential member of the Society of the Army of the Cumberland, which had commissioned Ward's *Thomas* (cat. no. 61) and *Garfield* (cat. no. 78). Owing to the success of these projects, the general and the sculptor had come to know each other and had even discussed a possible statue of Sheridan. Following the general's death in 1888, the Society of the Army of the Cumberland asked Ward to prepare a model for an equestrian statue of him. The society enthusiastically approved the sketch model, and in April 1892 Ward signed a contract that called for the statue's completion by July 1, 1898, for the sum of $35,000. Three years later, in response to the society's request for a progress report, Ward wrote:

I can not, at present, name a date when the statue will be finished. All that I can say is, I have

devoted the past two years exclusively to it and shall continue to give all my time to the work until it is completed. This, of course, involves considerable pecuniary loss to myself, as I have refused other important commissions in order to give all my time to this one.

This is the last of a series of important works that the Society of the Army of the Cumberland has honored me with, and my ambition is to make it the best work of my life.[193]

Despite this avowal, little apparent progress was made on the statue during the next few years, and there was no communication between the sculptor and the society until November 1898, when Ward again responded to a society inquiry:

Your telegram inquiring "what is the condition of the Statue of Sheridan" is something that I have expected and dreaded to receive at any time during the past six months - it put me on the defensive. A year ago I had the large model well advanced but found that it would never satisfy me - that I should never be happy with it - so pulled it down and made new studies entirely - these are now all completed and I have made all preparations for setting up the large model again which I do not propose ever to change except in detail study.[194]

Ward's commitment was overly optimistic, for it was not until the summer of 1903 that he had a life-size study of Sheridan's head completed in clay (fig. 71), and it was not until the

Fig. 71. John Quincy Adams Ward, *General Philip Henry Sheridan*, about 1887. Photograph. National Museum of American Art, Smithsonian Institution, Washington, D.C.

next year that he finished a new working model. After waiting sixteen frustrating years, the society and the Sheridan family had built up a hostility that the merits of Ward's model were not able to bridge. The general's widow was particularly critical, and the society, at its 1905 reunion, approved a resolution canceling Ward's contract. That adversity notwithstanding, Ward continued to work on the full-scale model, and by the fall of 1905 the figure was completed (fig. 72). Following a request from the War Department, which, because federal funds had been appropriated for the statue, was now involved in the project, Ward agreed to invite Mrs. Sheridan to inspect the model. Mrs. Sheridan rejected it, and Ward was notified by the Congressional Committee of the Sheridan Statue that his contract was nullified. Hoping to salvage the commission, Ward brought legal suit against the society, but the

Fig. 72. John Quincy Adams Ward, full-scale model for the *General Philip Henry Sheridan*, 1905. Photograph. National Museum of American Art, Smithsonian Institution, Washington, D.C.

Sheridan contract was awarded instead to Gutzon Borglum, whose equestrian statue was unveiled at the intersection of Massachusetts Avenue and Twenty-third Street in Washington in 1908.

Seemingly moribund, Ward's *Sheridan* was given new life six years after the sculptor's death. The general had been born in Albany, and in February 1914, in a rousing address before the members of the Philip H. Sheridan Camp No. 200, Sons of Veterans, Governor Martin H. Glynn of New York pledged that if the legion raised the sum of ten thousand dollars for the erection of a statue of Sheridan, he would see to it that the state appropriated double that amount. The statue committee that was formed reported on the existence of Ward's working model and the willingness of Daniel Chester French to superintend the statue's erection, within a two-year period, for a fee of $25,000. French's offer was accepted. The statue, on a simple rectangular pedestal designed by Henry Bacon, was unveiled on October 7, 1916. The design and concept of the *Sheridan* are brilliant. The general, in full military dress, is depicted as if riding in a parade past a reviewing stand, acknowledging the adulation of the nation his courage helped to preserve. In the composition of the statue is a dichotomy—a tension—between the poised image of the general and the energy-packed horse he holds in check. By studying the juxtaposition of the simple monumental portrait of Sheridan and the galvanized horse, why Ward made such a painstaking effort to perfect the relationship between the two figures can be better understood.

In 1898, at the very time that his *Sheridan* was to have been unveiled in Washington,

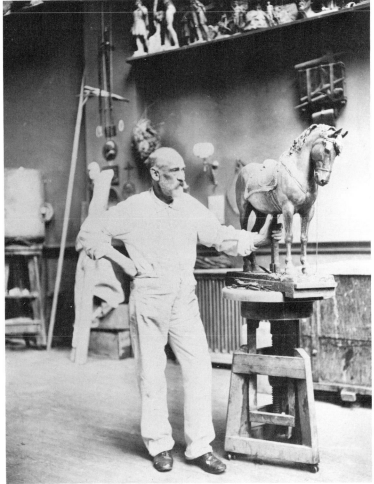

;. 73. *The Smith Memorial*, 1898–1910. Fairmount Park, Philadelphia, insylvania. Reproduced from Fairmount Park Art Association, *Sculpture a City*, 1974. Permission of Walker & Company.

Fig. 74. John Quincy Adams Ward with model of the horse for the *General Winfield Scott Hancock* for the *Smith Memorial*, about 1900. Photograph. American Academy of Arts and Letters.

Ward accepted a commission to do an equestrian statue of General Hancock (cat. no. 115) for the *Smith Memorial,* at the gateway to West Fairmount Park in Philadelphia (fig. 73). The enormous semicircular memorial, containing fifteen individual pieces of bronze sculpture, was commissioned by Richard Smith, the wealthy Philadelphia owner of an electroplate and type foundry. The memorial, designed by James H. Windrim, a Philadelphia architect, honors Pennsylvania's military and naval heroes of the Civil War. A printed broadside announcing the planned statuary was issued to a long list of the country's sculptors in 1897, but Ward did not respond to it. A delegation from the Fairmount Park Art Association thereupon visited the sculptor in his New York studio to persuade him to participate in the project. Ward, agreeing, was assigned the *Hancock* (fig. 74), while the corresponding equestrian statue on the opposite side of the memorial—that of Major General George B. McClellan— was awarded to Paul Wayland Bartlett. Ward was to receive $32,000 and Bartlett $35,000 for their work, and the statues were to be in place within four years. The committee heard nothing further from Ward until December 1901, when its members met with Ward and Bartlett in Ward's studio. After inspecting Ward's model, representatives of the committee wrote, "It had progressed very much further than we had anticipated, and met with our enthusiastic approval, the whole design being serious, dignified, and most interesting."[195] As for Bartlett, he assured the committee that his full-size model was nearing completion and could soon be brought from France (where he was working at the same time on an equestrian statue of Lafayette for Paris) to be cast in bronze. He also explained that he and Ward had worked closely together on their models of the *Hancock* and the *McClellan* in order to make them harmonious. The committee was favorably impressed, and a new contract calling for the statues to be in place within fifteen months was issued in March 1902. Ward failed to meet the new deadline, but the committee delayed further action until January 1906, when they again visited his studio. There Bartlett's full-size plaster model of the *McClellan* was ready for inspection. Whether exasperated by Bartlett's procrastination or by his continual absence because he was still working on the *Lafayette* in Paris, or simply because the committee was dissatisfied with his model, the association notified both Bartlett and Ward that their contracts were nullified. The sculptors nevertheless continued to work on their statues, and the association, since it made no move to select new artists to execute the figures, seemed still to hope that the works would be completed. But three years later, in December 1908, when Bartlett had still not come forward with a new model and Ward, because of poor health, had given up his studio, the association finally made the inevitable decision to recommission the works. It was at that point that Daniel Chester French came to the rescue. Aware of Ward's failing health, and out of admiration for the model the sculptor had finally created, he wrote the association:

> Mr. Ward has completed a model which, in the eyes of his fellow artists, is a work of unusual merit, admirably suited to the place, dignified and impressive, so that the success of the finished statue is practically assured. It is possible to finish the statue and erect it in bronze so that it can be put in place by June 1, 1910.[196]

The committee wanted nothing more to do with Ward, but agreed to let French handle the commission for the *Hancock.* (The *McClellan* was given to Edward C. Potter.) On June 4, 1909, French signed a contract calling for the *Hancock* to be in place by October 1910. Edward Potter and sculptor Carl A. Heber assisted French in enlarging the *Hancock,* and the statue was finished and in place on the *Smith Memorial* by the specified date. As it turned out, that was several months after Ward's death. The *Hancock,* like the *Sheridan,* is an extremely complicated statue. Not only is it a powerful work in its own right but, in addition, Ward has succeeded in coordinating the figure with the curve of the architecture: he has portrayed the arched head of Hancock's horse in a turned position, thus directing the viewer's eye back and around the semicircular arch. His daring and imaginative representation is especially notable when contrasted with the stilted, conventional figures portrayed elsewhere on the memorial.

In 1901, around the time that Ward was renegotiating his *Hancock* contract with the Fairmount Park Association, he agreed to undertake, with Bartlett's assistance, the sculpture program for the pediment of the New York Stock Exchange (cat. no. 112). Ward arranged his theme—"Integrity Protecting the Works of Man"—in a measured, harmonious composition that would complement the severe classical facade designed by the architect George B. Post. At the center of the pediment stands *Integrity*, her arms outstretched and two small children at her feet. On her right are two male figures representing Mechanical Arts and Electricity; on her left stand a farmer, bending under the weight of a large sack he carries, and his wife, whose hand rests on the head of a ram. In the pediment corners, kneeling and semireclining groups represent designers and prospectors. The figures have a strong classical air, though their grouping shows a similarity to David d'Angers's pediment for the Pantheon in Paris (1837). Ward's composition is carefully balanced, and the figures, each an entity in itself, are endowed with the poses, gestures, and robes of antiquity. Nevertheless, they were modeled from life, and that imparts to them an enduring naturalism. The carving of the marble was done by the Piccirilli brothers, and the figures were in place by 1904. The complicated and time-consuming work was undoubtedly partly responsible for Ward's inability to complete his statue for the *Smith Memorial.*

After having finished the Stock Exchange sculpture, with the *Sheridan* and the *Hancock* still awaiting his attention, Ward was approached by August Belmont's children to execute a seated portrait of the family patriarch (cat. no. 116; Pls. XXXVII–XL). It had been Belmont, in contracting for the *Perry* in 1865, who had given Ward his first major commission. Belmont and Ward had remained close friends, and in 1890, when the financier died, the family had had Ward take the death mask, from which he modeled a bust (cat. no. 90). Because of his friendship with Belmont and his long association with the family, Ward consented to undertake the statue. He completed a sketch model in 1903, but probably put it aside not long after in order to direct his full attention to the *Sheridan* and the *Hancock.*

Time was running out for Ward. In 1909, he hired sculptor Frank H. Parker to enlarge and to cast the *Belmont.* The statue was completed shortly after Ward's death. Situated today in front of the Belmont Chapel, in Island Cemetery, Newport, the statue reveals that despite Ward's tribulations his creative powers had not failed him. The seated Belmont, wearing a heavy, fur-lined overcoat and holding his chin with the fingers of his left hand, seems lost in thought. The simple massiveness of the figure and its subtly textured surface exemplify the intuitive statuary portraiture that was Ward's forte.

The last five years of Ward's life were filled with frustration. His increasingly poor health robbed him of his lifelong vitality, and his anguish over not being able to get on with his work surely contributed to his deterioration. The business of running his house and studio on West Fifty-second Street became more than he could handle, and he finally moved to a boarding-house operated by Mrs. Rachel Ostrander Smith, a widow. On July 19, 1906, she became Ward's third wife.[197] Although he still had hopes of completing the *Hancock* and the *Belmont* himself, Ward sold his Fifty-second Street studio two years later to the sculptor Charles Niehaus.[198] His worsening heart condition, along with other health problems, forced him to take to his bed in November 1908.[199] Though he never left it again, he continued to follow anxiously the work on the *Hancock* and the *Belmont.* When he was informed that the *Hancock* was at last completed, he reportedly said to his wife, with a sigh, "Now I can go in peace."[200]

Ward, almost eighty years old, died on May 1, 1910. For over fifty years at the forefront of American sculpture, he had been the dominant force in the transition from neoclassicism to post–Civil War naturalism and, later, one of the pioneers in American Beaux-Arts sculpture. After his death, his long and distinguished career was evaluated by several notable men.

Homer Saint Gaudens, in reviewing some of the contemporary sculptors on behalf of his father, wrote in 1913:

Throughout this onward advance of sculpture Saint-Gaudens continued to regard J.Q.A. Ward as

the dean of the school. Up to the year of his death, Ward, as President of the National Sculpture Society, maintained his independence and intellectual preëminence, strong in the understanding of the technique of his art, free from the clap-trap of over-cleverness or appeal to sentimentality, truly a sculptor both in conceptions and training.[201]

In March 1911, at the reception for the opening of a "Memorial Exhibition of Works By the Late John Quincy Adams Ward, N.A.,"[202] that displayed 121 photographs and models of works by the sculptor, Herbert Adams presented an address, which included these passages:

It is an honor for me as a sculptor to offer here my tribute of profound respect and admiration for the work of John Quincy Adams Ward. His position among American sculpture is not merely commanding, but unique; and I believe it will remain so.

Broadly speaking, the entire history of American sculpture is bound up within the span of his life time. He is the only American sculptor who may be regarded both as a pioneer in our art and as a modern leader. He alone could say of the whole drama, as thus far enacted, "All of it I saw, and part of it I was. . . ."

But not alone from a chronological standpoint is his place among us to be considered as unique. The days of a man's years, whether more or less than the allotted "three score years and ten" are scarcely as important as the character of his service. Mr. Ward's distinctive service in our sculpture is not unlike that of Winslow Homer in our paintings. The artistic expression of both these men is rugged. Large, sincere; it is technically excellent; most of all, it is as wholly American and national as it is possible for any cultivated utterance to be, in a land whose art annals are still as short and simple as ours.

The real and abiding value of Mr. Ward's contribution to our art is due to this; that he had a highly personal, fundamentally American, and extremely virile ideal as to what an American artist should be and do,—an ideal which he pursued to the end of his days, devoting to it all the gifts of his large nature,—imagination, love of beauty, sympathetic insight, sincerity, perseverance. Whatever his work, he never could bear not to do his best. . . .

Let it not be supposed that because Mr. Ward did his work chiefly in his own country, he was at any time indifferent to or unacquainted with the true worth of foreign training and environment. On the contrary, he had a very just appreciation of such values. He kept himself posted. He always knew the "movement," even if he did not choose or was chosen to join it. He was always ready to listen to the "last cry" in foreign sculpture, in the hope that it might perhaps hold for him, as an American artist, some message of significance and truth. It was precisely a gift of his, as an earnest seeker after truth to "prove all things and to hold fast to that which is good." He scorned only the littlenesses, the affectations, the insincerities. . . .

I like to think of him, thus finding rest after strife; and I would that every man of our craft might make so gallant a stand "all in the days work" and afterward find so peaceful an ending.[203]

Paul Wayland Bartlett, who spent most of his life in France, spoke at length of Ward in a lecture on American Sculpture in France that he presented in January 1913 before the Comité France-Amerique in Paris. He said, in part:

The guiles and charms of the Neo-Greek were never a danger for Ward, and with him the "portrait statue" came to its full expression. He signed a large number of them and the best ones are marvels of precise skill. . . .

He often succeeded where others would have failed. Ugliness did not rebuff him. He had the faculty of gleaning character from all of his subjects.

In him one must not seek for grace, for charm, for the pure sculptural phrase; but nobility, dignity and virility, those he had, and plenty to spare.

His figures are often more than portrait statues, they are psychological studies, executed with a shrewdness of observation and causticity of execution amounting to genius. Everyone felt he had met a "man," after meeting him, and a man dangerous to deceive. His personality was commanding, but his quiet authority was easily transformed into sympathy and encouragement for all those who seemed to him honest and sincere. . . .

He enjoyed a far-reaching influence, based entirely on the probity of his achievements, and his

manly sense of justice. With indomitable will he devoted his whole life to his art, to the development of American Sculpture, and to the advancement of the younger men. . . .

In America, we are all very proud of this truly fine figure which combined so many of the qualities of ancient Greece, and I am very happy to have the chance, to render, here, this public homage to an artist, whose silhouette will not be blurred by time.[204]

The most touching and perceptive tribute was given by Ward's former student and close friend Daniel Chester French. In response to an invitation from Mrs. Ward to the unveiling of *The Indian Hunter* in Oak Dale Cemetery (fig. 75) in Urbana, Ohio, on June 29, 1914, the sculptor's eighty-fourth birthday, he wrote:

I send you enclosed a few words of appreciation of Mr. Ward. I know that it is entirely inadequate, but I am not skilled in this sort of literature. . . .

Urbana is indeed fortunate to have for its enjoyment forever one of Mr. Ward's best works and the

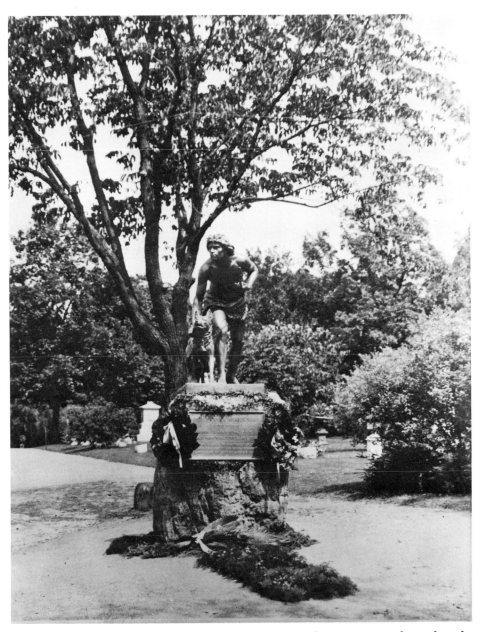

Fig. 75. John Quincy Adams Ward, replica of *The Indian Hunter* in the Oak Dale Cemetery, Urbana, Ohio. Unveiled June 29, 1914, on the eighty-fourth anniversary of the sculptur's birth. Photograph. Chesterwood, Stockbridge, Massachusetts.

one that instantly made his reputation. I regard the Indian Hunter as among the very finest examples of modern sculpture. It is the more remarkable having been made at a time when the classic influence was so strong as almost to stifle originality and freshness in sculpture. It is a beautiful statue.

My acquaintance with Mr. Ward dates back to the Spring of 1870, when a youth of twenty I was so fortunate to work for a short time under his guidance in his studio in Forty-ninth Street as a special pupil. What he taught me at that time, and what he was, have influenced my whole life to a marked degree, and his close friendship, until his death, I regard as one of my most valuable privileges, not only for its effect upon my work, but for the example that he set by his sterling qualities of character. No one who knew him could fail to be impressed by his essential manliness, his hatred of sham and impatience with affectation, his high ideals in his art and his thoroughness. The masculine quality as exhibited by his powerful physique, his strong resonant voice, his decisive motions was one of the first things that affected a new acquaintance, and this quality was equally apparent in his sculpture in which directness, power and virility were dominant notes.

One of the first essentials of an artist is to see nature with fresh eyes, to interpret new phases of her and to open people's eyes to new beauties in the common things of life. Mr. Ward exhibited this power. . . .

Mr. Ward's influence upon the Art of sculpture in this country, and the example that he set to his contemporaries, in high ideals and thoroughness and conscientiousness, can hardly be over-estimated, and when the history of American Sculpture is written the name of John Quincy Adams Ward will cut out clearly all other sculptors as a unique personality, standing alone a dominant figure in the development of art in this country.[205]

These heartfelt tributes reveal the deep respect and affection in which four of America's foremost sculptors, leaders in the American Beaux-Arts movement, held the artist they regarded as the unquestionable master of their profession, or, as he had been so aptly named, the "dean" of American sculpture.

Notes

For explanation of abbreviations used throughout the notes, see pages 280–88. Annotated sources have been deleted wherever possible in the essay, since they appear in the entry of the work under discussion.

1. *New York Times*, November 20, 1879, p. 1.
2. Clark 1954, pp. 244, 273.
3. Howe 1913, p. 123; Tomkins 1970, p. 365. Ward resigned from the board in 1871 but was reelected in 1873.
4. Framed certificates (AIHA).
5. Letter from E. H. Blashfield to JQAW, April 23, 1893 (AIHA).
6. Letter from T. Morgan to author, December 5, 1983 (APS). There is some confusion over when JQAW stepped down and DCF took over as president of the society. Late in 1904 JQAW's title seemed to be an honorary one. DCF was then acting president, although he did not assume the position officially until 1905.
7. Adams 1912, p. 54.
8. Ibid. See also letter from R. U. Johnson to JQAW, January 25, 1905 (N-YHS).
9. Address by M. Schuyler, March 16, 1911 (AIHA).
10. Reed 1947, p. 2.

11. Howells 1916, p. 216.
12. Adams 1912, p. 22.
13. Paper presented by E. Weaver [1900] (OES).
14. Lombardo 1944, p. 296.
15. JQAW, "Sculpture in America," *Ainslee's Magazine* 4 (October 1899), p. 285.
16. Paper presented by H. Adams [March 16, 1911] (AIHA).
17. NAD minutes, October 23, November 12, November 30, 1865, Archives, NAD. Dryfhout 1982, p. 2, reports that in 1866 Augustus Saint-Gaudens attended afternoon and evening classes at the NAD instructed by Daniel Huntington, Emanuel Leutze, Launt Thompson, and JQAW.
18. Prospectus, Art Schools of the MMA 1888–1889, no. 6 (APS).
19. Letter from C. Eliot to JQAW, October 23, 1893 (AIHA).
20. An affectionate and respectful relationship existed among all these men except for Desbois, a Parisian sculptor who had studied at the École des Beaux-Arts between 1872 and 1875. In an expression of the age-old antagonism that can exist between a master and his assistant, an 1879 article called into question the degree to which

Desbois was actually responsible for some of Ward's finished works. *Art Amateur* 1 (August 1879), p. 46. According to Thieme-Becker, s.v. "Jules Desbois," Desbois worked for Ward on the *Washington*, and, after he returned to Paris, became a studio assistant and close friend of Auguste Rodin's.

21. Cresson 1947, p. 62.

22. Sheldon 1878, p. 66.

23. Ibid., p. 64.

24. *The World* [New York], December 29, 1895, p. 33.

25. Sheldon 1878, p. 66.

26. Ibid., p. 63.

27. Howe 1913, p. 252.

28. Young 1960, p. 44. In a letter (7/25/1874) to his mother, J. A. Weir wrote that the French sculptor Frédéric-Auguste Bartholdi had helped JQAW to select casts for the NAD. See also letter from T. A. Richards to JQAW, November 3, 1887 (N-YHS). In 1908 Ward also gave the academy a series of fourteen training models: statuettes by one F. Müller of Nuremberg that show the different and changing proportions at varying ages of men and women. Archives, NAD.

29. JQAW Sketchbooks nos. 8, 9, 12 (AIHA).

30. Larkin Mead, who had worked along with Ward with HKB, demonstrated the knowledge the two young sculptors had of plaster casts when he described a studio he set up in 1856: "Supported on brackets around the walls of the room I see the Fighting Gladiator same as one at studio, Venus de Milo about four feet high & bust of the Apollo, Cow and calf by Mene, Race-horse same as yours, Dying Gladiator, Dante, small statuettes of the Apollo and Venus de Medici, Two Anatomical figures etc. [I] invested some forty dollars [in the collection]." Letter from L. Mead to JQAW, December 10, 1856 (AIHA).

31. Sheldon 1878, p. 66.

32. Ibid., p. 63.

33. Townley 1871, p. 404.

34. Sheldon 1878, p. 66.

35. Letter from H. K. Bush-Brown to JQAW, June 6, 1886 (AIHA).

36. Saint-Gaudens 1913, 1, p. 170.

37. Baker 1980, p. 65.

38. Ibid., pp. 300–314; 587. Ward–Hunt collaborations include: Commodore Matthew C. Perry, Newport, R. I. (1868); Seventh Regiment Memorial, New York City (1869); Major General John F. Reynolds, Gettysburg, Pa. (1871); *Alliance and Victory*, Yorktown, Va. (1881); Marquis de Lafayette, Burlington, Va. (1883); George Washington, New York City (1883); *The Pilgrim*, New York City (1884); William Earl Dodge, New York City (1885); Lincoln Goodale, Columbus, Ohio (1888); Henry Ward Beecher, Brooklyn, N.Y. (1891). Hunt designed a pedestal for the statue of Simon Kenton (about 1891) for Urbana, Ohio, but Ward's statuette was never enlarged. The two artists also worked together on the *Shakespeare*, for Central Park (1870), but in the end the pedestal on which the statue was erected was one by Jacob Wrey Mould. Ward and Hunt collaborated on designs for Soldiers and Sailors monuments for Brooklyn, N. Y. (1886) and Indianapolis, Ind. (1887), but they were never executed. The two men did not actually collaborate on the statue of August Belmont, Newport, R.I. (1910), as Ward was not approached to do the work until 1903, some eight years after Hunt's death.

39. From "Biography of Richard Morris Hunt" by Catherine Clinton Howland Hunt (Mrs. RMH), typescript, p. 277, AIFA. Paraphrased in Baker 1980, p. 300.

40. Baker 1980, pp. 540, 544.

41. Hargrove 1980, p. 31.

42. Holderbaum 1980, pp. 39–40.

43. Ibid., p. 41.

44. Ibid., p. 221.

45. Hargrove 1980, pp. 24–25.

46. Saint-Gaudens 1913, 1, p. 277.

47. In paper presented by E. Weaver [1900], she stated: "As my Grand Father was a great admirer of John Quincy Adams he named his little son for him" (OES).

48. Genealogical notes, JQAW, n.d. (AIHA).

49. Ibid. See also Middleton 1917, 1, p. 1088.

50. Middleton 1917, 1, p. 1088.

51. Letter from J. R. Macbeth to JQAW, February 7, 1866, photocopy (APS).

52. Middleton 1917, 1, p. 1089.

53. Macbeth to JQAW (see n. 51).

54. Genealogical notes, JQAW, n.d. (AIHA). See also Middleton 1917, 1, p. 1089.

55. Middleton 1917, 1, p. 606.

56. Genealogical notes, JQAW, n.d. (AIHA). Ward records that his parents were married by a Rev. Brich on January 30, 1823; also that his mother was born on June 19, 1797, and died on January 23, 1866.

57. Macbeth to JQAW (see n. 51).

58. Ibid.

59. Genealogical notes, JQAW, n.d. (AIHA).

60. Howe 1890, 1, p. 383.

61. JQAW, "Reminiscent Sketch of a Boyhood Friend," p. 8, Joseph Downs Manuscript and Microfilm Collection, Winterthur Museum, Winterthur, Delaware. A copy is also at AAAL.

62. Howe 1890, 1, p. 383. In a letter to JQAW, May 11 [1887], R. C. Hulburd wrote: "Do you remember way back in the forties—yes thirties, when we attended school together, first Mashons and afterward Ogdens?" (AIHA).

63. Townley 1871, p. 404.

64. Dreiser 1899, p. 4.

65. Ibid.

66. Townley 1871, pp. 403–404.

67. Ibid., pp. 404–405.

68. W. D. Howells, *Stories of Ohio* (New York: American Book Co., 1897), p. 269. In a letter to JQAW, March 8, 1850, H. D. McDonald wrote: "I

saw quite a curiosity at your house—a cabin nicely made out of clay—it was very nicely done the girls all wanted to take it home" (AIHA).

69. Townley 1871, p. 405.

70. Dreiser 1899, p. 4. Howe (1890, 1, p. 383) reports that the "first work of art [Ward] ever saw was a copy of a head of Apollo in terra cotta by Hiram Powers, which was owned by John H. James, of Urbana."

71. Dreiser 1899, p. 4.

72. Ibid.

73. Townley 1871, p. 405.

74. Ibid. (See also Howe 1890, 1, p. 383.)

75. Ibid.

76. Ibid.

77. Ibid.

78. "Painters and Sculptors," *Art Age* 4, (August 1886), p. 10.

79. Ibid.

80. Dreiser 1899, p. 4.

81. Townley 1871, pp. 405–406.

82. Ibid., p. 406.

83. Ibid.

84. In paper presented by E. Weaver [1900], she stated that Ward studied with Brown six years (OES). All other accounts have it at seven years.

85. Anatomical drawing by Alberto Durero (Albrecht Dürer), from a collection published in Nuremberg in 1532, inscribed on reverse: "Mr. Ward copied from H. K. Brown's study of proportions" (AAAL).

86. Adams 1912, p. 14.

87. Howells 1886, p. 26.

88. Letter from L. Mead to JQAW, March 24, 1856 (AIHA).

89. Howells 1886, p. 26.

90. Letter from JQAW, March 7, 1852, HKB Papers, p. 619, Library of Congress.

91. Letter from HKB to JQAW, June 17, 1852 (AIHA).

92. Ibid.

93. Miller 1957, p. 170.

94. Ibid., p. 171.

95. Craven 1968, p. 152.

96. Ibid.

97. Fairman 1927, pp. 191–193.

98. Dreiser 1899, p. 4. (Notes in DCF's handwriting on a photograph at Chesterwood of the *Washington* cite the statue as having been done by JQAW. A possible inference is that French saw in it more of Ward's hand than of Brown's.)

99. Ibid., pp. 4–5.

100. *DAB*, s.v. "JQAW."

101. Letter from JQAW, June 7, 1856, quoted in Craven 1968, p. 152.

102. Letter from JQAW, March 7, 1852, HKB Papers, p. 618, Library of Congress.

103. Dreiser 1899, p. 4.

104. Letter from G. Fuller to JQAW, August 25, 1856 (AIHA).

105. JQAW Sketchbook no. 12. Two drawings

of a dog "Tiger" are inscribed "Urbana 1856" (AIHA).

106. Townley 1871, p. 406.

107. HKB to JQAW, August 24, 1857 (AIHA). The similarity of some of Ward's pencil and wax sketches of Indian subjects to statuettes he did in about 1860 (*The Indian Hunter* [cat. no. 12], *Indian Stringing His Bow* [cat. no. 11], and *Indian Killing a Buffalo* [cat. no. 15]) would support the theory that Ward made an earlier trip west in addition to the one in 1864 on which he made studies for his enlargement (1865, cat. no. 38) of *The Indian Hunter* (Tuckerman 1867, p. 581).

108. Reed 1947, p. 10. Reed based this information on notes in Mrs. ROS's possession. Reed gives the spelling as "Bamman," while *DAB*, s.v. "JQAW," states it more fully: "[Ward] married Anna, daughter of John and Rebecca (Noyes) Bannan."

109. *DAB* and *NCAB*, s.v. "JQAW"; *The Architects' and Mechanics' Journal*, May 12, 1860, p. 54.

110. Letter from HKB to JQAW, May 8, 1859 (AIHA).

111. Fairman 1927, pp. 185–189.

112. Letter from H. P. Gray to JQAW, January 22, 1859 (N-YHS).

113. Galt 1820, p. 105.

114. Letter from L. Mead to JQAW, December 10, 1856 (AIHA). For an excerpt of the letter, see n. 30.

115. Letter from E. M. Ward to JQAW, June 1, 1859 (AIHA). Edgar, JQAW's younger brother, wrote, "So *your trip* 'across the sea' is *definite*—wait about three years and we will go together. . . ."

116. Howells 1916, pp. 215–216.

117. Ibid.

118. Ibid., pp. 215, 235.

119. Letter from W. D. Howells to JQAW, July 23, 1861 (AIHA).

120. Townley 1871, p. 406.

121. Tuckerman 1867, p. 581.

122. Clark 1954, p. 273.

123. *The Freedman* is also very similar to *The Boxer* (Rome, Museo Nazionale delle Terma), but the resemblance must have been accidental: the classical bronze was not discovered until 1884, twenty-one years after *The Freedman* was cast.

124. Clark 1954, p. 273.

125. *New York Times*, June 24, 1863, p. 2.

126. Jarves 1960, pp. 225–226.

127. Tuckerman 1867, p. 582. See n. 107 regarding dates of Ward's pencil and wax sketches.

128. *Westchester Times*, n.d., JQAW Scrapbook (AIHA).

129. *The Press* [New York], March 10, 1895, part 6, p. 1.

130. Saint-Gaudens 1913, 2, p. 52.

131. Schuyler 1909, p. 645.

132. Other Belmont commissions include a re-

lief of Jane Pauline Belmont (cat. no. 57); bust (cat. no. 90) and statue (cat. no. 116) of August Belmont; and casts (cat. no. 105) of the hands of Mrs. Belmont's mother, Mrs. Edward Morgan.

133. "The Shakespeare Statue," *Harper's Weekly* 11 (April 27, 1867), p. 269.

134. Unaddressed JQAW letter, n.d. (AIHA).

135. Letter from E. Booth to JQAW, n.d. Typewritten copy (APS).

136. Sheldon 1878, p. 63.

137. Buley 1967, 1, p. 108, quoting *The Insurance Monitor* 19 (December 1871).

138. Letter to JQAW from the architectural firm of Olmsted and Vaux, n.d. (AIHA).

139. MacKaye 1927, 1, p. 99.

140. Letter from JQAW to T. Gaghindi, August 3, 1867 (N-YHS).

141. *Trow's New York City Directory*, published annually in New York, lists JQAW at these consecutive addresses: 1863/64: bus. 204 5th Ave; res. 110 W. 15th St. 1864/65: bus. 212 5th Ave; res. 170 E. 18th St. 1865/66: bus. 212 5th Ave; res. 68 Hammond St. 1866/67: bus. 212 5th Ave; res. 68 Hammond St. 1867/68: bus. 212 5th Ave; res. 274 W. 11th St. 1868/69: bus. 161 5th Ave; res. 274 W. 11th St. 1869/70: 9 West 49th St.

142. Baker 1980, pp. 228, 230.

143. "From New York: A Visit to Ward, the Sculptor," a newspaper clipping inscribed "Springfield Republican" by Ward, JQAW Scrapbook (AIHA).

144. Tomkins 1970, pp. 29–32.

145. Letter from T. A. Richards to JQAW, May 12, 1870 (N-YHS).

146. Cresson 1947, p. 62.

147. Letter from DCF to W. Brewster, April 3, 1870, Museum of Comparative Zoology, Harvard University.

148. Letter from DCF to S. F. Bartlett, April 11, 1870, DCF Papers, Library of Congress.

149. *New York Daily Tribune*, May 7, 1870, p. 5; Townley 1871, p. 408.

150. Letter from JQAW to J. T. Johnson, April 3, 1871, Archives, MMA.

151. JQAW Sketchbook no. 4 (AIHA).

152. Young 1960, p. 44.

153. Clipping from unidentified, undated newspaper, JQAW Scrapbook (AIHA).

154. Craven 1968, p. 246.

155. "What the Sculptors Are Doing," *The Monumental News* 25 (January 1913), p. 39.

156. Saint-Gaudens 1913, 1, p. 277.

157. Letter from JQAW to J. Sturges, May 19, 1873, Archives, MMA. See also Tomkins 1970, p. 365.

158. Clark 1954, p. 244. As president of the academy, Ward was a member of the Department of Public Parks' Committee on Statues. Letter from W. Irwin to JQAW, February 10, 1874 (N-YHS).

159. Saint-Gaudens 1913, 1, p. 170. See also ranscription of letter from JQAW to A. Saint-

Gaudens, n.d. "I have not yet had time to see your statue at Mr M - but I saw the Silence at the Masonic Temple last week. With reference to the proposed statue of Farragut I sincerely hope that the gentlemen of the committee in charge of the affair will commission you to do the work and if you think that any reference to me in the matter would assist them in coming to such a conclusion I should most cheerfully express my faith in your ability to give them an earnest and most interesting statue. You can refer to me in any way you choose. I spoke to Mr. Field about the matter some three or four weeks ago." A. Saint-Gaudens Papers, Dartmouth College, Hanover, New Hampshire. Dryfhout 1982, p. 76, speculates that a pair of cameo cuff links that Saint-Gaudens supposedly carved and gave to JQAW were a token of his appreciation for securing the *Farragut* commission. W. Vanamee, in a letter to Mrs. JQAW of June 27, 1929 (AAAL), acknowledges the gift to the academy of the cuff links. Their present location is unknown.

160. Photocopy of wedding announcement (APS).

161. *Trow's New York City Directory*, 1877/78.

162. *American Architect and Building News*, August 28, 1880, no. 244. See also letter from C. Booth to T. Wisedell, July 23, 1878, regarding a stained-glass window being made for Ward's house (AIHA).

163. Letters from JQAW to J. Atkinson, November 12, November 22, 1877; April 26, 1878, New England Historic Genealogical Society. J. B. Bell and C. D. Fleming, "Furniture from Atkinson–Lancaster collection at the New England Historic Genealogical Society, *Antiques* 113 (May 1978), p. 1083, illustrates some of the "Bombay" furniture John Atkinson brought to America for himself in about 1855.

164. *New York Daily Tribune*, February 4, 1879, p. 8; Reed 1947, p. 21.

165. Letter from JQAW to E. F. Gladwin, June 25, 1886, photocopy (APS). Ward had approached Olin Warner about doing a memorial to Mrs. JQAW. Letter from O. Warner to JQAW, June 6, 1881 (AIHA). See also G. Gurney, "Olin Levi Warner (1844–1896): A Catalogue Raisonné of His Sculpture and Graphic Works," Ph.D. dissertation, University of Delaware, 1978, 3, pp. 928–929.

166. Cowpens 1896, p. 48.

167. *New York Times*, November 25, 1883, p. 9.

168. Baker 1980, pp. 300, 544. See also a number of estimates, bills, and receipts from RMH to JQAW: March 28, May 19, July 15, August 8, November 15, November 22, November 29, December 29, 1882 (AIHA). JQAW also kept his former studio/residence at 7 and 9 West Forty-ninth Street.

169. Author interview with Mrs. ROS, November 28, 1969. See also photograph album,

given by A. W. Dimock to JQAW (AIHA). The album contains many photographs of Ward and other friends at Peekamoose. An article in *The Collector* 7 (September 15, 1896), p. 291, gives an account of the club and of the falling-out Ward and Dimock had in 1896.

170. Dimock 1915, p. 251. In the chapter titled "Camping with Comanches," Dimock reported: "Ward was an excellent rider, measured by white man's standards, and he carried his rifle in the Buffalo chase and killed his bull in good shape."

171. Letter from W. H. Ames to JQAW, November 17, 1886 (N-YHS).

172. Letter from H. C. Corbin to JQAW, April 24, 1883 (AIHA).

173. Adams 1912, p. 42.

174. Letter from S. P. Avery to A. Lucas, May 19 [1887] (AIHA).

175. Letter from S. P. Avery to L-J. F. Bonnat, May 15, 1887 (AIHA).

176. Letter from S. P. Avery to Mr. Moreau-Vauthier, May 15, 1887 (AIHA).

177. Letter from F. Aucaigne to H. Vignand, May 21, 1887 (AIHA).

178. Letter from F. Aucaigne to A. Chabard, May 21, 1887 (AIHA).

179. Letter from T. A. Richards to JQAW, November 3, 1887 (N-YHS).

180. JQAW note at bottom of letter from A.E. Jones, May 2, 1887 (AIHA).

181. Letter from J. W. A. MacDonald to JQAW, December 7, 1887 (N-YHS).

182. Telegram from H. C. King to JQAW, March 8, 1887 (N-YHS).

183. Contract between the executive committee of the Beecher Statue Fund Committee and JQAW, April 6, 1888 (N-YHS).

184. Hargrove (1980, p. 32) writes: "In simple eloquence, Chapu's personification of *Youth* stretches up to bestow her palm at the base of Regnault's bust. This combination of architecture and figure with a portrait bust was widely imitated."

185. Saint-Gaudens 1913, 2, p. 42.

186. Craven 1968, p. 254.

187. Contract between the Executors of the Estate of E. Fogg and JQAW, April 6, 1894 (N-YHS).

188. R. G. Wilson, "Architecture, Landscape, and City Planning," *The American Renaissance, 1876–1917* (New York: The Brooklyn Museum, 1979), pp. 87–92.

189. Adams 1912, p. 55.

190. Letter from C. de Kay to JQAW, April 26, 1893 (N-YHS).

191. *New York Times,* May 31, 1893, p. 7.

192. B. Wennberg, *French and Scandinavian Sculpture in the Nineteenth Century* (Atlantic Highlands, N.J.: Humanities Press, 1978), p. 127.

193. SAC 1895, p. 107.

194. Letter from JQAW to Gen. H. C. Corbin, November 16, 1898 (AIHA).

195. Smith Memorial 4, p. 526, report from L. W. Miller and C. J. Cohen, February 14, 1902.

196. Ibid., 6, p. 724, letter from DCF to J. M. Gest, February 19, 1909.

197. Author interview with Mrs. ROS, November 28, 1969.

198. *New York Herald,* October 3, 1908, p. 10. Mrs. JQAW did not sell the Forty-ninth Street studio/residence until 1927. Letter from Mrs. JQAW to E. E. Brown, September 30, 1927 (WMC).

199. *New York Times,* November 30, 1908, p. 1.

200. *DAB,* s.v. "JQAW." Paper presented by H. Adams, [March 16, 1911] (AIHA).

201. Saint-Gaudens 1913, 2, p. 210.

202. Memorial Exhibition 1911, Vertical Artist File, Watson Library, MMA.

203. Paper presented by H. Adams, [March 16, 1911] (AIHA).

204. Extract from a paper presented by P.W. Bartlett, January 1913 (AIHA).

205. Letter from DCF to Mrs. JQAW, June 22, 1914 (AIHA).

PLATE 1 Eleanor Macbeth Ward, 1853 (cat. no. 3).

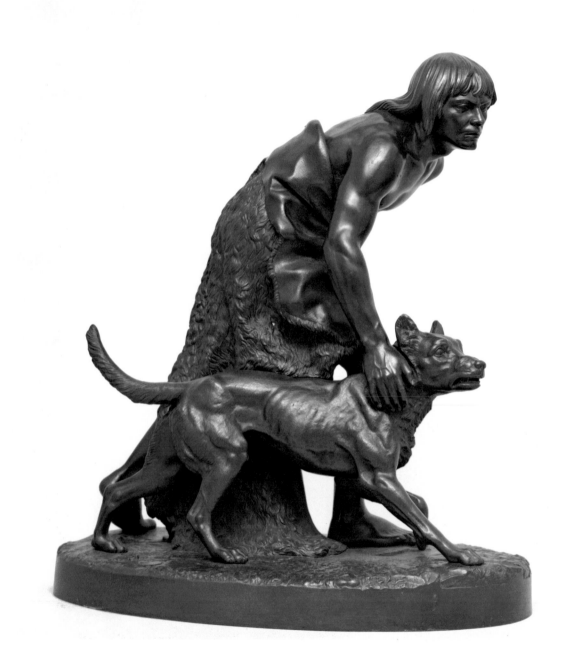

PLATE II *The Indian Hunter*, 1860 (cat. no. 12.2).

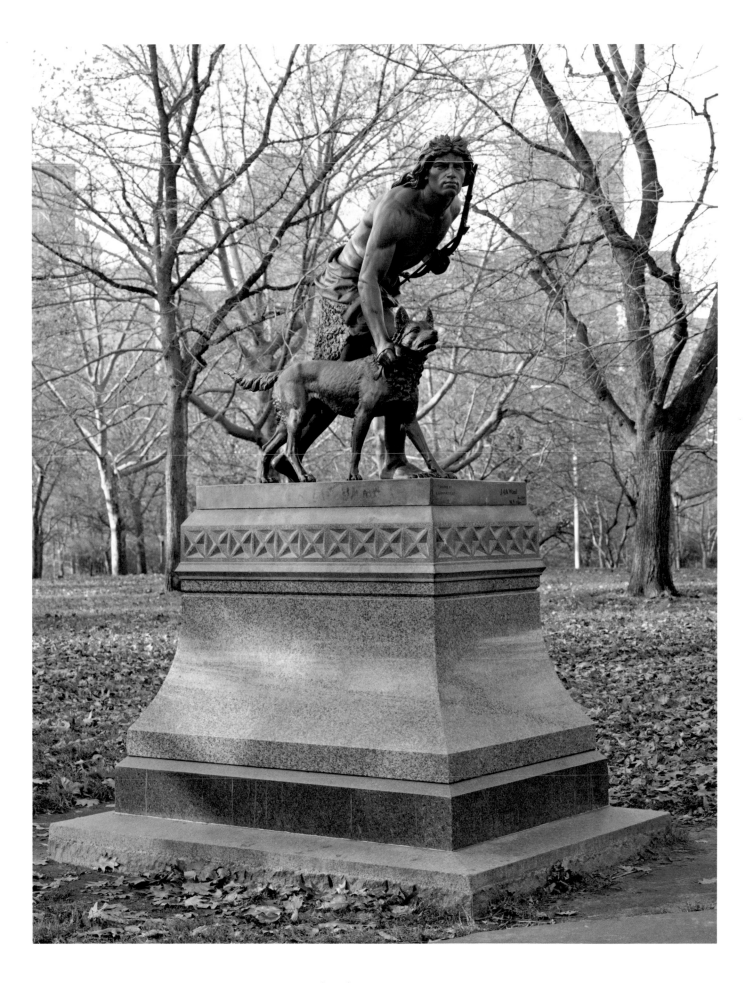

PLATE III *The Indian Hunter*, 1866 (cat. no. 38).

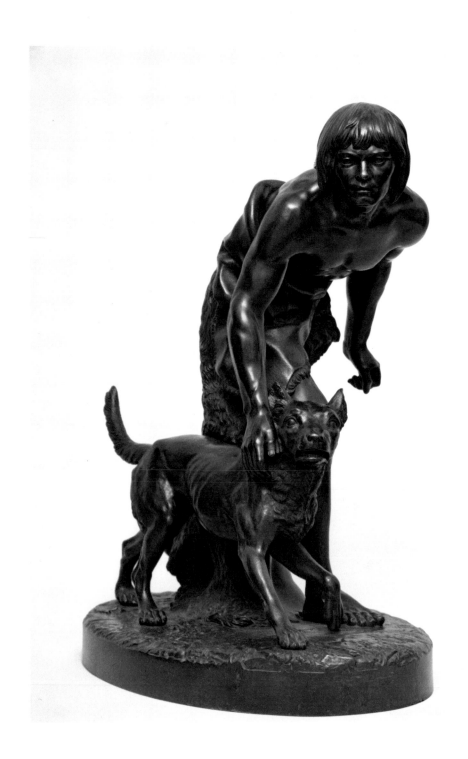

PLATE IV *The Indian Hunter*, 1860 (cat. no. 12.2).

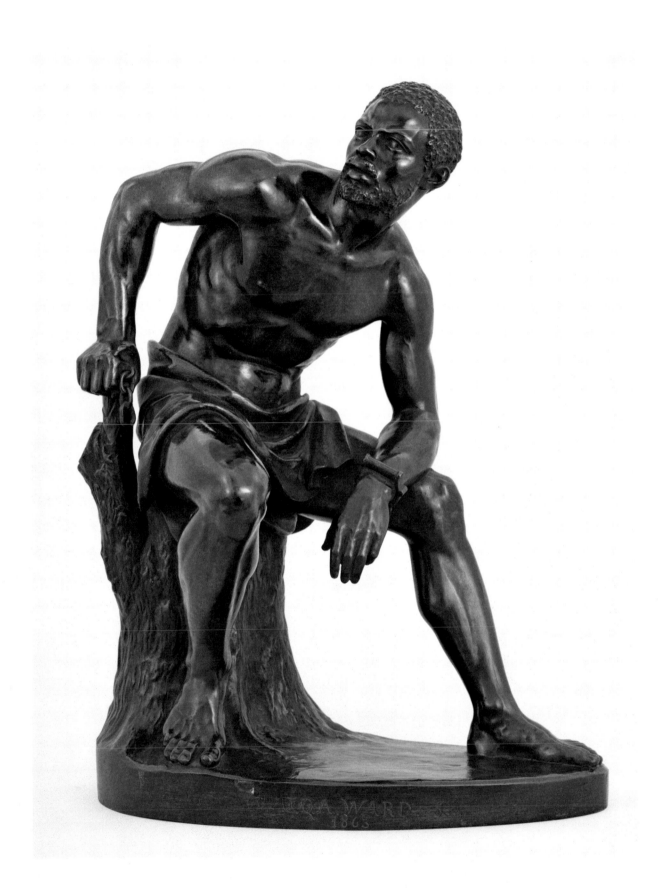

PLATE V *The Freedman*, 1863 (cat. no. 21.7).

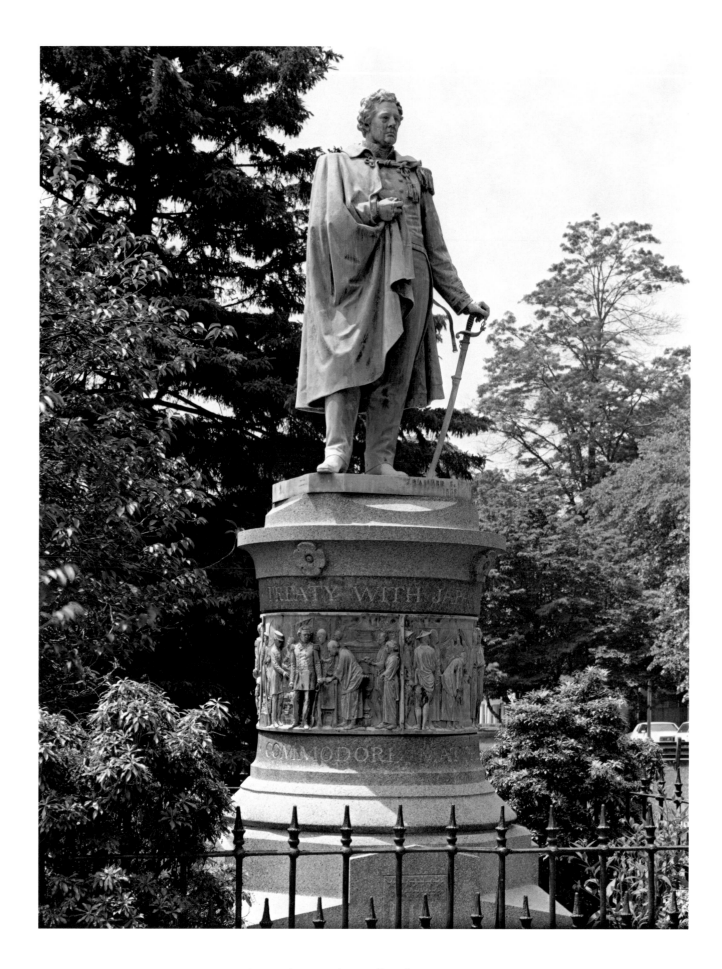

PLATE VI Commodore Matthew Calbraith Perry, 1868 (cat. no. 46).

PLATE VII Major General John Fulton Reynolds, 1871 (cat. no. 53).

PLATE VIII Israel Putnam, 1873 (cat. no. 55).

PLATE IX Israel Putnam, 1873 (cat. no. 55).

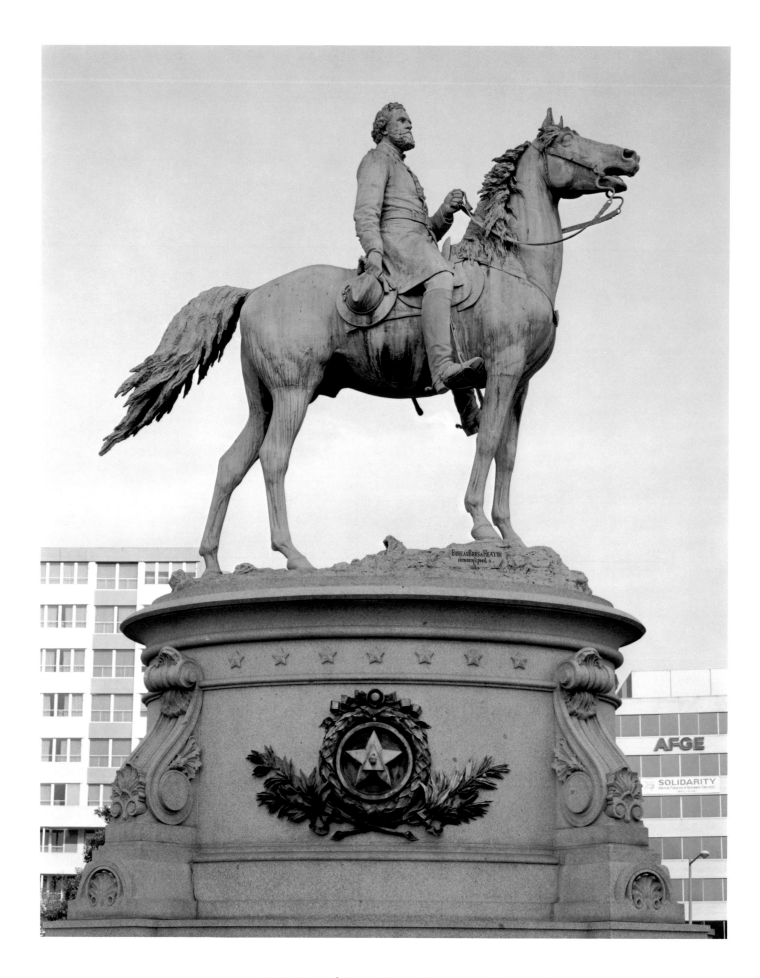

PLATE X Major General George Henry Thomas, 1879 (cat. no. 61).

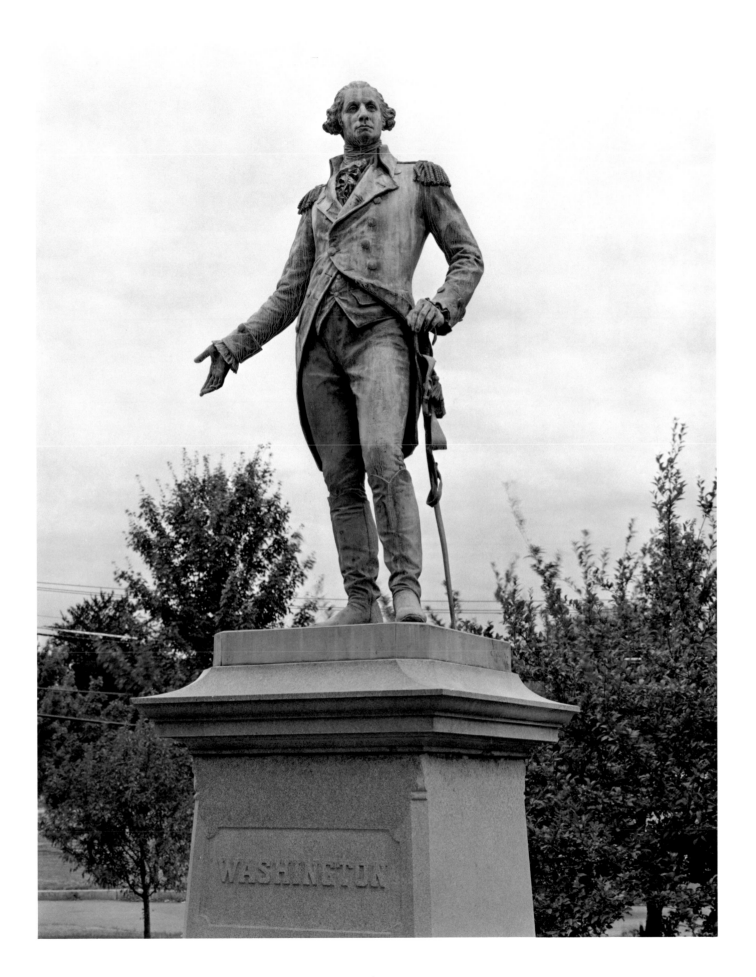

PLATE XI George Washington, 1878 (cat. no. 59).

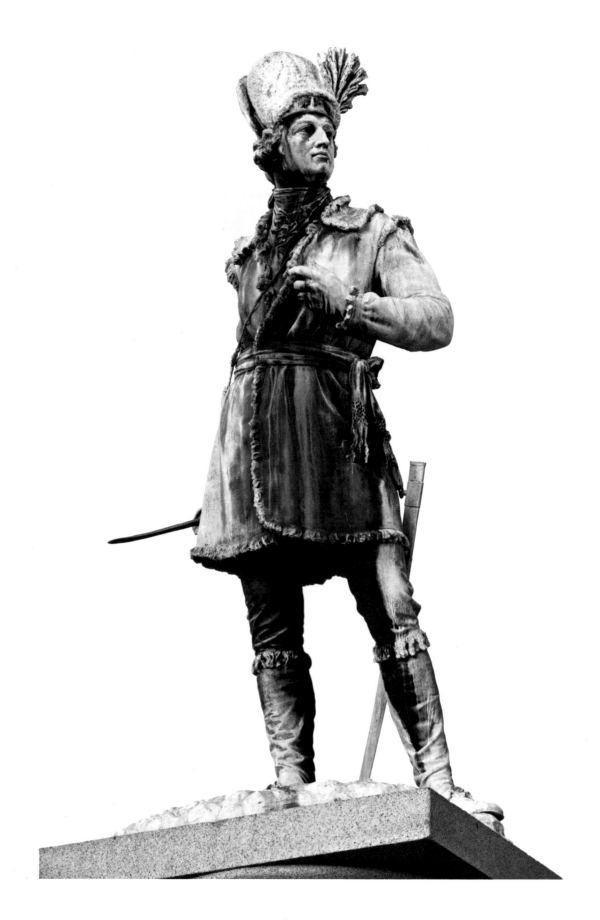

PLATE XII Daniel Morgan, 1881 (cat. no. 67).

PLATE XIII Daniel Morgan, 1881 (cat. no. 67).

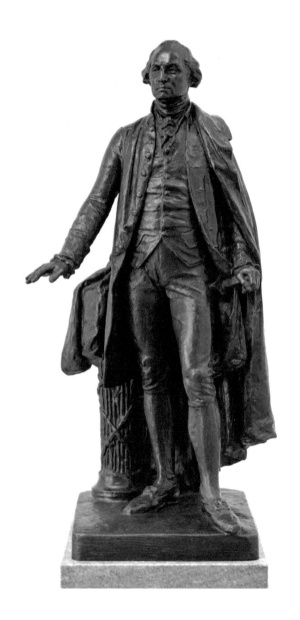

PLATE XIV The Marquis de Lafayette, 1883 (cat. no. 68.3). PLATE XV George Washington, 1883 (cat. no. 69.5).

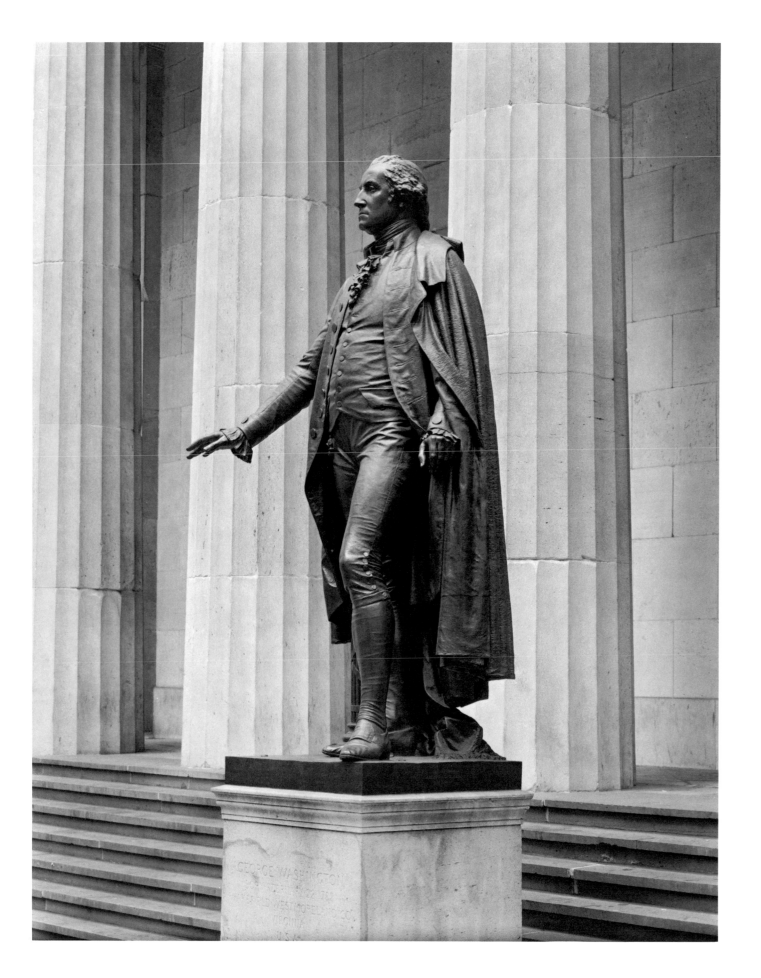

PLATE XVI George Washington, 1883 (cat. no. 69).

PLATE XVII William Hayes Fogg, 1886 (cat. no. 74).

PLATE XVIII William Hayes Fogg, 1886 (cat. no. 74).

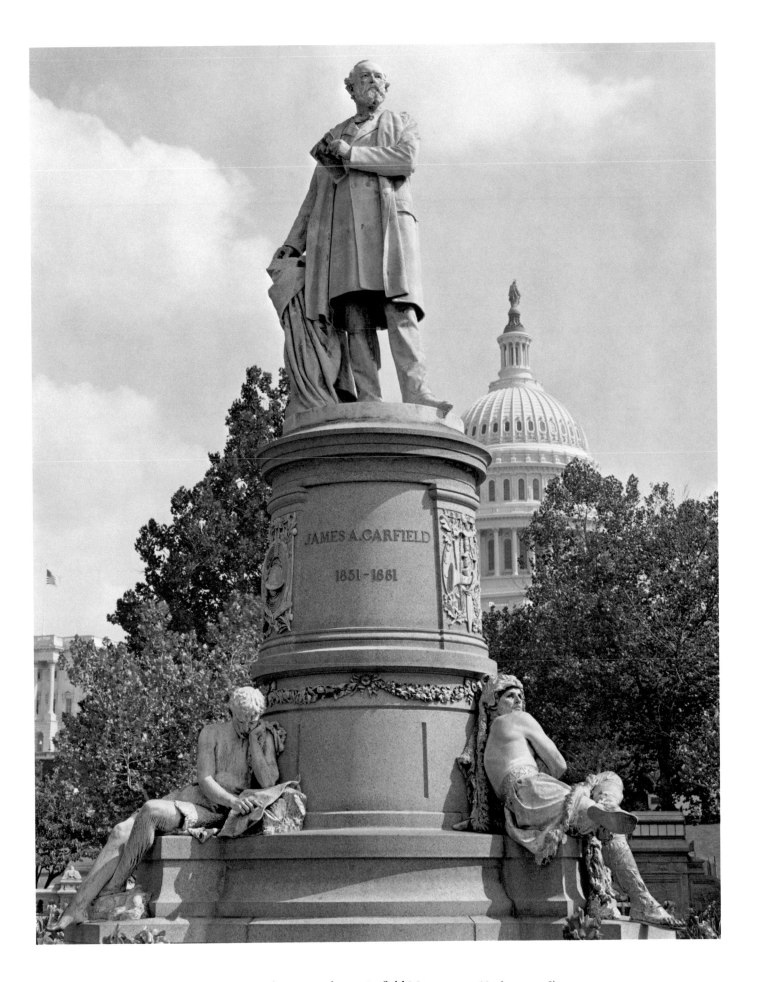

PLATE XIX The James Abram Garfield Monument, 1887 (cat. no. 78).

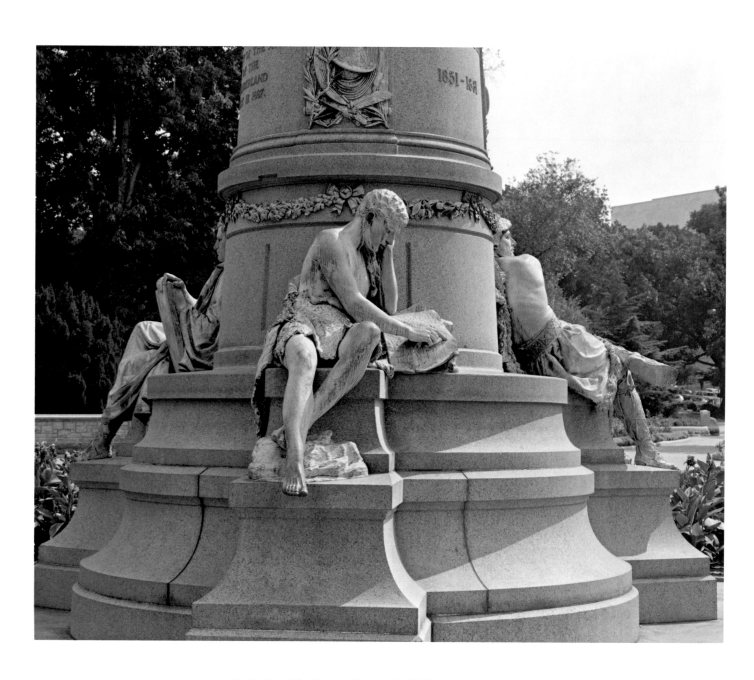

PLATE XX *The Student*, The James Abram Garfield Monument, 1887 (cat. no. 78).

PLATE XXI *The Warrior*, The James Abram Garfield Monument, 1887 (cat. no. 78).

PLATE XXII William Earl Dodge, 1888 (cat. no. 82.1).

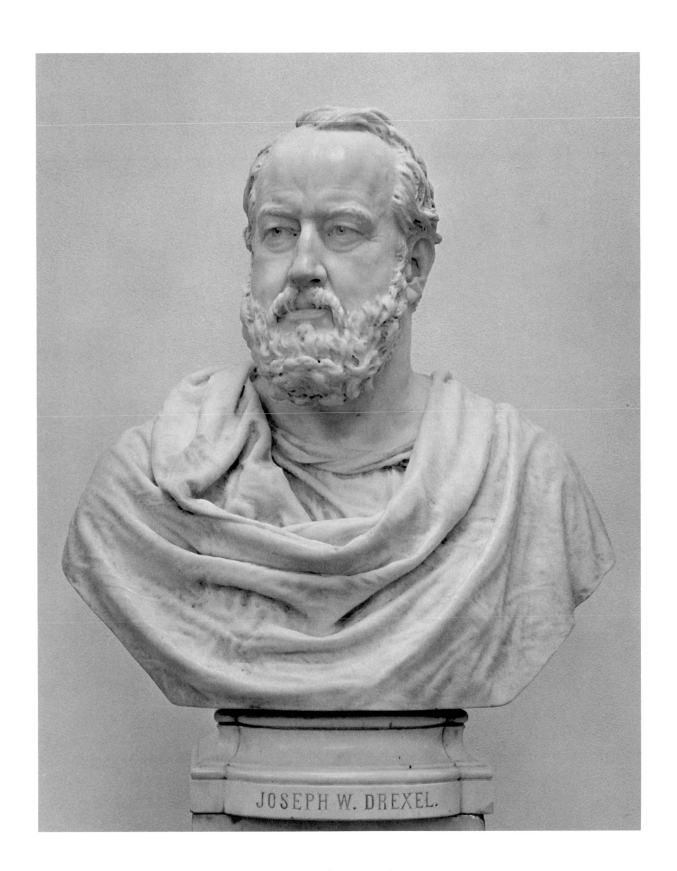

PLATE XXIII Joseph William Drexel, 1889 (cat. no. 86).

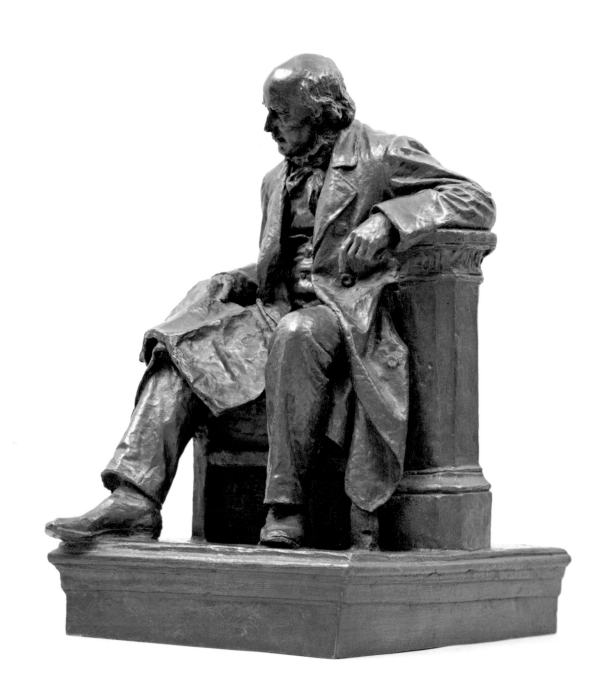

PLATE XXIV Horace Greeley, 1890 (cat. no. 89.1).

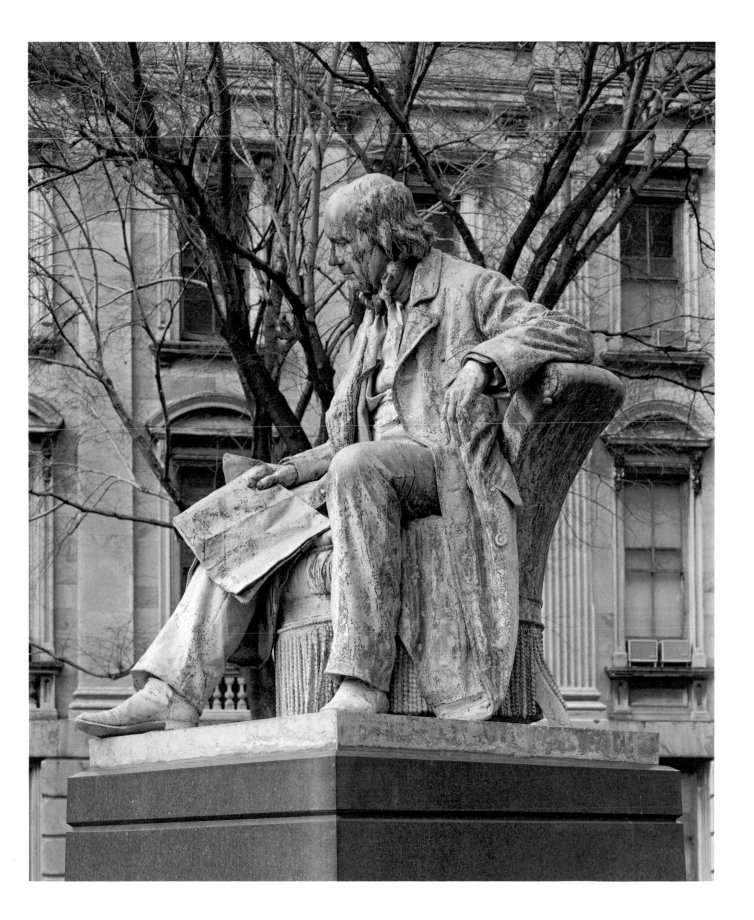

PLATE XXV Horace Greeley, 1890 (cat. no. 89).

PLATE XXVI Young Black Girl, Henry Ward Beecher Monument, 1891 (cat. no. 91).

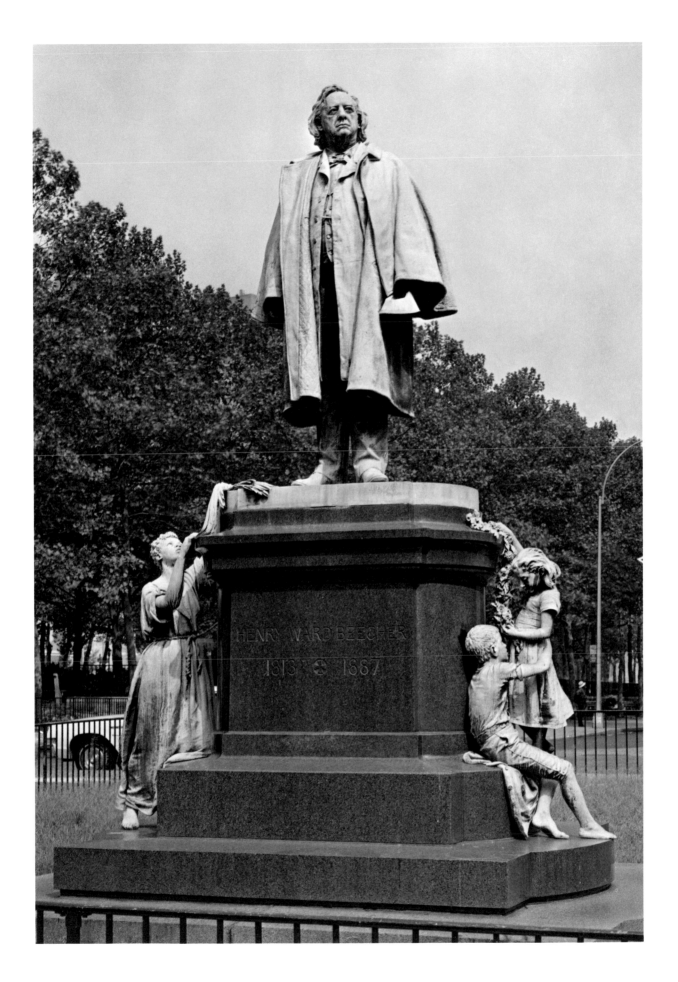

PLATE XXVII Henry Ward Beecher Monument, 1891 (cat. no. 91).

PLATE XXVIII Head of Young Boy, Henry Ward Beecher Monument, 1891 (cat. no. 91).

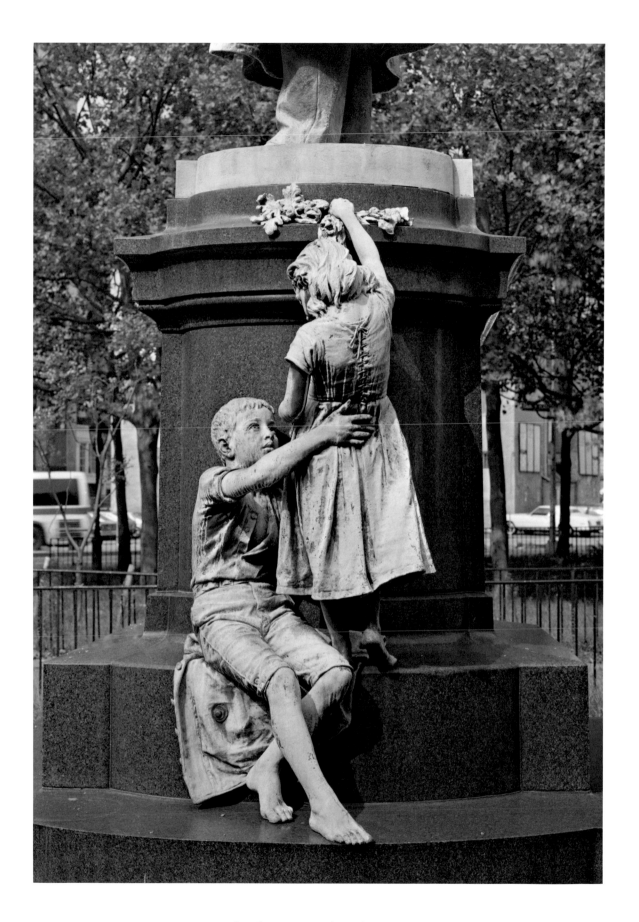

PLATE XXIX Young Boy and Girl, Henry Ward Beecher Monument, 1891 (cat. no. 91).

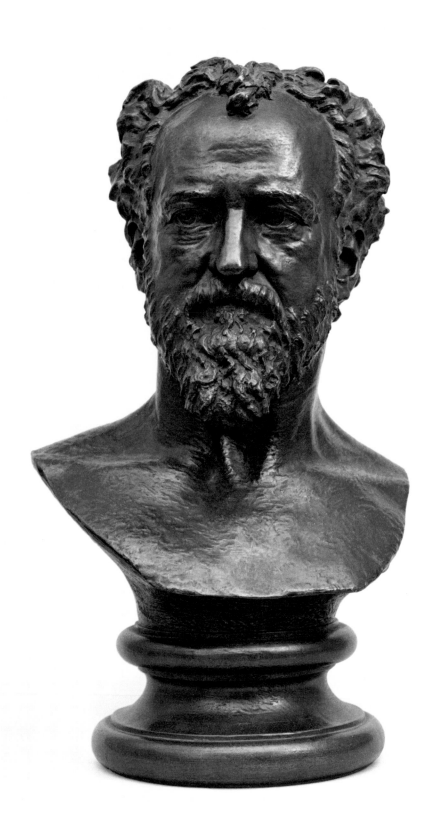

PLATE XXX Roscoe Conkling, 1892 (cat. no. 93).

PLATE XXXI Roscoe Conkling, 1892 (cat. no. 93).

PLATE XXXII Horace Fairbanks, 1893 (cat. no. 95).

PLATE XXXIII Stephen Wilcox, 1894 (cat. no. 96.1).

PLATE XXXIV Henry Baldwin Hyde, 1901 (cat. no. 110).

PLATE XXXV Henry Baldwin Hyde, 1901 (cat. no. 110).

PLATE XXXVI General Philip Henry Sheridan, 1906 (cat. no. 114).

PLATE XXXVII August Belmont, 1910 (cat. no. 116).

PLATE XXXVIII August Belmont, 1910 (cat. no. 116).

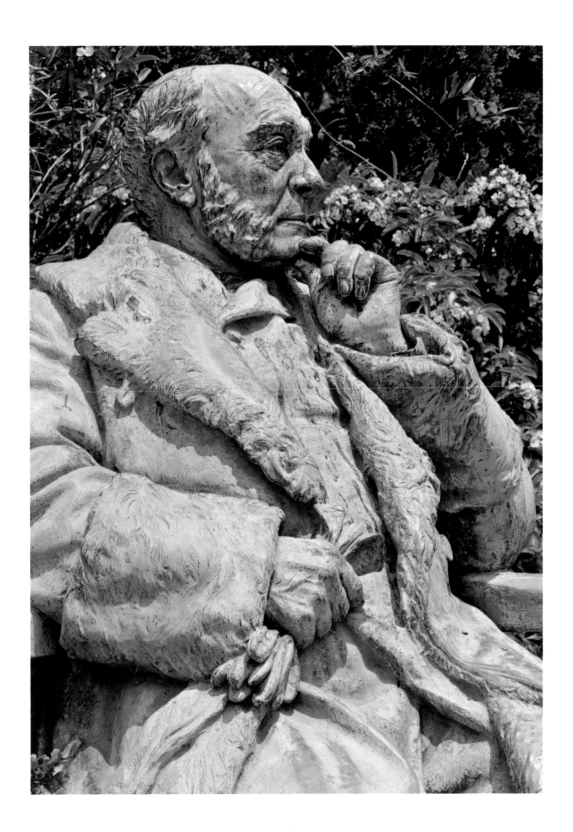

PLATE XXXIX August Belmont, 1910 (cat. no. 116).

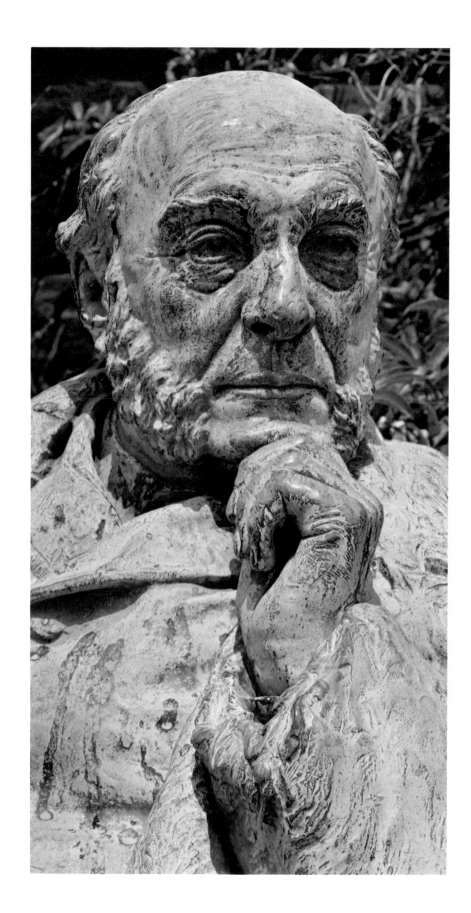

PLATE XL August Belmont, 1910 (cat. no. 116).

CATALOGUE

Object List

1. *Irish Workman.* Figurine, about 1849.
2. Eleanor Weaver. Bust, about 1850.
3. Eleanor Macbeth Ward. Relief, 1853.
4. *Hercules.* Statuette, about 1855.
5. Jonathan Wheelock Thomas. Bust, about 1855.
6. Wolf's head. Fountain decoration, about 1855.
7. Simon Kenton. Statuette, 1857.
8. Alexander Hamilton Stephens. Bust, 1858.
9. Joshua Reed Giddings. Bust, about 1858.
10. *A Horse.* Relief, before 1860.
11. *Indian Stringing His Bow.* Statuette, before 1860.
12. *The Indian Hunter.* Statuette, 1860.
13. Hannibal Hamlin. Bust, 1860.
14. *Indian Chief.* Statuette, about 1860.
15. *Indian Killing a Buffalo.* Proposed design, about 1860.
16. John Parker Hale. Bust, about 1860.
17. William Dennison. Bust, about 1861.
18. William Dean Howells. Relief, about 1861.
19. Henry Peters Gray. Bust, before 1862.
20. Table bell. About 1862.
21. *The Freedman.* Statuette, 1863.
22. Presentation sword for General Ulysses S. Grant. 1863.
23. Presentation sword for Admiral Andrew Hull Foote. 1863.
24. Presentation sword for General Richard James Oglesby. 1863.
25. Matchbox. 1863.
26. Bronze box. 1863.
27. Sanitary Commission Medal. Relief design, 1863.
28. Pair of swords for the kings of Siam. 1863.
29. Sword. 1863.
30. Pistols for the governor of Turkey. 1863.
31. Cane tops. About 1863.
32. General George Brinton McClellan. Equestrian relief, 1864.
33. Vase. 1864.
34. James F. Drummond. Bust, about 1864.
35. Pistol. 1865.
36. William Tilden Blodgett. Bust, 1865.
37. Orville Dewey. Bust, 1865.
38. *The Indian Hunter.* Statue, 1866.
39. An unidentified man. Bust, 1866.
40. Medallion. 1866.
41. Valentine Mott, M.D. Bust, before 1867.
42. Horace Webster. Bust, before 1867.
43. W. J. Gordon, Bust, before 1868.
44. The Ether Monument. Statue and reliefs, 1868.
45. General George Brinton McClellan. Bust, 1868.
46. Commodore Matthew Calbraith Perry. Statue, 1868.
47. James Morrison Steele MacKaye. Bust, about 1868.
48. The Seventh Regiment Memorial. Statue, 1869.

49. Edwin Bartlett. Bust, before 1870.
50. William Shakespeare. Statue, 1870.
51. Erastus Fairbanks. Bust, 1870.
52. Octavius Brooks Frothingham. Bust, before 1871.
53. Major General John Fulton Reynolds. Statue, 1871.
54. *The Protector.* Statue, 1871.
55. Israel Putnam. Statue, 1873.
56. James Topham Brady. Bust, before 1874.
57. Jane Pauline Belmont. Relief, about 1876.
58. Dome of the Connecticut State Capitol. Emblematic statues, 1878.
59. George Washington. Statue, 1878.
60. Memorial to William Gilmore Simms. Bust, about 1878.
61. Major General George Henry Thomas. Equestrian statue, 1879.
62. Washington Monument. Proposed design, 1879.
63. *Leif the Norseman.* Statue, 1879.
64. Frieze for the Assembly Chamber of the New York State Capitol. Proposed design, about 1879.
65. Fletcher Harper. Medallion, about 1880.
66. Yorktown Monument *(Alliance and Victory).* Statue and reliefs, 1881.
67. Centennial Memorial to the Victors of Cowpens. Statue of Daniel Morgan, 1881.
68. The Marquis de Lafayette. Statue, 1883.
69. George Washington. Statue, 1883.
70. William Wilson Corcoran. Bust, 1883.
71. Joseph Meredith Toner, M.D. Bust, 1883.
72. *The Pilgrim.* Statue, 1884.
73. William Earl Dodge. Statue, 1885.
74. William Hayes Fogg. Bust, 1886.
75. William H. Vanderbilt. Bust, 1886.
76. The Anthony Weston Dimock armchair. Carved decoration, 1886.
77. Soldiers and Sailors Monument, Brooklyn. Proposed design, 1886.
78. The James Abram Garfield Monument. Statues, 1887.
79. David Hunter McAlpin. Bust, 1887.
80. Soldiers and Sailors Monument, Indianapolis. Proposed design, 1887.
81. Mr. Chase. Bust, before 1888.
82. William Earl Dodge. Bust, 1888.
83. Memorial to Lincoln Goodale, M.D. Bust, 1888.
84. Julius Augustus Durkee. Bust, 1888.
85. Memorial to Alexander Lyman Holley. Bust, 1889.
86. Joseph William Drexel. Bust, 1889.
87. Professor Reichard. Bust, before 1890.
88. Silas Sadler Packard. Bust, 1890.
89. Horace Greeley. Statue, 1890.
90. August Belmont. Bust, 1891.
91. Henry Ward Beecher Monument. Statues, 1891.
92. Charles L. Brace. Bust, about 1891.
93. Roscoe Conkling. Bust, 1892.
94. Roscoe Conkling. Statue, 1893.
95. Horace Fairbanks. Bust, 1893.
96. Stephen Wilcox. Bust, 1894.
97. Elliot Fitch Shepard. Bust, 1894.
98. Francis Lieber. Bust, 1895.
99. James Hazen Hyde. Relief, 1895.
100. William Hayes Fogg. Statue, 1895.
101. William Henry Vanderbilt. Bust, 1895.
102. Son of Hugh O'Neill. Bust, 1895.
103. Reading Room of Library of Congress. Statue of *Poetry,* 1896.
104. Memorial to Abraham Coles. Bust, 1897.
105. Elizabeth Morgan. Hands, about 1898.
106. *Head of a Black Man.* Relief, 1898.
107. George William Curtis. Bust, 1899.
108. The Dewey Arch. Statue of *Victory Upon the Sea,* 1899.
109. John Quincy Adams Ward. Bust, about 1899.
110. Henry Baldwin Hyde. Statue, 1901.
111. James Ormsbee Murray. Relief, about 1901.
112. The New York Stock Exchange. Pediment statuary, 1903.
113. Cornelius Vanderbilt. Bust, 1903.
114. General Philip Henry Sheridan. Equestrian statue, 1906.
115. The Smith Memorial. Equestrian statue of General Winfield Scott Hancock, 1910.
116. August Belmont. Statue, 1910.
117. Baptismal Font. Model, undated.
118. Fountain figure. Model, undated.
119. Relief, Goshen. Design, undated.
120. Dr. Jones. Bust, undated.
121. *Silenus.* Newel post, undated.
122. *Head of a Young Black Boy.* Relief, undated.
123. *Head of a Young Indian Girl.* Relief, undated.
124. George Hanson Hite. Bust, undated.
125. Margaret Leupp. Bust, undated.

1. *IRISH WORKMAN*
Figurine, about 1849

Alabaster, h. approx. 6 in.
Collection of Mr. & Mrs. Oliver E. Shipp,
 Newburgh, New York

In 1886 a note in *Art Age* reported Mrs. Jonathan Wheelock Thomas, Ward's eldest sister, Eliza, as having

> . . . a curious statuette in alabaster, about six inches high, under a glass case in the drawing-room of her handsome country-seat near Newburgh on the Hudson. It is the figure of an Irishman who used to work for her family thirty-five years ago in Brooklyn, and shows the patches in his trousers, the rent in his coat, and the creases in his narrow-brim stove-pipe hat. The work was executed with a penknife by her brother, then in his teens, while on a visit at her house. It so pleased her that she took it to the sculptor H. K. Brown. "Madam," said he, admiring it, "this boy has something in him." For six years afterward Mr. Ward was a pupil in Brown's studio, laying the foundations of the most prosperous career yet achieved by an American sculptor.[1]

While the information this account contains is at variance with that provided by Ward's early biographers,[2] it has a certain credibility. Mrs. Thomas, who lived in Brooklyn in the 1840s, was responsible for introducing Ward to Henry Kirke Brown. The "alabaster figure" fits descriptions of small statuettes that Ward modeled and carved in his teens,[3] and its existence, as well as the relatively early (1886) publication of the anecdote, is persuasive evidence that the work was shown by Eliza Thomas to Henry Kirke Brown in 1849.

NOTES

1. "Painters and Sculptors," *Art Age* 4 (August 1886), p. 10. See also paper presented by E. Weaver [1900], who was Eleanor (cat. no. 2), the daughter of Eliza Thomas. In her paper she reported that in the Ward house in Urbana was "a small figure of an old man cut out of alabaster by means of a pen knife" (OES).
2. Townley 1871, pp. 405–406; Dreiser 1899, pp. 4–5.
3. Ibid.

2. ELEANOR WEAVER
Bust, about 1850

Plaster
Location unknown

Eleanor Weaver was Ward's niece, the daughter of Eliza and Jonathan Wheelock Thomas (cat. no. 5). In 1890 Henry Howe wrote that the Ward house in Urbana contained

> . . . an elaborately carved mantelpiece, in front of which

stood the parents of the artist when they were married. Among the curiosities is a plaster bust of a young girl, a niece, which is the first model he ever made—the expression is sweet and soft.[1]

Eleanor Weaver herself positively identified the bust in a paper she presented to a group of people in 1900. She reported that in the old Ward homestead in Urbana was "the first bust made by Mr. Ward, a likeness of the writer, when she was twelve."[2] There is no additional information related to the piece, but in style it was likely similar to the bust of Margaret Leupp (cat. no. 125) that was probably also done in the early 1850s either by Ward or by Henry Kirke Brown.

NOTES

1. Howe 1890, 1, p. 383.
2. Paper presented by E. Weaver [1900] (OES).

Cat. no. 3 *Eleanor Macbeth Ward*

3. ELEANOR MACBETH WARD
Relief, 1853
(Plate I)

Marble, oval, 22½ × 20¼ in.
Signed: J Q A WARD/1853
Collection of Erving and Joyce Wolf, New York
 City

This portrait was handed down in the family of Eliza Thomas, Ward's eldest sister. While family members are certain that a bust that also descended from Eliza

is of Eliza's husband, Jonathan Wheelock Thomas
(cat. no. 5), they have never believed that this relief is
of her. Reportedly, among the curiosities in the Ward
house in Urbana was "a portrait of [Ward's] mother in
basso-relievo."[1] It is thus possible that the relief is the
one of Eleanor Ward (June 19, 1797–January 23,
1866), who would have been fifty-six at the time.[2]

The profile portrait, an ambitious and accomplished
first work, shows the right side of the subject's head.
Though it possesses a neoclassical quality evidenced
by the stylized treatment of the hair and silhouette,
the finely polished marble finish free of any surface
texture, and the use of sharp lines and broad planes to
define the head's sculptural form, the naturalism that
was to become the pervasive characteristic of Ward's
sculpture is already suggested in the sensitive por-
trait.

The relief remained in the Thomas family until
1978, when Mrs. Oliver E. Shipp, Eliza's great-
granddaughter, sold it to Glenn Opitz, a Poughkeep-
sie art dealer, who resold it to the present owners.

NOTES

 1. Howe 1890, 1, 383.
 2. JQAW genealogical notes, n.d. (AIHA).

4. *HERCULES*
Statuette, about 1855

Bronze, h. 26 in.
American Academy of Arts and Letters, New York
 City

The *Hercules*, bequeathed to the academy in 1933
by Mrs. Rachel Ward, was listed at the time as being
by the sculptor.[1] It is derived, with only slight varia-
tion in the placement of the hands, from the *Farnese
Hercules*,[2] which in the nineteenth century was one of
the best known of antique statues. Ward probably did
the statuette while a student in Brown's studio. There
are no additional references to the piece,[3] and there is
no record of when or by whom it was cast.

RELATED WORKS:

4.1. Monogram dye
 Bronze, h. 3 in.
 American Academy of Arts and Letters, New
 York City

Ward adapted the head and shoulders of the *Her-
cules* for the handle of his monogram dye, which was
also bequeathed to the academy in 1933 by Mrs.
Ward.[4]

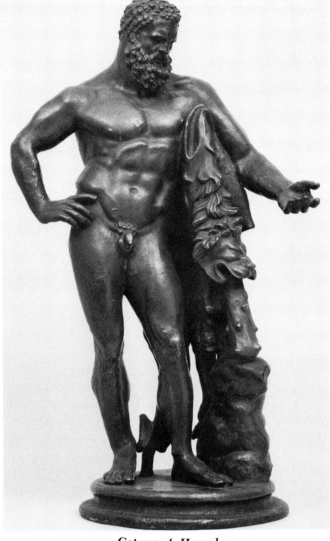

Cat. no. 4 *Hercules*

NOTES

 1. Gifts from the JQAW Estate, April 18, 1934 (AAAL).
 2. F. Haskell and N. Penny, *Taste and the Antique: The
Lure of Classical Sculpture, 1500–1900* (New Haven: Yale
University Press, 1981), pp. 229–232.
 3. Letter from F. T. Parsons to JQAW, January 27, 1909
(N-YHS), instructs Ward to notify his sister-in-law when he
has put the finishing touches on the "Infant Hercules."
There is seemingly no connection between the reference
and this statuette of Hercules, nor is there any other men-
tion of Ward's having anything to do with an "Infant Her-
cules."
 4. Accession card, AAAL.

5. JONATHAN WHEELOCK THOMAS
Bust, about 1855

Marble, h. 27 inches
Collection of Edward Pawlin, Old Lyme,
 Connecticut

Jonathan Wheelock Thomas (about 1821–October

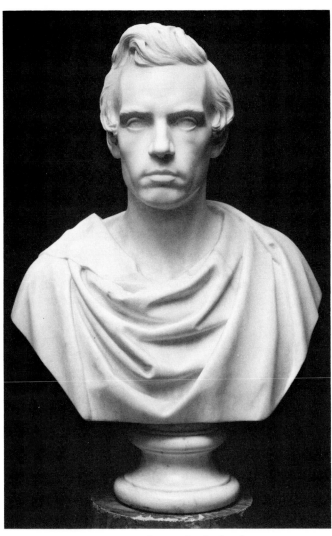

Cat. no. 5 *Jonathan Wheelock Thomas*

1910), who was married to the sculptor's sister Eliza, was a successful New York merchant. He and his wife were influential in encouraging Ward to pursue a career as an artist, and introduced him to the sculptor Henry Kirke Brown. The Thomases, who had a country house in Newburgh, New York, and Ward, whose summer home in Peekamoose was not far away, undoubtedly maintained a close relationship.

The bust was probably begun in the 1850s, as in it Jonathan appears to be in his mid-thirties.[1] A pronounced stylistic similarity exists between this bust and the one Henry Kirke Brown did in 1847 of Asher B. Durand (fig. 14),[2] suggesting that the *Thomas* was probably executed while Ward was in Brown's studio. The likeness of Jonathan, like that of Durand, shows the idealized, Byronic quality characteristic of Italianate sculpture rather than the invigorated naturalism that typifies Ward's portraiture after 1870, and the robe arranged over the subject's shoulders lacks the naturalistic folds found in the drapery of Ward's mature work.

The bust remained in the collection of Mrs. Oliver E. Shipp, Jonathan's great-granddaughter, until 1979, when it was acquired by Glenn Opitz, a Poughkeepsie art dealer who sold it to its present owner.

NOTES

1. Mrs. OES wrote that she had "seen a letter from J. Q. A. Ward (the sculptor and my great-great uncle) to his sister Eliza Ward Thomas, wife of J. W. Thomas, stating that he had worked on the statue for thirty years and that it was an over-due gift, or words to that effect." Photocopy of an affadavit by Margery (Mrs. Oliver E.) Shipp, February 1, 1979 (APS).
2. H. K. Brown's *Asher B. Durand* is in the NAD collection.

6. WOLF'S HEAD

Fountain decoration, about 1855

Location unknown

Henry Howe reported that Ward "executed a wolf's head for a fountain in Mexico, for which Brown paid him $10. the first money he ever earned."[1] There is no other information related to this piece.

NOTES

1. Howe 1890, 1, pp. 383–384. See also *NCAB*, s.v. "JQAW."

7. SIMON KENTON

Statuette, 1857

Multiple edition

In June 1855, *The Crayon* reported that Ward, a pupil of Henry Kirke Brown's, had modeled in plaster a proposed statue of *Simon Kenton* for Columbus, Ohio.[1] Ward continued to rework the figure, and in a lengthy article in October 1857, a year after he had left Brown's studio, *The Crayon* noted:

We have seen with great pleasure the completed model of a statue of SIMON KENTON [April 3, 1755–April 29, 1836], the celebrated Ohio backwoodsman, by J. Q. A. Ward. It is designed for the State of Ohio, an appropriation having been made by the government for a marble monument in honor of this great pioneer.

The name of Kenton is not so well known in the Eastern States as that of Daniel Boone, to whose career and character his bore a marked resemblance. But in Ohio his memory is cherished, and the traditions of his wonderful deeds are household words. . . .

As a recognition of the important, though humble events of her early history, the conception of this monument is creditable to the State. As an authentic type of the

costume and external appearance of the pioneer it will be always interesting and useful. . . . Kenton is represented in the picturesque hunting costume of his time. He stands leaning on his rifle, just paused for the moment as if entertaining a sudden thought. His dog, an admirably modelled animal, looks up to his face inquiringly at his unwonted quiet. There is no grand effort at effect or meritricious ornament in the statue. The composition is unaffected and simple, and pleases as much by its chaste forbearance as by its evident fidelity and knowledge of detail. The face, air, attitude, costume, and accessories all happily unite in giving the idea of a free, wild, adventurous borderer, and nothing else. The State of Ohio, already distinguished for its appreciation of sculptured Art, will do itself credit by the erection of this truly admirable work.[2]

Work on the statue was delayed, however, and Ward turned to the pursuit of a federal commission in Washington, D.C.[3] When that was not forthcoming, he traveled back to Columbus, Ohio, in 1860, probably in the hope of securing the *Kenton* commission. But events of the time ran against him; the outbreak of the Civil War prevented the final enlargement of what would have been his first public monument. Reflecting on the period, William Dean Howells, who was also in Columbus at the time and who developed a close friendship with Ward, wrote:

> The great sculptor, J. Q. A. Ward . . . had come to the capital of his native state in the hope of a legislative commission for a statue of Simon Kenton. It was a hope rather than a scheme, but we were near enough to the pioneer period for the members to be moved by the sight of the old Indian Fighter in his hunting-shirt and squirrel-skin cap, whom every Ohio boy had heard of, and Ward was provisionally given a handsome room with a good light, in the State House. . . . But the "Kenton" was never to be eternized in bronze or marble for that niche in the rotunda of the capitol where Ward may have imagined it finding itself. The cloud thickened over us, and burst at last in the shot fired on Fort Sumter; the legislature appropriated a million dollars as the contribution of the state to the expenses of the war, and Ward's hopes vanished as utterly as if the bolt had smitten his plaster model into dust.[4]

After the war there was a renewed effort to erect a memorial to Kenton. (In 1865, the remains of the old pioneer were brought from Zanesfield, Ohio, and interred in Oak Dale Cemetery in Urbana, Ohio.)[5] A modest appropriation was finally secured by 1884, but it was not sufficient to permit the enlargement of Ward's figure.[6] Probably on Ward's suggestion, Richard Morris Hunt was commissioned to design a granite memorial to be placed in Oak Dale Cemetery.[7] On the south side of the memorial is the head of an Indian and the inscription 1775–1836/SIMON KENTON; on the north side, the head of a wolf and the inscrip-

tion ERECTED BY THE STATE/OF OHIO 1884; on the west side, the head of a bear; and on the east side, the head of a panther. The top was left in a rough, unfinished condition, reportedly on a suggestion by Ward that there might at a future time be sufficient public interest to sponsor a worthy capital for the memorial.[8] The necessary funds were never secured, however, and the uncompleted memorial today stands in the Oak Dale Cemetery only a short distance from the replica of *The Indian Hunter* that marks the sculptor's burial site.

RELATED WORKS:

Two plaster statuettes of the *Kenton* and a bronze one cast posthumously have been located to date. Mrs. Rachel Ward, the sculptor's widow, lent a plaster model to Washington's Headquarters in Newburgh, New York, where it was damaged in 1914.[9] There is no further record of it at the headquarters. Anna P. Mac-Vay, of the American Classical League in New York, wrote the director of the American Academy of Arts and Letters in 1939 to say that she owned a damaged plaster copy of the *Kenton*.[10] That could have been the one that had been on loan to the headquarters, but its present location is unknown. In the same letter Ms. MacVay reported that Mrs. Ward had given a plaster of the *Kenton* to a Dr. and Mrs. William Van V. Hayes of Greenwich, Connecticut.[11] That piece has not been located either. A statuette of the *Kenton* owned by one Thad. Norris was exhibited at the Pennsylvania Academy of the Fine Arts in 1859,[12] but there is no other reference to that piece, and its present location is also unknown. In 1915 one of the *Kentons* (probably cat. no. 7.3) was exhibited at the Panama-Pacific International Exposition.[13]

7.1. Statuette
 Plaster, h. 27 5/16 in.
 Cincinnati Art Museum, Cincinnati, Ohio

Formerly in the collection of John H. James, a prominent Urbana citizen who was a close friend of the Ward family, the statuette was given to the Cincinnati Museum in 1957.[14]

7.2. Statuette
 Plaster, 27½ in.
 Collection of Mr. and Mrs. Oliver E. Shipp,
 Newburgh, New York (fig. 16)

Mrs. Shipp is the great-granddaughter of Eliza Thomas, Ward's eldest sister.

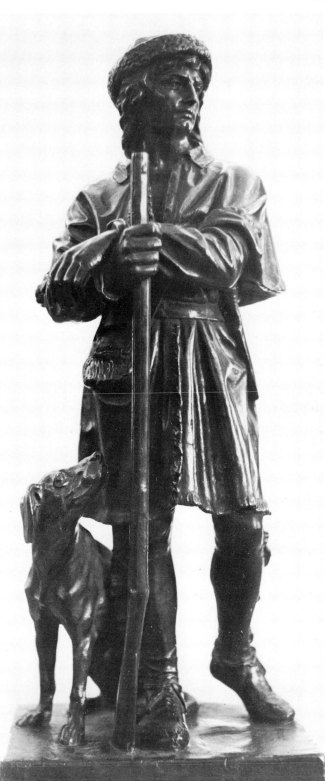

Cat. no. 7.3 *Simon Kenton*

7.3. Statuette
Bronze, h. 26 in.
Signed: J.Q.A. WARD/SC.
Founder's mark: GORHAM. CO. FOUNDERS.
Champaign County Library, Urbana, Ohio

Undoubtedly one of the models Mrs. Ward had the Gorham foundry cast shortly after her husband's death, the statuette was bequeathed to the Champaign County Library in Mrs. Ward's will (1933).[15] It had been on loan for a number of years to the American Academy of Arts and Letters, and was lent by that institution to an exhibition at the Museum of Modern Art in 1932/33.[16]

NOTES

1. "Sketching," *The Crayon* 1 (May 9, 1855), p. 300.
2. "Domestic Art Gossip," *The Crayon* 4 (October 1857), pp. 315–316.
3. An unidentified and undated newspaper clipping, JQAW Scrapbook (AIHA), reports that since the state legislature was unable to decide on a location for the *Kenton* the project was shelved, which might explain why the Wards moved to Washington rather than to Columbus at that time.
4. Howells 1916, pp. 215–216.
5. *DAB*, s.v. "Simon Kenton." According to Middleton (1917, 2, p. 1086), Kenton's body was moved to Oak Dale Cemetery in 1884.
6. Middleton 1917, 2, p. 1087.
7. Stamped drawing by RMH for the base of the Kenton Memorial (AIHA).
8. Middleton 1917, 2, p. 1087.
9. Condition report by A. E. Farrington, October 30, 1914, Archives, Washington's Headquarters, Newburgh, New York.
10. Letter from A. P. MacVay to W. Vanamee, August 2, 1939 (AAAL).
11. Ibid.
12. PAFA 1859, no. 383.
13. PPIE 1915, p. 246.
14. CAM 1970, p. 145.
15. Archives, Champaign County Library, Urbana, Ohio.
16. MOMA 1932, p. 45, no. 147.

8. ALEXANDER HAMILTON STEPHENS
Bust, 1858

Marble, life-size
Location unknown

Alexander Stephens (February 11, 1812–March 4, 1883) was one of the leading Southern statesmen in the second half of the nineteenth century. In 1834 he was admitted to the bar; between 1836 and 1843 he was a member of the Georgia legislature; and from 1843 to 1859 he served in the United States House of Representatives. A champion of states' rights, he defended the institution of slavery on both economic and moral grounds. He opposed Georgia's secession from the Union but followed the state once the step was taken. As vice president of the Confederacy, Stephens unsuccessfully opposed President Jefferson Davis's

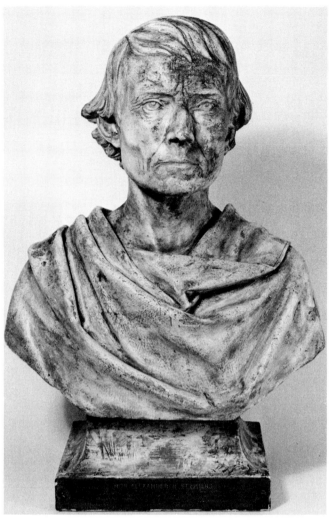

Cat. no. 8 *Alexander Hamilton Stephens*

demand for emergency powers to curtail states' rights and civil liberties. He was arrested by Federal troops and briefly imprisoned when the Confederacy collapsed. Like all others from the "rebel" states, he was excluded from taking his elected seat in the United States Senate in 1866, but he returned to the House of Representatives in 1873 and served there until elected governor of Georgia in 1882. He died in office in 1883.[1]

In May 1859, Henry Kirke Brown wrote to Ward, "What will you do with Stephens Bust? perhaps carry it on with you?"[2] A plaque on the working model of the bust given by Ward to The Museum of the Confederacy states that Ward modeled the portrait in 1858 at Stephens's home in Crawfordsville, Georgia, and that Stephens presented it the following year to Mrs. Robert Toombs, who was married to one of Stephens's close friends and political colleagues. In 1860 the Toombses lent the bust to the Washington Art Association's annual exhibition.[3] A critic for *The Crayon* filed a review of the exhibition on February

21, 1860, reporting that "Ward, a pupil of H. K. Brown," had exhibited a statuette of an Indian stringing his bow and a marble bust of the honorable Alexander Stephens, "both works of real power."[4] The location of the marble bust is unknown.

The working model reveals that the bust was a thoughtful portrait of the Southern statesman. The frail physical condition of "Little Ellick," as Stephens was called, is visible in his delicate bone structure and hollow cheeks, yet his forceful personality and determined will are shown in the piercing gaze of his eyes, the set of his jaw, and the tilt of his head. Though Stephens's hair is stylized and his shoulders are draped in a classical robe, the pervasive quality of the portrait is its realism.

RELATED WORKS:

8.1. Working model
 Plaster, life-size
 The Museum of the Confederacy, Richmond,
 Virginia

The working model remained in Ward's possession until 1909, when his artist friend Charles R. Lamb made arrangements to have it given to The Museum of the Confederacy.[5] The bust was then cleaned, and a new base was added by a Mr. Osie.[6] On the base is a bronze plaque inscribed with the legend composed for the bust by Lamb and Ward:

HON. ALEXANDER H. STEPHENS/MODELED BY J. Q. A. WARD SCULPTOR AT THE STEPHENS HOME CRAWFORDS-VILLE GA./A.D. 1858. CARVED IN MARBLE AND PRESENTED TO MRS. ROBERT TOOMBS BY MR./STEPHENS A. D. 1859. THIS THE ORIGINAL BUST IS PRESENTED BY THE SCULP-TOR/TO THE CONFEDERATE MUSEUM RICHMOND VA. A. D. 1909.

NOTES

1. *DAB*, s.v. "Alexander Hamilton Stephens."
2. Letter from HKB to JQAW, May 8, 1859 (AIHA).
3. WAA 1860, no. 124.
4. "Sketching," *The Crayon* 7 (March 1860), p. 84.
5. Letter from C. R. Lamb to JQAW, January 4, 1909 (N-YHS).
6. Ibid., March 8, 1909.

9. JOSHUA REED GIDDINGS
Bust, about 1858

Location unknown

While Ward was in Washington, D.C., between 1857 and 1860, he modeled the portraits of a number of prominent figures. Joshua Giddings (October 6, 1795–May 27, 1864), one of those early sitters, was a

The Museums at Stony Brook, Stony Brook, New York

This statuette and cat no. 12.14 bear the Henry-Bonnard Bronze Company monogram, the only two statuettes of *The Indian Hunter* with foundry marks that were cast during the sculptor's lifetime. The Museums at Stony Brook owned both this figure and cat. no. 12.12; which of the statuettes was that acquired by the Melvilles at the Plaza Gallery in 1951 is impossible to determine.[29]

12.14. **Statuette**
Bronze, h. 16 in.
Signed: J.Q.A. WARD/1860
Founder's mark: H B B C Co, bullets
between, within a diamond; 3340 beneath
Collection of Richard Schwartz, New York
City

Mr. and Mrs. Vance Brand of Woodstock, Ohio, who owned the statuette, reported that it had been given to Mrs. Brand's mother, a friend of Mrs. Ward's.[30] Coated in recent years with gold radiator paint, it was acquired by its present owner at auction in 1982.[31] The piece has been repatinated.

12.15. **Statuette**
Bronze, h. 16¼ in.
Signed: J.Q.A. WARD/1860
Collection of Erving and Joyce Wolf, New
York City

Acquired by Hirschl & Adler Galleries at auction in New York in 1980,[32] the piece was sold to the present owners in 1984.

12.16. **Statuette**
Bronze, h. 16 in.
Signed: J.Q.A. WARD/1860
Founder's mark: GORHAM CO. FOUNDERS
OGF
Present location unknown

This piece was sold at auction in New York in 1978.[33] According to a statement on a paper label attached to its base, it had been bequeathed by Mrs. Ward to her lawyer, Mr. Richmond Weed. The Gorham foundry mark indicates that it was probably cast for Mrs. Ward after her husband's death.

NOTES

1. "The Indian in American Art," *The Crayon* 3 (January 1856), p. 28.
2. Tuckerman 1867, p. 581.
3. WAA 1859, no. 210, where referred to as *The Hunter*.
4. PAFA 1859, no. 381.
5. "The Pennsylvania Academy of the Fine Arts," *The Crayon* 6 (June 1859), p. 193.
6. Clark 1954, p. 273.
7. Tuckerman 1867, p. 582. While Ward undoubtedly made the trip to the Dakotas that Tuckerman refers to, the similarity of some of the wax (AAAL) and pencil (AIHA) sketches to the statuettes he had done before 1860 (*The Indian Hunter* [figs. 25, 26], *Indian Killing a Buffalo* [cat. no. 15], and *Indian Stringing His Bow* [cat. no. 11]) raises the distinct possibility that he had made an earlier trip west. That may have been the trip referred to in the letter from HKB to JQAW, August 24, 1857 (AIHA), see pp. 35–36.
8. T. Matthews, *The Biography of John Gibson, R.A., Sculptor, Rome* (London: William Heinemann, 1911), illustrations of *The Hunter and the Dog* opp. pp. 98, 100. The similarity was discussed in "The Indian Hunter in Central Park," *Fine Arts* 1 (October 1872), pp. 130–132.
9. Accession card, "1575, Four Wax Male Indian Heads"; "1578, Two Wax Female Indian Heads"; "1582, Wax Dog's Head"; and "1585, One Wax Male Indian Head," AAAL.
10. B. Proske, *Brookgreen Gardens, Sculpture* (Brookgreen, South Carolina: Brookgreen Gardens, 1943), p. 5.
11. Receipt from Ames Manufacturing Co. to JQAW, May 19, 1866 (N-YHS).
12. Receipt from Robert Wood & Co. to JQAW, December 22, 1871 (N-YHS).
13. Rutledge 1955, p. 242.
14. Tuckerman 1867, p. 582.
15. Receipt from the Henry-Bonnard Bronze Co. to JQAW, July 29, 1885 (N-YHS).
16. WAA 1859, no. 210.
17. PAFA 1859, no. 381.
18. Letter from H. Adams to A. P. MacVay, May 13, 1934 (AAAL).
19. Accession card, AAAL. Gifts from the JQAW Estate, May 16, 1934 (AAAL).
20. Accession file, Washington's Headquarters, Newburgh, New York.
21. Accession file, N-YHS.
22. A. H. Mayer and M. Davis, *American Art at the Century Association* (New York: The Century Association, 1977), pp. 108, 155.
23. Archives, MMA.
24. Public Auction, C. G. Sloan & Company, Inc., sale 701 (February 3–6, 1977), lot no. 1305.
25. Ibid., sale 704 (October 6–9, 1977), lot no. 1434.
26. *American Paintings, Drawings and Sculpture of the 18th, 19th and 20th Centuries*, Christie, Manson & Woods International, Inc. (June 3, 1983), lot no. 77.
27. Accession file, Suffolk Museum and Carriage House, Stony Brook, New York.
28. Ibid. (See also *The Estate of Louise K. Boese and Others*, O'Reilly's Plaza Art Galleries, sale 3087 [September 13, 1950].)
29. Ibid.
30. Author interview with Mr. and Mrs. William C. Katker, December 28, 1970, Urbana, Ohio. Mrs. Katker is the daughter of Mr. and Mrs. Vance Brand.
31. *American 19th Century and Western Paintings, Drawings and Sculpture*, Sotheby Parke Bernet (October 22, 1982), lot no. 94.
32. *American 18th Century, 19th Century & Western Paintings, Drawings, Watercolors & Sculpture*, Sotheby Parke Bernet (October 17, 1980), lot no. 3.
33. *18th, 19th and 20th Century American Paintings,*

Drawings and Sculpture, Christie, Manson & Woods International, Inc. (June 21, 1978), lot no. 45.

13. HANNIBAL HAMLIN
Bust, 1860

Plaster
Location unknown

During Ward's stay in Washington, D. C., he is reported[1] to have executed a bust of Senator Hamlin (August 27, 1809–July 4, 1885) of Maine, who was soon to be elected vice president in Lincoln's first administration. Winslow M. Watson, in a postscript on a June 1860 letter to Henry Kirke Brown, wrote: "Ward is modelling a bust of Hamlin—very good work."[2] The following month Watson enthusiastically reported: "Ward has made a fine bust of Hamlin, which he intends taking to N. York. He ought to make something out of it at this time, as the political warfare is beginning to wax warm."[3] Watson's concern that the bust be executed in a permanent material proved prophetic—the portrait was never completed, as Ward explained to Hamlin's first biographer, Charles Eugene Hamlin, in 1898:

> In 1858 or 1859 (?) at the request of some of his friends I modeled a bust of Hannibal Hamlin and promised to put it in bronze or marble but was called away from Washington. In mean time the war broke out and this model . . . was destroyed or entirely lost to me—which I have often regretted as the bust was one of the most faithful likenesses that I had produced. . . . I can recall but little connected with his sittings for the bust. Although he was much occupied during those exciting times yet he was very punctual in his appointments and patient and agreeable during his poses—and perhaps it was the contrast of a quiet studio with his official duties which led him into reverie and reminiscence. . . .[4]

NOTES

1. Tuckerman 1867, p. 580.
2. Letter from W. M. Watson to HKB, June 14, 1860, HKB Papers, p. 1115, Library of Congress.
3. Ibid., July 1, 1860.
4. Letter from JQAW to C. E. Hamlin, March 23, 1898, Hamlin Family Papers, Special Collections Department, Raymond H. Fogler Library, University of Maine at Orono.

14. *INDIAN CHIEF*
Statuette, about 1860

Multiple edition

There is no reference to this statuette in the Ward literature or in Ward's correspondence. The head of the figure is very similar to one of the wax sketches (cat. no. 12, "Related works) that Ward made in the Dakotas in 1860.

Cat. no. 14.1 *Indian Chief*

14.1. Statuette
Bronze, h. 16 in.
Signed: not recorded
Location unknown

This figure was illustrated in a Tillou Gallery advertisement in 1963.[1] In the photograph, the spear the chief originally held in his right hand is missing. There is no additional information relating to the figure, and its present location is unknown.

14.2. Statuette
Bronze, h. not recorded
Signed: J.Q.A. Ward
Location unknown

Unlike cat. no. 14.1, which has a polygon base, this figure's base is circular.[2]

NOTES

1. *Antiques* 84 (November 1963), p. 509.
2. Letter and photograph from W. Craven to D. Beck, November 12, 1969, photocopy (APS).

Cat. no. 15 John Quincy Adams Ward, *Indian Killing a Buffalo*, pencil on paper. American Academy of Arts and Letters, New York City.

15. *INDIAN KILLING A BUFFALO*
Proposed design, about 1860

As an unidentified newspaper article in Ward's scrapbook reported:

J. Q. A. Ward is making a spirited study for a large and characteristically American group—a great, shaggy buffalo rushing desperately to its last charge upon a rearing mustang and the little Indian who has just given the huge creature its death wound. The Buffalo is indeed making its last charge on the prairie, and soon would be nothing but a labeled skeleton in a museum were it not for Mr. Ward's valuable work, which, it is to be hoped, will not be allowed to remain merely a study.[1]

Two pencil sketches in one of Ward's sketchbooks undoubtedly are related to this piece;[2] the sketchbook also contains drawings that relate to the statuette of *The Indian Hunter* (cat. no. 12; fig. 25) and *Indian Stringing His Bow* (cat. no. 11), which were both done in about 1860.[3] There is no further information related to this piece.

NOTES

1. JQAW Scrapbook (AIHA).
2. JQAW Sketchbook no. 5 (AIHA).
3. Ibid.

16. JOHN PARKER HALE
Bust, about 1860

Location unknown

Tuckerman[1] and Townley[2] reported that while Ward was in Washington he executed a bust of John P. Hale (September 2, 1820–June 12, 1900), New Hampshire lawyer, politician, and diplomat. Like Joshua Giddings (cat. no. 9), Hale possessed strong antislavery sentiments, and was a leading abolitionist in the United States Senate at the time Ward modeled his bust.[3]

No illustrations of the portrait have yet come to light, nor is there any related material either in Hale's manuscript material at the New Hampshire Historical Society or in Ward's correspondence.

NOTES

1. Tuckerman 1867, p. 580.
2. Townley 1871, p. 406.
3. *DAB*, s.v. "John Parker Hale."

17. WILLIAM DENNISON
Bust, about 1861

Location unknown

The bust of William Dennison (November 23, 1815–June 15, 1882) was probably modeled in 1861, just before Ward left Columbus to settle permanently in New York City. Dennison, then governor of Ohio, went on to become chairman of the Republican National Convention in 1864 and, later, Lincoln's postmaster general.[1]

An 1888 newspaper account at the time of the unveiling of Ward's *Goodale* memorial (cat. no. 83) in Columbus, Ohio, reported that the sculptor's busts of Dennison and Chase (cat. no. 81) were in the state Capitol.[2] The present location of the *Dennison*, however, is unknown, and no related manuscript material exists in Ward's correspondence. The bust was recorded by both Tuckerman[3] and Townley,[4] but the only extensive reference appears in Alexander Black's popular history of Ohio (fig. 20), published in 1888:

On a certain day in 1861, shortly before the coming of Lincoln's call for troops, Ward was at work in an ante room of the Executive building at Columbus, Ohio, modeling a head of Governor Dennison. In the course of the sitting a young State Senator entered the apartment in search of the Governor. "Garfield," said Dennison, turning to the newcomer, "this is Mr. Ward, a rising young sculptor. Now, when you get to be a famous statesman," added the Governor, with a twinkle, "Ward, here, will make a statue of you."[5]

NOTES

1. *DAB*, s.v. "William Dennison."
2. *Columbus Daily Press*, September 27, 1888, p. 1.
3. Tuckerman 1867, p. 580.
4. Townley 1871, p. 406.
5. A. Black, *The Story of Ohio* (Boston: D. Lothrop Company, 1888), p. 291; p. 293 (ill.). In this seemingly fictitious episode, Senator Garfield was actually James A. Garfield, who was to become the twentieth president of the United States. Ward's statue of him was unveiled in Washington, D.C., in 1887.

Cat. no. 18 *William Dean Howells*

18. WILLIAM DEAN HOWELLS
Relief, about 1861

Plaster, 13½ in. diam.
American Academy of Arts and Letters, New
 York City

William Dean Howells (March 1, 1837–May 11,
1920) was one of nineteenth-century-America's fore-
most novelists, critics, and editors. Howells, like
Ward, was born and reared in Ohio. In 1861, the two
aspiring artists were both in Columbus; Howells had a
job as a newspaper reporter and Ward, as Howells
wrote in his *Years of My Youth,* "had come to the
capital of his native state in the hope of a legislative
commission for a statue of Simon Kenton."[1] The two
men became close friends. They frequently dined to-
gether, took long walks in a local park,[2] and discussed
literature, art, and aesthetic life in New York City.[3]

Ward's hope of a *Kenton* commission was dashed by
the outbreak of the Civil War. It was undoubtedly
during the long months when Ward was awaiting the
Kenton committee's approval that he modeled this
portrait of the twenty-four-year-old Howells. The un-
textured surface of the relief and the stylized treat-
ment of Howell's hair, beard, and physiognomy are
typical of Ward's youthful work of the 1860s, replaced
in his mature work by subtly articulated surfaces and
factual representation of subjects. The relief was given
in 1923 by the sculptor's widow to the American
Academy of Arts and Letters.[4]

RELATED WORKS:

18.1. Relief
 Bronze, 14 in. diam.
 Signed: J Q A Ward Sculptor
 Founder's mark: The Henry-Bonnard Bronze
 CO Founders. N-Y. 1898
 National Portrait Gallery, Washington, D.C.

Cast thirty-seven years after the two men were in
Columbus together, the bronze was probably a per-
sonal gift from Ward to Howells. It was deposited at
the National Gallery in 1954 by Mildred Howells, the
subject's daughter. It was then transferred to the Na-
tional Portrait Gallery in 1964.[5]

NOTES

 1. Howells 1916, p. 215.
 2. Ibid., p. 235.
 3. Ibid., p. 215.
 4. Accession card, AAAL.
 5. Accession file, National Portrait Gallery, Washington,
D.C.

19. HENRY PETERS GRAY
Bust, before 1862

Location unknown

In the 1862 exhibition at the National Academy of
Design, Ward showed *The Indian Hunter* (cat. no. 12)
and this bust of Henry Peters Gray (June 23, 1819–
November 12, 1877),[1] acting vice president of the
academy. Gray, a highly respected portrait and genre
painter, had befriended Ward and encouraged and
promoted his work.[2]

NOTES

 1. NAD 1862, no. 91.
 2. Letter from H. P. Gray to JQAW, January 22, 1859
(N-YHS). In the letter Gray compliments Ward for his
figures of an Indian and a woodsman. For a complete text of
the letter, see p. 37.

20. TABLE BELL
about 1862

Multiple edition

After Ward had set up a studio in the Dodsworth
Building in New York in 1861 the Ames Manufactur-
ing Company employed him to model presentation
swords and small art objects that included cane tops,
pistol mounts, and table bells.[1] Mrs. R. Ostrander
Smith, the sculptor's stepdaughter-in-law, who in-
herited a cast of this bell, reported that it was done by
Ward when he first moved to New York.[2]

The bell reveals the influence of Renaissance art—in this instance, Michelangelo's sculpture—on Ward's work of the early 1860s. Ward adapted the handle from Michelangelo's *Dying Slave*. Only the right arm of the figure is altered, probably because of its intended function. The cup of the bell is decorated with characteristically grotesque Renaissance motifs consisting of small animals, intertwining foliage, and four medallions equally spaced around the lower rim.

RELATED WORKS:

20.1. Table bell
Bronze, h. 7½ in.
Ex coll.: Mrs. R. Ostrander Smith, Bronx, New York

The list of objects bequeathed (1933) to the American Academy of Arts and Letters by Mrs. Ward reported that her daughter-in-law, Mrs. Smith, owned an example of this bell in gold.[3] The author, on a visit to Mrs. Smith in 1969, saw only this bronze casting, and Mrs. Smith made no reference to its having been cast in a precious metal.[4] Its present location is unknown.

20.2. Table bell
Bronze, h. 7½ in.
American Academy of Arts and Letters, New York City

This bell was recorded in the list of objects bequeathed by Mrs. Ward in 1933 to the academy as a "replica of the gold bell owned by Mrs. Smith."[5]

NOTES

1. *DAB*, s.v. "John Quincy Adams Ward."
2. Author interview with Mrs. ROS, November 28, 1969.
3. Gifts from the JQAW Estate, May 16, 1934 (AAAL).
4. Author interview with Mrs. ROS, November 28, 1969. Adams 1912, p. 27, quoted in Craven 1968, p. 247, recalls "a delightful little table-bell of silver, with figures in high relief, a marvel of delicate beauty." That the table bell was originally made in precious metal is plausible, but the author has found no substantiating evidence.
5. Gifts from the JQAW Estate, May 16, 1934 (AAAL).

Cat. no. 20.1 *Table Bell*

21. *THE FREEDMAN*
Statuette, 1863
(Plate V)

Multiple edition

When Ward began work on this seated, seminude Negro from whose wrists hang the broken chains of servitude is not recorded, but it seems likely that the subject was inspired by Lincoln's Emancipation Proclamation, which was issued in September 1862. A newspaper article of January 16, 1863, reported that Ward had just finished his *Freedman*.[1] That same year he exhibited a "model for the Freedman" at the National Academy of Design[2] and at the Pennsylvania

Academy of the Fine Arts.[3] The figure was enthusiastically received, and Ward, who only a year before had been elected an Associate of the National Academy, was made an Academician.[4] *The Freedman* and the enlarged figure of *The Indian Hunter* were exhibited at the Paris Exhibition of 1867,[5] and were displayed with the other American entries at the National Academy of Design in 1868.[6]

The Freedman was lauded in the press when it was first exhibited in 1863. A critic for the *New York Times* noted that although the statuette was poorly displayed in a cramped, dimly lit corner at the National Academy, it attracted considerable attention. The figure, he wrote, "was a welcome shift from the decorative pieces incessantly exhibited and called 'Hope,' 'Faith,' or 'Innocence' to suit the pleasure of the purchaser, and may be changed at his sweet will, so that one statue can be made to do service for a whole gallery of sentiments."[7] In a later general review of the National Academy's exhibition, the critic for the *Times* focused again on *The Freedman*:

> Ward's statuette of the "Contraband," [in contrast to the neoclassical pieces] is. . . an encouraging effort, especially as it has elicited very hearty appreciation. It is a full length figure of a Negro, modeled from select specimens of the race, and shows that the African shares with the European the exalted proportions of the human figure. The work has been inspired by a mind ambitious of the higher reaches of the sculptor's art. We know of no American statue which more nearly approaches the classic, either in conception or execution.[8]

Even James Jackson Jarves, the art critic who rarely spoke favorably of a work by a fellow American, praised the statuette in his *Art-Idea*:

> [It is] a genuine inspiration of American history, noble in thought and lofty in sentiment. . . . A naked slave has burst his shackles, and, with uplifted face, thanks God for freedom. It symbolizes the African race of America—the birthday of the new people. . . . We have seen nothing in our sculpture more soul-lifting, or more comprehensively eloquent. It tells in one word the whole sad tale of slavery and the bright story of emancipation. In spiritual significance and heroic design it partakes of the character of Blake's unique drawing of Death's Door, in his illustration of the Grave. The negro is true to his type, of naturalistic fidelity of limbs, in form and strength suggesting the colossal, and yet of an ideal beauty, made divine by the divinity of art. . . . It is the hint of a great work, which, put into heroic size, should become the companion of the Washington of our nation's Capitol, to commemorate the crowning virtue of democratic institutions in the final liberty of the slave.[9]

All the critics spoke perceptively of both the naturalism and the ideal beauty of *The Freedman*. The representation of the figure's physiognomy and anatomy, and the highly polished dark patina of the statuette, which was modeled from life, evoked a realism then unprecedented in American sculpture. The subject was intended not to evoke esoteric philosophical or literary associations but to address the major political and moral issues of the day, yet pervading the work's relevance and naturalistic detail is a classical character. The muscular, seated contraband, turned looking over his shoulder, is contained within a formal, triangular composition; the torso of the figure—the focal point of the composition—was probably derived from the *Belvedere Torso*.[10] Though the critics did not note *The Freedman*'s exact classical prototype, they were aware of the successful, revolutionary combination of a subject relevant to the era naturalistically rendered within a classical framework.

RELATED WORKS:

In 1900 Ward wrote, "I never made but one size of this subject. Five or six copies were made in bronze by subscription."[11] According to Tuckerman, six bronze statuettes were made.[12] To date, eight copies have been located—three of 1863 casting, two from later Henry-Bonnard castings, one Gorham casting, one 1863 plaster cast, and a possibly spurious bronze cast at the Museum of the American China Trade, Milton, Massachusetts. The latter piece has no provenance, and several deviations make its authenticity suspect. It is not as finely cast or finished as are the others, and its inscription, "J.Q.A. Ward. Scp. 1863," varies from that on all the other casts of *The Freedman*, which is "J.Q.A. WARD. sc./1863." Ward was aware of the possibility of a pirated casting of *The Freedman*, for he wrote, "Some one informed me . . . that copies were being made in Paris but I could not ascertain that such was the case."[13]

Ward's correspondence contains references to casts of *The Freedman* that were in the possession of J.B. Fremont,[14] George E. Baker,[15] John J. Foster,[16] the Arts Club,[17] and Jessie Benton Fremont,[18] but to link these references to any of the known pieces is impossible. A bill of December 1864 from the founder L.A. Amouroux includes the making on October 8 of a pattern for one Negro for $100, and, on December 3, for the bronzing of one Negro for $150.[19] In June 1866 the Ames Manufacturing Company billed Ward $105 for casting one "Freeman."[20] A plaster cast was included in the Ward Memorial Collection that Mrs. Ward gave to New York University in 1922;[21] its present location is not known.

21.1. Statuette

Bronze, h. 20 in.
Signed: J.Q.A. WARD. sc./1863
Cincinnati Art Museum, Cincinnati, Ohio

This, one of the original 1863 castings, was given to the museum in 1921 by Mrs. Howard Hollister and Mary Eva Keys.[22]

21.2. Statuette
Bronze, h. 20 in.
Signed: J.Q.A. WARD. sc./1863
Boston Athenaeum, Boston, Massachusetts

The Athenaeum was given this original 1863 casting of the statuette in 1922 by Mrs. William Lincoln Parker.[23]

21.3. Statuette
Bronze, h. 19½ in.
Signed: J.Q.A. WARD. sc./1863
Detroit Institute of Arts, Detroit, Michigan

This 1863 cast of *The Freedman* was given to the institute in 1945 by Ernest Kanzler.[24] It had been purchased in Paris in about 1891 by Richard Solomon Waring, and was inherited by his daughter and her husband, James J. Robinson.[25] In 1900, in response to a letter from Robinson, Ward wrote, "I know of but one copy in Paris which belonged to James [Morrison Steele] MacKaye, who was one of the original subscribers. It may have been sold after his death. I saw it in his house when he was alive in 1887."[26]

21.4. Statuette
Plaster, h. 20¼ in.
Signed: J.Q.A. WARD sculptor.
Pennsylvania Academy of the Fine Arts,
 Philadelphia, Pennsylvania

Ward gave this piece to the academy in 1866.[27] It is probably the figure that was exhibited regularly in the academy's annual exhibitions.

21.5. Statuette
Bronze, h. 20 in.
Signed: J.Q.A. WARD sc/1863
Founder's mark: THE HENRY-BONNARD
 BRONZE CO/FOUNDERS./N-Y • 1899 •
National Academy of Design, New York City

No provenance is recorded at the academy, but the statuette was probably a gift from the sculptor or from his widow.

21.6. Statuette
Bronze, h. 20 in.
Signed: J.Q.A. WARD. sc./1863
Founder's mark [cursive]: Cast by the
 Henry-Bonnard Bronze Co./New York 1891.
The Metropolitan Museum of Art, New York
 City (fig. 22)

Charles R. Lamb, prominent New York architect and designer of the Dewey Arch, acquired this replica from Ward in 1909.[28] It was given to the museum in 1979 by Charles Anthony Lamb and Barea Lamb Seeley, in memory of their grandfather, Charles Rollinson Lamb.[29]

Cat. no. 21.7 *The Freedman*

21.7. Statuette
Bronze, h. 20 in.
Signed: J.Q.A. WARD. sc./1863
Founder's mark: GORHAM CO. FOUNDERS
American Academy of Arts and Letters, New
 York City

Ward was a charter member of the academy. This

piece was bequeathed to the academy in 1933 by the sculptor's widow, along with a large number of other objects.[30]

NOTES

1. *Boston Evening Transcript*, January 16, 1863, p. 1.
2. NAD 1863, no. 467.
3. PAFA 1863, no. 394.
4. Clark 1954, p. 273.
5. Leslie 1868, p. 40.
6. NAD 1867–8, no. 690.
7. *New York Times*, May 3, 1863, p. 5.
8. Ibid., June 24, 1863, p. 2.
9. Jarves 1960, pp. 225–226.
10. *The Freedman* is very similar to *The Boxer* (Rome, Museo Nazionale delle Terme), but the classical bronze was not discovered until 1884—twenty-one years after *The Freedman* was cast.
11. Letter from JQAW to J. J. Robinson, n.d. Accession file, Detroit Institute of Arts, Detroit, Michigan.
12. Tuckerman 1867, p. 581.
13. JQAW to Robinson, see n. 11.
14. Letter from J. B. Fremont to JQAW, n.d. (AIHA). Fuller sent Ward a check, saying, "let it burn your pocket until I get my *Freedman*."
15. Letters, R. S. Chilton to JQAW, December 24, 1863; January 28, 1864 (AIHA). Chilton suggests that Ward send Baker a cast of *The Freedman* and then acknowledges its arrival.
16. Letter from J. J. Foster to JQAW, August 23, 1866 (AIHA). Foster informs Ward that *The Freedman* has arrived.
17. Letter from the Arts Club to JQAW, n.d. (AIHA). Letter acknowledges Ward's gift of *The Freedman* to the club.
18. Letters from J. B. Fremont to JQAW, n.d. (AIHA), concerning purchase of *The Freedman*.
19. Bill from L. A. Amouroux to JQAW, December 3, 1864 (AIHA).
20. Bill from Ames Manufacturing Co. to JQAW, June 20, 1866 (AIHA).
21. Memorandum from H. O. Voorhis, October 10, 1922 (WMC).
22. CAM 1970, p. 145.
23. Accession file, Boston Athenaeum, Boston, Massachusetts.
24. Accession file, Detroit Institute of Arts, Detroit, Michigan.
25. Letter from J. J. Robinson to JQAW, March 8, 1900 (AIHA).
26. JQAW to Robinson, see n. 11.
27. Minutes, PAFA Board, March 12, 1855, Archives, PAFA.
28. Letter from C. R. Lamb to JQAW, March 16, 1909 (N-YHS).
29. Archives, MMA.
30. Accession card, AAAL.

22. PRESENTATION SWORD FOR GENERAL ULYSSES S. GRANT
1863

Steel, goldplate, diamonds, and tortoise shell, 37⁷⁄₁₆ in.

Inscribed [on scabbard]: Palo Alto, Resaca de la Palma, May 9th, 1846; Monterey, Sept. 19, 20, 21, 1846; Vera Cruz Siege, Mar. 7 to 27, 1847; Cerro Gordo, Apr. 18, 1847; San Antonio, Aug. 20, 1847; Churubusco, Aug. 20, 1847; Molino del Rey, Sept. 8, 1847; Chapultepec, Sept. 13, 1847; Garita, San Cosmo, September 14, 1847; City of Mexico, September 14, 1847; Belmont, Nov. 7, 1861; Fort Henry, Feb. 6, 1862; Fort Donelson, Feb. 13, 14, 15, 16, 1862; Shiloh, Apr. 6, 7, 1862; Corinth Siege, Apr. 22 to May 30, 1862; Iuka, Sept. 19, 1862; Corinth, Oct. 3, 4, 1862; Hatchie, Oct. 5, 1862; Tallahatchie, Dec. 1, 1862; Port Gibson, May 1, 1863; Raymond, May 12, 1863; Jackson, May 14, 1863; Champion Hill, May 16, 1863; Black River Bridge, May 17, 1863; Vicksburg, July 4, 1863; Chattanooga, Nov. 23, 24, 25, 26, 1863.

National Museum of American History, Smithsonian Institution, Washington, D.C.

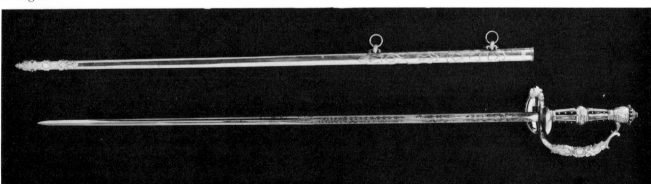

Cat. no. 22 *Presentation Sword for General Ulysses S. Grant*

The sword, made by the Ames company, was presented in 1863 at a cost of $2,000[1] to Ulysses Simpson Grant (April 27, 1822–July 23, 1885) by the citizens of Jo Dairess County, Illinois (fig. 21).[2] At the time a major general in the Union army, Grant was put in command of the United States Army the following year. The sword and other memorabilia were given to the government in 1886 by the general's widow and William H. Vanderbilt.[3]

Cat. no. 22 *Grant Sword*, detail.

NOTES

1. *Springfield Sunday Republican*, January 15, 1899, p. 10. See also *Illustrated Catalogue and Price List of the Ames Sword Company* [1886], p. 12, letter L (Providence, Rhode Island: *Man at Arms Publications*).

2. T. T. Belote, "American and European Swords in the Historical Collections of the United States National Museum," *Smithsonian Bulletin* 163 (1932), p. 67.

3. Ibid.

23. PRESENTATION SWORD FOR ADMIRAL ANDREW HULL FOOTE
1863

PRESENTATION NAVY.

No. Q — Embossed and Engraved Scabbard; Pebble Grip; Fine Gold Etched Blade, Gilt,
No. R — Embossed and Engraved Scabbard; Metal Chased Grip; Fine Gold Etched Blade, Gilt,
No. S — Embossed and Engraved Scabbard; Pebble Grip; Fine Gold Etched Blade, Gilt,
No. T — Engraved Mountings; Leather Scabbard; Pebble Grip; Gold Etched Blade, Gilt Mtd.,

Cat. no. 23 (Q). *Presentation Sword for Admiral Andrew Hull Foote.* Reproduced from *Illustrated Catalogue and Price List of the Ames Sword Company, Chicopee, Mass. U.S.A.* [1886].

Location unknown

Townley reports that in 1861 Ward had an agreement with the Ames company to model presentation swords for General Oglesby and Admiral Foote.[1]

A staunch disciplinarian, Andrew H. Foote (September 12, 1806–June 26, 1863) gained national attention in 1849–51 for the zeal with which he protected American ships from British search off the African coast and again in 1856, when the forces under his command destroyed four Chinese barrier forts off Canton in retaliation for an attack against the American flag. Outfitting twelve gunboats at the outbreak of the Civil War, Foote commanded the Union navy in hard-fought battles at Fort Henry on the Tennessee River and Fort Donelson on the Cumberland River, which in 1862 broke the Confederate line of defense in Tennessee. Wounded at the battle of Fort Donel-

son, he was eventually forced to give up his command, and he died the following year.[2]

In May 1862 a number of men from Brooklyn, New York, informed Foote of their wish to present him with a sword "as a token of personal esteem and admiration for his public service."[3] In September 1863 the presentation was made at the Brooklyn Athenaeum.[4] The present location of the sword is unknown, but an illustration of it appears in an Ames Sword Company catalogue,[5] and a detailed description of it was reported in a newspaper article:

> . . . It is, perhaps, the most magnificent sword that has ever been made in this country—is gracefully proportioned, rich and artistic in design, with scabbard and hilt of gold.
>
> The pummel represents a golden hemisphere, studded with stars, on which rests a branch of olive and oak, beneath a group of trophies. The guard, which is perhaps the chief feature of the whole, is a superb work of art, containing a basso-relievo of Neptune returning triumphant in his car. The figure of Neptune, bold and spirited, stands in the car, leaning upon his trident; at his feet are the spoils of victory; two vigorous sea-horses draw the car of the god, attended by tritons and sea-nymphs, bearing trumpets and wreaths of laurel for the hero. This basso-relievo is encircled by open scroll and ornamental work, forming a rich and harmonious arrangement of lines, whose effect is exceedingly graceful. At the bottom of the guard is a boldly modeled head of a dolphin.
>
> On the scabbard are a series of relievos, illustrating some of the prominent exploits of the bold sailor who is to be the recipient of the gift. . . . Further below, and toward the end of the scabbard, are emblematic allusions to FOOTE's experiences and actions on the African coast in bygone years. . . .
>
> The sword blade is no less a master-piece of workmanship and material than the scabbard. It is richly covered with artistic designs, and near the hilt, surrounded with graceful scroll work, is the patriotic motto, "Ducit amor patriae."
>
> The whole thing, in conception and in execution, is unequaled by any sword ever made in the United States. The exquisite artistic designs on the scabbard and blade were moulded by the distinguished American sculptor of this City, J. Q. A. WARD, who, though heretofore employed in works of greater magnitude and repute, has, in these designs, shown a wonderful flexibility and scope of genius. . . . [The] sword will remain no less an evidence of American art and skill than of the heroism of the great sailor to whom this night it will be presented.[6]

RELATED WORKS;

The following fragments are pieces from the Admiral Foote sword.

23.1. Guard
 Bronze, 6¼ × 3⅝ in.

American Academy of Arts and Letters, New York City

Bequeathed to the academy by Mrs. Ward (1933).[7]

23.2. Guard
 Bronze, dimensions not recorded
 Collection of Henry M. Stewart

Mr. Stewart reported in an article that he had purchased the guard from John Hintlian, who had acquired it in an assortment of finished and unfinished items from the Ames estate.[8]

23.3. Pommel
 Bronze, dimensions not recorded
 Collection of Norman Flayderman, New Milford, Connecticut

The pommel, originally acquired by John Hintlian from the Ames estate, was purchased by a man named Peter Hlinka for Mr. Flayderman. The above-mentioned guard and the pommel were reunited for a photograph in Mr. Stewart's 1975 article.[9]

NOTES

1. Townley 1871, p. 406. The *Springfield Sunday Republic*, January 15, 1899, p. 10, gives a history of the Ames company and refers to Admiral Foote's sword.
2. *DAB*, s.v. "Andrew Hull Foote."
3. J. M. Hoppin, *Life of Andrew Hull Foote, Rear-Admiral United States Navy* (New York, 1874), p. 361. The book contains a detailed description of the sword.
4. Ibid.
5. *Illustrated Catalogue and Price List of the Ames Sword Company* [1886], p. 16, letter Q (Providence, Rhode Island: *Man at Arms Publications*).
6. "Admiral Foote's Sword." Unidentified and undated newspaper clipping (AIHA).
7. Accession card, AAAL.
8. Henry M. Stewart, "The Ames Presentation Naval Hilt," *Monthly Bugle* (June 1975), pp. 2, 3.
9. Ibid.

24. PRESENTATION SWORD FOR GENERAL JAMES OGLESBY
1863

Destroyed

The second presentation sword that Ward was reported by Townley to have made while employed by the Ames company shortly after the outbreak of the Civil War was for General Oglesby.[1] Richard J. Oglesby (July 25, 1824–April 24, 1899), after the Civil War a leading politician from Illinois, served two terms as governor (1865–69 and 1885–89) and one as

PRESENTATION MILITARY.

I J K L

No. I.—Embossed and Engraved Scabbard; Goddess of Liberty Hilt; Fine Gold Etched Blade, Gilt,
No. J.—Embossed and Engraved Scabbard; Zouave Head Pebble Grip; Fine Gold Etched Blade, Gilt,
No. K.—Embossed and Engraved Scabbard; Pebble Grip; Fine Gold Etched Blade, Gilt,
No. L.—Embossed Scabbard; Gold and Shell Grip; Fine Gold Etched Blade, Gilt,

Cat. no. 24 (I). *Presentation Sword for General Richard James Oglesby.* **Reproduced from** *Illustrated Catalogue and Price List of the Ames Sword Company, Chicopee, Mass. U.S.A.* **[1886].**

senator (1872–78). Having fought in the battles of Vera Cruz and Cerro Gordo in the Mexican War, he was made a colonel of the Eighth Illinois Volunteers at the outbreak of the Civil War. A brigade commander under General Grant at Fort Henry and Fort Donelson, he was severely wounded at the Battle of Corinth in October 1862. When he returned to duty, in April 1863, he was promoted to the rank of major general. He resigned from the army the following spring, and was then elected governor of Illinois.[2]

In February 1862 a man named Alex Hawes wrote to a J. Swinton, instructing him to have Ward proceed with the presentation sword for General Oglesby.[3] A year later Hawes informed the sculptor that the money for the sword was being deposited in a bank in New York, and would be paid him when the piece was completed.[4] At $2,200, the Oglesby presentation sword was the most expensive one that the Ames com-

pany produced.[5] It was reported that "The handle was of solid gold, the grip being a figure of Liberty holding a broken shackle; the guard was composed of a flag surmounted by the American eagle, with one wing over the flag and the other over a figure of Liberty."[6] There is no record of an inscription on the sword or on the scabbard, but in an undated letter to Ward one was suggested: "To Major Gen. Richard J. Oglesby from The Officers and Soldiers of 2nd Brigade, 2nd Division, 13th Army Corps., Army of the Tennessee/A Mark of Their Personal Regard—A Token of Their Appreciation of his Virtues as a Soldier and Citizen, and especially of his gallant Conduct at the Battle of Corinth, October 3–4, 1862."[7]

The sword was probably given to Oglesby in 1863. It was destroyed in a fire in his home in Elkhart, Illinois, in 1898.[8] The illustration of the sword appears in the Ames Sword Company catalogue.[9]

NOTES

1. Townley 1871, p. 406.
2. *DAB*, s.v. "Richard James Oglesby."
3. Letter from A. G. Hawes to J. Swinton, February 3, 1862 (AIHA).
4. Letter from A. G. Hawes to JQAW, February 13, 1863 (AIHA).
5. *Springfield Sunday Republican*, January 15, 1899, p. 10.
6. Ibid.
7. Letter from J. Swinton to JQAW, n.d. (AIHA).
8. Letter from J. D. Hamilton to author, August 9, 1983. Mr. Hamilton credits the information as being given to him in January 1981 by William K. Alderfer, state historian, Illinois State Historical Society.
9. *Illustrated Catalogue and Price List of the Ames Sword Company* [1886], p. 12, letter I (Providence, Rhode Island: *Man at Arms Publications*).

25. MATCHBOX
1863

Location unknown

L. A. Amouroux cast one matchbox for Ward in August 1863.[1] A small metal flint box bearing Ward's monogram was bequeathed by Mrs. Ward to the American Academy of Arts and Letters (1933),[2] but to conclude that the two are related is not possible.

NOTES

1. Bill from L. A. Amouroux to JQAW, December 3, 1864 (AIHA). The bill was for small works done over the previous year.
2. Accession card, AAAL.

26. BRONZE BOX
1863

Location unknown

In December 1863 L. A. Amouroux billed Ward three dollars for casting one bronze box.[1] There is no other information related to this piece.

NOTES

1. Bill from L. A. Amouroux to JQAW, December 18, 1863 (AIHA).

27. SANITARY COMMISSION MEDAL
Relief design, 1863

Location unknown

A forerunner of the American National Red Cross organized by Clara Barton in 1881, the United States Sanitary Commission was established in 1861 on the model of its British prototype, which Florence Nightingale had founded during the Crimean War. The commission, a privately supported volunteer auxiliary to the Army Medical Corps, gave aid by fitting out and supplying hospital units, caring for the wounded at the front, and seeing to the comfort of soldiers.[1]

In March 1863 a representative of the Sanitary Commission wrote to Ward:

Your note containing the photograph of the relief design for a medal has been much admired: but as various suggestions may be made before we can decide, I think it is not worth yet to re-model in wax, because we can discuss it as well in the present form. . . . The two prominent suggestions in regard to it are
1. That *one* of the figures at least should be a *surgeon.*
2. That "the female figure should be more simply dressed & in more obviously appropriate costume for the serious work of the field."[2]

There is no additional information pertaining to the relief or to Ward's having done any more work on it.

NOTES

1. T. H. Johnson, *The Oxford Companion to American History* (New York: Oxford University Press, 1966), p. 704.
2. Letter from H. G. Clark to C. Vaux, March 25, 1863. Vaux forwarded the letter to JQAW on March 26, 1863 (AIHA).

28. PAIR OF SWORDS FOR THE KINGS OF SIAM
1863

Location unknown

In 1863 Ward received a Department of State memorandum regarding a commission for five presentation swords, one each for the First and Second Kings of Siam, one for the Prime Minister, one for the Minister for Foreign Affairs, and one for the Lord Mayor.[1] That March, R. S. Chilton of the department

wrote Ward, "It has been determined to have but two of the swords (those for their Duplicate Majesties of Siam) made at present. . . . The matter has been entrusted to my hands, and I am anxious that you should execute the commission."[2] An official order from the department followed on March 29, 1863, stipulating that the cost of the two swords was "not to exceed sixteen hundred dollars."[3]

In January 1864 Chilton wrote Ward that the swords had arrived in Washington and were greatly admired.[4] They were displayed briefly in the Department of Foreign Ministry[5] and then were on public display at Galt's gallery in Washington.[6] As with the presentation swords for General Grant, General Oglesby, and Admiral Foote, the swords for the kings of Siam were made at the Ames Sword Company.[7]

NOTES

1. Memorandum to JQAW, n.d. (AIHA).
2. Letter from R. S. Chilton to JQAW, March 19, 1863 (AIHA). See also Tuckerman 1867, p. 581.
3. Letter from G. E. Baker to JQAW, March 29, 1863 (AIHA).
4. Letter from R. S. Chilton to JQAW, January 28, 1864 (AIHA).
5. Ibid.
6. Ibid., February 17, 1864.
7. *Springfield Sunday Republican* of January 15, 1899, p. 10, mistakenly reports that the company made one sword, for "The King of Siam."

29. SWORD
1863

Location unknown

In addition to the presentation swords for General Grant, General Oglesby, Admiral Foote, and the kings of Siam that Ward made for the Ames Sword Company, the founder A. L. Amouroux billed him fifty dollars in 1863 "for chasing of a sword piece."[1] Other than the aforementioned presentation pieces, there is no information on any swords Ward made.

RELATED WORKS:

It is not possible to ascribe the following fragment and wax studies either to the Amouroux sword or to any of the Ames presentation pieces.

29.1. Sword guard[2]
 Bronze, h. 6⅜ in., w. 3¼ in.
 Inscribed: U.S.N.
 American Academy of Arts and Letters, New
 York City

29.2. Four fragments of scabbard fittings

Wax on brass
American Academy of Arts and Letters, New
York City

In Gifts from the JQAW Estate these pieces are
listed as numbers 1575, 1577, 1579, and 1583.[3]

NOTES

1. Bill from L. A. Amouroux to JQAW, July 29, 1863
(AIHA).
2. Accession card, AAAL.
3. Gifts from the JQAW Estate, April 18, 1934 (AAAL).

30. PISTOLS FOR THE GOVERNOR OF TURKEY
1863

Location unknown

It was reported in 1867 that Ward had made a pair
of pistols—their handles covered with figures and cast
in silver, their barrels inlaid with gold—that the presi-
dent of the United States had presented to the Turkish
governor.[1] These are probably the pistols that R. S.
Chilton of the Department of State wrote to the sculp-
tor about in December 1863:

Your letter came on Tuesday, and yesterday the pistols
came, and they have been looked [at] and admired in a
way that would, I am sure, have gratified you. . . . They
are really beautiful;—models of fine taste and craftsman-
ship. My only regret is that such a pair were not sent to
the Kings of Sweden and Denmark, instead of the orna-
mental things with Colt's advertisement inlaid on the bar-
rels, which went as presents to their Scandinavian Majes-
ties a year ago.[2]

RELATED WORKS:

30.1. Study for a pistol handle
Wax, 4½ in. high
American Academy of Arts and Letters, New
York City

This study was likely for the handles of the pistols
commissioned by the Department of State for the
Turkish governor, though there is also a September
1865 bill from L. A. Amouroux for casting and chasing
a pistol butt (cat. no. 35).[3] The study was bequeathed
to the academy by Mrs. Ward (1933).[4]

NOTES

1. Tuckerman 1867, p. 581.
2. Letter from R. S. Chilton to JQAW, December 24,
1863 (AIHA).
3. Bill from L. A. Amouroux to JQAW, September 26,
1865 (AIHA).
4. Accession card, AAAL.

31. CANE TOPS
About 1863

Location unknown

Adeline Adams, in her entry on Ward, reported
that among the "small objects to be cast in precious
metal" made by the sculptor for the Ames Company
during the Civil War were cane tops.[1] There is no
other reference to the cane tops and none have been
located.

NOTES

1. *DAB*, s.v. "John Quincy Adams Ward."

32. GENERAL GEORGE BRINTON McCLELLAN
Equestrian relief, 1864

Multiple edition

Although George B. McClellan (December 5,
1826–October 29, 1885) had a checkered military
career, he was a popular Civil War general and an
influential leader in Union politics. In 1862 McClellan
was given command of the Army of the Potomac,
which he quickly and efficiently reorganized. In the
field, however, he proved to be too cautious; after the
collapse of his Peninsular campaign in the summer of
1862 and when he failed that fall to pursue Lee's
forces after stopping him at the Battle of Antietam,
McClellan was relieved of his command. At the
Democratic convention in 1864 he was nominated to
run for the presidency against Abraham Lincoln. He
campaigned on the party's platform of immediate
peace, though he was less enthusiastic about it than
were many of his followers. He was defeated when
Sherman's military victories in the South, particularly
his capture of Atlanta in September 1864, assured
Lincoln's reelection.[1]

This small, commercially produced equestrian por-
trait of General McClellan reveals Ward's struggle to
support himself as a sculptor during the Civil War.
The relief was designed by F. O. C. Darley, a well-
known illustrator, and a patent was issued for it to
James F. Drummond (cat. no. 34) of New York on
January 15, 1864, with the following description:

The General is represented seated in upright attitude
looking forward with the reins in the left hand, the head
uncovered and cap in the right hand which hangs down in
an easy position. His dress consists of undress regulation
coat, belt, gauntlets and high riding boots worn outside
the pantaloons.
The horse is represented as saddled, furnished with

holsters and with ornamental stirrups. The position is that
of having been just pulled up and stopped on a walking
pace, resting on the right fore foot and left hind foot and
the neck arched. The left fore foot is represented as raised
to its highest position, and the right hind foot as just about
to be raised from the ground.[2]

The relief was distributed by John H. Williams of
353 Broadway, who on September 15, 1864, issued
the following circular:

We are just issuing a beautiful EQUESTRIAN BAS-RELIEF
OF MAJOR GEN. GEORGE B. MCCLELLAN, executed in Sil-
ver and Bronze, from a model by Ward, after an original
design by Darley. This exquisite Work of Art we furnish,
in the separate styles submitted, at $75 and $150 per
dozen, framed complete, a price much lower than any
thing of like merit has ever before been introduced to the
public. We have thought best to present the Work ready
framed, because of the delay usually experienced in get-
ting up suitable styles, and the necessity that exists of
putting a work of this character promptly before the
public. The styles of frames will be found tasty and appro-
priate, and being manufactured in quantities, are placed
at a price less than they can be got up in a more limited
way.[3]

While the relief was intended for popular distribu-
tion, it reveals that Ward in 1863 was capable of ex-
ecuting a somewhat complex relief. McClellan is con-
vincingly portrayed; the prancing horse, with its
waving mane and tail, its arched neck, and alert eyes,
is an animated steed with a striking silhouette.

RELATED WORKS:

There is no record of how many reliefs were cast; to
date, only four bronze examples are known. A bill
from L. A. Amouroux in December 1864 includes a
three-dollar-charge for one "MacClellan rebronzed."[4]

32.1. Equestrian relief
 Bronze, h. 18¾ in.
 Signed: F.O.C. Darley, Fecit Patented Jan.
 5th 1864 J.Q.A. Ward, Sculptor
 Print Room, New York Public Library, New
 York City

Dr. I. Wayman Drummond, son of James F. Drum-
mond, gave this relief to the library in 1932.[5]

32.2. Equestrian relief
 Bronze, h. 18¾ in.
 Signed: F.O.C. Darley, Fecit J.Q.A. Ward,
 Sculptor
 Collection of Joseph P. Daxon, Waterbury,
 Connecticut

Mr. Daxon reports that the relief has been in his
family for three generations.[6]

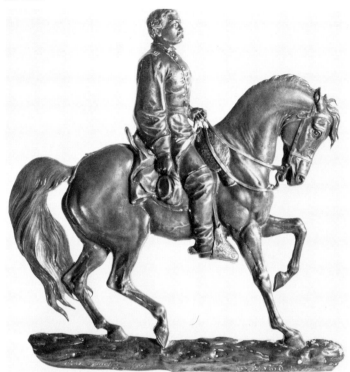

Cat. no. 32.3 *General George Brinton McClellan*

32.3. Equestrian relief
 Bronze, h. 18¾ in.
 Signed: F.O.C. Darley, Fecit J.Q.A. Ward,
 Sc[illegible]
 Collection of Lewis and Susan Sharp, New
 York City

This example was acquired in 1976 from Samuel
Feldman, a New York City art dealer. No prior history
related to the relief is known.

32.4. Equestrian relief
 Bronze, h. 18¾ in.
 Signed: F.O.C. Darley, Fecit Patented Jan.
 5th 1864 J.Q.A. Ward, Sculptor.
 Ex coll.: Alice Davison Gates

The relief, mounted on a black ground and in its
original arched walnut frame, was auctioned in New
York in 1984.[7]

NOTES

1. *DAB,* s.v. "George Brinton McClellan."
2. Patent for the Bas-Relief of General George B.
McClellan issued to James F. Drummond, Patent No.
1882, January 15, 1864, Print Room, NYPL.
3. Printed circular letter from J. H. Williams, Septem-
ber 15, 1864, Print Room, NYPL.
4. Bill from L. A. Amouroux to JQAW, December 3,
1864 (AIHA).
5. Accession file, Print Room, NYPL.
6. Letter from J. P. Daxon to author, June 8, 1972 (APS).
7. *American Furniture, Silver and Decorative Arts,*

Christie, Manson & Woods International, Inc. (January 21, 1984), lot 143 (where subject incorrectly identified as General Mead).

33. VASE
1864

Location unknown

In January 1864, L. A. Amouroux cast a vase for Ward for six dollars.[1]

NOTES

1. Bill from L. A. Amouroux to JQAW, December 3, 1864 (AIHA).

Cat. no. 34 *James F. Drummond*

34. JAMES F. DRUMMOND
Bust, about 1864

Marble, h. 22 in.
The New-York Historical Society, New York City

There is no reference to a bust of James F. Drummond either in Ward's correspondence or in the pub-lished literature pertaining to Ward or his work.[1] The bust nevertheless has a traditional attribution of being by Ward, as James D. Herbert, the subject's grandson, recounted when he gave it to the Historical Society in 1946.[2] Ward and Drummond were associated in 1864 in a venture to market the equestrian relief of General George Brinton McClellan (cat. no. 32). On January 15, 1864, Drummond was issued a patent to execute the relief, which was drawn by F. O. C. Darley and modeled by Ward.[3] Ward probably did the bust of Drummond at that time. The Ward attribution and the suggested date are reinforced by the naturalistic likeness—the essence of Ward's sculpture. The stylized treatment of Drummond's hair and beard and the smooth, completely untextured surface of the head correspond to the portraiture Ward executed before 1870.

NOTES

1. [J. F.] Drummond wrote to JQAW in April 1872 requesting information on his statue of Putnam (cat. no. 55), and again on March 30, 1880, regarding a position in the MMA's art school for a Mr. Butler (AIHA).
2. N-YHS 1974, 1, p. 227.
3. Patent for the Bas-Relief of General George B. McClellan . . . Patent No. 1882, January 15, 1864, Print Room, NYPL.

35. PISTOL
1865

Location unknown

Ward was billed forty dollars by L. A. Amouroux in 1865 for casting and chasing one pistol butt.[1] The wax study for a pistol handle refered to at cat. no. 30.1 could instead be the model for this pistol.

NOTES

1. Bill from L. A. Amouroux to JQAW, September 26, 1865 (AIHA).

36. WILLIAM TILDEN BLODGETT
Bust, 1865

Marble, h. 26 in.
The Metropolitan Museum of Art, New York City

William T. Blodgett (February 18, 1823–November 4, 1875) was a New York entrepreneur, philanthropist, and patron of the arts. He was a central figure in the great 1863 Sanitary Commission Fair (to raise money for the forerunner of the American Red Cross) and was a member of the committee that selected the American entries to the Paris Exposition in 1867 at

Cat. no. 36 *William Tilden Blodgett*

which Ward's statue of *The Indian Hunter* and statuette of *The Freedman* were shown. He served on a similar committee for the Centennial Exhibition held in Philadelphia in 1876. Blodgett founded the magazine *The Nation*, was the principal organizer of the Union League Club, and was one of the original trustees of both the American Museum of Natural History and The Metropolitan Museum of Art. He was an active member of the latter's Board of Trustees, to which he was elected vice president, and he was instrumental in the museum's 1871 acquisition of the 174 Dutch and Flemish paintings that became the core of the museum's painting collection. He was a member of the Century Club, exercising a "cordial and elegant hospitality towards artists—the most obscure and struggling as well as the most eminent."[1]

The *Evening Post* reported in May 1865 that Ward was at work on a bust of Blodgett, "which is a spirited

and faithful likeness."[2] In a photograph of the sculptor's studio taken in about 1885 (fig. 54), in which Ward is sitting in front of the finished model of the *Garfield* monument, the bust of Blodgett is in the background.

The *Blodgett* was given to the museum by Mrs. Ward shortly after her husband's death in 1910. A note in the museum *Bulletin* acknowledged the gift:

The portrait bust in marble of William Tilden Blodgett, by the late John Quincy Adams Ward, which has just been presented by the widow of the sculptor, Mrs. Ward, is peculiarly acceptable to the Trustees of the Museum. It is the work not only of an artist whom the whole community honors, one who has long stood in the foremost rank of American sculptors, but also of a man who in the capacity of Member and Trustee has identified himself with the upbuilding of the Museum.

The gift is esteemed, also, because of its subject. Mr. Blodgett was a worker with Mr. Ward in the early days of the Museum's struggle for permanence and usefulness and closely identified with every step of progress that was made. It is, indeed, a happy coincidence that binds the two men together in this memorial.[3]

NOTES

1. R. W. de Forest, "William Tilden Blodgett and the Beginnings of the Metropolitan Museum of Art," *Bulletin of the Metropolitan Museum of Art* 1 (February 1906), pp. 37–39. See also Blodgett's obituary, *New York Times*, November 6, 1875, pp. 6, 7.
2. "Fine Arts," *Evening Post* [New York], May 17, 1865, p. 2.
3. "Principal Accessions," *Bulletin of the Metropolitan Museum of Art* 5 (December 1910), p. 289.

37. ORVILLE DEWEY
Bust, 1865

Marble, h. 20¾ in.
Signed: J.Q.A. W[obliterated]
Unitarian Community Church, 40 East 35th
 Street, New York City

The bust of the Reverend Orville Dewey (March 28, 1794–March 28, 1882) was done for the Church of the Messiah in New York City, where Dr. Dewey was pastor from 1835 until 1848, when ill health forced him to retire. An influential figure in the Unitarian Church, he published a number of theological treatises and, from 1845 to 1847, was president of the American Unitarian Association. A "vivacious and charming companion," he was a member of the Sketch Club, later the Century Association, which brought him into contact with many of the leading artists of the day.[1]

The bust of Dr. Dewey was exhibited at Schaus's gallery in New York in 1865. It is draped in the classi-

cal robes characteristic of Ward's early portraiture, but the likeness is thoroughly realistic. The garments fall in simple, plastic folds and the face is conceived in broad planes. The portrait is a penetrating study of the clergyman in a pensive mood. A reviewer for *The Round Table* enthusiastically reported that the bust was a good likeness and that America had "not a better sculptor than Mr. Ward."[2] The critic for *The Nation* went as far as to say that "no better portrait in marble has been made in America," and added:

The sculptor takes the features in their most perfect repose, and in them finds the man and his past life. It is a great pleasure to us to see no tricks and no devices resorted to for effect. Form only is represented, and form is truly represented. Every one knows American statues in which the eyelids are deeply undercut, for shadow - the pupil of the eye raised in relief, for effect - the hair defined in threads, for exciting the popular admiration of dexterity - the surface worked down with sand-paper and pumice-stone, to get the look of *flesh*. It is a pleasure to see none of these things. The treatment of the hair is just what it should be, its masses shown and left in solid marble locks. The surface is as it should be, cut to its right form and filed smooth, and left so.[3]

The bust is in extremely bad condition today—the nose is completely missing and there are numerous chips, cracks, and stains.

NOTES

1. *DAB*, s.v. "Orville Dewey."
2. "Art Notes," *The Round Table* 2 (October 28, 1865), p. 125.
3. "Sculpture," *The Nation* 1 (October 12, 1865), p. 474.

38. *THE INDIAN HUNTER*
Statue, 1866
(Plate III)

Bronze, over life-size
Signed: J.Q.A. Ward/Sculptor./N.Y. 1866
Founder's mark: BRONZE BY/L. A. AMOUROUX. N.Y.
Unveiled: February 4, 1869
Central Park, New York City

Ward made plans to enlarge the statuette of *The Indian Hunter* following its success at the National Academy of Design in 1862. He showed the unfinished clay model of the statue to a *Round Table* reporter in March 1864,[1] and displayed the completed, larger-than-life-size plaster cast in the fall of 1865 at the Broadway gallery of John Snedicor (fig. 27).[2] Only a few minor changes were made in the enlargement: the oval base was replaced with a rectangular one, the aboriginal quality of the facial fea-

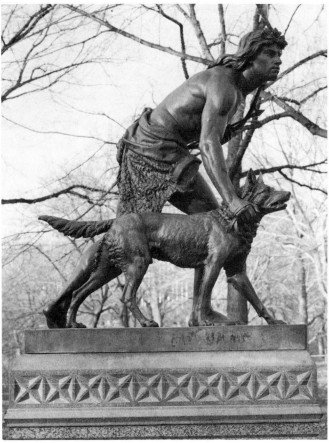

Cat. no. 38 *The Indian Hunter*

tures was strengthened, the bow arm was raised, the skin worn around the Indian's waist was reduced and simplified, and the surface was textured more richly. Ward, widely acclaimed in the press for *The Indian Hunter*[3] and now with financial backing, contracted with the founder L. A. Amouroux on June 21, 1866, to have the statue cast in bronze for $10,000.[4] The finished bronze statue was sent to the Paris Exposition of 1867.[5] When it and the other American entries returned to the United States, in 1868, they were displayed at the National Academy of Design.[6] On December 28, 1868, *The Indian Hunter*, underwritten by twenty-three of the country's most prominent artists and art patrons, was presented to the City of New York for erection in Central Park.[7] Unveiled the following February, the statue was the first piece of American sculpture to be placed in the eleven-year-old park (fig. 28).[8]

RELATED WORKS:

See cat. no. 12, "Related works." The original full-size plaster model, given by Ward in 1901 to the Corcoran Gallery of Art in Washington, D.C.,[9] does not survive.

38.1. Statue
 Bronze, over life-size
 Signed: not recorded
 Founder's mark: not recorded
 Cooperstown, New York

Frank H. Presby, agent for the estate of Edward Clark and Alfred Corning Clark, contracted with Ward in 1897 to have a replica cast of *The Indian Hunter* for Cooperstown. The agreement stipulated that the statue be completed in eight months for $7,500.[10] It was formally unveiled in May 1898.[11]

38.2. Statue
 Bronze, over life-size
 Signed: J.Q.A. Ward/Sculptor/N.Y. 1866
 Founder's mark: Cast by/Jno. Williams
 Inc./Bronze Foundry New York/1914
 Inscription on base: John Quincy Adams
 Ward/Sculptor/Born Urbana, June 29,
 1830/Died New York City, May 1,
 1910/This
 replica of his first statue/is a memorial gift to
 his/fellow townsmen/erected by his wife to
 mark his grave.
 Oak Dale Cemetery, Urbana, Ohio (fig. 75)

38.3. Statue
 Bronze, over life-size
 Signed: J Q A Ward Sculptor 186[obliterated]
 Founder's mark: ROMAN BRONZE WORKS NY
 Inscription on base: THE INDIAN
 HUNTER/BY/JOHN Q A WARD/PRESENTED TO
 THE CITY OF BUFFALO/BY/ELLA SPENCER
 DARR/IN MEMORY OF HER HUSBAND/MARCUS
 M DARR
 Delaware Park Meadow, Buffalo, New York

Mrs. Darr presented the replica to the city of Buffalo in 1926.[12]

NOTES

1. *The Round Table* 1 (March 5, 1864), p. 184.
2. Townley 1871, p. 407.
3. "Mr. Ward's Indian Hunter," *The Nation* 1 (October 19, 1865), pp. 506–507; "Ward's Statue," *Harper's Weekly* 9 (December 23, 1865), p. 812; "Mr. Ward's 'Indian Hunter,'" *The Round Table* (October 28, 1865), pp. 124–125; *The Evening Post*, November 3, 1865, p. 1; and *Cincinnati Daily Gazette*, November 25, 1865, p. 1.
4. Contract between A. L. Amouroux and JQAW, June 21, 1866 (N-YHS).
5. Leslie 1868, p. 40.
6. NAD 1867–8, no. 688.
7. CPC 1868, pp. 101–102. The twenty-three members of the "Committee of the Indian Hunter Fund" were: Lucius Tuckerman, Le Grand Lockwood, Robert Hoe, Cyrus Butler, Henry G. Stebbins, Samuel G. Ward, H. Pier-

pont Morgan, R. M. Olyphant, W. E. Dodge, Jr., Charles S. Smith, Sheppard Gandy, W. H. Raynor, John Taylor Johnston, William T. Blodgett, J. F. Kensett, William H. Fogg, C. E. Detmold, Levi P. Morton, Richard M. Hunt, D. Huntington, H. G. Marquand, James McKaye, R. E. Hawkins.
8. *New York Times*, February 5, 1869, p. 2.
9. Letter from F. B. McGuire to JQAW, June 19, 1901 (N-YHS).
10. Letter from F. H. Presby to JQAW, July 29, 1897 (N-YHS).
11. Letter from E. S. Clark to JQAW, June 2, 1898 (N-YHS).
12. R. W. Bingham, ed., "Niagara Frontier Miscellany," *Buffalo Historical Society Publication* 34 (1947), p. 163.

Cat. no. 39 *An Unidentified Man*

39. AN UNIDENTIFIED MAN
Bust, 1866

Marble, h. 24 in.
Signed: J.Q.A. WARD 1866
Location unknown

The bust, draped in a classical robe, is a realistic likeness of a young man approximately thirty years old. Ward's unlocated busts of Dr. Valentine Mott, Edwin Bartlett, W. J. Gordon, Horace Webster, and

the Reverend Octavius Brooks Frothingham also date from the mid-1860s, but to link this portrait to any of them is not possible.

The bust was owned by an art dealer in Lakeland, Florida, in the 1970s.[1] Its present location is unknown.

NOTES

1. A photograph of the bust was given to the author by Professor William Gerdts. The Lakeland art dealer's name is inscribed on the reverse side of the photograph, but his present whereabouts are unknown.

40. MEDALLION
1866

Location unknown

In March 1866 a man named James J. Higginson wrote Ward that he would like to see a cast of a medallion they had "agreed upon" during his next trip to New York. He also requested that Ward establish a price for the work.[1] There is no additional information concerning Mr. Higginson or the medallion.

NOTES

1. Letter from J. J. Higginson to JQAW, March 11, 1866 (N-YHS).

41. VALENTINE MOTT, M.D.
Bust, before 1867

Location unknown

Valentine Mott (August 20, 1785–April 26, 1865) was an internationally respected surgeon and teacher. He assisted in founding a medical college at Rutgers University and at the University of the City of New York, and he taught at the College of Physicians and Surgeons in New York City until his death.[1]

Ward's bust of Dr. Mott is listed by both Tuckerman[2] and Townley,[3] but no other contemporary or later references to it exist. The portrait was probably commissioned either by a member of Mott's family or by an institution with which Mott had been closely associated. Its present location remains unknown.

NOTES

1. *DAB*, s.v. "Valentine Mott."
2. Tuckerman 1867, p. 581.
3. Townley 1871, p. 406.

42. HORACE WEBSTER
Bust, before 1867

Location unknown

In 1867, the College of the City of New York lent a bust of Horace Webster (September 21, 1794–July 12, 1871) by Ward to the annual exhibition of the National Academy of Design.[1] Webster was a distinguished teacher and college administrator who taught mathematics and philosophy at the United States Military Academy between 1818 and 1825 and at Geneva (now Hobart) College between 1825 and 1848. After leaving Geneva College, he became principal of the Free Academy in New York, where he also taught courses in moral, intellectual, and political philosophy. In 1866 the name of the school was changed to the College of the City of New York, and Webster continued as its head until he retired in 1869.[2]

The College of the City of New York has no record of the bust nor any knowledge of its present location. There is no mention of the portrait in Ward's correspondence, and the only published reference (other than that in the academy's 1867 catalogue) appears in a listing of portraits by Ward in Townley's article.[3]

NOTES

1. NAD 1867, no. 611.
2. *ACAB*, s.v. "Horace Webster."
3. Townley 1871, p. 406.

43. W. J. GORDON
Bust, before 1868

Marble
Location unknown

In 1894 a bust by Ward of a W. J. Gordon was displayed at the Cleveland Art Loan Exhibition.[1] Gordon had lent the portrait in 1868 to the National Academy of Design's annual exhibition, but at that time it was titled just "Marble Portrait Bust."[2] It had been commissioned in 1866 by Gordon, who wrote Ward from Paris about the bust and a replica of it that Ward was to carve:

. . . when the bust is completed, I will thank you to inform one *addressed* to the care of John Munroe Co. No. 7 Rue Scribe Paris & if you will at same time enclose statement of account showing the *balance due*, I will make provisions for prompt settlement.[3]

The only other reference to the bust was in 1870, when Robert Cushing, Ward's agent in Italy supervising the carving of *The Protector*, wrote Ward that he had not seen a better portrait than Ward's busts of Dewey, Bartlett, and Gordon.[4]

NOTES

1. *Catalogue of the Cleveland Art Loan Exhibition* (Cleveland, Ohio: The Cleveland Printing and Publishing Co., 1894), p. 79, no. 20.
2. NAD 1868, no. 555.

3. Letter from W. J. Gordon to JQAW, December 4, 1866 (AIHA).

4. Robert Cushing to JQAW, February 23, 1870 (N-YHS).

Cat. no. 44 *The Ether Monument*

44. THE ETHER MONUMENT
1868

Granite crowning figure, *The Good Samaritan*, over life-size

Four marble relief panels, each approximately 2 ft. × 2 ft., for the die of the monument

Architects of monument: William R. Ware and Henry van Brunt

Inscription on monument [front]: TO COMMEMORATE/THE DISCOVERY/THAT THE INHALING OF ETHER/CAUSES INSENSIBILITY TO PAIN/AT THE/MASS. GENERAL HOSPITAL/IN BOSTON/OCTOBER A. D. MDCCCXLVI [left]: NEITHER SHALL THERE BE ANY MORE PAIN [back]: IN GRATITUDE/FOR THE RELIEF/OF HUMAN SUFFERING/BY THE INHALING OF ETHER/A CITIZEN OF BOSTON/HAS ERECTED/

THIS MONUMENT/A.D. MDCCCLXVII [right]: THIS ALSO COMETH FORTH/FROM THE LORD OF HOSTS/WHICH IS WONDERFUL/IN COUNSEL,/AND EXCELLENT/IN WORKING.

Unveiled: September 26, 1868

Boston Public Garden, Boston, Massachusetts

Henry van Brunt, of the Boston architectural firm of Ware and van Brunt, wrote Ward on January 22, 1866:

I have been commissioned by a gentleman of this city to build a monument to commemorate the discovery of ether as an anaesthetic. It is proposed to be an expression of gratitude, as it were, for the alleviation of human suffering, and, as such, may safely assume somewhat of a poetic character. . . .

I have ventured to write to you in this connection with a view to ascertain whether you would be willing to furnish me with models for the sculpture and on what terms. . . .

As you may guess from my sketch I have supposed the monument to be placed in a *pool* partly for the associations of healing connected with the pool and partly that I might thereby get rid of the necessity of an iron fence. The main feature is a grouped or "clustered" shaft of this section: ⚓ , supporting or finishing with a group of 2 or 3 figures of life size by which I hope to express some symbol of the *relief of suffering*, using perhaps the *Good Samaritan* as the most recognizable type. This is to be in white granite and, as you may suppose, should be treated not with academic nicety but with somewhat of the naiveté and simplicity of the mediaeval statues. It should be pyramidal and should be treated in its general line as subsidiary to the architecture—to carry the perpendicular lines quietly into the sky, as it were. My idea is that it should be in mass, not broken, and just enough *relievant* from the block of granite to be recognizable as a type. It should not have value for its own sake so much as for its suitableness for the position. Over the place for the inscription & under the arches are four surfaces (marked A) on the four sides of the monument which I propose to occupy with *high reliefs*, expressing in the most realistic manner the use of ether in the hospital, on the battle field, etc. These should occupy a space each about 2 feet wide by as many high.

The whole thing should be done not classically but with the greatest directness and simplicity. The sculpture is merely to decorate and express ideas, I may almost say, in the rudest way consistent with artistic feeling. The thing seems to me to be one in which *an artist* should take peculiar interest, and I therefore feel that you will not misunderstand the somewhat prolix way in which I have ventured to talk to you.[1]

Van Brunt's letter reveals that the plans for the monument had been completed when Ward was first approached, and that the sculpture from the outset was regarded as merely decorative, or, as he said, "subsidiary to the architecture." The "gentleman of this city" to whom van Brunt referred as commissioner of the monument was Thomas Lee, who only

two years earlier had engaged William Rimmer to execute the statue of Alexander Hamilton for the Commonwealth Avenue Mall in Boston. Ward reportedly was awarded the commission because Dr. William T. G. Morton, the discoverer of ether, felt that Ward's *Freedman* displayed an anatomical as well as an aesthetic understanding of the human body.[2] On February 17, 1866, less than a month after van Brunt's initial letter, Ward signed a contract to supply the models for *The Good Samaritan* and the four reliefs for $6,300, to be paid in installments: two of $1,400 each on completion of the plaster models for the reliefs and on completion of the reliefs in marble; $2,000 on completion of the model of *The Good Samaritan;* and $1,500 on its completion in granite.[3]

Following van Brunt's recommendation, Ward used as the crowning group of *The Ether Monument* the Good Samaritan of the parable, whom he depicted administering to the wounds of the suffering. The group's basic composition is closely related to that in van Brunt's sketch, though its ultimate source was probably the Michelangelo *Pietà* at the Cathedral of Santa Maria del Fiore in Florence.

From the beginning, Ward recommended that the sculpture be done in bronze rather than stone, but van Brunt's adamant opinion concerning the material is expressed in a letter:

> Another point of difficulty is the detraction from the dignity of the monument by introducing a third color and a third material. White marble and white granite are antagonistic (are they not?) in colour and texture. You remember we recognized this when we determined to *stain* the reliefs. Would it not be a hazardous experiment, would it not savour of unwarrantable artifice to stain so large and so important a part of the monument as this crowning group? And would not the contrast of colour and material, that of the upper sculpture being more precious, make the substructure appear as if it were intended to support the group, instead of the group being an integral part of an architectural composition?[4]

Van Brunt's wishes prevailed, and Ward's finished model of *The Good Samaritan* was shipped by rail to Boston in September 1866.[5] The group was then transferred to West Quincy, where Garret Barry, a stonemason who had also carved Rimmer's *Hamilton*, began the tedious job of cutting the statue. On December 26, van Brunt wrote Ward that Barry had finished blocking out the group.[6] Eight months later, he reported to Ward:

> All the drapery is finished and is remarkably well done; the effect is vigorous sharp and clear, the folds are well defined. You could wish for no better work. The torso and border extremities of the young man are finished, and with great fidelity and precision. He has a beautiful surface and the modelling, however delicate, "tells." The head and turban are well advanced. Otherwise the arms, hands and head are nearly all that remain to be done. Yet the old fellow talked about not calling the thing finished till next Spring. This seems to me unreasonable and preposterous. But I didn't venture to dispute the matter.[7]

Almost a year later, on July 1, 1868, Barry wrote Ward that the group was completed and was ready to put in place.[8]

Work on the reliefs did not progress as rapidly as that on *The Good Samaritan*, and van Brunt, concerned about Mr. Lee's failing health, repeatedly urged Ward to finish them quickly so the elderly patron could see the monument completed.[9] Carved in marble and set into the four sides of the granite die of the monument, the reliefs depict, on the front, a doctor administering ether to a patient undergoing an operation; on the left side, an angel of mercy descending to relieve the suffering of a semireclined figure in the right foreground; on the back, a doctor administering ether to a wounded soldier in a Civil War field hospital; and on the right side, an enthroned female figure in classical robes personifying the Triumph of Science. There is no record of when Ward completed the models for the reliefs or who did the carving. A letter from van Brunt dated October 19, 1867, reported that the marbles had arrived in Boston.[10] In a letter he wrote to Ward dated April 10, 1868, van Brunt expressed his satisfaction with the reliefs and with the final use of marble:

> I must again apologize for the unwarrantable neglect of not reporting to you the effect of the bas reliefs *in loco*. They are on the whole the most successful adaptation of high sculpture to architecture which we have yet produced in this country. . . . The contrast of material is not striking and is therefore quite as I wished. Perhaps it would have been better if the scale of the compositions had been larger.[11]

With all elements of the sculpture in place, the monument was formally dedicated in the Boston Public Garden on September 26, 1868.[12] The quasi-Gothic monument focused considerable attention on the architects and on the sculptor. The commission was especially important for Ward, for even though the sculpture was regarded as merely decorative, it was Ward's first public work to be unveiled, preceding by several months the dedication of his statues of Commodore Matthew C. Perry in Newport, Rhode Island, and *The Indian Hunter* in New York City.

RELATED WORKS:

A letter of acknowledgment to Mrs. Ward from the Polyclinic Hospital in New York City records that the sculptor's widow gave the model of *The Good Samari-*

tan in 1914,[13] but there is no longer any record or knowledge of it at the hospital.

NOTES

1. Letter from H. van Brunt to JQAW, January 22, 1866 (AIHA).
2. Author interview with Mrs. ROS, November 28, 1969. See also Reed 1947, p. 113.
3. Contract between T. Lee and JQAW, February 17, 1866 (AIHA).
4. Letter from H. van Brunt to JQAW, June 25, 1866 (AIHA).
5. Bill from A. Underhill to JQAW for packing the model of *The Good Samaritan*, September 27, 1866 (AIHA).
6. Letter from H. van Brunt to JQAW, December 26, 1866 (AIHA).
7. Ibid., August 23, 1867.
8. Letter from G. Barry to JQAW, July 1, 1868 (AIHA).
9. Letters from H. van Brunt to JQAW, December 26, 1866; February 18, 1867 (AIHA).
10. Ibid., October 19, 1867.
11. Ibid., April 10, 1868.
12. Walton 1910, p. LXXXVIII.
13. Letter from the Polyclinic Hospital to Mrs. JQAW, February 24, 1914 (AIHA).

45. GENERAL GEORGE BRINTON McCLELLAN
Bust, 1868

Signed: stylized JQAW monogram and ROMA 1868 within an oval
Marble, h. 27½ in.
West Point Museum Collections, United States Military Academy, West Point, New York

In 1868, four years after Ward had collaborated with F.O.C. Darley on the small equestrian relief of General George Brinton McClellan (cat. no. 32), he made this bust of the Civil War general. McClellan is shown in military uniform, though he had resigned his commission to run for the presidency against Lincoln in 1864. The naturalistic representation of McClellan, combined with the stylized treatment of the subject's hair, mustache, and beard and the smoothly polished surface of the marble, bears a striking similarity to Ward's busts of William T. Blodgett and James F. Drummond that were also executed before the sculptor's first trip to Europe, in 1872. The monogram signature and inclusion of ROMA on the bust occurs only this once in Ward's work, leading to the assumption that it was the mark of an agent or an Italian stonecutter who carved the bust for Ward abroad.

The bust was reportedly in the collections of Samuel Ward McAllister, New York, in 1892; Charles Stebbins Fairchild, Cazenovia, New York; and H. E. Ketzler, Omaha, Nebraska, who presented it to the Military Academy in 1966.[1]

Cat. no. 45 *General George Brinton McClellan*

NOTES

1. Letter from R. E. Kuehne to author, February 3, 1971.

46. COMMODORE MATTHEW CALBRAITH PERRY
Statue, 1868
(Plate VI)

Bronze, over life-size
Signed: J.Q.A. WARD SC. 1868
Founder's mark: BRONZE BY L.A. AMOUROUX N.Y.
Architect of base: Richard Morris Hunt
Inscription on base [back]: ERECTED/IN 1868 BY/AUGUST & CAROLINE S. BELMONT [above relief panels]: TREATY WITH JAPAN 1854 • AFRICA 1843 • MEXICO • 1856. [below relief panels]: COMMODORE MATTHEW C. PERRY U.S.N. DIED 1858 AGED 64.
Unveiled: October 1, 1868
Touro Park, Newport, Rhode Island

Cat. no. 46 *Commodore Matthew Calbraith Perry*

In 1865, the New York banker August Belmont commissioned this memorial to his father-in-law, Matthew C. Perry (April 10, 1794–March 4, 1858). One of the greatest naval heroes of the nineteenth century, Commodore Perry was a pioneer in the field of naval instruction and in the application of steam power to warships. Perry's crowning achievement came after President Millard Fillmore directed him in 1852 to initiate a trade agreement between the United States and Japan; two years later, he successfully negotiated the epoch-making Treaty of Kanagawa, which opened Japanese ports to American trade.[1]

The *Perry*, erected in the commodore's hometown of Newport, Rhode Island, was Ward's first major portrait commission. The sculptor was reported in a 1909 article as saying:

[The successful exhibition of *The Indian Hunter* at Snedicor's gallery in 1865] attracted some attention and it had not been there very long before a visitor appeared in my studio, announced himself as August Belmont, explained that he had been interested in my work, and then and there gave me an order for a statue of Commodore Perry. From that day to this, I have never been without a commission.[2]

The statue, for which Ward was paid $17,000,[3] was cast by the founder L. A. Amouroux. On a pedestal designed by Richard Morris Hunt (figs. 5, 29),[4] it was unveiled in Touro Park on October 1, 1868.[5] The relief panels on the base showing the major military events in Perry's career were completed and installed at a later date.[6]

The *Perry* established several important precedents in Ward's work: It was the first in a long series of projects he undertook in collaboration with Hunt; it initiated his career as a sculptor of monumental portrait statues; and it established the basic formula for his early statuary—the combining of a static, classically posed figure with a naturalistic representation of its physical features and costume. In the *Perry*, the carefully studied physiognomy and attire represented in a Praxitelean figure standing quiescently on an engaged leg, the other slightly bent, was a pose Ward would choose often throughout his career. In conceiving the statue, Ward based the head on Erastus Dow Palmer's 1859 bust (fig. 30) of the commodore.[7] He also undoubtedly drew on his experience in Henry Kirke Brown's studio when Brown was executing the statue of DeWitt Clinton (1850–52) for the Greenwood Cemetery in Brooklyn (fig. 11). The classical repose and objective naturalism Ward learned from Brown, successfully embodied in the statue of Perry, were to become the essence of his sculpture.

RELATED WORKS:

There are twelve watercolors and drawings (fig. 5) and one photograph (fig. 29) related to the *Perry* in the Hunt papers.[8] The plaster model of the *Perry* was included in the Ward Memorial Collection given by Mrs. Ward to New York University in 1922. Its present location is unknown.[9]

NOTES

1. *DAB*, s.v. "Matthew Calbraith Perry."
2. Schuyler 1909, p. 645.
3. Townley 1871, p. 408.
4. Baker 1980, pp. 301, 540. See also letter from RMH to JQAW, January 15, 1866; bill from J. Hogan, Granite Yard, to JQAW, October 23, 1868 (AIHA).

5. *Harper's Weekly* 12 (October 17, 1868), pp. 661–662. See also JQAW Scrapbook (AIHA).
6. JQAW Scrapbook (AIHA). (See also bill from N. Vanni to JQAW, November 4, 1869 [AIHA].)
7. Ibid., "The Perry Statue."
8. "Commodore Matthew C. Perry," AIAF.
9. Memorandum from H. O. Voorhis, October 10, 1922 (WMC).

Cat. no. 47 *James Morrison Steele MacKaye*. Reproduced from Percy MacKaye, *Epoch: The Life of Steele Mac-Kaye*, 1927.

47. JAMES MORRISON STEELE MACKAYE
 Bust, about 1868

 Marble
 Location unknown

James Morrison Steele MacKaye (June 6, 1842–February 25, 1894), popularly known either as James or Steele, was a well-known dramatist, actor, and inventor of theatrical effects. The son of a prominent lawyer, he counted among his friends many of the day's leading politicians, industrialists, and artists.

The young MacKaye studied art briefly in Paris, but lacked the discipline to become proficient in any of its branches. When he reached the age of twenty-seven, his father forced him to go out on his own, and during the next thirty years he wrote and acted in a number of highly successful plays. He also built several important theaters and invented a number of electrical and mechanical stage devices. A man of kinetic energy, he died at the age of fifty-two.[1]

Following MacKaye's return from Paris in 1859 he tried his hand as a painter and art dealer, and also invented a photographic technique called "photo-sculpture."[2] He developed a close, supportive friendship with Ward, posing for the statues of Shakespeare[3] and the Seventh Regiment soldier. Of the latter, his son later wrote, "My father, as a young man, posed in his regimental uniform for his friend, Ward, and the statue bears in its features and form remarkable personal resemblance to my father."[4] In his role as art dealer, MacKaye was instrumental in having *The Indian Hunter* displayed in Snedicor's Broadway gallery in 1865 and, in March 1868, in organizing a committee of leading financiers and artists to raise funds to purchase the bronze for it and to have it placed in Central Park.[5]

Ward reportedly modeled the bust of James Mac-Kaye in about 1868.[6] Known today only through an illustration in his biography,[7] it is a striking portrait. MacKaye's shoulders are draped in a classical robe, and his abundant short hair is combed straight back. His furrowed forehead, set jaw, and steadfast gaze accented by thick eyebrows and mustache convey the intensity of his personality.

NOTES

1. *DAB*, s.v. "James Morrison Steele MacKaye."
2. Ibid.
3. MacKaye 1927, 1, p. 79.
4. Ibid., p. 99.
5. Ibid., p. 78. Percy MacKaye mistakenly places the exhibiting of the plaster statue of *The Indian Hunter* in a Broadway art store in 1868 rather than in 1865. He states that the plaster cast of *The Indian Hunter* was MacKaye's personal copy and was kept by him for years after, an interesting sidelight.
6. Ibid., pp. 78–79.
7. Ibid., p. 123.

48. SEVENTH REGIMENT MEMORIAL
 Statue, 1869

 Bronze, over life-size
 Signed: J.Q.A. WARD 1869
 Founder's mark: R. WOOD & CO/BRONZE
 FOUNDERS/PHIL.^{A.}
 Architect of base: Richard Morris Hunt

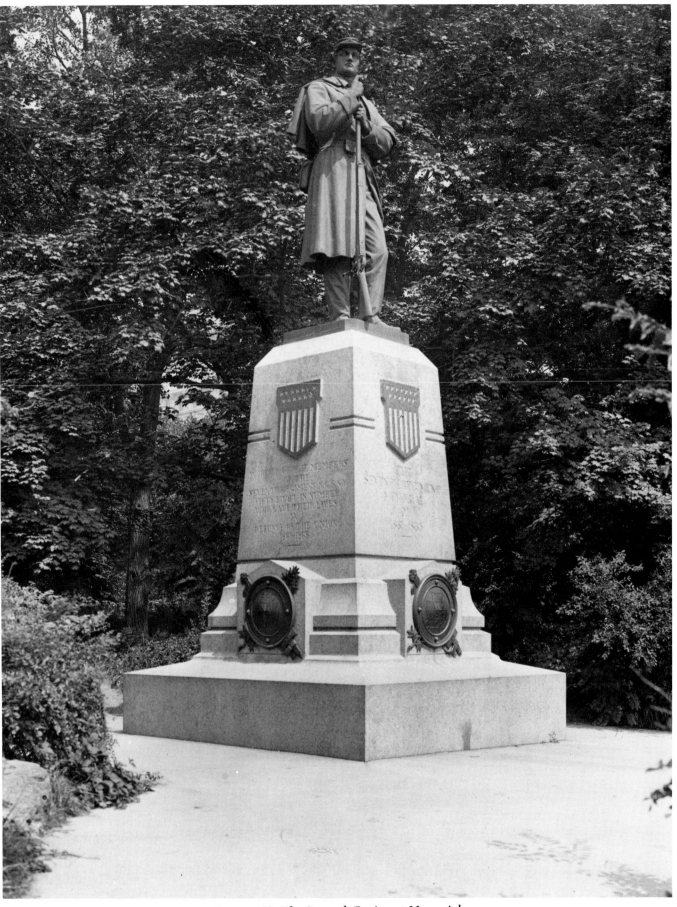

Cat. no. 48 *The Seventh Regiment Memorial*

Inscription on base [front]: THE/SEVENTH REGI-
MENT/MEMORIAL/OF/1861–1865 [back]:
ERECTED/BY THE/SEVENTH REGIMENT/
NATIONAL GUARD, S.N.Y./MDCCCLXXIII [right
and left sides]: IN HONOR OF THE MEMBERS/OF
THE/SEVENTH REGIMENT N.G.S.N.Y./FIFTY
EIGHT IN NUMBER/WHO GAVE THEIR LIVES/IN/
DEFENSE OF THE UNION/1861–1865 [on bronze
medallions on all four sides]: PRO/PATRIA/ET/
GLORIA

Unveiled: June 22, 1874
Central Park, New York City

Following the Civil War there was a rush to erect
memorials both to the nation's political and military
heroes and to the soldiers and sailors who had fought
to preserve the Union. The Seventh Regiment, which
had lost fifty-eight men in the war, formed a Monu-
ment Association shortly after peace was signed to
oversee the erection of an appropriate memorial to
their men. In response to the request that the memo-
rial be placed in Central Park, the park's Board of
Commissioners resolved at a meeting on February 14,
1867:

That the Comptroller of the Park be authorized to set
apart the site hereafter mentioned, upon which the
Seventh Regiment Monumental Association may erect a
monumental structure, provided that such structure nor
any of its appendages be of sepulchral character, and that
the design and plan of said structure shall be submitted to
and approved by this Board before any site be set apart,
and provided that before any site be set apart the Associa-
tion shall give satisfactory evidence to this Board of its
pecuniary ability to complete the structure, according to
such design and plan as shall be approved by the Board,
and provided, further, that said structure, when erected,
shall be subject to the regulations made or to be hereafter
established by the Board for the care and preservation of
monuments, statuary and such structures within the Park.
The site for said structure shall be either at a point just
south of the Warrior's Gate, or at such other point as may
be approved by the Board upon the report and recom-
mendation of this Committee.[1]

When Ward began work on the project is not re-
corded, but by March 4, 1868, he had presented a
model to the association.[2] On April 9, on the basis of
the model, the Board of Commissioners of the park
approved the memorial,[3] and a month later, on
May 11, the Seventh Regiment Monument Associa-
tion contracted with Ward to have him execute a ten-
foot-high statue for $23,000.[4]

The ensuing conflict over the memorial was a major
episode in Ward's career. The project was carried out
in collaboration with Richard Morris Hunt, who had
worked successfully with Ward on the *Perry* in New-

port, and who was then designing a combination
townhouse and studio for him in New York (fig. 37).
For the Seventh Regiment Memorial the artists en-
visioned a complex architectural monument (fig. 34),
the main statue to be flanked by base sculptures
(fig. 35). Hunt, trained in Paris at the École des
Beaux-Arts, was undoubtedly the prime force behind
the memorial's conception, but Ward must have been
an enthusiastic follower: by the early 1870s he was
himself thoroughly indoctrinated into the Beaux-Arts
principles.

To sort out all the crosscurrents in the Seventh
Regiment controversy is impossible, for they included
individual and political differences as well as
philosophical questions as to the park's original in-
tended use and aesthetic questions about how the
memorial would visually affect its integrity. An un-
questionable factor in the conflict was Hunt's grandi-
ose plan for architectural gateways which is fully dis-
cussed in Paul R. Baker's fine biography of the
architect.[5] French in inspiration and populated with
statues and fountains, the gateways were designed as
entrances to the park along Fifty-ninth Street—at
Fifth Avenue, "The Gate of Peace"; at Sixth Avenue,
"The Gate of Commerce"; at Seventh Avenue, "The
Artist's Gate"; and at Eighth Avenue, "The Warrior's
Gate." Hunt had submitted the plans in 1863 with the
encouragement of his brother-in-law Charles H. Rus-
sell, a New Yorker who was one of the Central Park
commissioners as well as a member of the park's Com-
mittee on Statuary, Fountains, and Architectural
Structures. Hunt and Russell, outspoken Repub-
licans, were at odds with Commissioner Andrew H.
Green, a Democrat. While personal and political in-
trigue fulminated behind the scenes, a debate in the
newspapers over the park's function and character
raged on from 1863 to 1865. As Baker points out,
Hunt's gateways were compatible with his own con-
cept of the park as a pleasure garden of manifold uses,[6]
but Frederick Law Olmsted and Calvert Vaux con-
sidered them aristocratic, pompous, and foreign. Op-
posed to any intrusion into the park of nonlandscape,
architectural elements, Olmsted and Vaux "were de-
termined that the area should remain rural, an oasis of
greenery and 'natural' land contours in the center of
the island city."[7] In the end, the forces of Green and
Olmsted and Vaux won out. Hunt's designs were re-
jected, though a special committee paid him ten
thousand dollars in 1868 for the work he had done.[8]

The gateway controversy was over by the time
Hunt and Ward began work on the Seventh Regiment
Memorial, but there must have been a continuing
bitterness between Hunt and Olmsted and Vaux. In

their official capacity as landscape architects to the Central Park Commissioners, Olmsted and Vaux wrote Ward a detailed letter regarding the statue, the site of the memorial, and the design for its base.

If the proposed 7th Reg. Memorial is to be erected at the C.P. it is desirable that it should express in some specific way the relation of the 7th Regt to the City of New York and to the war and that the location should be peculiarly adapted to the design.

The typical idea represented by the Regt seems to have been "*Vigilance.*" When the war commenced it was found to be *on Guard*, prepared for immediate action and ready to take its place as a watchful *Sentinel* in front of the Picketline and it may probably be more fairly and honorably represented in this character than in any other.

A bronze Statue seven or eight feet high of a private soldier in the uniform of the regiment and with the heavy army overcoat on, would it seems to us make a good subject for the principal statue in such an artistic composition as the 7th Regt have in contemplation.

Perhaps a general outline, somewhat similar to the one enclosed would answer the purpose the aim of course being to make the central figure of the sentinel look rather lonely and unsupported.

The base would give room for a large number of names and allow of some subordinate decorations. The idea has been conceived with reference to a position that we are inclined to think will be found more suitable for the purpose than any other.

The Seventh Avenue Entrance at the North End of the Park is named the Warrior's Gate and the Memorial had better be in some way designed in connection with this gate, although by no means necessarily as any part of it, in fact it is rather desirable that the Memorial should be complete in itself.

If it were placed within the Park immediately opposite the centre of the 7th Avenue entrance . . . it would be backed by foliage and high ground and when approaching from the North it would connect itself naturally with the Gate composition and yet when seen close at hand it would be perceived that it was an entirely distinct design. . . .

It would certainly be a clear artistic gain to the City, for all time, to have the volunteer private soldier nobly delineated in bronze and no one would question the right of the 7th Regt to be thus represented. . . .

It would add to the completeness of the design if the lower base were extended at each end and two semi-recumbent figures introduced in profile, as it were, with reference to the central figure, one of a tired soldier asleep and leaning on his arm, but with his musket at hand. The other of a soldier writing or reading a letter but fully equipped as if in expectation of an immediate call to action. . . .

The sitting figures, would lead the eye up to the principal figure, but of course would add very naturally to the expense.[9]

Ward and Hunt apparently tried to follow Olmsted and Vaux's suggestions. Ward had experimented with the figure of a standing soldier, one foot resting on a fallen cannon (fig. 78), but most of the Ward/Hunt sketches show the figure of a solitary foot soldier standing leaning on his rifle.[10] Hunt, in a burst of creative energy, produced a number of architecturally complex monument sketches, some of which included base figures. Ward even executed models for flanking groups for the base: one, of two soldiers resting in

Fig. 76 John Quincy Adams Ward, *The Seventh Regiment Memorial* base figures, about 1870. Photograph. The American Institute of Architects Foundation, Washington, D.C.

Fig. 77 John Quincy Adams Ward, *The Seventh Regiment Memorial* base figures, about 1870. Photograph. The American Institute of Architects Foundation, Washington, D.C.

camp; the other, of a soldier supporting a wounded companion (figs. 76, 77).

Ward and Hunt's vision of the Seventh Regiment Memorial was completely revolutionary in the field of American public sculpture. In its complexity and in its integration of architecture and sculpture the monument, if completed as designed, would have been executed in the fully developed Beaux-Arts style, and would have predated by a decade the one to Admiral David Farragut created by Augustus Saint-Gaudens and Stanford White. However, the vision and force of Hunt and Ward's creative energy were sapped by the multiple obstacles put in their path, and, sad to say, the Beaux-Arts memorial they had so fervently planned was never executed.

After signing the contract in 1868, Ward's work on the statue progressed quickly; the finished figure, inscribed 1869, was cast in Philadelphia by Robert Wood. Completion of the memorial was nevertheless delayed for five years over the apparent issues of the

design of the base and where the monument was to be placed.

There is no documentation of why the site at Seventh Avenue and 110 Street was rejected, but a letter dated July 30, 1872, in the Seventh Regiment's Letter Book reveals that Frederick Law Olmsted and William Green, architect and president of the park, respectively, were in favor of the memorial's being placed on the West Walk of Central Park opposite 69th Street.[11] Exasperated by the delay, the regiment agreed to the West Walk site, but in a review of the unveiling ceremony, which occurred on June 22, 1874 (fig. 36), the *New York Times* noted that at a later date the memorial might be moved to the Warrior's Gate entrance.[12]

Seemingly frustrated by the whole affair, Hunt

Fig. 78 John Quincy Adams Ward, *The Seventh Regiment Memorial* soldier, about 1867. Ink on paper. The American Institute of Architects Foundation, Washington, D.C.

Fig. 79 John Quincy Adams Ward, *The Seventh Regiment Memorial*, 1870. Pencil on paper. Albany Institute of History and Art, Albany, New York.

merely adapted the simple base he had employed in the Gettysburg memorial to Major General John F. Reynolds (cat. no. 53), which had been unveiled two years earlier. Constructed of Quincy granite, the base contains on each side an emblematic shield carved in high relief and, below, bronze heraldic medallions impressed with the regiment's motto, PRO/PATRIA/ET/ GLORIA.[13]

Characteristic of Ward's sculpture, the *Seventh Regiment Memorial* soldier is a standing figure dressed in authentic military garb and imbued with a vigorous naturalism. Although the statue was intended as a representation of any Seventh Regiment soldier, it was modeled from life. Steele MacKaye (cat. no. 47), a well-known actor, "posed in his regimental uniform for his friend, Ward, and the statue bears in its features and form remarkable personal resemblance."[14]

The concept of the *Seventh Regiment Memorial*—a solitary soldier leaning on his rifle—is similar to Martin Milmore's 1869 Civil War Memorial in Boston's Forest Hill Cemetery. The popularity of Milmore's and Ward's statues was undoubtedly the source for the numerous commercially produced Civil War memorials that were erected throughout the country during the last quarter of the nineteenth century.[15] Nevertheless the works were initially conceived as fitting and moving memorials to the common soldiers who had fought and died in defense of the Union.

RELATED WORKS:

In January 1870, John H. Bird, the regiment's secretary, "gratefully received and accepted" Ward's gift of the full-scale plaster model of the statue,[16] but there is no further record of it, and its present location is unknown. Twenty drawings and watercolors and three photographs related to the memorial are in the Hunt papers (figs. 34, 35, 76, 77, 78).[17] A sketch by Ward that corresponds closely to the final statue is at the Albany Institute of History and Art (fig. 79).[18]

NOTES

1. CPC 1867, p. 3.
2. Contract between the Seventh Regiment and JQAW, May 11, 1868 (AIHA). The contract stipulated a ten-foot-high statue based on the design submitted by Ward to the regiment on March 4, 1868.
3. CPC 1868, p. 129.
4. Contract between the Seventh Regiment and JQAW, May 11, 1868 (AIHA).
5. Baker 1980, pp. 146–161.
6. Ibid., p. 154.
7. Ibid.
8. Ibid.
9. Letter from Olmsted and Vaux to JQAW, n.d. (AIHA).
10. "Seventh Regiment," AIAF, see "Related works."

11. Letter from the Commander of the Seventh Regiment to F. L. Olmsted, July 30 1872, "Seventh Regiment Letter Book, 1867–1875," Seventh Regiment Collection, N-YHS.
12. *New York Times*, June 23, 1874, p. 2.
13. The four bronze medallions were replaced in 1923. "The Seventh Regiment Memorial." File 1183-A (April 18, 1923), Art Commission of the City of New York.
14. MacKaye 1927, 1, p. 99.
15. An example of a similarly posed statue entitled "Soldier at Parade Rest" was illustrated in a catalogue of inexpensive public statues. W. H. Mullins, *Stamped Sheet Bronze, Copper and Zinc Statuary*, Print Department, MMA.
16. Letter from J. H. Bird to JQAW, January 1870 (AIHA).
17. "Seventh Regiment," AIAF.
18. JQAW Sketchbook no. 6 (AIHA).

49. EDWIN BARTLETT
Bust, before 1870

Marble
Location unknown

The only reference to the Bartlett bust is in a 1870 letter from Robert Cushing, Ward's agent in Italy supervising the carving of *The Protector* (cat. no. 54).

Your portrait busts of Rev. Dr. Dewey Mr. Edwin Bartlett & Mr. Gordon is far beyond anything I have seen in any studio—and I believe I have seen the most of them.[1]

There is no further information about any Edwin Bartlett.

NOTES

1. R. Cushing to JQAW, February 23, 1870 (N-YHS).

50. WILLIAM SHAKESPEARE
Statue, 1870

Bronze, over life-size
Signed: J.Q.A. WARD./1870.
Founder's mark: R. WOOD & CO/BRONZE
 FOUNDERS/PHIL^A.
Architect of base: Jacob Wrey Mould
Inscription on base: ERECTED BY/CITIZENS OF
 NEW YORK/APRIL 23 1864/THE THREE
 HUNDREDTH ANNIVERSARY/OF THE BIRTH OF
 SHAKESPEARE
Central Park, New York City

In celebration of the tercentenary of the birth of William Shakespeare (April 23, 1564–April 23, 1616), a group of men that included the noted Shakespearean actor Edwin Booth proposed to erect a memorial to the poet in Central Park. A cornerstone was laid on the South Mall on April 23, 1864,[1] but nothing further was done until the Civil War had

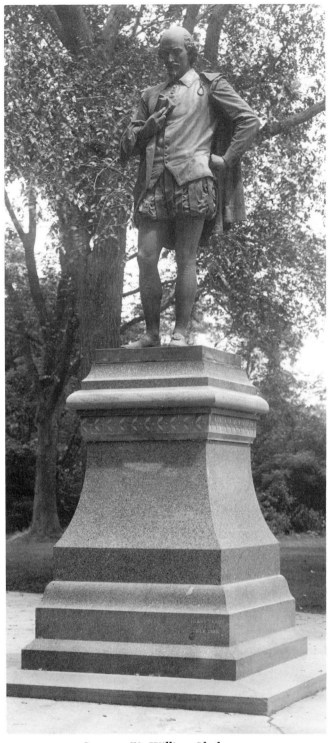

Cat. no. 50 *William Shakespeare*

final selection was between Ward and a second sculptor whose name Booth abbreviated to L—— but who was probably Launt Thompson:

> I wanted to see you long ago - soon after the meeting of the Committee - but my days and nights have been all devoted to this new revival . . . and I have likewise been puzzled how I could arrange the matter between us. L— asked me about a cloak and a certain portion of the dress and I told him at the time I was "scratching my head" over the promise I had made you. In a day or so I will arrive at some method whereby we three can all be accommodated. I need not tell you that your design was the only one looked at with any degree of patience and that it was highly spoken of, but it is a difficult matter to make folks look at a sketch as a mere thought—they will pass judgment as on a finished work. I am glad (for Shakespeare's sake) that the two big men are fighting for it now! So far as my humble self is concerned my heart is centered on the object, while it is equally balanced in its wishes for the artists.[4]

Ward's sketch model dated "Oct. 1866" was illustrated in *Harper's Weekly* of April 1867 (fig. 31), with a notice that Ward had been awarded the commission for the *Shakespeare*.[5] The only major change Ward made when enlarging the statue was in attenuating the proportions of the figure. The finished bronze statue, for which Ward was paid $20,000,[6] was inscribed in 1870 by the artist, and was cast by the Robert Wood Bronze Foundry in Philadelphia in 1871. The pedestal was designed by Jacob Wrey Mould, chief architect of public parks in New York City.[7] The granite of which it was made was purchased and cut in Scotland, but delays in its delivery forced postponement of the dedication for over a year: when the monument was unveiled on May 23, 1872—a month after Shakespeare's birthday, the intended date— it was erected on a temporary base (fig. 32).[8]

The *Shakespeare* is typical of Ward's early standing figures. Combined with the classical pose is Ward's usual objective study of the subject, evidenced in his concern for details of dress, pose, and likeness. The statue is dressed in the doublet, slashed trunks, and full cloak mentioned by Booth in a letter to Ward;[9] regarding the likeness, Ward wrote that for it he relied primarily on the Stratford bust.[10] The contemplative pose that Ward first chose for the figure proved to be too much of a problem to create from his imagination alone, and he eventually worked from a life model. Percy MacKaye, in a biography of his father, the well-known dramatist and actor James Morrison Steele MacKaye, wrote that he had posed several times for Ward's Shakespeare:

> The first occasion—as my mother has often recounted to me—occurred in this way. One day, when young Mac-

ended. In 1866, an executive committee was formed to raise funds and to select the monument's sculptor, and models were solicited from all the principal Americans.[2] Even before the executive committee's action Ward had begun work on a model. Henry Kirke Brown wrote in 1865 to his wife, "Quincy has made a sketch of the Shakespeare Monument. It is very good."[3] Booth, in a letter to Ward, implied that the

Kaye dropped into his studio, Ward said: "Jim, I've been working like the devil on this pose but I can't get what I want. I want the old bard to be thinking—but he ain't. What ails him?"

"That's simple, J. Q.," said Jim. "Instead of making him pensive you've made him sleepy. The difference in pose is slight but radical. It affects the whole body—legs, torso as well as head. The posture of thought should be like this." And Jim illustrated by assuming a posture of absorbed thinking.

"Hold it! Don't move!" cried Ward, and began working furiously at his clay to catch the pose, which MacKaye resumed again on further visits.[11]

RELATED WORKS:

In addition to the 1866 sketch model, six reductions—one plaster and five bronzes—have come to light. Ward's correspondence contains a reference to a plaster of the *Shakespeare* that was sent to a man named Frederick McGuire,[12] but to connect it with

any of the known pieces is not possible. Ward's scrapbook contains an unidentified clipping that reports that Mrs. Ward gave a plaster statuette of the *Shakespeare*, overlaid with bronze, to the Carnegie Library at Ohio University in 1914. The article concluded that bronze replicas could be purchased from the Gorham Foundry for $500.[13] The Metropolitan Museum's statuette (cat. no. 50.7) is undoubtedly one of these pieces.[14] The American Institute of Architects Foundation has twelve drawings and watercolors of the base and sculpture by Richard Morris Hunt (fig. 80), a pencil sketch by Ward of the statue (fig. 81), and a photograph of Ward's original sketch model.[15] A statuette of the *Shakespeare* was exhibited at the Panama-Pacific International Exposition in 1915.[16]

Fig. 80 Richard Morris Hunt, *William Shakespeare*, about 1870. Watercolor. The American Institute of Architects Foundation, Washington, D.C.

Fig. 81 John Quincy Adams Ward, *William Shakespeare*, about 1867. Pencil on paper. The American Institute of Architects Foundation. Washington, D.C.

Two statuettes were included in the Ward Memorial Collection that the sculptor's widow gave to New York University in 1922.[17] The present locations of these pieces are unknown.

50.1. Sketch model
 Plaster, h. 27 in.
 Signed: Ward Sculptor/Oct 1866
 Collection of Mr. and Mrs. Raymond Auyang,
 Poughkeepsie, New York

The sketch model was purchased from Mrs. Oliver E. Shipp, great-granddaughter of Ward's sister Eliza Thomas.

50.2. Statuette
 Bronze, h. 28 in.
 Signed: J.Q.A. WARD
 Founder's mark: CAST BY THE
 HENRY-BONNARD BRONZE CO. N.Y. 1894
 Collection of Louis Marder, Evanston, Illinois

The statuette was acquired from Mrs. Oliver E. Shipp in 1976.[18]

50.3. Statuette
 Plaster, h. 28½ in.
 Signed: not recorded
 Champaign County Library, Urbana, Ohio

A gift to Ward's hometown library in 1914 by Mrs. Ward.[19]

50.4. Statuette
 Bronze, h. 28 in.
 Signed: J.Q.A.WARD.
 Founder's mark: CAST BY THE
 HENRY-BONNARD CO./NEW YORK 1894
 Collection of Mrs. John B. Cunningham,
 Bronxville, New York

Provenance not known.

50.5. Statuette
 Bronze, h. 28 in.
 Signed: not recorded
 Founder's mark: not recorded
 Ex coll.: Mrs. R. Ostrander Smith, Bronx,
 New York

The late Mrs. Smith, Ward's stepdaughter-in-law, inherited this piece and the rest of the sculptor's effects on her mother-in-law's death in 1933. The present location of this bronze is unknown.

50.6. Statuette
 Bronze, h. 28 in.
 Signed: not recorded
 Founder's mark: not recorded
 Collection of Edwin English, Urbana, Ohio

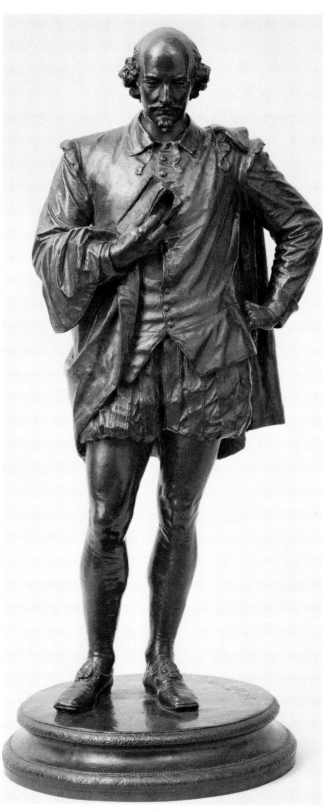

Cat. no. 50.7 *William Shakespeare*

Mr. and Mrs. Vance Brand report that this statuette was originally a gift to Mr. Brand's mother, Louise Vance Brand, who was a friend of Mrs. Ward's.[20] It was acquired by Mr. English from the Brands.

50.7. Statuette
Bronze, h. 28 in.
Signed: J. Q. A. WARD. SC/1870
Founder's mark: GORHAM. CO. FOUNDERS.
The Metropolitan Museum of Art, New York City

The statuette was purchased by the Metropolitan Museum from the Gorham Foundry in 1917.[21]

NOTES

1. Daley 1873, p. 6.
2. "Shakespeare," *The Art Journal* 4 (January 1878), p. 26.
3. Letter from HKB to Mrs. HKB, dated only "N. York, Tuesday 1865," HKB Papers, p. 1764, Library of Congress.
4. Letter from E. Booth to JQAW, n.d., typed copy (APS).
5. "The Shakespeare Statue," *Harper's Weekly* 11 (April 27, 1867), p. 269.
6. Townley 1871, p. 408.
7. Daley 1873, p. 8. Baker 1980, p. 540, mistakenly lists the Shakespeare pedestal as having been done by Hunt in 1872. Hunt had been approached about a design for the base, but in the end it was done by Jacob Wrey Mould.
8. Daley 1873, p. 8.
9. Letter from E. Booth to JQAW, n.d., typed copy (APS). For an extract of this letter see p. 49.
10. Unaddressed letter from JQAW, n.d. (AIHA). For an extract of this letter see p. 49.
11. MacKaye 1927, 1, p. 79.
12. Letter from R. S. Chilton to JQAW, n.d. (AIHA).
13. Unidentified newspaper clipping in Ward, "Scrapbook," p. 100, N-YHS.
14. Archives, MMA.
15. "William Shakespeare," AIAF.
16. PPIE 1915, p. 246.
17. Memorandum from H. O. Voorhis, October 10, 1922 (WMC).
18. Letter from L. Marder to author, December 24, 1983.
19. Archives, Champaign County Library, Urbana, Ohio.
20. Author interview with Mr. and Mrs. William C. Katker, Urbana, Ohio, December 28, 1970.
21. Archives, MMA.

51. ERASTUS FAIRBANKS
Bust, 1870

Location unknown

In 1870 Ward carved a posthumous bust of Erastus Fairbanks (October 28, 1792–November 24, 1864). A successful New England entrepreneur, Fairbanks in 1831 had become president of the firm in St. Johnsbury, Vermont, that produced the platform scale invented by his brother Thaddeus. A member of the Vermont Legislature between 1836 and 1838, he was elected governor of the state in 1851 and again in 1860.[1]

The bust of Fairbanks was commissioned by his son Horace, whose own bust Ward was to do twenty-three years later (cat. no. 95). Regarding the likeness, and referring to the death of Anna Bannan Ward, Horace wrote to Ward from St. Johnsbury on May 16, 1870:

I hoped to have seen you again before leaving New York . . . I called at your house on the day of the funeral of your wife and there learned of your great bereavement. . . .

I have only one suggestion to make in regard to the bust of my Father and that is to straighten out the hair somewhat. If you will examine the photograph you will observe that the hair and beard was quite straight, especially the hair on the head. You represent it as quite curly. With this modification I think the bust will be perfect.

I cannot suggest any further alteration in the likeness or face.[2]

A week later, Fairbanks again wrote Ward to instruct the sculptor to have the bust done in the "best Italian marble."[3] In July 1870, Fairbanks forwarded $500 to Ward and reported that he was pleased that the portrait was progressing well.[4] In May 1871, Robert Cushing, Ward's agent in Carrara, Italy, wrote to the sculptor that the pedestal for the Fairbanks bust was one of the two being shipped to New York.[5] There is no further reference to the bust in Ward's correspondence, and its present location is unknown.

NOTES

1. *ACAB*, s.v. "Erastus Fairbanks."
2. Letter from H. Fairbanks to JQAW, May 16, 1870 (N-YHS).
3. Ibid., May 25, 1870.
4. Ibid., July 15, 1870.
5. Letter from R. Cushing to JQAW, May 12, 1871 (N-YHS).

52. OCTAVIUS BROOKS FROTHINGHAM
Bust, before 1871

Location unknown

The Reverend Octavius Brooks Frothingham (November 26, 1822–November 27, 1895) was a well-known clergyman and author whose outspoken views on radical issues such as the abolition of slavery gained him a reputation as a man of great spiritual power and won him a wide circle of admirers. In 1859 the Third Congregational Unitarian Society was organized in New York City and Frothingham named its pastor. By 1867 Frothingham found himself outside the bounds

of orthodox Unitarianism, and he helped found the Free Religious Association, which he served as first president. His weekly sermons were regularly published in newspapers and pamphlets until ill health forced him to retire in 1879 at the age of fifty-seven.[1]

As a newspaper article dated 1871 reported:

> While in Washington, Ward executed busts of Alexander H. Stephens and John P. Hale, and he has since had sittings from Rev Dr Dewey, Dr Mott, the late eminent surgeon, Rev O. B. Frothingham and others.[2]

The only other references to the bust are two unlocated photographs of it that were shown at the 1911 memorial exhibition of Ward's sculpture.[3]

NOTES

1. *DAB*, s.v. "Octavius Brooks Frothingham."
2. "From New York: A visit to Ward, the Sculptor," inscribed "Springfield Republican" by Ward, JQAW Scrapbook (AIHA).
3. Memorial Exhibition 1911, nos. 41, 89.

53. MAJOR GENERAL JOHN FULTON REYNOLDS

Statue, 1871
(Plate VII)

Bronze, over life-size
Signed: J. Q. A. WARD./1871
Founder's mark: R WOOD & CO/BRONZE FOUNDERS/PHIL^{A.}
Architect of base: Richard Morris Hunt
Inscription on base [front]: MAJOR • GENERAL/ JOHN • F • REYNOLDS/U • S • V • [back]: TO HIS MEMORY/BY THE/FIRST/ARMY • CORPS [right]: BORN/AT/LANCASTER • PA/ SEPTEMBER • XXI/MDCCCXX [left]: KILLED/ AT/GETTYSBURG/JULY • I/MDCCCLXIII
Unveiled: August 31, 1872
Gettysburg National Cemetery, Gettysburg, Pennsylvania

Following Robert E. Lee's advance in 1863, General George G. Meade ordered General Reynolds (September 20, 1820–July 1, 1863) and the Union troops under his command to occupy Gettysburg. On the morning of July 1—the first day of the Battle of Gettysburg—General Reynolds found part of his cavalry in a perilous position. As he reached a grove of trees while leading reinforcements to the battlefield, he is reported to have turned and said to his troops, "Push forward men and drive those fellows out of the woods." A moment later he was killed by a Confederate bullet.[1]

In 1867 the First Corps of the Army of the Potomac approached Ward about erecting a memorial to mark

Cat. no. 53 *Major General John Fulton Reynolds*

the spot where their leader had been killed. The statue itself was to be paid for by the soldiers of the corps; $2,000 for the pedestal was appropriated by the Gettysburg Cemetery Association; and the state of Pennsylvania promised the bronze for casting the statue from cannons captured in the war.[2] A two-year delay ensued. It was not until June 1869 that a representative of the corps wrote to inquire about a sketch Ward was preparing, at the same time supplying him with a photograph of Reynolds and telling him that the corps had "about settled on the design for the pedestal with Mr. Hunt."[3] In July, pleased with Ward's sketch, the corps informed him that Reynolds's family had been notified that he had been selected to "furnish a model." Further, he was advised that the family thought the best portrait of the general was that painted by Hansen Balling of New York.[4] Ward completed a model of the *Reynolds* by the following spring, and in May 1870 a group of the officers of the First Corps commissioned him to execute a bronze statue eight feet high for $9,500.[5] The completed statue was inscribed "1871" by the sculptor, and in January 1872 the Robert Wood foundry in Philadelphia agreed to cast the statue for $2,400 from metal supplied to the foundry.[6]

The finished bronze was exhibited briefly in the window of Bailey & Company in Philadelphia[7] before being unveiled at Gettysburg on August 31, 1872.[8] In a lengthy review, the critic for *Forney's Weekly Press* wrote that he felt the statue was Ward's best work. He went on to describe the *Reynolds:*

> The General [is represented] in the undress uniform of his rank—as he appeared upon the field—standing in an erect and soldierly position, his left hand resting upon his sword, and his right hanging by his side grasping a field-glass, which he is apparently about to raise to his eyes. The head is slightly turned, and he seems to be surveying some distant object upon the battlefield with a quick and fiery glance. The pose is very simple; but it gains much from its very simplicity, especially as the artist has succeeded in conveying the idea of a strong, vigorous, and impulsive man in a moment of repose which may in an instant be succeeded by fiery action. . . .
>
> Mr. Ward's portrait of General Reynolds, like the best Greek works, although perfectly quiescent, suggests motion. . . . By turning down the boot tops, and one or two minor incidentals of like character, a certain picturesqueness is given to the figure which adds greatly to its attractiveness.[9]

NOTES

1. *DAB*, s.v. "John Fulton Reynolds." There, his birthdate is given as September 20, although the statue's inscription has it as the twenty-first.
2. Letter from C. S. Wainwright to JQAW, July 2, 1867 (N-YHS).

3. Ibid., June 20, 1869.
4. Letter from T. H. Bache to JQAW, July 15, 1869 (N-YHS). Ole Peter Hansen Balling was a Norwegian-born portrait painter who worked in New York City from 1856 to 1906.
5. Contract between the Officers of the First Corps and JQAW, May 6, 1870 (N-YHS).
6. Letter from R. Wood to JQAW, January 6, 1872 (N-YHS).
7. "Ward's Statue of General Reynolds," *Forney's Weekly Press*, August 31, 1872, p. 1.
8. Walton 1910, p. LXXXIV.
9. "Ward's Reynolds," see n. 7.

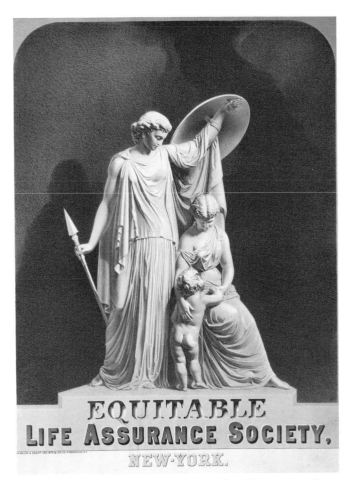

Cat. no. 54 *The Protector.* Lithograph. The Metropolitan Museum of Art, New York City.

54. *THE PROTECTOR*
Statue, 1871

Marble, over life-size
Unveiled: November 21, 1871
The Equitable Life Assurance Society, New York City. Removed to storage, 1887; destroyed, about 1886

In 1868, Henry B. Hyde (cat. no. 110), founder of the Equitable Life Assurance Society, commissioned

Ward to execute a marble statue, *The Protector,* for the pediment over the entrance of the Equitable building at 120 Broadway in New York City.[1] Ward adopted his composition—the genius of Life Insurance with spear and shield protecting a widow and her child—from an 1860 vignette designed for the Equitable by the American Bank Note Company.[2] In reworking the design, Ward compressed the composition and transformed the naturalistic, mythological figures of the vignette into those of a more visibly classical mode. His first model (fig. 82), dated June 1868, was considered unacceptable because the female figures were not sufficiently draped and the naked infant faced the viewer.[3] When a revised model was approved, it was sent to Carrara, Italy, where Ward's agent Robert Cushing and a group of Italian stonecutters put the work into marble.[4] The finished group, weighing ten tons and standing eleven feet high, was shipped to New York in September 1871.[5]

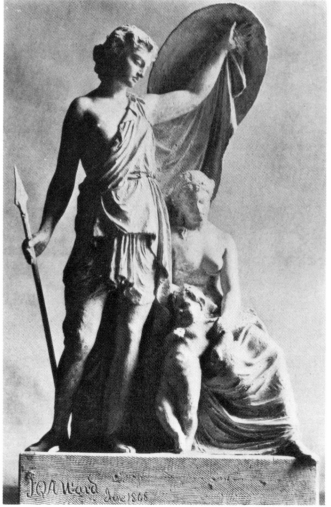

Fig. 82 John Quincy Adams Ward, preliminary study for ***The Protector,*** **June 1868. Photograph. The Equitable Life Assurance Society, New York City.**

The statue was installed that fall, but it was left wrapped in a canvas sheet until a suitable occasion arose for the unveiling company. That came when Grand Duke Alexis, son of Emperor Alexander II of Russia, visited New York City (fig. 33). On November 21, as the Grand Duke's procession moved up Broadway, the bells of Trinity Church rang out the Russian national anthem. When the duke's carriage reached the Equitable building, his attention was drawn to the canvas over the building's entrance. All eyes followed his gaze, whereupon the canvas fell away to reveal the sculpture. The Grand Duke saluted, his carriage moved on, and he turned to gaze back at the statuary.[6]

Hyde, a dominant figure in the American insurance industry, was early to realize the value of having as his company's logo a lofty mythological figure created by one of the leading artists of the day. To further enhance the company's high-minded intent as well as the artistic importance of the sculpture, the company newsletter (also named *The Protector*) published a twelve-stanza poem by William A. Van Duzer. Entitled "Ward's Sculpture," stanzas V and XII read:

> Who art thou, goddess! all enrobed in white,
> Whose heavenly mien this palace front adorns,
> With form and features as serenely bright
> As Dian's beauty limned in silver horns?
> Thyself and those beside thee we would know,
> And what thy teaching and example show.

> Celestial goddess! in thy marble form
> We recognize thee now, and homage pay;
> Thou art "Protection," and the wintry storm
> And summer heat from them thou turn'st away,
> Thy shield "Assurance," *providence* thy spear
> Invulnerable Queen! thou reignest here.[7]

The life of *The Protector* was lamentably short. When the Equitable building was enlarged and partly rebuilt in 1886/87, the sculpture, found to be badly weathered, was removed.[8] It was stored for a time, but during the winter water got into the cracks of the stone and froze, causing the marble to break.[9] In 1896, Hyde found that two of the heads still survived. By then sentimental about the Equitable's early years, he had them restored and asked Ward to have them mounted on suitable pedestals.[10] Their present location is unknown.

Though *The Protector* was one of Ward's largest architectural sculpture commissions, it is rarely listed as part of his oeuvre. The omission results from the group's not being regarded as fine art because of its commercial associations and because it survived only for fifteen years. Nevertheless, a critic no less than Montgomery Schuyler wrote of the piece in 1909:

It may be characteristically American and New Yorkish

that the most dignified and successful, if not the only dignified and successful, sculptural monument of our chief thoroughfare for so long should have had a "business basis," but it by no means follows that in this case the characteristic is one to be ashamed of. And assuredly there was nothing to be ashamed of in the monument itself, so austerely sculptural and so clearly and even "colossally" monumental, independently of its actual scale, so impressive in contour and line, and so attractive in its detailed modelling.[11]

RELATED WORKS:

In 1886 Edward E. Raht, who was to become the architect of the Equitable buildings in Europe,[12] wrote to Ward about having a bronze replica of *The Protector* made for the company's Boston building,[13] but there is no record that it was done. Two years later, Raht again approached Ward about casting a bronze replica of the group for the Equitable buildings in Boston, Berlin, and Madrid.[14] An illustration of the Madrid building shows that a different statue was installed over its entrance.[15]

In 1896 Henry B. Hyde asked Ward to cast a model of *The Protector*.[16] Whether the statuette was made is not known. The first model of *The Protector* (fig. 82) was destroyed when the home office burned in 1912.[17] A large plaster replica was made by Thomas Piccirilli for the 1939 New York World's Fair.[18]

NOTES

1. For a complete and accurate history of *The Protector* see "Equitable Statue Group: History," Statue Group Folder, ELAS.
2. Buley 1967, 1, p. 106.
3. Ibid., p. 107.
4. A large number of letters exist from R. Cushing to JQAW regarding progress on the work (N-YHS).
5. Bill of lading from American-European Express Company to JQAW, September 14, 1871 (N-YHS).
6. Buley 1967, 1, pp. 107–108. (See also *Frank Leslie's Illustrated Newspaper*, December 9, 1871, p. 198.)
7. Ibid., p. 108. (For all twelve stanzas see "Equitable Group," Statue Group Folder, ELAS.)
8. Ibid., p. 109.
9. Memorandum from J. F. Wilson, October 23, 1889, Statue Group Folder, ELAS.
10. Buley 1967, 1, pp. 109, 533. See also letters from H. B. Hyde to JQAW, February 24 and February 26, 1896 (AIHA). In the February 26 letter Hyde states that J. F. Wilson had had the heads sent to Batterson to be restored. That was probably J. G. Batterson, the Connecticut stonecutter who had carved Ward's statues for the Connecticut State Capitol in 1879.
11. Schuyler 1909, pp. 647–648.
12. Buley 1967, 1, p. 312, n. 51.
13. Letters from E. E. Raht to JQAW, February 4 and March 11, 1886 (N-YHS).
14. Ibid., April 15, 1888.
15. Buley 1967, 1, between pp. 356 and 357. (For additional photographs see Record Group B, Audio-Visual Material, Buildings and Facilities, ELAS.)
16. Ibid., p. 533, where Buley reports that the model

was cast in bronze. See also letters from H. B. Hyde to JQAW, November 13 and December 1, 1896 (AIHA). Ward wrote on the bottom of the December 1 letter, "Price of Statuette 18 inches high in plaster $3,300."
17. R. L. Barbour, "The Spectacular Fire of 1912 Destroyed the Equitable Society's 'Statue Group' Cast," *Insurance Field* 71 (March 6, 1942), n.p., Statue Group Folder, ELAS.
18. "Garden of Security Exhibit at the World's Fair in 1939," clipping, Statue Group Folder, ELAS.

55. ISRAEL PUTNAM
Statue, 1873
(*Plates VIII, IX*)

Bronze, over life-size
Signed: J.Q.A. WARD/1873
Founder's mark: R. WOOD & CO/BRONZE
FOUNDERS./PHILA.
Architect of base: unknown
Inscription on base [front]: ISRAEL PUTNAM
[back]: PRESENTED/BY THE HONOURABLE/
JOSEPH PRATT ALLYN/MDCCCLXXIII
Unveiled: June 17, 1874
Bushnell Park, Hartford, Connecticut

The statue of Israel Putnam (January 7, 1718–May 29, 1790) was the first of six revolutionary-war memorials that Ward executed.[1] Putnam was the legendary Connecticut militiaman, Indian-fighter, and staunch patriot who left his plow and rushed to Massachusetts when he heard of the fighting in Lexington. He was appointed a major general in the Continental Army and took command of the troops in the Battle of Bunker Hill. Because of his delay in obeying some orders, and his disregarding others, he was rebuked by Washington, and thereafter played a lesser role in the war. A stroke ended his military career in December 1779. Putnam's energy, confidence, and bravery had made him one of the most popular military figures of the Revolution.[2]

In December 1871, Charles D. Warner of the city of Hartford wrote to Ward:

A Mr Allyn [Joseph P. Allyn] left $5,000 (now with two years accrued interest) to Gov. Jewell [Marshall Jewell of Connecticut], his father and myself as trustees, in order that we might put some figure on the [Bushnell] Park; some soldier or some historical character identified with the history of the state.

After cogitation, we think that the Continental figure of Gen. Putnam—"Old Put"—would look well and be appropriate. . . . How does it strike you? It seems to me a character that your genius would rather incline to.

As to cost. Of course $5,000 is not enough. But Mr. Allyn said that if you would undertake the work (to go into bronze) he would add to the legacy what was needed.[3]

On May 15, 1872, Warner informed Ward that Mr. Allyn was pleased with the proposed statue and that a contract would be sent shortly.[4] Three days later, the contract calling for Ward to execute the eight-foot-high bronze statue for $12,000 was signed.[5] In July

Cat. no. 55 *Israel Putnam*

1873 Ward approached Robert Wood & Company about casting the statue,[6] which was done at the Philadelphia foundry that December.[7] The work was unveiled on June 17, 1874, in Bushnell Park, in front of the still unfinished Connecticut State Capitol, for which Ward was to design the twelve cupola figures four years later (cat. no. 58).

In the *Putnam*, the first statue Ward executed after his 1872 trip to Europe, can still be found his reliance on the antique for his composition and his usual painstaking research into likeness and attire. That concern for historical accuracy is revealed in letters to him with information on Putnam from Charles D. Warner,[8] James F. Drummond[9] and J. Hammond Trumbull.[10] *The Aldine* reported at the time of the unveiling that the statue was "modeled from the Trumbull portrait and from a pen-and-ink profile in possession of the Putnam family," while "Old Put's" uniform was "copied from authentic relics, even to the shape and number of the buttons and braids, and the sword with its lion-headed hilt."[11] Now, however, there is a difference, a step forward. The *Putnam*, though derived from the *Apollo Belvedere* (fig. 17), is no longer a static figure frozen in time but a candid portrait of a fleeting moment as the self-assured general strides forth, his sword under his arm. The candid quality, which Ward undoubtedly learned in France, was to give his portraits a more natural, spontaneous character and to heighten greatly the realism of his sculpture. While a radical departure from his work of the post-Civil War period, it marked in it a new and important dimension.

RELATED WORKS:

55.1. Working model
　　 Bronzed plaster, h. 26 in.
　　 American Academy of Arts and Letters, New
　　　 York City

　　Given in 1923 by Mrs. Ward to the academy.[12]

NOTES

1. Ward's five other revolutionary-war memorials are *George Washington* (1878), Newburyport, Mass.; *Daniel Morgan* (1881), Spartanburg, South Carolina; *Alliance and Victory Monument* (1881), Yorktown, Virginia; *George Washington* (1883), New York City; and *Lafayette* (1883), Burlington, Vermont.
2. *DAB*, s.v. "Israel Putnam."
3. Letter from C. D. Warner to JQAW, December 13, 1871 (AIHA).
4. Ibid., May 15, 1872.
5. Contract between J. P. Allyn and JQAW, May 18, 1872 (AIHA).
6. Estimate from R. Wood & Co. to JQAW, July 14, 1873 (AIHA).

Cat. no. 55.1 *Israel Putnam*

7. Bill from R. Wood & Co. to JQAW, December 10, 1873 (AIHA).

8. Letter from C. D. Warner to JQAW, March 7, 1872 (AIHA).

9. Letter from [J. F.] Drummond to JQAW, April 1, 1872 (AIHA).

10. Letter from J. H. Trumbull to JQAW, May 19, 1872 (AIHA).

11. "Some Recent Statues," *The Aldine* 7 (August 1874), p. 168. See also two long articles, "Old Put" and "Ward's Putnam," from unidentified periodicals, JQAW Scrapbook (AIHA).

12. Accession card, AAAL.

56. JAMES TOPHAM BRADY
Bust, before 1874

Location unknown

Ward exhibited the bust of James T. Brady (April 9, 1815–February 9, 1869) at the annual exhibition of the National Academy of Design in 1874.[1] Because his entries in the academy's exhibitions were always of a recently executed work, the bust of Brady was probably done shortly before that spring. Brady, who died in 1869, had been a successful New York lawyer influential in state politics.[2] The bust was probably commissioned either by a member of Brady's family or by an institution with which he had been closely associated.

RELATED WORKS:

A plaster model of the bust of Judge Brady was among those in the collection given by Mrs. Ward to New York University in 1922.[3] Its present location is unknown.

NOTES

1. NAD 1874, no. 407.
2. *DAB*, s.v. "James Topham Brady."
3. Memorandum from H. O. Voorhis, October 10, 1922 (WMC).

57. JANE PAULINE BELMONT
Relief, about 1876

Location unknown

Jane Pauline Belmont (April 11, 1856–October 15, 1875), called "Jeannie," was the fourth of August and Caroline Belmont's six children. (For a biographical sketch of August Belmont see cat. no. 90.)[1] Plagued with severe stomach trouble from infancy, Jeannie was never able to enjoy the elite position her rich and powerful father had achieved as a banker and a leading force in the Democratic party. By the time she was seventeen her pain had become so acute that her doctors were prescribing increasingly large doses of morphine for her.[2] She was unable to eat properly, and her condition continued to deteriorate. Two years later she died. She was nineteen.[3]

In January 1876 August Belmont wrote Ward:

You were kind enough to promise me that you would let me hear from you as soon as you had made up your mind about complying with my earnest solicitation for you to undertake the basrelief for the grave of my darling child. If you knew how anxious her mother and I are to obtain your consent I am sure that you would not withhold it. All we can do for her whom God has taken away from us is to cherish and venerate her memory and to evince our lasting affection and grief for the sweetest and best child a parent was ever blessed with.

I feel that nobody could so well do justice to the pure and poetical conception of your sketch than yourself and by your kindly undertaking the erection of the monument you would really relieve two sorrowing hearts more than I can express.[4]

There is no further information regarding the por-

trait, but it seems unlikely that Ward would have let the wishes of his rich and powerful patron go unheeded. (Belmont, with the *Perry* [cat. no. 46], had given Ward his first major commission in 1865.) Jeannie was interred in the family vault in Island Cemetery in Newport,[5] and in 1886, eleven years after her death, Belmont had work begun on a chapel in the cemetery in his daughter's memory.[6] Ward's relief, if executed, might have been first in the family vault in Island Cemetery and then moved to the chapel, but it has not as yet been located.

NOTES

1. See also Black 1981, p. 147.
2. Ibid., p. 418.
3. Ibid., pp. 425, 451.
4. Letter from A. Belmont to JQAW, January 8, 1876 (N-YHS).
5. Black 1981, p. 452.
6. Ibid., p. 698; *New York Times*, November 4, 1886, p. 1.

58. DOME OF THE CONNECTICUT STATE CAPITOL

Emblematic statues, 1878

Marble, over life-size
Signed: not visible from the ground
Hartford, Connecticut

On August 6, 1878, A. E. Burr, president of the State Capitol Commission, contracted with J. G. Batterson, a Hartford stonecutter, to have him

. . . furnish twelve statues of blue Carrara or Sicilian marble, each in one block, carved according to six models made by J. Q. A. Ward . . . duplicate statues to be cut in accordance with each of said models . . . and to set the said statues in their designated places on the dome-tower, on or before the 15th day of May, A.D. 1879.
. . . The material is to be of the best and most durable quality, perfectly sound and free from all defects, and . . .

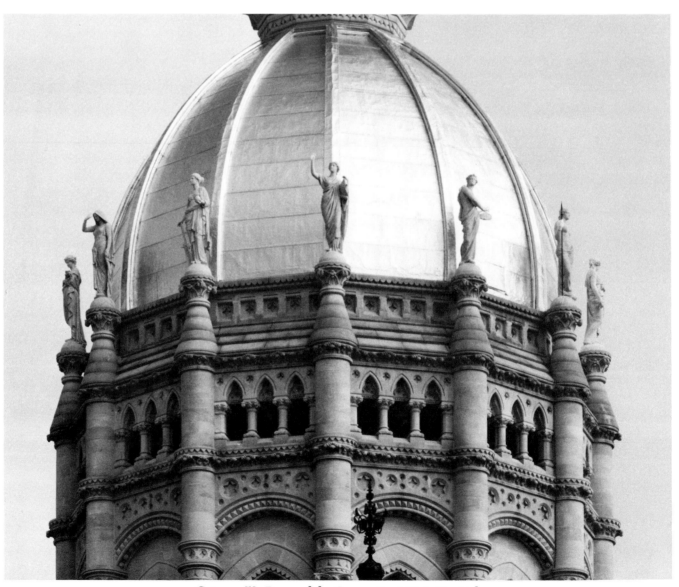

Cat. no. 58 *Dome of the Connecticut State Capitol*

the cutting is to be executed in the City of Hartford, in the most skillful manner and in an artistic and effective style. . . .[1]

The statues, six allegorical figures executed in duplicate for the dome-tower, are personifications of *Agriculture*, a classically draped maiden with an apple in her right hand and a sheaf of wheat cradled in her left arm; *Law*, who raises an arm to proclaim the laws inscribed on the scroll she holds in her left hand; *Commerce*, hooded, and shielding her eyes as if to peer into the distance, resting one hand on an anchor at her side; *Science*, with a caduceus in her right hand and, in her left, a globe; *Music*, a partly nude figure playing a lute; and *Equity*, also partly nude, who stands passively, a spear in her hand. There is no record either of who selected the subjects and iconography of the statues or of when Ward became a participant in the project, though a drawing dated 1873 by Richard M. Upjohn, architect of the Capitol, shows classical figures encircling the dome-tower.[2] *The American Architect and Building News* reported in January 1879 that five or six of the statues had been carved, and that the figures, which weighed about eight tons each, would be in place by the spring, adding "much to the effect of the dome."[3] When all the statues were in place is not recorded, either, which leads to the assumption that Batterson completed the work by the contracted date of May 15, 1879.

The classical maidens, well-conceived, three-dimensional figures, are characteristic Ward statues. Typical of the architectural sculpture of the period, they are endowed with the didactic attributes suitable for a public building. Their sculptural quality and symbolic meaning are not discernible from the ground, since the dome-tower rises to over seventy-five feet above the roof of the Capitol. Thus they become mere picturesque silhouettes on the eclectic, Gothic revival-style building.

RELATED WORKS:

Twelve plaster statuettes—two replicas of each of the six emblematic figures for the dome: *Agriculture*, *Law*, *Commerce*, *Science*, *Music*, and *Equity*, each approximately fifty-five inches high—are displayed (six on the right landing, six on the left) on the stairs leading to the Spectator's Gallery on the third floor of the Capitol. When they were acquired or put in place is not recorded.

58.1. Statuette of *Agriculture*
 Wood, h. 26 in.
 American Academy of Arts and Letters, New
 York City

Cat. no. **58.1** *Agriculture*

Bequeathed to the academy in 1933 by Mrs. Ward.[4]

58.2. Statuette of *Music*
 Wood, h. 26 in.
 American Academy of Arts and Letters, New
 York City

Also bequeathed to the academy in 1933 by Mrs. Ward.[5] The lute is missing from the figure's left hand.

Cat. no. 58.2 *Music*

NOTES

1. SCC 1878, pp. 80–81.
2. Richard M. Upjohn, *Architectural Drawings of the Connecticut State Capitol* 1, p. 54, Connecticut State Library, Hartford, Connecticut. The figures are identified in Sheldon 1878, p. 66.
3. "Statues for the Hartford Capitol," *The American Architect and Building News* 5 (January 4, 1879), p. 8.
4. Accession card, AAAL. See also Gifts from JQAW Estate, April 18, 1934 (AAAL).
5. Ibid.

59. GEORGE WASHINGTON
Statue, 1878
(Plate XI)

Bronze, over life-size
Signed: J.Q.A. WARD SC. 1878
Founder's mark: G. FISCHER & BRO/FOUNDRY
Architect of base: Rufus Sargent
Inscription on base [front]: WASHINGTON/
 PRESENTED BY DANIEL I. TENNY/NOV. 1878
Unveiled: February 22, 1879
Bartlett Mall, Newburyport, Massachusetts

Ward's Newburyport statue portrays George Washington addressing a crowd as commander in chief. The statue was commissioned by the New York jeweler Daniel I. Tenny, a native of Newburyport, Massachusetts.[1] Tenny had already made several modest gifts to Newburyport[2] when on March 15, 1877, he commissioned Ward to execute within a two-year period a statue of Washington eight feet high for $12,000.[3]

By the summer of 1878 Ward had completed his working model of the *Washington,* and he accepted an estimate from George Fischer & Company of New York to cast, crate, and ship the statue for $1,345.[4] The finished bronze statue, on a gray granite pedestal designed by Rufus Sargent of Newburyport, was unveiled on February 22, 1879[5]—the hundred-and-forty-seventh anniversary of Washington's birth.

The Newburyport *Washington,* revealing the influence of French sculpture that characterizes Ward's mature work, combines a candid pose with Ward's concern for historical accuracy. Ward would have been completely familiar with both the attire and physiognomy of Washington from his experience in assisting Henry Kirke Brown on his equestrian statue of the first president for Union Square Park in New York City (fig. 12). No particular historical event was represented in the Newburyport *Washington.* But by simply showing Washington with his left hand resting on the pommel of his sword and his right hand open and slightly extended in salutation or a conversational gesture Ward created a striking and memorable statue.

RELATED WORKS:

A pencil sketch by Ward of the *Washington* (fig. 83) is in the collection of the Albany Institute of History and Art.[6]

NOTES

1. Martha J. Tenney, *Tenney Family, or the Descendants of Thomas Tenny of Rowley, Mass. 1838–1890* (Boston, 1891), pp. 109–110.

Cat. no. 59 *George Washington*

Fig. 83 John Quincy Adams Ward, *George Washington*, 1878. Pencil on paper. Albany Institute of History and Art, Albany, New York.

2. *Presentation of the Statue of Washington to the City of Newburyport* (Newburyport, 1879), p. 8.
3. Contract between D. I. Tenny and JQAW, March 15, 1877 (AIHA).
4. Letter from George Fischer & Co. to JQAW, August 20, 1878 (AIHA).
5. *Presentation of the Statue of Washington. . .*, pp. 11–12; *Newburyport Daily Herald*, February 22, 1879 [p. 1].
6. JQAW Sketchbook no. 2 (AIHA).

60. MEMORIAL TO WILLIAM GILMORE SIMMS

Bust, about 1878

Bronze, over life-size
Signed: J.A.Q. WARD/sculptor
Founder's mark: GEO. FISCHER & BRO./BRONZE FOUNDRY N.Y.
Architect of base: Colonel Edward B. White

Cat. no. 60 *Memorial to William Gilmore Simms*

Inscription on base [front]: SIMMS/WILLIAM
GILMORE SIMMS/1806–1870/AUTHOR/
JOURNALIST/HISTORIAN. [back]: THIS
MONUMENT DEDICATED JUNE 11, 1879
Unveiled: June 11, 1879
White Point Garden, Charleston, South Carolina

William Simms (April 17, 1806–June 11, 1870) was
a leading Southern writer who is primarily remem-
bered for his romantic novels based on South Carolina
history and frontier life. He lived most of his life in
Charleston and devoted considerable energy to de-
fending slavery and the Confederate cause in the Civil
War. Although his novels such as *Guy Rivers, The
Partisan,* and *The Yemassee* were highly respected in
the North, in the South his writing was largely ne-
glected. This lack of recognition, coupled with the
defeat of the Confederacy, the death of his wife and

two children during the war, and the burning by Sher-
man's raiders of his family home, left him spiritually
and financially a broken man.[1]

Bent on correcting the ignominious treatment
Simms had suffered in his homeland during his
lifetime, a group of twenty-four men met in Charles-
ton in 1872, two years after Simms's death, to pro-
mote a memorial honoring "the most distinguished
man of letters that South Carolina had produced, and
the foremost literary man of the South in his day."[2] A
subcommittee of nine was appointed to oversee the
erection of the memorial, but the project floundered
for several years. A twenty-five-foot obelisk form was
suggested, but the subcommittee expressed a prefer-
ence for a bronze bust on a pedestal of Carolina gran-
ite.[3] After soliciting the advice of William Cullen Bry-
ant, friend and admirer of Simms, the subcommittee
approached Ward in 1875 about undertaking the bust
and pedestal for the memorial.[4] On June 30, a mem-
ber of the subcommittee wrote Ward that the cost of
the bust and pedestal was

> . . . rather more than we had expected, as the large size, is
> what we require—if you can name a lower price, we
> should be obliged—as to the pedestal, with such a design
> as you would suggest or approve, it is the wish to have it of
> native granite, and so could be done here. We have
> likenesses of W. Simms, would these suffice for your
> work? We could also refer you to some of his New York
> friends, who could assist you, by conversation, as to de-
> tails of head, face etc.[5]

A month later, members of the subcommittee wrote
Ward that "the bronze bust at $1,900, with granite
pedestal, is what [the Executive Committee] have
concluded to do."[6] A formal contract for Ward to ex-
ecute the bust was signed in November 1875.[7] By the
following year Ward had completed the plaster
model. After it was examined by a number of Simms's
friends it was approved,[8] and was cast in New York by
George Fischer and Brothers. There followed an inex-
plicable delay, and not until March 1878 was Ward
instructed to have the bust shipped to Charleston.[9]
The pedestal, cut from local granite, was designed by
Colonel Edward B. White,[10] a Charleston architect
who would later design the base for Ward's statue of
Daniel Morgan in Spartanburg, South Carolina (cat.
no. 67). The *Simms* memorial was unveiled in White
Point Garden in Charleston on June 11, 1879, the
ninth anniversary of the writer's death.[11]

The *Simms* was one of the first public monuments
in this country to honor an American artist or writer.
Aware of present and future obstacles to the erecting
of a memorial to a man of arts and letters, the subcom-
mittee had cautioned Ward:

There is no such memorial in this section and we are therefore solicitous about having this well done—as the style is we think, very acceptable, and likely to attract attention for other similar work.[12]

Though the commission was a financially modest one and the bust is not regarded as one of Ward's major works, the *Simms* is one of his most expressive portraits. The nude torso and the sheer size give the bust a heroic, monumental quality. The boldness of Ward's rendering of the writer's facial features reveals his masterly understanding of physiognomy.[13] The attitude of Simms's upturned head conveys a sense of pride and courage; the forward thrust of his jaw projects nobility; his lowered eyes and contracted eyebrows suggest a hidden rage and despair; and his tightly compressed mouth bespeaks the decisiveness and resolution of his character.

NOTES

1. *DAB*, s.v. "William Gilmore Simms."
2. Simms 1879, p. 6.
3. Ibid., p. 7.
4. Ibid.
5. Letter from W. A. Courtenay to JQAW, June 30, 1875 (AIHA).
6. Letter from the subcommittee to JQAW, July 20, 1875 (AIHA).
7. Simms 1879, p. 8.
8. Ibid.
9. Letter from W. A. Courtenay to JQAW, March 7, 1878 (AIHA).
10. Simms 1879, p. 5.
11. Ibid.
12. Letter from the subcommittee to JQAW, July 20, 1875 (AIHA).
13. For a complete discussion of physiognomy in nineteenth-century American sculpture, see J. S. Crawford, "Physiognomy in Classical and American Portrait Busts," *The American Art Journal* 9 (May 1977), pp. 49–60.

61. MAJOR GENERAL GEORGE HENRY
 THOMAS
 Equestrian statue, 1879
 (Plate X)

 Bronze, over life-size
 Signed: J. Q. A. WARD./sculp. 1879.
 Founder's mark: BUREAU BROS &
 HEATON/FOUNDERS. PHIL^A.
 Architect of base: J. L. Smithmeyer
 Inscription on base [front]: MAJ. GEN. GEORGE H.
 THOMAS/SAN FRANCISCO CAL./MARCH 28, 1870
 [back]: ERECTED BY HIS COMRADES/OF THE
 SOCIETY OF/THE ARMY OF THE CUMBERLAND
 Unveiled: November 19, 1879
 Thomas Circle, Washington, D.C.

George H. Thomas (July 31, 1816–March 28, 1870)

Cat. no. 61 *Major General George Henry Thomas*

was one of the most able Union generals of the Civil War. From the outbreak of the war Thomas, a Virginia-born graduate of West Point, remained loyal to the Union. The heroic stand of the forces under his command during the Chattanooga Campaign of 1863 saved the Union army and earned Thomas the title "The Rock of Chickamauga." Given command of the Army of the Cumberland, he served first under General Grant, then, in the Atlantic campaign, under General Sherman. Though Thomas never enjoyed the confidence that Grant placed in Sherman and Sheridan, he was made a major general after his rousing victory in the Battle of Nashville, and gained recognition as one of the Union's best leaders.[1]

Following Thomas's death in 1870, the Society of the Army of the Cumberland resolved at its annual reunion:

That some fitting monument should be erected by his countrymen to mark the spot where the remains of our beloved commander rest; and that this Society shall take the initiatory steps for its erection; and to that end a committee of one from each State represented in the Society be now appointed to arrange some method to procure the necessary funds, and to provide a design, specifications, and estimates therefor, and to report at the next meeting.[2]

Adopting an amendment proposed by General Joseph Hooker at the society's reunion in 1871, the location selected for the monument was Washington, D.C.[3] The next year a Committee of Five, composed of Generals C. H. Grosvenor, J. A. Garfield, Charles Cruft, James Barnett, and James D. Morgan, was appointed to secure from Congress a donation of bronze for the Thomas statue.[4] At the 1873 reunion, the Committee of Five submitted the following request, which it had presented to the United States Senate and the House of Representatives:

. . . One year ago, a committee was appointed, of one from each State, with power to select sub-committees in each county of the interior country, to raise money for the proposed object [the monument to Thomas]. At our last meeting, it was ascertained that something less than $10,000 had already been raised; and it was agreed, at that meeting, that on the 30th of May next—the anniversary of Decoration Day—a combined movement should be made throughout the United States to raise money for this purpose. But it was also deemed necessary to solicit from Congress a donation of discarded and unserviceable cannon, to be used in the construction of the monument, and the undersigned are charged with the duty of soliciting such donation.

We find, on arriving here, that House resolution 3,302, accompanied by a bill introduced by MR. MAYNARD, of Tennessee, has already been presented in the House of Representatives, read twice, and referred to the Committee on Military Affairs. We respectfully ask that the bill may be so amended as to provide for the donation of eighty-eight pieces of cannon, in addition to such sum of money as Congress shall see fit to appropriate.[5]

In 1873, Congress and President Grant, approving the request, authorized the secretary of war to deliver eighty-eight pieces of condemned bronze cannon to the society.[6] The governor of the District of Columbia cabled the society that the district would furnish the pedestal for the statue.[7] The federal government honored its pledge of the cannon, but the district never fulfilled its offer, and in 1876 Congress appropriated $25,000 for the pedestal.[8]

According to the minutes of the 1873 reunion, the monument committee informed the members of the society that in response to the circular letter that had been issued the following artists had sent models of the proposed Thomas statue: Giovanni Turini, William McDonald, and George W. Hess, of New York;

Joseph Bailey, of Philadelphia; Miss Vinnie Ream and Theodore A. Mills, of Washington, D.C.; and Olin L. Warner, of Worcester, Massachusetts.[9] Disappointed in the models submitted and anxious that the society be more fully represented, the committee requested that its group be enlarged (adding the names of Generals Philip H. Sheridan, Joseph Hooker, and Thomas J. Jordan); and, further, that it be empowered to employ an artist of national reputation to execute the proposed statue of Thomas.[10]

At the society's 1874 reunion the monument committee reported that at its September 1873 meeting Generals Hooker and Whipple had been elected chairman and secretary, respectively.[11] In New York, in February 1874, the committee resolved that Ward should be commissioned to execute the statue of Thomas.[12] On February 12, the two parties came quickly to terms and, two days later, Ward signed a contract to execute within three years a fourteen-foot-high equestrian statue for the sum of $35,000.[13]

Mrs. Thomas supplied Ward with a number of photographs of her husband and the general's saddle, uniform, and other equipment.[14] By the summer of 1874 Ward had completed a sketch model, and on July 2 the committee visited his studio to inspect it. After suggesting "some slight changes" they approved it.[15] The committee's approval by no means meant that Ward's creative responsibility was completed; rather, he continued to refine the piece as he enlarged it. A year later, responding to apparent criticism of his progress on the statue, he wrote to a member of the committee:

My whole time was devoted to the statue. I am not discouraged by the progress made, and expect to have it done within the time specified. I do not show the work to anybody yet.[16]

Ward's optimism was not justified, for the full-scale model was not completed until the spring of 1879.[17] When it was, however, any frustration that had resulted from the delay was forgotten—the statue was an overwhelming success (fig. 84). As a newspaper enthusiastically reported:

The plaster model of Mr. Quincy Ward's equestrian statue of General George H. Thomas, intended to be cast in bronze and set up in the City of Washington, is now completed, and has been shown by the sculptor to the press, to his own friends, and to certain Army officers and friends of the late illustrious General, before beginning the work of taking it to pieces and preparing it for the operation of casting.

The attitude chosen by the sculptor for the horse and his rider is remarkable alike for its novelty and its dignity. No particular incident is intended to be represented, or even suggested, and while the composition is picturesque

ig. 84 John Quincy Adams Ward, full-scale model for
the *Major General George Henry Thomas*, 1879. Photo-
graph. Collection of Mr. and Mrs. Oliver E. Shipp,
Newburgh, New York.

and animated to an uncommon degree there is nothing
theatrical in it, it is clean from all pretentiousness or striv-
ing for effect. . . . Mr. Ward has learned that General
Thomas was not a particularly good horseman. . . . So that
he had a good horse, well equipped, he was content, and
unless there was need, he seldom rode faster than a trot.
With this in mind, the sculptor felt himself at liberty to
choose an action that should be unconventional, unusual
even in works of this nature. . . . The General in reconnoi-
tering the position of the enemy has ridden his horse over
the ground between, and brought him to a stand on the
summit of a gently rising ridge. He holds the reins lightly
in his left hand, and warmed by the brisk exercise has
removed his hat and holds it in his right hand, the arm
hanging straight at his side. His forward calm but eager
gaze is directed toward the right so that his body is gently
swayed in that direction, and the horse, excited by the
stop and by the new horizon, snuffs the air with lifted

head and dilated nostrils. Great repose and dignity come
from the solid planting of all four of the horse's feet upon
the ground, and from the quiet seat of the rider in his
saddle; while animation and picturesqueness are gained
by the upward swing of the lines in the horse's body, and
the alert intelligence of his head. We do not recall any
equestrian statue of modern times that is content with this
simplicity, and it is no small praise in this day when the
stores of attitude and gesture are so stingy of a new mo-
tive, to say that Mr. Ward has given us a composition one
of whose striking merits is its freshness, a freshness that
amounts to originality.[18]

The plaster was shipped to Philadelphia, where it was
cast by Bureau Bros. and Heaton.[19] The finished
bronze was then taken to Washington and placed on
an ornate Beaux-Arts-style pedestal designed by the
Washington architect J. L. Smithmeyer.[20] The unveil-
ing was held on November 19, 1879, on the occasion
of the eleventh reunion of the Society of the Army of
the Cumberland (fig. 1).[21] A correspondent for the
New York Times reported that though the day was
gray and wintery, the demonstration was "the most
imposing witnessed in Washington since the grand
review of the victorious Union armies in 1865." A
procession of troops two miles long led to the square
and the grandstands where the president, members of
the cabinet, and other important dignitaries were
seated. Following the playing of "Hail to the Chief"
and the "Star-spangled Banner," General Buell of the
Society of the Army of the Cumberland stepped for-
ward and pulled the rope triggered to the four large
flags that enclosed the statue. As the flags dropped
and the *Thomas* stood out in bold relief against the
sky, the crowd broke into a chorus of cheers.[22]

Dramatically situated in a circle at the intersection
of Massachusetts and Vermont avenues and 14th and
M streets, the *Thomas* is one of Ward's most innova-
tive and successful works (fig. 40). The statue is de-
void of complicated action, but Ward has imbued it
with a dynamic quality by placing the horse on a slight
incline. The angle creates a downward diagonal sweep
along the back of the mount that is reinforced by all its
secondary lines. In addition, the alertness conveyed
in the long legs of the powerful stallion and the move-
ment implicit in his wind-blown mane and tail charge
the work with a dramatic immediacy that compares
with that found in contemporary sculpture of the
French Beaux-Arts school. Augustus Lukeman, recog-
nizing the *Thomas*'s spirited and revolutionary de-
sign, wrote in 1913 that it "is the finest example of
equestrian art in Washington."[23] In 1911, Daniel
Chester French wrote of it:

In the Thomas statue the sculptor can claim the credit of
being a pioneer and possessing one of the first requisites

of the artist, the ability to see nature freshly and not through another person's eyes. The horse in this statue is a clean-limbed, up-to-date American thoroughbred, and a radical departure from the conventional animal that had hitherto posed as the model for equestrian statues. It is difficult for us today, accustomed as we have become to the realistic representation of the horse, to appreciate what an innovation this spirited stallion of General Thomas was, and we naturally fail to credit the sculptor with the ability to conceive it and the temerity that dared to face the storm of criticism certain to greet so novel a work.[24]

RELATED WORKS:

A plaster cast of the head of General Thomas was offered to West Point in 1907 to decorate the academy's mess hall.[25] Its present location is unknown. General Joseph Hooker wrote Ward in June 1879 about the possibility of a second bronze of the *Thomas* being cast for the Soldier's Asylum in Dayton, Ohio,[26] but it was never done.

61.1. Study for the horse
 Bronze, h. 18½ in.
 Signed: J Q A Ward Sc
 Founder's mark: ROMAN BRONZ WORKS
 American Academy of Arts and Letters, New
 York City

In 1933, Mrs. Ward bequeathed the original wax model for the study of the *Thomas* horse to the American Academy. Because of its fragile condition, the academy had it cast by the Roman Bronze Foundry in 1951. The wax figure was destroyed in the process.[27]

61.2. Study for the horse
 Bronze, h. 19½ in.
 Signed: J. Q. A. WARD
 Founder's mark: JNO. WILLIAMS INC. N.Y.
 The Metropolitan Museum of Art, New York
 City

This study was purchased by the Metropolitan Museum from the Gorham Foundry in 1917.[28]

NOTES

1. *DAB*, s.v. "George H. Thomas".
2. SAC 1870, p. 29.
3. SAC 1871, p. 31.
4. SAC 1872, p. 44.
5. SAC 1873, pp. 28–29.
6. Ibid., pp. 30–31.
7. Ibid., p. 51.
8. SAC 1876, p. 38.
9. SAC 1873, pp. 47–48.
10. Ibid.
11. SAC 1874, p. 37.
12. Ibid., p. 38.

Cat. no. 61.2 Study of the horse for the *Major General George Henry Thomas*.

13. Ibid., pp. 38–39. Contract between SAC and JQAW, February 11, 1874 (AIHA). It seems that the contract was dated to when it was first presented to Ward rather than to when it was actually signed.
14. Letter from W. D. Whipple to JQAW, March 10, 1874 (N-YHS). See also letter from I. A. Kellogg to JQAW, March 17, 1874 (AIHA).
15. SAC 1874, p. 40.
16. SAC 1875, p. 46.
17. Letter from W. D. Whipple to JQAW, May 1, 1879 (N-YHS).
18. *New York Daily Tribune*, May 3, 1879, p. 7. See also "Ward's Statue of General Thomas," *Harper's Weekly* 23 (May 24, 1879), p. 413 and cover illustration.
19. Receipt from Bureau Bros. and Heaton to JQAW for payment of $7,500, December 2, 1879 (AIHA).
20. Letters from J. L. Smithmeyer to JQAW, February 20, 1877, May 21, 1877, June 13, 1877 (AIHA); May 2, 1879 (N-YHS).
21. Invitation to the unveiling, November 19 and 20, 1879 (AIHA).
22. *New York Times*, November 20, 1879, p. 1.
23. "What the Sculptors Are Doing," *The Monumental News* 25 (January 1913), p. 39.
24. Eulogy by D. C. French, read by H. MacNeil, for the opening of Memorial Exhibition, March 16, 1911 (N-YHS).
25. Letter from Major Zalenski to JQAW, May 6, 1907 (N-YHS).
26. Letter from J. Hooker to JQAW, June 3, 1879 (AIHA).
27. Accession card, AAAL.
28. Archives, MMA.

Cat. no. 62 H. R. Searle, *Design for the Washington Monument*, proposed design. Photograph.
The American Academy of Arts and Letters, New York City.

62. WASHINGTON MONUMENT
Proposed design, 1879

In 1783 the Continental Congress approved a bill authorizing an equestrian statue of George Washington to be placed on the Mall of the new capital. In 1833, after years of delay, a group of prominent citizens founded the Washington Monument Society to raise funds for a suitable memorial, and in 1836, a design by Robert Mills was selected. An Egyptian obelisk, it included a circular base a hundred feet high

surmounted by a quadriga and classical statues. Because of lack of funds, the base colonnade and the sculpture were not executed, and work on the shaft, which had reached a height of a hundred and fifty feet, was stopped in 1854, when the money ran out. In August 1876, for the country's centennial celebration, Congress voted to complete the monument.[1]

In response to an Act of Congress dated October 23, 1877, Henry Robinson Searle, a New England architect who was then working in the office of the United States Supervising Architect in Washington,[2]

submitted a design. His proposal was for an Egyptian revival-style monument composed of a tall fluted obelisk standing on a three-tiered base decorated with statues and reliefs.[3] Ward's name is inscribed on a photograph of the plan as the proposed monument's sculptor, although the sculpture was not included in the $975,000 estimated cost submitted in 1879.[4] In the end, only Mills's simple obelisk was completed. Ward's part in Searle's plan was probably limited to his agreeing to execute the sculpture if Searle's design was awarded the commission. The only information that associates Ward with the project is the inclusion of his name on the photograph of the design.

NOTES

1. J. M. Goode, *The Outdoor Sculpture of Washington, D.C.* (Washington, D.C.: Smithsonian Institution Press, 1974), p. 267.
2. H. F. Withey and E. R. Withey, eds., *Biographical Dictionary of American Architects* (Los Angeles: Hennessy & Ingalls, 1970), p. 544.
3. H. van Brunt, "Design for the Completion of the Washington Monument: Mr. H. R. Searle, Architect, Washington," *American Architect and Building News* 5 (March 1, 1879), pp. 67–68, ill. no. 166. Van Brunt makes no reference to Ward's involvement in the project.
4. Photographic files, JQAW, AAAL.

63. *LEIF THE NORSEMAN*
Proposed design, 1879

In January 1878, Thomas Gold Appleton, a Boston philanthropist, wrote Ward about undertaking a statue of the Norseman Leif Ericson for Post Office Square in Boston.[1] The financing of the proposed monument was insecure from the start, but Appleton was confident that the necessary funds would be forthcoming once people saw the model for the statue. In December, he wrote Ward that he was still not sure of the money for the monument, but he outlined an ambitious plan for it, which included a fountain and pedestal in addition to the sculpture.[2] The statue of the *Norseman*, Appleton wrote, should represent Leif in

. . . the action of arrival, gazing eagerly around, and showing the energy that belongs to the Northern races.

Though he was quite young he should be strong limbed and of powerful mould, his face might show a budding, youthful beard, thus leaving the handsome features of the Scandinavian type to be fairly seen.

The dress as I understand it, should be something like this, a shirt of mail, not extending to the elbow, and only to the upper part of the thigh, loose trousers, with thongs wound across wise above, a shallow helmet with a little spike on top somewhat like the Prussian helmet. He should wear a belt with ornaments like a disc whence a heavy two handed sword hangs. That is my notion about

it, but the sculptor should be very exact to follow the correct dress.[3]

The following May, Appleton wrote Ward that Mayor Edward Prince of Boston was enthusiastic about the monument, and that he hoped the mayor would authorize the use of $30,000 that Jonathan Phillips of Boston had given for the embellishment of the city; the Post Office would contribute an additional $10,000.[4] In conclusion, he urged Ward to finish his model, as it would certainly help in obtaining money for the project. His confidence proved unjustified, for even with a photograph of Ward's model in hand by January 1880,[5] Appleton was unable to convince the city fathers to sponsor the project. Next an effort was made to move the statue to a triangle of land in front of the Museum of Fine Arts,[6] but this too failed. Finally, in December 1881, Appleton wrote Ward to abandon further work on the monument until the necessary money was raised.[7] The commission for a memorial to Leif Ericson was eventually awarded to Anne Whitney for the greatly reduced sum of $11,000, and her statue was unveiled on Commonwealth Avenue on October 29, 1887.[8]

RELATED WORKS:

A figure of Ward's *Norseman* was exhibited in gallery 58 at the Panama-Pacific International Exposition in San Francisco in 1915.[9]

63.1. Sketch model
Bronze, h. 28½ in.
Inscribed: 1879
Founder's mark: JNO. WILLIAMS INC./BRONZE FOUNDRY N.Y.
Stamped on bottom of base: 1818
American Academy of Arts and Letters, New York City

Ward's figure corresponds very closely to Appleton's description of the *Norseman*. It was bequeathed (1933) to the academy by Mrs. Ward.[10]

NOTES

1. Letter from T. G. Appleton to JQAW, January 3, 1878 (N-YHS). It was apparently the second letter Appleton had written Ward regarding the commission.
2. Ibid., December 13, 1878.
3. Ibid.
4. Ibid., May 27, 1879 (AIHA).
5. Ibid., January 27, 1880 (N-YHS). The photograph was exhibited at the mayor's office. "Monuments," *The American Art Review* 1 (May 1880), p. 320.
6. "Monuments," *The American Art Review* 2 (May 1881), p. 43.
7. Letter from T. G. Appleton to JQAW, December 16, 1881 (N-YHS).

8. E. R. Payne, "Anne Whitney, Sculptor," *The Art Quarterly* 25 (Autumn 1962), p. 254.

9. PPIE 1915, p. 246.

10. Accession card, AAAL. See also Gifts from the JQAW Estate, April 18, 1934 (AAAL).

64. FRIEZE FOR THE ASSEMBLY CHAMBER OF THE NEW YORK STATE CAPITOL
Proposed design, about 1879

In the late 1870s Ward participated in the decoration of the New York State Capitol then being built in Albany. When its architect, Thomas Fuller, was dismissed on July 1, 1876, Leopold Eidlitz, Henry Hobson Richardson, and Frederick Law Olmsted had assumed the responsibility for its completion.[1] Fuller had to a great extent ignored the inside of the Capitol, and the new architects approached the leading artists of the day to see to its decoration. William Morris Hunt was commissioned to paint two great allegorical frescoes in the lunettes in the ceiling vaults for Eidlitz's Assembly Chamber; Ward was invited to do a series of historical friezes between its two ranges of windows (fig. 85);[2] and Augustus Saint-Gaudens was to do the reliefs for the chimney breast of the Senate Chamber, which Richardson was designing.[3]

In this commission, Ward, who always enjoyed the companionship of fellow artists, was brought into contact with three of the nation's most prominent architects. Years later, in recalling to Montgomery Schuyler a night boat trip he had taken up the Hudson River to Albany with the three newly appointed architects, Ward said, "There was never so much wit and humor and science and art on that boat before or since."[4] The Albany venture also brought Ward and Erastus Dow Palmer into a close professional relationship, though the details of their collaboration are still unclear. An obviously annoyed Palmer wrote Ward to complain of the poor working conditions at the Capitol and to request specific information as to what it was the architects wanted. Exactly what Palmer was commissioned to do is not known, but his remark, "I began to think the conditions for the appearance of the bas-reliefs will be very good, though the light will not enter the room as we could wish,"[5] lead one to wonder if he was working in some capacity with Ward on the friezes for the Assembly Chamber.

With the exception of Hunt's murals (since hidden from view by a new ceiling),[6] the interior decorating projects were abandoned when Governor Lucius Robinson cut by half the 1879 appropriation for the Capitol and restricted the use of the money to the outside walls and the roof "without any internal ornamentation."[7] All that survives of Ward's reliefs for

Cat. no. 63.1 *Leif the Norseman*

Fig. 85 *Assembly Chamber of the New York State Capitol.* Photograph. The New York State Library, Albany, New York

Fig. 86 John Quincy Adams Ward, *Peace Pledge*, Repro-
duced from Adeline Adams, *John Quincy Adams Ward:
An Appreciation*, 1912.

the Assembly Chamber is a photograph (fig. 86) of the
part that was to commemorate Henry Hudson's voy-
age up the river that bears his name. Titled "The
Peace-pledge of the Hudson River,"[8] it represents an
Indian breaking his arrows and burning them while an
Indian youth looks on. No information exists on
Ward's intended themes for the rest of the series of
friezes.[9] The termination of the Capitol commission
must have been a bitter blow to the sculptor, since it
curtailed what would have been one of the most chal-
lenging artistic collaborations of the late nineteenth
century.

NOTES

1. Roseberry 1964, pp. 31–41.
2. Schuyler 1908, p. 370. H. van Brunt, "The New Ar-
chitecture at Albany," *The American Architect and Build-
ing News* 5 (January 25, 1879), pp. 28–29, gives the follow-
ing description of the two walls that Ward's reliefs would
have decorated: "On each side we have thus two stages of
windows, the lower stage showing three great round-

arched windows on the main floor level, the upper showing six small divisions of the famous so-called Romanesque arcade, all glazed; two other continuous divisions of the arcade flank this range over the square compartments on either side. Between these two stages is a frieze or belt of panels to be occupied by Mr. Ward's bas-reliefs, and in the tympanum, formed on each side of the hall by the pointed lateral vault impinging against the wall-surface over the archivolts of the arcade, appears Mr. Hunt's decorative painting."

3. Roseberry 1964, p. 55.

4. Schuyler 1908, p. 370. See also letter from M. Schuyler to JQAW, July 29 [1908] (AIHA). In the letter Schuyler informs Ward of what he has written for *The Architectural Record* article.

5. Letter from E. D. Palmer to JQAW, March 12 [probably 1878] (AIHA).

6. Leaks in the wall of the Assembly Chamber caused large areas of Hunt's murals to flake and discolor. Eidlitz's vaulted ceiling began to crack, and was replaced by a wooden one. Set twenty feet lower, it concealed the painting from public view.

7. Roseberry 1964, p. 55.

8. Sturgis 1902, p. 386.

9. A rough sketch by JQAW, n.d. (N-YHS), of a relief panel annotated with an unorganized list of themes cannot be tied in with the Capitol project, nor at this time is it possible to glean much information from it.

65. FLETCHER HARPER
Medallion, about 1880

Location unknown

Fletcher Harper (January 31, 1806–May 29, 1877) was the youngest of the four brothers who comprised the famous publishing house of Harper & Brothers. In Fletcher, who was regarded as the ablest of the four, "was concentrated more of the vigor, dash, enterprise and speculative spirit of the house than in any of the others, or perhaps all combined."[1] His political and literary influence was particularly evident in *Harper's Weekly* and *Harper's Bazaar*, both of which he personally managed.

In 1880, three years after Fletcher's death, Ward executed a portrait medallion of him modeled from a painting and photographs.[2] A Harper representative informed Ward in a letter that the fee he had named was acceptable to the family, but stipulated that they must approve the medallion and added that five extra duplicates might be required.[3] No examples of the work have yet come to light.

NOTES

1. *New York Tribune*, May 30, 1877, as quoted in *DAB*, s.v. "Fletcher Harper."

2. Letter from J. H. Harper to J. C. Cady, April 3, 1880 (AIHA).

3. Letter from J. C. Cady to JQAW, March 8, 1880 (N-YHS).

66. YORKTOWN MONUMENT *(ALLIANCE AND VICTORY)*
1881

Marble statue of *Liberty*, over life-size

Marble relief of Thirteen Classical Female Figures, over life-size

Marble base emblems

Signed: MONUMENT TO THE ALLIANCE AND VICTORY/YORKTOWN MONUMENT COMMISSIONERS, 1881/R. M. HUNT, ARCHITECT, CHAIRMAN/HENRY VAN BRUNT, ARCHITECT/J. Q. A. WARD, SCULPTOR/—OSKAR J. W. HANSEN, SCULPTOR OF LIBERTY, 1957

Architects of base: Richard Morris Hunt and Henry van Brunt

Inscription on base [north]: ERECTED/IN PURSUANCE OF/A RESOLUTION OF CONGRESS ADOPTED OCTOBER 29, 1781/AND AN ACT OF CONGRESS APPROVED JUNE 7, 1880/TO COMMEMORATE THE VICTORY/BY WHICH/THE INDEPENDENCE OF THE UNITED STATES OF AMERICA/WAS ACHIEVED [west]: THE PROVISIONAL ARTICLES OF PEACE CONCLUDED NOVEMBER 30, 1782/AND THE DEFINITIVE TREATY OF PEACE CONCLUDED SEPTEMBER 3, 1783/BETWEEN THE UNITED STATES OF AMERICA/AND GEORGE III KING OF GREAT BRITAIN AND IRELAND/DECLARE/HIS BRITANNIC MAJESTY ACKNOWLEDGES THE SAID UNITED STATES/VIZ. NEW HAMPSHIRE MASSACHUSETTS BAY RHODE ISLAND AND/PROVIDENCE PLANTATIONS CONNECTICUT NEW YORK/NEW JERSEY PENNSYLVANIA DELAWARE MARYLAND VIRGINIA NORTH CAROLINA/SOUTH CAROLINA AND GEORGIA TO BE FREE SOVEREIGN AND INDEPENDENT STATES [south]: AT YORK ON OCTOBER 19 1781 AFTER A SIEGE OF NINETEEN DAYS/BY 5500 AMERICAN AND 7000 FRENCH TROOPS OF THE LINE 3500 VIRGINIA MILITIA/UNDER COMMAND OF GENERAL THOMAS NELSON AND 36 FRENCH SHIPS OF WAR/EARL CORNWALLIS COMMANDER OF THE BRITISH FORCES AT YORK AND GLOUCESTER SURRENDERED HIS ARMY 7251 OFFICERS AND MEN/840 SEAMEN 244 CANNON AND 24 STANDARDS/TO HIS EXCELLENCY GEORGE WASHINGTON/COMMANDER IN CHIEF OF THE COMBINED FORCES OF AMERICA AND FRANCE/TO HIS EXCELLENCY THE COMTE DE ROCHAMBEAU/COMMANDING THE AUXILIARY

TROOPS OF HIS MOST CHRISTIAN MAJESTY IN
AMERICA/AND TO HIS EXCELLENCY THE
COMTE DE GRASSE/COMMANDING IN CHIEF
THE NAVAL ARMY OF FRANCE IN CHESAPEAKE
[east]: THE TREATY CONCLUDED FEBRUARY 6
1778/BETWEEN THE UNITED STATES OF
AMERICA AND LOUIS XVI KING OF
FRANCE/DECLARES:/THE ESSENTIAL AND
DIRECT END OF THE PRESENT DEFENSIVE
ALLIANCE/IS TO MAINTAIN EFFECTUALLY/THE
LIBERTY AND SOVEREIGNTY AND
INDEPENDENCE/ABSOLUTE AND UNLIMITED OF
THE SAID UNITED STATES/AS WELL IN
MATTERS OF GOVERNMENT AS OF COMMERCE

Dedicated: October 10, 1884
Colonial National Historic Park, Yorktown,
Virginia

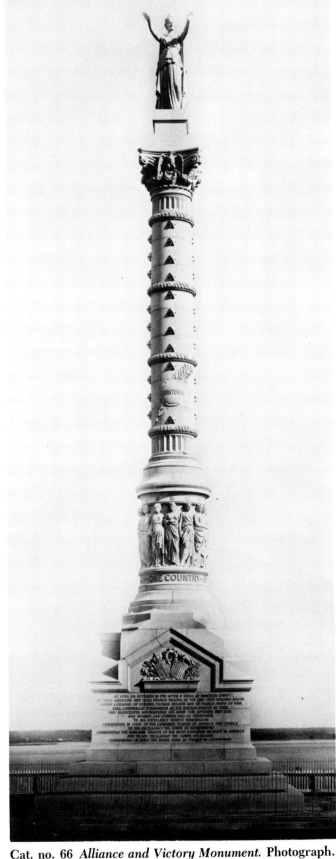

On July 22, 1880, Alexander Ramsey, secretary of war, wrote to Ward and the architects Richard Morris Hunt and Henry van Brunt:

> Enclosed you will find a copy of Public Act No. 75, approved June 7th, 1880, which provides for the erection of a Monumental Column at Yorktown, Virginia. . . .
>
> Desiring to secure a design for this monument which shall be worthy [of] the artistic talents of the country, it gives me great pleasure to invite the gentlemen addressed in this circular letter to constitute the Commission authorized and directed in the law.
>
> Should you consent to serve on this Commission, two courses would seem open to it for the accomplishment of its purposes: 1st, For the Commission itself to prepare the "design," "sketch of Emblems," and "narrative"; or, 2nd, For the Commission to cause and procure the same to be prepared under its direction and subject to its approval, and for transmission and recommendation to the Secretary of War. . . .
>
> The total cost for the erection of the Monumental Column in its place at Yorktown cannot . . . exceed ninety-seven thousand dollars.
>
> It is also required that the finished design in its entirety be transmitted to the Secretary of War in time to enable him to submit it to the Joint Committee of Congress by the 15th of December, 1880.[1]

The three artists submitted their design within the six-month deadline.[2] Although the design for the monument was governed by a 1781 Congressional resolution that a memorial "to be erected at York, in Virginia," have a classically derived column, the architects adapted a design similar to those submitted by contemporary French architects for a Constitutional Assembly memorial to be built at Versailles (fig. 46).[3] The proposed monument consisted of three parts: first, a base thirty-seven feet high and thirty-eight feet square, on which a narrative of the *Alliance*

Cat. no. 66 *Alliance and Victory Monument*. Photograph. The American Institute of Architects Foundation, Washington, D.C.

and Victory would be inscribed; second, a sculptured podium twenty-five and a half feet high and thirteen feet in diameter; and third, a column sixty feet high.[4] The sculpture designed by Ward included the emblems for the base, the thirteen classical maidens that encircle the sculpture podium at the base of the shaft of the column, and the figure of *Liberty* that surmounts the Composite order of the column.[5] The three artists collaborated on the initial model, submitting three variations for the crowning figure. One was a *Winged Victory* displaying in her unpraised right hand a foliate wreath; her lowered left hand held a laurel branch (fig. 87). Both the other models were figures of *Liberty* represented with the left hand on a shield that rested on the ground; in one, the right hand was outstretched; in the other, the outstretched arm was raised over the head. All three models were rejected, and the eventual choice was a *Liberty* portrayed with both arms raised in benediction.

The site of the monument was on the edge of the town of York, just within what had been the line of defense of Cornwallis and "visible from vessels sailing on a part of Chesapeake Bay and a large portion of the York River."[6] By October 1881 the foundation was set,[7] but the memorial nevertheless took over three years to construct. In August 1884, William P. Craighill of the United States Engineers Office wrote to the Hallowell Granite Company:

It seems almost certain now that the stones will all be in place in a week. The contract requires the architect to be entirely satisfied. Messrs. Hunt and Ward are to be here as soon as the crowning figure is set. Mr. Ward might think that figure or the drum needed retouching. If he did, which of your people would do the work? To avoid delay, ought they not be here ready?[8]

With the final adjustments made (fig. 45) and the scaffolding removed, Craighill sent Ward photographs of the completed monument in February 1885.[9] Although it was a major government commission, the finished *Yorktown Monument* received little attention in the press. The neglect probably resulted from the fact that the anniversary of the surrender of Cornwallis had been three years earlier and because of the monument's remote geographical location. In a letter to Ward, Craighill lamented:

If this monument were in Washington or Richmond, where indeed it ought to be, we should doubtless have a *grand to-do* over its dedication; but, as it is at Yorktown, where people don't like to go or stay, little or no notice is taken of it.[10]

These circumstances, combined with the primarily architectural quality of the monument, probably explain why it is seldom included on lists of Ward's oeuvre.

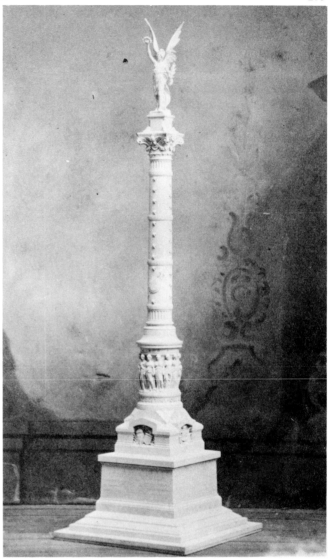

Fig. 87 Preliminary model for *Alliance and Victory Monument*, Yorktown, Virginia, about 1879. Photograph. The American Institute of Architects Foundation, Washington, D.C.

RELATED WORKS:

The American Institute of Architects Foundation has a large holding of material related to the Yorktown Monument, including photographs of the three working models (fig. 87), a series of photographs of the completed monument, and twelve related drawings and watercolors.[11]

NOTES

1. Letter from A. Ramsey to R. M. Hunt, H. van Brunt, and JQAW, July 22, 1880 (AIHA). There are over 230 documents related to the monument in the General Record Division, Boxes 32–50, Old Army and Navy, National Archives, Washington, D.C. Wm. P. Craighill, the army engineer overseeing the construction of the monument, filed annual reports that are recorded in the *Index to the Executive Documents of the House of Representatives, 1882–83,*

pp. 547–549; ibid. (1883–84), pp. 703–712; ibid. (1884–85), pp. 867–873 (Washington, D.C.: Government Printing Office, 1883; 1884; 1885). See also *Outline Description of Military Post and Reservations in the United States and Alaska and of National Cemeteries* (Washington, D.C.: Government Printing Office, 1904), pp. 622–623.

2. "Summary of News," *The American Architect and Building News* 9 (January 1, 1881), p. 2; "Monuments," *The American Art Review* 2 (January 1881), p. 131.

3. "The Design for the Yorktown Monument," *The American Architect and Building News* 10 (October 15, 1881), pp. 182–183; ill. no. 303.

4. "Monuments," *The American Art Review* 2 (September 1881), p. 213.

5. Ward's *Liberty* was struck by lightning on July 29, 1942, and was badly damaged. A replica was carved in 1957 by Oskar J. W. Hansen.

6. *Index 1882–83* (see n. 1), p. 547.

7. Ibid., pp. 547–549.

8. Copy of letter from W. P. Craighill to J. R. Bodwell, August 8, 1884 (AIHA).

9. Letter from W. P. Craighill to JQAW, February 7, 1885 (AIHA).

10. Ibid.

11. "Yorktown Monument," AIAF.

67. CENTENNIAL MEMORIAL TO THE VICTORS OF COWPENS

1881

(Plates XII, XIII)

Bronze statue of Daniel Morgan, over life-size
Signed: not visible from the ground
Founder's mark: not visible from the ground
Architect of base: Col. Edward B. White
Inscription on base [east]: TO/THE AMERICAN SOLDIERS,/WHO,/ON THE FIELD OF COWPENS,/JANUARY 17TH, 1781,/FOUGHT VICTORIOUSLY/FOR/THE RIGHT OF SELF-GOVERNMENT/AND/CIVIL LIBERTY./WE ENJOY THE RESULT OF THEIR TOIL/AND SACRIFICE, LET US EMULATE/THEIR FORTITUDE AND VIRTUE./THIS COLUMN IS ERECTED BY THE/STATES OF/NEW HAMPSHIRE, MASSACHUSETTS,/CONNECTICUT, RHODE ISLAND,/NEW YORK, NEW JERSEY,/ PENNSYLVANIA, DELAWARE,/MARYLAND, NORTH CAROLINA,/VIRGINIA, GEORGIA,/AND/ SOUTH CAROLINA./THE OLD THIRTEEN STATES,/AND/THE STATE OF TENNESSEE,/1881./ MORGAN. [east sub-base]: THE UNANIMOUS RESOLVE/OF/THE CONGRESS OF THE UNITED STATES/CROWNS/THIS MEMORIAL COLUMN WITH THE FORM AND FACE/OF/GENERAL DANIEL MORGAN,/THE HERO OF COWPENS, WHO, ON THAT FIELD, WAS/VICTORIOUS IN THE GREAT CAUSE OF/AMERICAN INDEPENDENCE. [north]: N.H.—MASS.—R.I.— CONN./TO/PATRIOTISM AND THE BRAVE./

Cat. no. 67 *Daniel Morgan*

FOREVER/IN THE PAST IS SACRIFICE./IN THE FUTURE/PROGRESS./LIBERTY AND UNION./HOWARD. [west]: ONE HUNDRED YEARS AGO/THE MEN/OF THE NORTH AND THE SOUTH/FOUGHT TOGETHER,/AND BY THEIR BLOOD SECURED/THE INDEPENDENCE,/AND CEMENTED THE UNION OF THE/AMERICAN STATES./THE BOND THAT THEN BOUND

THEM/TOGETHER IS THE/BOND OF THEIR
FELLOW-COUNTRYMEN/TODAY./THE COMMON
COUNTRY/THEY CREATED IS THE HERITAGE OF
ALL/THEIR SONS./THE PERPETUATION OF THE
REPUBLIC/OF THEIR FATHERS/IS THE SAFETY
AND HONOR/OF NORTH AND SOUTH,/ALIKE
THE SENTIMENT AND DUTY OF ALL/THE
STATES./ESTO PERPETUA./WM.
WASHINGTON.[west sub-base]: THE
WASHINGTON LIGHT INFANTRY,/TO WHOSE
CUSTODY/THE WIDOW OF COL. WM.
WASHINGTON,/COMMITTED HIS CRIMSON
BATTLE-FLAG,/PROJECTED THIS MEMORIAL
COLUMN, AND PARTICIPATED/IN ITS
DEDICATION, AGAIN UNFURLING/"THE
GLORIOUS STANDARD, WHICH AT EUTAW
SHONE/SO BRIGHT,/AND AS A DAZZLING
METEOR SWEPT THRO' THE/COWPENS DEADLY
FIGHT."[south]: 1781/ONE PEOPLE./NO NORTH,
NO SOUTH,/NO EAST, NO WEST./A COMMON
INTEREST,/ONE COUNTRY—ONE
DESTINY./1881./AS IT WAS, SO EVER LET IT
BE./ PICKENS.
Unveiled: May 11, 1881
Morgan Square, Spartanburg, South Carolina

The brilliant victory of Daniel Morgan (1736–July 6, 1802) at the Battle of Cowpens on January 17, 1781, was one of the Continental Army's most decisive victories in the American War of Independence. Morgan and a thousand of his men had been trapped in western South Carolina by eleven hundred British regulars under the command of Col. Banastre Tarleton. His back to the Broad River, Morgan selected a cattle pasture called Cowpens to make his stand. In an unorthodox move, he positioned his raw militia in the front line, his seasoned soldiers farther back on a slight rise in the pasture, and, still farther back behind a low ridge, his cavalry. When the British regulars were within a hundred yards, Morgan had the front-line men fire two quick volleys and then retreat behind the line of the seasoned soldiers, who also pulled back. Tarleton, sensing a quick victory, ordered his reserves to attack. At that moment, Morgan had his men pull back again, and then, with fixed bayonets, charge the on-rushing British soldiers while his cavalry encircled them. Thrown into confusion by the sudden change of events, the British surrendered en masse. Tarleton's regulars suffered a hundred dead and two hundred wounded; the patriots lost only twelve, with sixty wounded.[1] The defeat was a crushing blow to the British forces, and established Morgan as one of the war's leading military tacticians.

At the seventy-fifth anniversary of the victory at Cowpens, a group of the veterans met at the site and agreed "to organize a second pilgrimage to the historic spot on Broad River, and there build an enduring memorial for the centuries" for the centennial anniversary.[2] Because the remote battlefield and a small memorial placed there had been neglected and vandalized in the years since the battle, they decided to erect the centennial memorial in the neighboring town of Spartanburg. The Washington Light Infantry of Charleston, which had participated in the historic event, combined efforts with the Spartanburg Town Council, and on the ninety-ninth anniversary of the victory they addressed the governors of the original thirteen states and the state of Tennessee regarding the ceremony they wished to hold to commemorate the Battle of Cowpens. They planned

> . . . the erection of a memorial column, in gray granite, 22 feet high, complete in itself, so designed as to ensure great permanency and as well to be adapted to the reception of the bronze statue of General Morgan, proposed to be ordered by the Congress of the United States, a joint resolution being now before the United States Senate and House of Representatives, authorizing the Secretary of War to order this work done.[3]

On May 26, 1880, Congress approved a resolution[4] authorizing $20,000 for the monument. The government's appropriation was channeled through the War Department, which had also administered the funds for Ward's equestrian statue of General George H. Thomas, unveiled only nine months earlier in Washington, D.C. The success of the *Thomas* was undoubtedly a factor in the War Department's choosing Ward to do the *Morgan*. With the anniversary of the Battle of Cowpens only seven months away, Ward must have devoted his time exclusively to the Spartanburg statue, but, as 1880 drew to an end, it became evident that neither the statue nor the preparations for the ceremony would be ready by January 17—the actual anniversary—and the celebration was postponed until spring.[5]

In the ensuing months work progressed rapidly on the monument. Ward's model for the statue was shipped to Philadelphia, where it was cast in bronze by Bureau Bros. and Heaton. On February 23, 1881, H. Pelham Curtis, an officer detailed by the War Department to inspect the finished statue, wrote that the nine-foot, two-thousand-pound figure "fulfills perfectly every requirement of both Joint Resolution and contract."[6] In a personal note to Ward of the same date, Curtis wrote, "The statue seems to me a very noble work of art, and one which will add to your already high reputation as an artist."[7] In March the

statue was shipped from Philadelphia,[8] and was erected on a high pedestal situated in Morgan Square in the center of Spartanburg.[9] The pedestal, composed of an octagonal sub-base and a shaft with a Doric capital, was designed by the South Carolina architect Col. Edward B. White,[10] who had also designed the base for Ward's memorial to William Gilmore Simms (cat. no. 60), unveiled in Charleston in 1879. The monument and the planning of the celebration completed, the *Centennial Memorial to the Victors of Cowpens* was unveiled with great fanfare on May 11, 1881.

Represented in the midst of battle, the figure of Morgan is related to François Rude's statue of *Marshal Ney* (fig. 44), executed between 1852 and 1853 and situated on the Avenue de l'Observatoire in Paris. The two works are similar in composition. Ward, like Rude, has succeeded in evoking the essence of a historical drama through the portrayal of a naturalistic image. The portraits of *Ney* and *Morgan* are exuberantly staged statues that re-create the patriotism and excitement of past action. They celebrate legendary events. Ward himself described the work:

> After reading the biography of General Morgan, and studying the history of his military career, I felt it essential to a proper portrayal of his character, that the statue should represent a man of action—intrepid, aggressive, alert—at the same time I wished to indicate, by certain movements of the head and left arm, that there was a sympathetic quality, even a tenderness, in the nature of the daring General.
>
> I represented him with drawn sword, advancing with his troops, his attention for the moment attracted by some movement of the enemy on his left.
>
> The costume I found portrayed very accurately by Trumbull, which agreed with all recorded descriptions.
>
> The coat or tunic was a fringed hunting shirt, a garment adopted from the Indian costume, and much worn by the frontiersmen of that time.
>
> The fringed leggins and moccasins belonged to the same costume, which was used by Morgan's Riflemen.
>
> The cap, a peculiar one of fur, with a cluster of pine leaves as a sort of pompon, was loaned me by a gentleman of Charleston, through the kindness of the Hon. Wm. A. Courtenay. This was an original cap, preserved from the Revolutionary War. Although the sword and sash which belonged to his rank were used, yet I added the powderhorn as an indication of Morgan's characteristic disposition to use his rifle whenever the occasion admitted. Of course, the manner of wearing the hair, the cravat and ruffled shirt front are all in the mode of his time.[11]

RELATED WORKS:

67.1. Preliminary sketch model
 Bronze, h. 10⅝ in.
 Signed [cursive]: J.Q.A. Ward Sc.

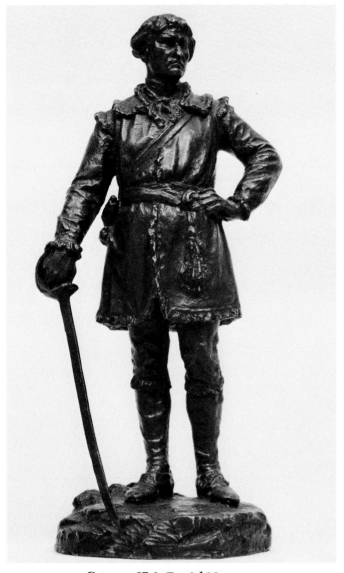

Cat. no. 67.1 *Daniel Morgan*

Founder's mark: GORHAM CO. FOUNDERS
Collection of Benjamin and Roslyn Bendit, New York City

This small, fluently modeled sketch reveals Ward's careful working of General Morgan's costume. The sketch lacks both the picturesque cap worn by the general and the exaggerated action that are found in the finished statue.

Ward's correspondence contains a note from a man who identifies himself as the husband of the great-great-granddaughter of General Morgan and who thanks the sculptor for the sketch model of the Morgan statue.[12] This piece, acquired by the present owners from a Vincent J. Stanulis of Torrington, Connecticut, is undoubtedly that work.

NOTES

1. H. S. Commager and R. B. Morris, eds., *The Spirit of*

'*Seventy-Six.* 2 vols. (Indianapolis and New York: The Bobbs-Merrill Company, 1958), 2, pp. 1153–1155.

2. Cowpens 1896, p. 18.

3. Ibid., p. 23.

4. Ibid., p. 47–48, quoting a letter from Major H. P. Curtis to Brig. Gen. R. C. Drum, February 23, 1881.

5. Ibid., p. 41.

6. Ibid., p. 47, letter from Curtis to Drum.

7. Letter from Major H. P. Curtis to JQAW, February 23 [1881] (N-YHS).

8. Letter from C. F. Heaton to JQAW, March 30, 1881 (AIHA).

9. In 1960, when the redesigning of Morgan Square was begun, the Battle Monument was moved 150 yards and turned 180 degrees. *Spartanburg Herald-Journal,* July 9, 1964.

10. Cowpens 1896, p. 42.

11. Ibid., p. 48–49. The "Hon. Wm. A. Courtenay" Ward referred to was the man with whom he corresponded in 1875 over the *Simms* memorial (cat. no. 60). In the letter from Major H. P. Curtis to Brig. Gen. R. C. Drum, p. 48, the basis for the costume is described: "A portrait of General Morgan in rifleman's dress, drawn by T. Herring, from a sketch by Colonel Trumbull, and engraved by Prudhomme, is given in the second volume of a work entitled "National Portrait Gallery of Distinguished Americans" published by Rice, Rutter & Co., in 1867, in Philadelphia." There is also a striking similarity in the attire of Ward's figure and that of Morgan as represented in Trumbull's "Surrender of General Burgoyne at Saratoga" in the United States Capitol.

12. Letter from F. B. McGuire to JQAW, December 29, 1898 (N-YHS).

68. THE MARQUIS DE LAFAYETTE

Statue, 1883

(Plate XIV)

Bronze, over life-size

Signed: J. Q. A. WARD/SCULP^{T.} 1883

Founder's mark: CHAS F. HEATON/FOUNDER
 PHILA PA

Architect of base: Richard Morris Hunt

Inscription on base [front]: LAFAYETTE [back]:
 THE GIFT OF/JOHN P • HOWARD

Unveiled: June 26, 1883

Burlington, Vermont

Marie Joseph Paul Yves Roch Gilbert du Motier Lafayette (September 6, 1757–May 20, 1834), French aristocrat, soldier, and statesman, was a hero of the American Revolution. In 1775, only nineteen years old, he became inflamed with the desire to aid the American colonists in their War of Independence. In 1777, he outfitted a ship and sailed for America, where he was appointed a major general in the Continental Army. He quickly won the trust and friendship of his idol, George Washington, whom he served as aide-de-camp at Valley Forge. Lafayette distinguished himself at the Battle of Monmouth and in the Yorktown campaign. He went home to France after the

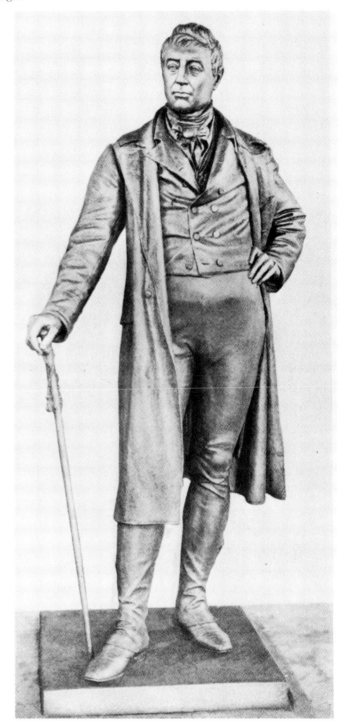

Cat. no. 68 *The Marquis de Lafayette.* Reproduced from Adeline Adams, *John Quincy Adams Ward: An Appreciation,* 1912.

war, spending five years in foreign prisons after the French Revolution. He dabbled in French politics when peace was restored, but was not effective in his own country. In America, however, he was always a hero. It was estimated that he had spent more than $200,000 of his own money during the American Revolution, and in 1803 Congress voted him a grant of land of 11,520 acres in Louisiana. Lafayette twice

made triumphal tours of the United States. In 1784 he was feted and toasted for six months as he traveled around the country, and a sixteen-month visit in 1824/25 inspired enthusiastic demonstrations unparalleled in American history.[1]

Ward's statue of Lafayette in Burlington, Vermont, portrays the sixty-four-year-old marquis on his second American tour. The monument, for which Ward was paid $25,000, was commissioned by John Purple Howard of Burlingham.[2] Ward completed two sketch models by June 1881, one showing Lafayette in military uniform; the other, in civil dress.[3] On Ward's recommendation, Howard selected the latter.[4] Over the next two years, Ward refined and enlarged the statue, which was finally cast in 1883 by Charles F. Heaton in Philadelphia. The memorial was unveiled on June 26, 1883, in a small park in front of the proposed site of the Billings Library, designed by Henry Hobson Richardson for the University of Vermont.

The naturalistic vigor of the *Lafayette* is superimposed on a classicized, Praxitelean figure. Ward's preoccupation with factual accuracy is revealed in William Walton's account of his search for a truthful likeness of the marquis:

> The sculptor had made unavailing efforts to find in France an authentic portrait of the period desired when, on the occasion of a moonlight excursion down the Potomac and a chance visit to Mount Vernon, he was overjoyed to discover in a corner just such a portrait bust [by David d'Angers], in plaster, of French workmanship, and liberally coated with whitewash by the careful guardians of the mansion. He was at that time modelling the head of the founder of the Corcoran Art Gallery; on his offer to present a copy of the bust in bronze in return for its loan Mr. Corcoran exercised a trustee's authority and enabled him to secure the portrait for his statue.[5]

RELATED WORKS:

Calling cards of a Madame A. Demetre contain notes that on June 27, 1922, she was reclaiming the statue of Lafayette she had lent to the American Academy of Arts and Letters the previous November at Mrs. J. Q. A. Ward's request.[6] The notes may refer to cat. no. 68.3. The American Institute of Architects Foundation has seven drawings by Hunt related to the base of the *Lafayette* (fig. 88).[7]

68.1. Preliminary sketch model
 Plaster, h. 15 inches
 The Art Commission of the City of New York

The Art Commission has no record of the provenance of the model.

Fig. 88 **Studio of Richard Morris Hunt, drawing for the base of the *Lafayette*, 1882. Pencil on paper. The American Institute of Architects Foundation, Washington, D.C.**

68.2. Preliminary sketch model
 Plaster, h. 15 in.
 Washington's Headquarters, Newburgh, New York

The statuette was given to the headquarters by Mrs. Ward in 1911.[8]

68.3. Preliminary sketch model
 Bronze, h. 14¾ in.
 Foundry mark: ROMAN BRONZE WORKS N-Y
 Collection of Lewis and Susan Sharp, New York City

This piece was acquired in New York City in 1983. It had no previous history.

NOTES

1. *DAB*, s.v. "Marie Joseph Paul Yves Roch Gilbert du Motier Lafayette."
2. "Monuments," *The American Art Review* 2 (July 1881), p. 137.
3. Letter from JQAW to J. P. Howard, June 30, 1881, Manuscript Division, Billings Library, University of Vermont, Burlington, Vermont.

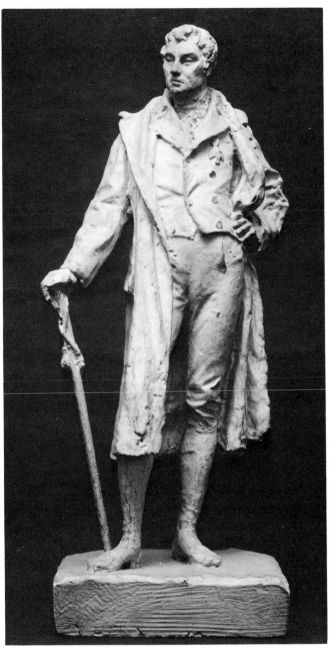

Cat. no. 68.1 *The Marquis de Lafayette*

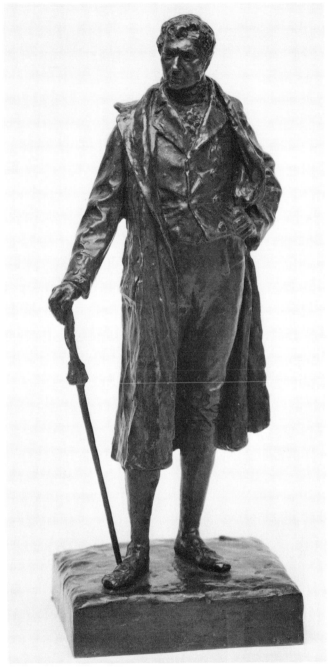

Cat. no. 68.3 *The Marquis de Lafayette*

4. Ibid.

5. Walton 1910, p. LXXXIV.

6. Calling cards, Madame A. Demetre, June 27, 1922 (AAAL).

7. "Lafayette," AIAF. See also Baker 1980, pp. 303, 306, 545; and letter from RMH to JQAW, February 22, 1882 (AIHA).

8. Accession file, Washington's Headquarters, Newburgh, New York.

69. GEORGE WASHINGTON
Statue, 1883
(Plates XV, XVI)

Bronze, over life-size

Signed and dated: J.Q.A. WARD/1883 Sculptor

Founder's mark: THE HENRY & BONNARD/
BRONZE MANUF'G COMPANY/NEW YORK 1883

Architect of base: Richard Morris Hunt

Inscription on base [lower base front]: ON THIS
SITE IN FEDERAL HALL/APRIL 30, 1789/
GEORGE WASHINGTON/TOOK THE OATH AS THE
FIRST PRESIDENT/OF THE UNITED STATES/OF
AMERICA [upper base front]: GEORGE WASH-
INGTON/BORN FEBRUARY • 22 • 1732/
WAKEFIELD • WESTMORELAND • CO/VIRGINIA •

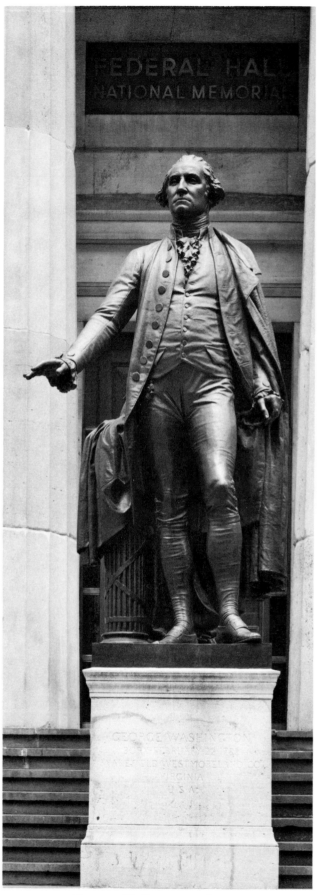

Cat. no. 69 *George Washington*

U • S • A [right]: ERECTED BY/VOLUNTARY
SUBSCRIPTION/UNDER THE AUSPICES/OF THE/
CHAMBER OF COMMERCE/OF THE/STATE OF
NEW YORK/NOVEMBER 26, 1883
Unveiled: November 26, 1883
Wall and Broad streets, New York City

This monumental statue, standing on the spot
where George Washington took the oath of office as
first president of the United States, commemorates
the moment that Washington lifted his hand from the
Bible, completing the swearing-in ceremony. The
monument was erected under the auspices of the
Chamber of Commerce of the State of New York from
funds raised by public subscription.[1] The proposal for
the statue was made by Elliot C. Cowdin, chairman of
the executive committee, and Horatio Seymour, gov-
ernor of the state, on February 5, 1880, at the Cham-
ber of Commerce's monthly meeting.[2] The proposal
was unanimously approved at a special meeting on
February 21, and a committee of twenty-five mem-
bers was appointed to oversee the project.[3] A bill sub-
mitted to Congress by Simeon B. Chittenden re-
quested permission to erect the statue on the steps of
the federally owned Sub-Treasury Building. Congress
approved the bill on December 22, 1880, with the
proviso that the statue become the property of the
government.[4]

When plans for the monument were initially an-
nounced, it was reported that the committee was con-
sidering as its sculptor Henry Kirke Brown, August
Saint-Gaudens, Olin Warner, or Ward.[5] On Decem-
ber 23, 1880, however, only Ward was requested to
make a model,[6] and on February 10, 1881, the Cham-
ber of Commerce issued a five-part formal recom-
mendation for:

1. The erection of a statue in bronze to George Washing-
ton alone, commemorative of his election as the first
President of the United States.
2. That it be placed on the abutment of the Subtreasury
Building on the corner of Wall and Nassau Streets.
3. That said statue shall be in all respects a complete
embodiment of the exalted character of Washington, to-
gether with the great event the statue commemorates,
and that no expense be spared to make it in all respects
worthy of the cause.
4. That J. Q. A. Ward, the sculptor, be requested to make
a model in clay of the statue, accompanied by suggestions
in regard to size, bas-reliefs, ornamentation of pedestal,
exact locality, etc., it being understood that, if the com-
mittee should approve and adopt his plans, designs, and
terms, Mr. Ward will be employed to do the work. If, on
the contrary, his plans, design, and terms should not meet
the approbation of the committee, he shall be paid $1,000
for his model.
5. That subscriptions be received at the rooms of the

Chamber of Commerce, and by the Treasurer, Morris K. Jesup, No. 52 William Street, for carrying out the foregoing recommendations. The statue is to cost from $30,000 to $50,000. The subscriptions received by Mr. Jesup, up to 2 P.M. on March 17th, amounted to $20,880.[7]

Though no specific reason was given for Ward's selection, he *was* the leading American sculptor at the time—a position that Saint-Gaudens would challenge some months afterward with the unveiling of his statue of Admiral Farragut in Madison Square Park in New York City.

Ward provided several models for the committee.[8] When compared with the finished statue, the sketch the committee approved (cat. nos. 69.2, 69.3) appears more attenuated, the position of Washington's feet is reversed, and the fascia and the cloak are omitted. In March 1882 Ward agreed to produce for $33,000 a thirteen-foot-high statue in bronze on a granite pedestal designed by Richard Morris Hunt.[9] The final, full-size statue, cast by the Henry-Bonnard foundry, was officially unveiled on November 26, 1883 (fig. 47)—the centennial anniversary of the evacuation of British troops from New York City.[10] The ceremony was witnessed on a cold rainy day by a crowd of six thousand people that included the president of the United States, Chester A. Arthur, and Grover Cleveland, governor of New York state.[11]

For historical accuracy Ward relied extensively on two of the most famous life portraits of Washington: Gilbert Stuart's Athenaeum painting and Jean-Antoine Houdon's statue at the Virginia State Capitol in Richmond.[12] While similarities in dress and composition between the two works indicate Houdon's strong influence on Ward, Ward's statue has a simplicity of detail lacking in the other. In his presentation of a major historical event Ward has produced a statue of complete creative integrity. Situated high on the steps of the old Sub-Treasury Building (now Federal Hall), the *Washington*, a well-developed, three-dimensional figure, dominates the plaza formed by the junction of Wall and Broad streets, and can be viewed to successful effect from any vantage point. One of the few statues by Ward that is regularly repatinated, the gleaming bronze figure stands out with perpetual drama against the light beige granite of Federal Hall.

RELATED WORKS:

Four preliminary sketch models of the *Washington* and one final one have been located to date. A sixteen-inch preliminary sketch model was advertised by Otto M. Wasserman, a New York City art dealer, in 1968,[13] but its present location is unknown. The original final sketch model, in plaster, that was offered by Mrs. R. Ostrander Smith to the Federal Hall National Memorial in 1941[14] also remains unlocated. It was undoubtedly the piece that Mrs. Ward lent to the Toledo Museum in 1912[15] and to the Panama-Pacific International Exposition in 1915.[16] Several of Ward's pencil sketches, preserved in the library of the Federal Hall Memorial, were given by Mrs. Smith in 1941.

69.1. Preliminary sketch model
 Plaster painted green, h. 15½ in.
 Federal Hall National Memorial, New York City

Gift of Mrs. R. Ostrander Smith, 1941.[17]

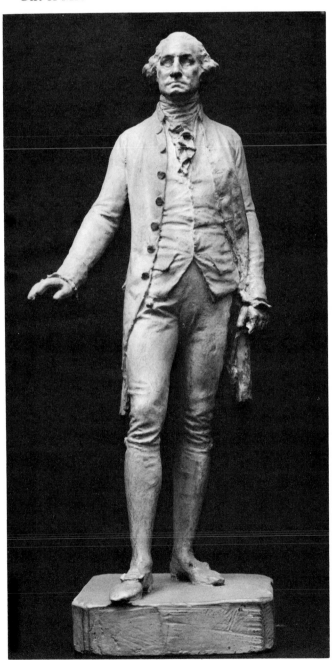

Cat. no. 69.2 *George Washington*

69.2. Preliminary sketch model
 Plaster, h. 15½ in.
 The Art Commission of the City of New York

There are no records pertaining to this piece.

69.3. Preliminary sketch model
 Plaster, h. 15½ in.
 Washington's Headquarters, Newburgh, New
 York

Given to the headquarters in 1911 by Mrs. Ward.[18]

69.4. Preliminary sketch model

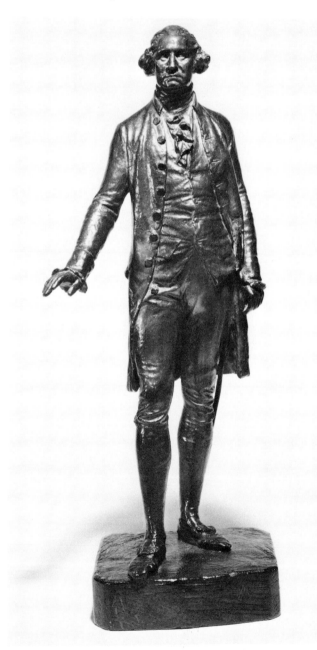

Cat. no. 69.4 *George Washington*

Bronze, h. 15¼ in.
Signed: J. Q. A. Ward Sc.
Founder's mark: GORHAM CO. FOUNDERS
Collection of Erving and Joyce Wolf, New York
City

James Graham & Sons, New York art dealers, pur-
chased this statuette at the Plaza Gallery in March
1961 from Arthur D. Whiteside.[19] Geraldine Rockefel-
ler Dodge then purchased it from Graham's in March
1962.[20] It was acquired by its present owners at the
Dodge estate sale in 1975.[21]

69.5. Final sketch model
 Bronze, h. 24 in.
 Signed [cursive]: J. Q. A. Ward/Sc.
 Founder's mark: GORHAM. CO. Founders./QGA
 Marble base inscribed: ORIGINAL SKETCH
 MODEL/FOR STATUE OF/GEORGE
 WASHINGTON/J.Q.A. WARD. SCULPTOR/
 ERECTED IN 1883/ON THE STEPS OF THE/
 SUB-TREASURY BUILDING/NEW YORK
 CITY/N.Y.
 The Metropolitan Museum of Art, New York
 City

The statuette was reportedly cast in bronze for Mrs.
Ward in 1911. It was purchased in 1968 by James
Graham & Sons of New York from Horace H. Tucker
of Manhasset, New York.[22]

NOTES

1. A complete financial record of the commission is in
the library of the Chamber of Commerce of the State of
New York, New York City. Also in the library is a summary
of the commission; see "Statue of George Washington,"
pp. 385–387.
2. COC 1880, pp. 93–94, 127.
3. "Statue of George Washington" (see n. 1), pp. 385–
386.
4. Ibid., p. 385.
5. "Summary," *The American Architect and Building
News* 9 (January 22, 1881), p. 8.
6. "Minutes of the Chamber of Commerce of the State of
New York," December 23, 1880.
7. "Notes and Clippings," *The American Architect and
Building News* 9 (February 19, 1881), p. 94; "Monuments,"
The American Art Review 2 (April 1881), p. 256.
8. COC 1882, p. XXI.
9. Typed copy of a letter from JQAW to R. Phelps,
March 2, 1882, library of the Federal Hall National Memo-
rial, New York City. There are numerous letters on the
subject from RMH to JQAW in the library as well as in the
Ward material at AIHA and N-YHS. See also Baker 1980,
pp. 306, 545.
10. Curtis 1883.
11. *New York Herald*, November 27, 1883, p. 3.
12. "Statue of George Washington" (see n. 1), p. 387.
13. *Antiques* 93 (February 1968), p. 185.
14. Letter from M. Kendall to G. Osborn, May 19, 1941,

library of the Federal Hall National Memorial, New York City.

15. *Catalogue of the Inaugural Exhibition: Toledo Museum of Art,* January 17–February 12, 1912, p. 63.

16. PPIE 1915, p. 246.

17. Letter from Kendall to Osborn, see n. 14.

18. Accession file, Washington's Headquarters, Newburgh, New York.

19. Sales records, James Graham & Sons, 1014 Madison Avenue, New York City, March 1961.

20. Ibid., March 1962.

21. *Important 19th and 20th Century American Paintings and Bronzes from the Collection of the Late Geraldine Rockefeller Dodge,* Sotheby Parke Bernet, sale 3802 (October 31, 1975), lot no. 2.

22. Letter from H. H. Tucker to R. Graham, February 5, 1968, copy (APS).

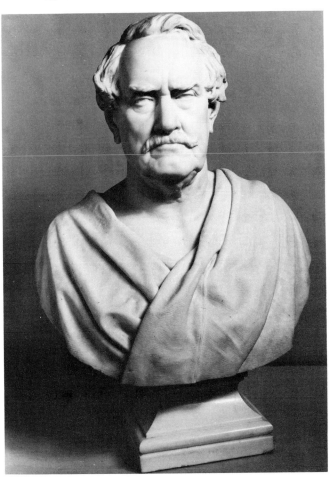

Cat. no. 70 *William Wilson Corcoran*

70. WILLIAM WILSON CORCORAN
Bust, 1883

Marble, h. 28 in.
Signed: J. Q. A. Ward/1883
In the Collection of The Corcoran Gallery of Art, The Trustees of Hillcrest, By Exchange. Washington, D.C.

William Corcoran (December 27, 1798–February 24, 1888) was a Washington banker and man of influence. He worked initially in his family's dry-goods business and managed his father's financial affairs. In 1840 he formed the banking firm of Corcoran and Riggs in Washington. The firm prospered, and through the successful buying and selling of federal bonds Corcoran established a personal fortune that enabled him in 1854 to retire from business to devote his time to the managing of his properties and the pursuit of his philanthropic activities. Corcoran gave large sums of money to universities, churches, and orphanages and founded, among other establishments, the Corcoran Gallery of Art.[1]

In 1882, in gratitude for Corcoran's generous gifts to it, the Washington City Orphan Asylum commissioned Ward to execute a portrait of its benefactor. In March, a representative of the orphange wrote Ward:

> The lady managers of the Asylum have *unanimously* voted to have the busts of Mr. Corcoran and Dr. Hall. I told them your price for the bust of Mr. Corcoran would be $1,200. . . .
> Mr. Corcoran says he would prefer you to model him in his *own* house & you can select a room with the proper light.[2]

When the bust of Corcoran was completed the following December, William MacLeod, curator of the Corcoran Gallery, wrote Ward that it had arrived safely in Washington and was "greatly admired by [Corcoran], the Art Committee and all who have seen it."[3] The bust was exhibited briefly at the Corcoran Gallery, during which time a critic wrote of the portrait:

> The Corcoran Gallery is recognized as the head centre of art in Washington. Its galleries are looked to for the latest gems, either purchased or on exhibition, and the close of 1883 finds exhibited there Mr. J. Q. A. Ward's marble bust of Mr. Corcoran. It was modelled nearly two years since, and was executed for a niche in the vestibule of the Protestant Orphan Asylum here, the recipient of a large share of Mr. Corcoran's wide range of charities, where it will be installed on his 85th birthday, December 27. . . .
> At present the bust is exhibited in the Greek Slave room, on one side of the north door, and just opposite is Calverly's marble bust of the late Dr. J. C. Hall, once President of the Board of Trustees of the gallery, and Mr. Corcoran's closest friend.[4]

The *Corcoran* is draped with the classical robe characteristic of Ward's portrait busts of the 1870s and 1880s. The portrait, modeled from life, is a naturalistic likeness of the pragmatic financier (fig. 89).

In 1939, Hillcrest, the Washington orphanage, exchanged the Ward *Corcoran* for the Corcoran Art Gallery's bust of its founder by Ulric S. J. Dunbar and a Dunbar sculpture entitled *The First Step.*[5] In 1949

Fig. 89 John Quincy Adams Ward, *William Wilson Corcoran*, sketch model, 1882. Photograph. National Museum of American Art, Smithsonian Institution. Washington, D.C.

Ward's bust of Corcoran was sent by the gallery on indefinite loan to the Louise Home, which Corcoran had founded as a refuge for destitute women in 1869.[6]

NOTES

1. *DAB*, s.v. "William Wilson Corcoran."
2. Letter from Fred [McGuire] to JQAW, March 8, 1882 (AIHA).
3. Letter from W. MacLeod to JQAW, December 14, 1883 (N-YHS).
4. "Art in Washington: Ward's Model of W. W. Corcoran," *Godey's Lady's Book* 108 (February 1884), pp. 179–180.
5. *Washington Times-Herald*, November 24, 1939.
6. Accession record work sheet, Corcoran Gallery of Art, Washington, D.C.

71. JOSEPH MEREDITH TONER, M.D.
 Bust, 1883

 Marble, over life-size
 Signed: not recorded
 Courtesy of the Library of Congress,
 Washington, D.C.

Dr. Joseph Toner (April 30, 1825–July 30, 1896), a Washington physician and writer, is remembered primarily as a collector of books and pamphlets on the career and writings of George Washington and on

America's contribution to medical history. In 1882 he gave his medical library to the United States government. The collection, numbering over 27,000 books, pamphlets, journals, pictures, charts, and medals, was the first major private library given to the Library of Congress.[1]

In testimony of its gratitude, the library authorized the commissioning of a bust of Dr. Toner.[2] The committee in charge initially wanted the portrait done for $1,000,[3] but Ainsworth R. Spofford, librarian in chief, wrote Ward in April 1883 that "all parties prefer a work from your design," and that they had agreed to a fee of $1,300.[4] On behalf of the committee, Spofford instructed Ward:

1. To select a choice block of marble, first class, for the purpose in view.
2. To model the Bust either life size, or a little above, as in your judgement is best suited to the subject, and to the locality where it is to go.[5]

Toner wrote to Ward in May 1883 to say that he would come to the sculptor's studio that month to begin the portrait.[6] The work was completed within eight months—an unusually short working time for

Cat. no. 71 *Joseph Meredith Toner, M.D.*

Ward—and was shipped to Washington in January 1884.[7]

The acutely realistic portrait of Dr. Toner, his shoulders wrapped in classical drapery, was modeled from life. The bone structure of the head is perceptible, as is the thickening of the flesh around the subject's chin and neck. In the lifelike anatomical likeness is a spirit and alertness visible in the upward tilt of the head and in the deeply undercut pupils gazing from the corners of the eyes; the compressed lips convey a sense of the determination, energy, and intelligence of the man himself.

NOTES

1. *DAB*, s.v. "Joseph Meredith Toner."
2. *Annual Report of the Librarian of Congress for the Fiscal Year Ending June 30, 1946* (Washington, D.C.: United States Government Printing Office, 1947), p. 125.
3. Letter from A. R. Spofford to JQAW, April 14, 1883 (N-YHS).
4. Ibid., April 20, 1883.
5. Ibid., n.d. (AIHA).
6. Letter from J. M. Toner to JQAW, May 11, 1883 (N-YHS).
7. Letter from A. R. Spofford to JQAW, January 9, 1884 (AIHA).

72. *THE PILGRIM*
Statue, 1884

Bronze, over life-size
Signed: J. Q. A. WARD/SCULPTOR 1884
Founder's mark: THE HENRY-BONNARD BRONZE CO./NEW YORK 1884
Architect of base: Richard Morris Hunt
Inscription on base [upper base front]: TO COMMEMORATE/THE LANDING OF THE/PILGRIM FATHERS/ON/PLYMOUTH ROCK/DECEMBER 21, 1620 [lower base front]: ERECTED BY THE/NEW ENGLAND SOCIETY/IN THE CITY OF NEW YORK/1885
Unveiled: June 6, 1885
Central Park, New York City

A proposal to erect a monument commemorating the early settlers of Massachusetts was made by Daniel F. Appleton on December 11, 1878, at the seventy-third annual meeting of the New England Society in the City of New York.[1] In his recommendation, Appleton suggested that

> . . . A statue of one of the Pilgrim Fathers of Plymouth, or of one of the Puritans of Massachusetts Bay—some typical historical personage of the earliest period of either of those colonies—would be the most acceptable and convenient form of the monument. . . .
>
> As for 'the ways and means,' I will only suggest that a small contribution might be asked from the members,

Cat. no. 72 *The Pilgrim*

limited in amount as to each one, to be continued until a sufficient sum would be secured. . . .[2]

No information exists relating to the commissioning of the monument or to Ward's progress on the statue. Ward's own correspondence contains only letters, receipts, and a contract pertaining to the pedestal designed by Richard Morris Hunt and constructed by the Hallowell Granite Company.[3]

At the presentation ceremony of the statue, it was noted that:

> The figure represents a Puritan of the early part of the seventeenth century, dressed in the severe garb of his sect, standing erect and looking off into the distance with earnest, searching gaze. One arm falls at his side; the

other rests on the muzzle of his old flint-lock musket. He wears the tall, broad-brimmed Puritan hat, which lends additional austerity to his stern but handsome features.[4]

Though in general the statue was well received by the press, a review written by Truman H. Bartlett in 1886 was severely critical.[5] In it he posed rhetorical questions: "What does the statue represent? What has it to do with the Pilgrims? and What are its merits as a work of art?"[6] To his own questions Bartlett replied, "[It] resembles the figure of a man dressed in old English costume . . . [and lacks] localization and historical connection, for there is nothing about it to show that it has any positive relation to Pilgrim life in Plymouth or any where else."[7] He continued: "As a work of art, what has the sculptor produced? 'The Pilgrim' as a work of art is, in its conception, meaningless, in its composition, discordant and extravagant; and, in its effect, pretentious."[8] His criticism of the statue as a mere costume piece was reinforced by Russell Sturgis in 1902, when he wrote:

In short, one would enjoy getting rid of the excessive call upon his attention made by the costume part of it, and getting at the man, with the hope of finding there the kind of human nature out of which the real Mayflower Pilgrim was made, to the almost complete exclusion of the clothes which invested that Pilgrim. It is sculpture we are talking about, and not costume, not archaeology, nor decorative art in the more common sense of the word, nor book illustration, nor historic record in the sense of that being the thing of prime importance. It is sculpture that we have in hand, and sculpture has as little to do as the conditions may allow with creased leather and crumpled cloth.[9]

The limitations of Ward's *Pilgrim* become even more evident when the work was compared to Augustus Saint-Gaudens's statue of a similar subject. *The Puritan*, erected in Springfield, Massachusetts in 1887, was intended, as Saint-Gaudens wrote in his *Reminiscences*, "to represent Deacon Samuel Chapin [one of the founders of Springfield], but I developed it into an embodiment . . . of the Puritan."[10] Saint-Gaudens, in conveying the determined, austere personality of one of the founders of the Massachusetts Bay Colony, was able to translate successfully an abstract idea into a sculpted form. *The Puritan*, dressed in flowing cloak and wide-brimmed hat and with cane and Bible in hand, is far more than a trite costume piece. The descriptive details do not detract from the statue's monumentality, but they are secondary to the sculptural mass of the figure, which is unified and contained within the formal triangular composition of the cape the Puritan wears. Ward, unlike Saint-Gaudens, was a factual, realistic sculptor; he understood the art of monumental sculpture but he was not

able, as *The Pilgrim* demonstrates, to commit to three-dimensionality anything his own eye did not see.

RELATED WORKS:

A sketch of *The Pilgrim* (fig. 90) was exhibited at the Panama-Pacific International Exposition in 1915.[11] It

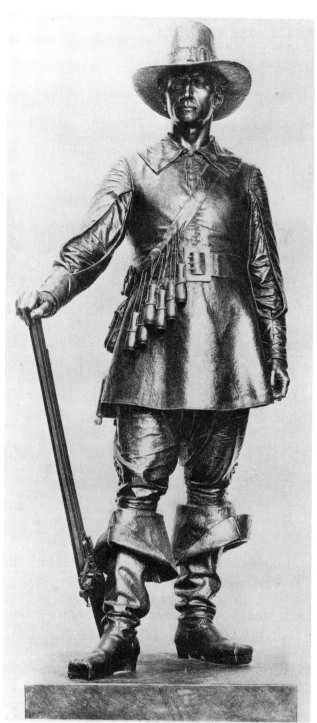

Fig. 90 John Quincy Adams Ward, statuette of *The Pilgrim*, 1884. Photograph. American Academy of Arts and Letters, New York City.

was probably the piece that Mrs. Ward lent to the American Academy of Arts and Letters in 1923[12] and that she instructed the academy to ship to a Dr. William V. V. Hayes in 1926.[13] The present location of that bronze statuette is not known. The full-size plaster model was acquired by the Art Institute of Chicago,[14] but it does not survive. There are three drawings related to the monument in the Hunt papers.[15]

NOTES

1. Pilgrim 1885, p. 6.
2. Ibid.
3. Series of letters between RMH and JQAW, and Hallowell Granite Co. and JQAW, November 25, December 3, 1884; March 7, March 17, June 25, December 3, 1885 (AIHA). See also Baker 1980, pp. 306, 308, 545.
4. Pilgrim 1885, p. 7.
5. Bartlett 1886, pp. 99–101.
6. Ibid., p. 107.
7. Ibid., pp. 107–108.
8. Ibid., p. 109.
9. Sturgis 1902, p. 389.
10. Saint-Gaudens 1913, 1, p. 354.
11. PPIE 1915, p. 246.
12. Letter from Mrs. W. Vanamee to Mrs. JQAW, January 26, 1923 (AAAL).
13. Letter from Mrs. JQAW to Mrs. W. Vanamee, December 10, 1926 (AAAL).
14. Reed 1947, p. 211.
15. "Pilgrim," AIAF.

73. WILLIAM EARL DODGE
Statue, 1885

Bronze, over life-size
Signed: J. Q. A. WARd/sculptor/1885
Founder's mark: THE HENRY-BONNARD BRONZE
 C⁰/NEW-YORK. 1885
Inscription on base [front]: WILLIAM EARLE [sic]/
 DODGE [back]: ERECTED BY/VOLUNTARY
 SUBSCRIPTION/UNDER THE AUSPICES OF THE/
 CHAMBER OF COMMERCE/OF THE/STATE OF
 NEW YORK/1885
Unveiled: October 22, 1885
Bryant Park, New York City

William E. Dodge (September 4, 1805–February 9, 1885), a prosperous dry-goods merchant in New York City, married Melissa Phelps in 1845. Five years later he formed the family firm of Phelps, Dodge and Company, which for two generations was a prominent dealer in copper and other metals. A deeply religious and civic-minded man, Dodge was one of the organizers and a strong supporter of the Young Men's Christian Association and the National Temperance Society.[1]

Cat. no. 73 *William Earl Dodge*

A published account of the unveiling of the *Dodge* reported that less than a month after Dodge's death:

It was suggested that a permanent memorial, to commemorate his life-long services to this community should be erected by his neighbors and fellow-townsmen. To carry out this suggestion, a number of his personal friends met at the rooms of the Chamber of Commerce (of which he had been the President for several years), on the 3d of March, 1883. At this meeting a Committee was appointed to consider and devise a plan which would most fittingly meet the wishes of the public. This Committee recommended that a bronze statue, of life-size, with a suitable pedestal, should be erected—by voluntary contributions—in some prominent part of the city. The recommendation was unanimously adopted, at an adjourned

meeting on the 12th of March. The Committee who were appointed to carry out this project were Messrs. William H. Fogg,* Samuel D. Babcock, Samuel Sloan, John A. Stewart, Morris K. Jesup, John Crosby Brown, and Charles Lanier. Mr. Jesup consented to act as Treasurer, and cheerfully devoted his time and energies to the undertaking until its successful completion. Three hundred and eighty persons contributed their subscriptions of money; and the construction of the statue was intrusted to the distinguished sculptor Mr. J. Q. A. Ward. The spot designated for its erection was at the intersection of Thirty-fourth Street, Broadway, and Sixth Avenue. In recognition of MR. DODGE's life-long devotion to the cause of temperance, a beautiful drinking-fountain of pure cold water is connected with the granite pedestal. The ceremonies of unveiling and dedicating the monumental statue took place on the afternoon of the 22d of October, 1885.[2]

Until 1939 the *Dodge* remained at Herald Square on its original pedestal designed by Richard Morris Hunt (fig. 53). It was relocated in Bryant Park in 1941.[3] Hunt's base was not saved, and the statue now stands atop a rectangular granite base which is conceived neither as an integral part of the monument nor of its urban surrounds.

The *Dodge*, while showing the influence of the French Beaux-Arts style, is rendered in the best tradition of the sculptor's objective naturalism. The self-assured Dodge is shown pausing in a speech, his right arm resting on two books placed on top of a fluted pedestal and his open overcoat revealing a double-breasted frock coat. Ward's gifted handling of the bronze endows the figure with a vibrant, vigorous presence.

The busts of Dodge (cat no. 82) at The New-York Historical Society and at The Chamber of Commerce of the State of New York were modeled preliminary to the statue but were not carved in marble until 1888.

NOTES

1. *DAB*, s.v. "William Earl Dodge."
2. Dodge 1886, pp. 13–14. "*Mr. Fogg subsequently died and Mr. A. A. Low was appointed to fill the vacancy" (p. 14). In a letter of July 17, 1885, to G. Wilson (Archives, The Chamber of Commerce of the State of New York) regarding a date for unveiling the *Dodge*, Ward wrote: "The statue will be all completed in bronze before the 1st of October next so that any date after the first suits me."
3. Files 2284-A, B, and C. The Art Commission of the City of New York. The *Dodge* was moved to make room for the James Gordon Bennett Memorial.

74. WILLIAM HAYES FOGG
Bust, 1886
(Plates XVII, XVIII)

Marble, h. 30 in.

Signed: J.Q.A. Ward/1886
Union Theological Seminary, New York City

William Fogg (December 27, 1818–March 24, 1884) was a New York philanthropist and China-trade merchant. A highly respected member of the New York business community, Fogg was associated with many of the city's leading financial and charitable institutions. One of the founders of the Union League Club, he was also an active member for twenty-five years of the Chamber of Commerce,[1] and a Fellow in Perpetuity of the National Academy of Design.[2]

After Fogg's death, Elizabeth Perkins Fogg commissioned Ward to execute a marble bust of her husband, and a model was completed by March 1886. After inspecting the portrait, Mrs. Fogg wrote Ward that she thought the hair on the back of the head was too thick and that instead of the coat and collar she preferred a cloak or drapery over the shoulder, in order that the style of the portrait "look as well fifty years hence as the present."[3] Ward undoubtedly made the minor adjustments that Mrs. Fogg requested, but he must have realized that a nineteenth-century China-trade merchant in classical dress and shaggy muttonchops would look ridiculous to future generations. In an effort to appease his patron, Ward draped a robe over the bust's left shoulder, but did not attempt to hide the businessman's attire. The drapery's agitated folds enliven the quality of the work, and Ward's portrait formula of the period is thus varied in a pleasing way.

Mrs. Fogg, in her bequest of 1892, left the bust to the Union Theological Seminary, along with funds for the library. The bust is displayed at the seminary on its original dark green pedestal, one of the few instances in which the two original elements have remained together. Mrs. Fogg also left thirty thousand dollars to the National Academy of Design and provision for a bronze statue of her husband.[4] Because Ward had already done the bust of Fogg, he was to be the executors' logical choice for executing the statue (cat. no. 100).

NOTES

1. *New York Times*, March 25, 1884, p. 5.
2. Clark 1954, p. 277.
3. Letter from E. Fogg to JQAW, March 15, 1886 (N-YHS).
4. Letter from D. Smith to JQAW, July 13, 1892 (N-YHS).

75. WILLIAM H. VANDERBILT
Bust, 1886

Bronze, h. 22 in.

Cat. no. 75 *William H. Vanderbilt*

Signed and dated [cursive]: J Q.A. Ward/1886
Founder's mark: THE HENRY-BONNARD BRONZE
 CO./N.Y. 1888
Inscribed: W<u>m</u> H VANDERBILT
College of Physicians and Surgeons, Columbia
 Medical Center, New York City

William H. Vanderbilt (May 8, 1821–December 8,
1885) was the only son of Cornelius, the steamship
and railroad tycoon. Although he was a sickly child,
underestimated at first by his father, William's astute
management of his Staten Island farm and of the local
railroad caused Cornelius to make him an executive in
the railroad empire he was then consolidating. When
Cornelius died, in 1877, he left the bulk of his estate,
estimated at a hundred million dollars, to William,
who expanded it to two hundred million dollars within
eight years. William built a large town house in New
York on Fifth Avenue between Fifty-first and Fifty-
second streets, and he acquired what was considered
one of the finest art collections in the country. A
generous philanthropist, he financed the transfer of

the Central Park Obelisk from Egypt and its erection
in the park, and gave large sums of money to the
Y.M.C.A., The Metropolitan Museum of Art, Vander-
bilt University, St. Bartholomew's Episcopal Church,
and, shortly before his death, five hundred thousand
dollars to the College of Physicians and Surgeons for
new buildings.[1]

Ward was modeling the bust of Vanderbilt at the
time of the financier's death in 1885. A contemporary
newspaper reported:

> Here is where Wm. H. Vanderbilt gave Ward a sitting and
> took his last sleep on earth two hours before his death.
> The bust of Mr. Vanderbilt intended for the new college
> of Physicians and Surgeons is in a good state of forward-
> ness, and can be easily finished. The artist perfected the
> profile at the last sitting, located the ear, gave the hair
> important touches, and completed all the 'large planes' of
> the face, as they are called.[2]

The *Vanderbilt*, a sensitive and realistic portrait of a
man dressed in contemporary clothing and sporting
bushy muttonchops, is proficiently modeled, cast, and
finished. It is dated 1886, and there is no record of
why it was not cast by the Henry-Bonnard foundry
until two years later. It was the sculptor's first bust not
done as a public work to be executed in bronze rather
than in marble, and that could explain the delay. Ward
had shown an affinity for working in bronze from the
beginning of his career. First in Brown's studio and
then on his own, he had used it for executing a large
number of statuettes and statues. He understood the
medium and was able to exploit its expressive qual-
ities to heighten greatly the vitality of his busts. In the
Vanderbilt, Ward's mastery of the technique of work-
ing the metal is evident in the contrasts of surface
texture and in the rich color of the patina: a vibrancy
of light results that endows the work with a more
intense realism.

RELATED WORKS:

Included in the Ward Memorial Collection busts
that the sculptor's widow gave to New York Univer-
sity in 1922 were "those of William K. Vanderbilt (two
of them), one of Vanderbilt's son," and a death mask.[3]
There is no record of Ward's having done a bust of
William K. Vanderbilt, and it must therefore be as-
sumed that the reference is to this bust of William H.
Vanderbilt or to that of William's son Cornelius (cat.
no. 113) or that of Cornelius's son William Henry (cat.
no. 101). The present locations of the objects men-
tioned as among the collection are not known.

NOTES

1. *DAB*, s.v. "William Henry Vanderbilt."

2. Unidentified newspaper clipping in Ward, "Scrapbook," opp. p. 26, N-YHS.

3. Memorandum from H. O. Voorhis, October 10, 1922 (WMC).

Cat. no. 76 *The Anthony Weston Dimock Armchair*

76. THE ANTHONY WESTON DIMOCK ARMCHAIR
Carved decoration, 1886

Oak, h. 59½ in.
Inscribed [on crest rail coat of arms]: PRO REGE
DIMICO
The Brooklyn Museum, Brooklyn, New York

This ornately carved armchair, originally upholstered in alligator, is the only piece of furniture that Ward is known to have carved. Anthony Weston

Dimock (August 27, 1842–September 12, 1918), a wealthy financier, sportsman, and author, was a close friend of Ward's. Before he was twenty-one, Dimock had been accepted as a member of the New York Stock Exchange, by twenty-three he dominated the country's gold market, and by thirty he controlled the Bankers and Merchants Telegraph Company and served as president of the Atlantic Mail steamship line and several other maritime companies. Later, he played a principal role in the development of Elizabeth, New Jersey.[1] In 1880, a small group of men including Ward and Dimock acquired two thousand acres at Peekamoose in the Catskill Mountains, and there established a fishing club (fig. 51).[2] The club was disbanded after Ward and Dimock had a falling-out in the 1890s,[3] and Ward bought up the club land adjoining his property (fig. 50). Despite the rupture in their relationship, Dimock, in a book he published in 1915, wrote affectionately of Ward and of the many hunting and fishing trips they had enjoyed together.[4]

An entry in Dimock's diary reads: "1887 January 6, Thursday, Carved chair arrived from J.Q.A. Ward. Took some good photographs of it. Wrote Ward in eve."[5] The chair is richly carved with floral motifs; its armrests, carved in the form of crocodiles, celebrate that Dimock was one of the first to establish that crocodiles and alligators were two separate species.[6] The chair was given to the museum in 1964 by Judge E. J. Dimock, Anthony W. Dimock's son.[7]

NOTES

1. *New York Times*, September 13, 1918, p. 11.

2. Photograph album, given to JQAW by A. W. Dimock (AIHA). The album contains many photographs of Ward and of other friends at Peekamoose.

3. "Chat of Collectorship," *The Collector* 7 (September 15, 1896), p. 291.

4. A. W. Dimock, *Wall Street and the Wilds* (New York: Outing Publishing Company, 1915), pp. 232, 251, 419. A photograph opp. p. 128 shows Ward at table with Dimock and his family outside their Catskill cabin.

5. Letter from E. J. Dimock to M. Schwartz, January 27, 1964, Archive file, Brooklyn Museum.

6. D. H. Pilgrim, "Decorative Art: The Domestic Environment," *The American Renaissance, 1876–1917* (Brooklyn Museum, 1979), p. 144.

7. Catalogue record, Archive file, Brooklyn Museum.

77. SOLDIERS AND SAILORS MONUMENT, BROOKLYN
Proposed design, 1886

In March 1883 Alexander E. Orr wrote Ward that the citizens of Brooklyn were planning to erect a memorial to the Americans who had died for their country in battles on land and sea. They intended to

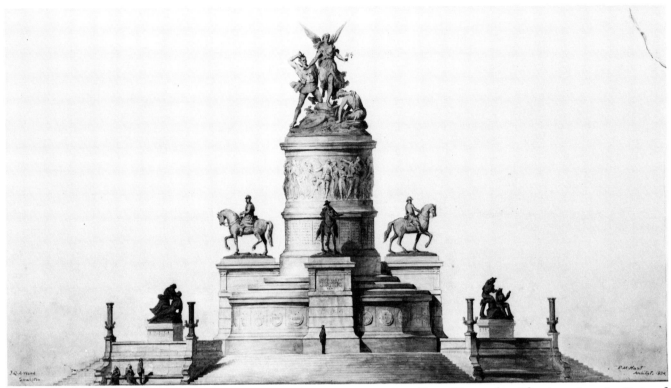

Cat. no. 77 Richard Morris Hunt, *Soldiers and Sailors Monument*, Brooklyn. Watercolor. The American Institute of Architects Foundation, Washington, D.C.

spend $250,000 for it, and were soliciting prominent sculptors and architects for their ideas. Orr, chairman of a subcommittee for the proposed monument, invited Ward to meet with the subcommittee with an architect of his choice (which was Richard Morris Hunt) on March 9.[1] In April, the subcommittee was still unsure of its course of action, but continued to be committed to a monument in the specified price range.[2]

Exactly when Ward and Hunt were selected to do the work is not clear, but by the spring of 1885 the design was so close to completion that a description of it was published in the *New York Tribune*.[3] The account caused some strain between Ward and Hunt, since the only name mentioned in the article was Ward's. In a letter to the sculptor, Hunt wrote:

The enclosed slip from yesterdays Tribune rather surprised me as I was under the impression that the design was mine. Now, it may be from pure "cussedness" on the part of the Tribune reporter—as I am not liked in that quarter—but be this as it may I wish you would write to the paper & adjust the matter right. This is not only to avoid future complications and misunderstandings but also to correct the mistake while fresh in the mind of the public.[4]

In response, Ward wrote to Orr:

The enclosed clipping from the New York Tribune has

been sent me by Mr. Hunt who feels aggrieved at the omission of his name in this matter. He has asked me to have the thing corrected, on general principles. I never ask a newspaper to correct any statement about any work in which I am at all involved. But there may be some one in Brooklyn connected with your committee who would ask for a simple correction of the paragraph. Stating that Mr. Hunt and myself act together in this matter, and that our names should not be used [one] without the other.[5]

Ward and Hunt's plan, if it had been executed, would have been at that time the largest and most complex public monument in America. While the artists were still gathering final cost estimates for the project,[6] Mayor Seth Low of Brooklyn, in a form letter to the general committee, invited them to the Art Association on February 9, 1886, to inspect the proposed model of the monument.[7] Anticipating that there might be objections to the monument's size and cost, Ward and Hunt wrote a detailed letter to Orr, which he had printed and distributed to the entire committee. It read:

119 West Fifty-second Street,
New York, February 8th, 1886

ALEX. E. ORR, Esq.
 Chairman Sub-Committee for the Brooklyn Soldiers and Sailors Monument.
DEAR SIR:
 At the request of your Committee, we have just com-

pleted a model of the proposed BROOKLYN SOLDIERS AND SAILORS MONUMENT, substantially the same in design as the drawing submitted to your Committee last year. The model is made on a scale of one-half (½) inch to the foot; the material proposed being the same as suggested by your Committee—granite and bronze.

As the purpose of this model is only to show the general aspect of the design from all points of view, you will not expect to find detailed expression carefully studied, either in the architectural forms or in the statuary.

All of the sculpture on the monument would be of bronze, except the "relief" on the upper drum of the shaft, which would be cut in the stone. A detailed description of the architectural portion of the design will not be necessary, as the model is before you; but, the main dimensions are as follows:

Whole height of monument from the ground to the top of the crowning group,	78 feet
Height of large platform, .	6 "
" base of column,	16 "
" of column, .	32 "
" of crowning group,	24 "
Diameter of platform, .	120 "
" base of column,	46 "
" lower drum of column,	18 "
" upper " " 	16½"
Dimensions of "relief" in stone on upper drum, .	9 feet by 49½"
Height of equestrian statues,	15 "
Dimensions of bronze "relief" encircling base of column,	5 feet by 120 "
Height of seated statues on large platform,	8 "

The sketches for the statuary require more explanation as, on such a small scale, it is difficult to make a clear statement without great labor and much time. Some of the members of your Committee who are familiar with the development of this design will, perhaps, kindly explain whatever I do not make clear in this letter. The crowning group represents PEACE, with extended olive branch separating two combatants; her right hand restrains the stronger, while her sympathies seem more directed towards the weaker, who, with broken shield and sword, is in a more defenseless condition. Below this group, on the upper drum of the shaft, is suggested a "relief," to be cut in the stone, symbolizing the Industries, Sciences, and Arts, that are fostered by a free and established government. On the lower drum, ample space has been provided for a record of all the battles in which Brooklyn's heroes have participated. On the four abutting pedestals, at the base of the shaft, stand equestrian statues of generals representing the four epochs in our military history:

> WASHINGTON—1776, with inscription: "To those
> who Founded." (the Nation).
> JACKSON—1812:
> "To those who Defended."
> SCOTT—1847:
> "To those who Extended."
> GRANT—1861:
> "To those who Preserved."

On this last pedestal, facing the front of the monument, would be placed the dedicatory inscription:

Surrounding the base of the shaft is indicated a bronze "relief" five (5) feet high, in which all such illustrations of the late war and its results, as are determined upon, could be portrayed in detail. The subjects to be illustrated must be selected with careful consideration—some, however, suggest themselves at once, for instance: the departure of volunteers to defend their country, "Woman's Work" in the late war, the battle of the "Monitor" and the "Merrimack," the emancipation of the slaves, etc.

On the outer circle of the large platform, and flanking the steps leading to it, are figures representing the four arms of the service: Infantry, Cavalry, Artillery, and the Navy.

On the upper part of the shaft, under the figure of PEACE, and over the statue of GRANT, are inscribed the words, "Let us have Peace."

When your Committee asked us to prepare a design for this monument, the sum of two hundred and fifty thousand dollars ($250,000) was suggested as a limit to the expense; but, after surveying the location and studying the scope and intention of the work, and its necessary magnitude, we have been led to submit to you a design which will involve a larger expenditure; but, in reviewing the whole matter at the present moment, it does not seem feasible to do less and meet the requirements of the subject, the place and the age.

The probable time in which to complete the whole work would be six or seven years.

Hoping that the design may interest your Committee and your citizens,

> We are,
> Very respectfully yours,
> R. M. HUNT,
> *Architect.*
> J. Q. A. WARD,
> *Sculptor.*[8]

The cost of the proposed monument sent shock waves through the members, and the project did not stir the patriotic sentiment that Low and Orr had hoped for. Low, as he left for a trip abroad, offered a compromise in a letter he wrote to the committee:

Since the meeting at the Art Rooms on the 9th inst. Feb. I have . . . succeeded in interesting several gentlemen who agreed to pledge $10,000 apiece and to serve upon the Mont. Com. provided the total sum needed could be raised within a reasonable time. . . .

Our efforts have led us to believe that it will not be practictable to raise so large a sum for this purpose and I am therefore unable to announce the commission as I had hoped to do before sailing for Europe on the 20th inst. I have requested Mr. Orr, the Chairman of the late Comtee on design to call the general Comm together in case you desire to take any action during my absence. I am happy to say that the five gentlemen who have pledged $10,000 apiece have agreed to renew their pledges upon the following conditions—

That a monument from acceptable designs costing not less than $250,000—shall be erected by the committee to be named by me & that the whole sum needed be in hand or

Fig. 91 Studio of Richard Morris Hunt, *Peace*, for the *Soldiers and Sailors Monument*, Brooklyn, 1885. Pencil on paper. The American Institute of Architects Foundation, Washington, D.C.

subscribed within two years from this date. . . .
I can not help thinking that very much that is admirable in the present model may be met within the figure named—$250,000. . . . It is not to be forgotten in this connection that the figure set by ourselves always has been $250,000 & the large sum was contemplated only to meet the estimated cost of building upon the model proposed by the architect and sculptor.[9]

In an effort to raise funds, the committee approached officials of the city government. In May 1887, after much debate and an unsuccessful effort to appropriate the full $250,000, they rejected the monument.[10]

RELATED WORKS:

The model for the monument does not survive. The American Institute of Architects Foundation has four drawings and watercolors relating to the work, including the large, finished watercolor of the proposed monument (cat. no. 77) and a sketch of the crowning group (fig. 91).[11]

NOTES

1. Letter from A. E. Orr to JQAW, March 7, 1883 (N-YHS).

2. Letter from A. E. Orr to S. Low, April 2, 1883 (N-YHS).
3. *New York Tribune*, March 25, 1885. See also Baker 1980, p. 308.
4. RMH to JQAW, March 26, 1885 (AIHA). Almost a year later, on March 3, 1886, RMH wrote to JQAW again (N-YHS). His complaint then was that in newspaper accounts of the presentation of the model at the Art Association only Ward's photograph was included.
5. Letter from JQAW to A. E. Orr, March 28, 1885 (N-YHS).
6. Letter from RMH to JQAW, January 23, 1886 (N-YHS).
7. Form letter from S. Low, January 30, 1886 (N-YHS).
8. Printed letter from JQAW & RMH to A. E. Orr, February 8, 1886 (N-YHS). A draft of the letter in JQAW's hand is also present.
9. Copy in JQAW's hand of a undated letter that was written by J. Low to the committee (N-YHS).
10. *New York Times*, May 10, 1887, p. 8.
11. "Soldiers and Sailors Monument, Brooklyn," AIAF.

78. THE JAMES ABRAM GARFIELD MONUMENT
1887
(Plates XIX, XX, XXI)

Bronze statue of James Abram Garfield, over life-size
Signed: J.Q.A. WARD/SCULP./1887
Founder's mark: THE HENRY-BONNARD BRONZE CO./NEW YORK

Bronze statue of the Student, over life-size
Signed: J.Q.A. WARD/sculp.

Bronze statue of the Statesman, over life-size
Signed: J.Q.A. WARD/sculp.

Bronze statue of the Warrior, over life-size
Signed: J.Q.A. WARD/sculp.

Architect of base: Richard Morris Hunt
Inscription on base [front]: JAMES. A. GARFIELD/1831–1881 [left]: MAJOR-GENERAL U-S-V,/MEMBER OF CONGRESS,/SENATOR,/AND/ PRESIDENT/OF THE/UNITED/STATES/OF/ AMERICA. [right]: ERECTED/BY HIS COMRADES/ OF THE/SOCIETY OF THE ARMY/OF THE/ CUMBERLAND/MAY 12, 1887.
Unveiled: May 12, 1887
The Mall, Washington, D.C.

The Garfield Monument, one of the finest statues in the sculptor's oeuvre, was the second work that the Society of the Army of the Cumberland commissioned Ward to execute for Washington, D.C.[1] James A. Garfield (November 19, 1831–September 19, 1881),

twentieth president of the United States, was, like Ward, a native of Ohio. Elected president in 1880, he was assassinated only four months after his inauguration by Charles J. Guiteau, a Chicago lawyer and disappointed office-seeker. Garfield's tragic death inspired a number of laudatory biographies and memorials in his honor.[2]

Garfield had been a member of the Society of the Army of the Cumberland. At the society's 1881 reunion, held in Chattanooga, a resolution was adopted providing for the appointment of a Garfield Monument Committee, composed of nine members of the society and chaired by General James Barnett.[3] At that time the committee was charged only with raising funds for the memorial. On November 16, 1881, it issued a fund-raising circular;[4] the following year it selected Washington, D.C., as the site of the memorial, in order to secure federal money;[5] and on July 15, 1882, Congress gave the society $7,500, an amount realized from the sale of condemned cannon.[6] The circular had proved ineffectual in attracting public funds, however, and to swell the coffers a Garfield Monument Fair was held in Washington on November 25, 1882. $14,990 was raised.[7] A resolution at the society's annual reunion that same year expanded the committee's responsibility and authorized it to "proceed to take the necessary steps to construct and erect said monument."[8]

At the society's next annual reunion, in 1883, Barnett reported that the Committee had accepted

> . . . a design prepared by Mr. J. Q. A. Ward, the eminent artist who so successfully and satisfactorily modeled and erected the *THOMAS* monument. The price agreed upon for statue and pedestal is $60,000, payable on the completion of the work, and its acceptance by the Committee. . . .
>
> The Committee have promises and assurances from prominent members of Congress that the sum of $30,000.00, which is the estimated price of the pedestal, will be appropriated in accordance with precedents on former like occasions. . . .
>
> A Sub-Committee on a Site for the Monument visited Washington, and there, aided by the artist, selected a place which to them seemed suitable; but the definite selection depends upon congressional concurrence and legislation.[9]

In response to the society's request for funds for the pedestal, Congress appropriated $33,000 on July 7, 1884, and appointed a committee of three men— William C. Endicott, secretry of war, Senator John Sherman, chairman of the Joint Committee on the Library; and General James Barnett, of the Society of the Army of the Cumberland—to oversee its expenditure.[10] On November 19, after reviewing possible sites

for the monument, the committee approved the one on the edge of the Capitol grounds, near the intersection of First Street and Maryland Avenue,[11] and requested Ward to submit designs and specifications for the pedestal.[12] Three months later Ward complied, offering Robert T. Lincoln, the new secretary of war, a model for the *Garfield* along with a plan and elevation drawn by architect Richard Morris Hunt.[13] In a letter of explanation to Lincoln, Ward wrote:

> I have your kind letter of the 7th inst. and send as suggested such drawings plans and specifications as I have prepared for your inspection.
>
> I send also . . . a small sketch model—to further illustrate my design—it is the same that was submitted to and accepted by the Garfield Monument Committee of the Society of the Army of the Cumberland.
>
> I cannot at present give you a more detailed representation of my intentions. . . . The final design . . . can only be determined when the full sized figures are advanced in the clay.
>
> Then as to how much bronze decoration can be safely applied to the granite with good effect . . . can only be properly determined as the work develops. . . .
>
> As to the limitations of time in which the work shall be finished, were it only the granite work, there would be no hesitation in fixing a precise date. I have contracted with the Committee of the Army of the Cumberland to finish and place in position the Statue of Garfield before the 15th of Sept. 1886 "unless sickness . . . should prevent" . . . the only reasonable promise that a sculptor can make, if he is conscientious.
>
> The motif of the figures on the base of the pedestal is to suggest what I considered the three important phases of Garfield's life. The *Student*, the *Warrior* and the *Statesman*. With the study that I should hope to give to these statues they would cost me much more time, *each one*, than the large statue of Garfield—and it is for this reason that I wished to control the design and construction of the entire pedestal in order that I might convert as much as possible of the appropriation into artistic work.[14]

Ward, his design and specifications having been approved by the Congressional committee, signed a contract on April 7, 1885, to provide the pedestal and its allegorical figures for $29,000 by September 15, 1886.[15] In February 1886, he wrote to Thomas Casey of the Army Corps of Engineers, requesting additional time to complete the pedestal. He said:

> My reason for wishing further time is that I may make a better work by studying the three figures on the pedestal with the statue of Garfield—to do this I must retain all of the models in my studio until the last one is nearly completed, thereby losing the advantage of sending some of them to the foundry in advance of others. I cannot safely let them leave the clay until they are studied "ensemble."[16]

Ward was given the extension, with May 1887 set as

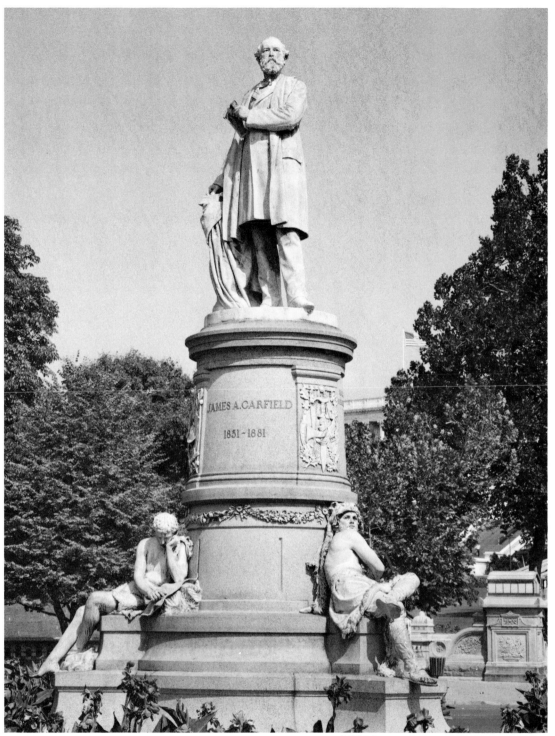

Cat. no. 78 *The James Abram Garfield Monument*

the new date for the unveiling ceremony.[17] Even so, he worked right up until the final date. On April 14, less than a month from the unveiling, he wrote to Col. John M. Wilson, who was in charge of the ceremony:

We expect to have the granite work all done by Saturday next. I have concluded to ship the bronze work on Tuesday next. The men from the foundry will follow immediately and begin mounting them on the granite.

I expect, however, as I told you, to use all the time I can before the 10th of May in completing details and wish to defer the coloring of the bronze figure until the last day, say the 10th proximo, so that they may not be handled until the monument is finally exposed.[18]

With all the statuary in place, the monument was unveiled on May 12, 1887, a beautiful, cloudless day. The ceremony was attended by President Grover

Cleveland, members of Congress and the Supreme Court, officers of the Society of the Army of the Cumberland, and both Ward and Hunt. After a lengthy address by General J. Warren Keifer, the monument was presented by General Philip H. Sheridan to President Cleveland, who received it on behalf of the nation.[19]

The *Garfield*, then Ward's most ambitious public monument, displays how thoroughly he had absorbed the neo-baroque style of the French École des Beaux-Arts. That influence is evident in the successful integration of the architecture and sculpture of the monument, in the invigorated realism and animated poses of the statues, and in the sculptor's use of allegorical figures to personify various periods in Garfield's life. Hunt's pedestal consists of a tapered cylinder superimposed on a triangular base whose corners form rectangular seats for Ward's three reclining figures. The cylinder is divided into horizontal sections by decorative moldings that produce a series of graduated architectural masses and lines—a rich movement of receding and projecting elements with inherent highlights and shadows that transport the viewer's eye to the dramatic figure of Garfield. As if pausing in an address, Garfield holds the text of his speech across his chest and looks emphatically out at his audience. The light topcoat he wears eliminates all extraneous detail and creates a simple, massive sculptural form over which his head, modeled in detail, stands out in vivid contrast. Equally animated in pose and far more complicated in decorative details are the base figures employed by Ward to show what he "considered the three important phases of Garfield's life."[20] The first, the *Student*, personifies Garfield's academic career as a teacher of literature and ancient languages before the Civil War, and is represented by a reflective young man draped in sheepskin, who leans his cheek on his left hand and marks his place on the parchment he is studying with his right index finger. A decorative tablet above the figure contains a globe set into a shield. The second statue, the *Warrior*, signifies Garfield's accomplishments as an officer during the Civil War and is portrayed in a bearded barbarian who sits with his left ankle resting on his right knee. His head is turned, and he looks defiantly back over his shoulder, supporting himself on his left hand and covering his body with his right arm to clutch the hilt of his sword. A wolfskin protects his head and shoulders, and he wears leather braccae. In the tablet above the figure a trumpet and sword hang from a shield. The third base statue, the *Statesman*, represents Garfield's career as congressman and president in the years after the Civil War. The statue is illustrated as a mature

man dressed in a classical toga and wearing sandals. His right foot rests on a stack of books; his right hand crosses his body and holds a tablet inscribed LAW/JUSTICE/PROSPERITY. The bronze panel above the figure contains a laurel wreath and scales of justice.

Hunt's rich pedestal bears a striking similarity to that of Jean-Baptiste Pigalle's 1765 *Monument to Louis XV* (fig. 56) in Rheims; in the *Student* is a strong resemblance to Pigalle's seated base figure of *The Citizen*; and in the *Warrior* is a close affinity to a reclining figure wearing an aminal skin on the base of the *Monument to Cavour* (fig. 57) that Giovanni Dupré executed between 1865 and 1873 in Turin, Italy. Though Ward's base figures are related to these examples of contemporary European sculpture, his ultimate source (and, possibly, that of the other men) was undoubtedly Michelangelo's figures of *Day* and *Night* and *Dawn* and *Dusk* in the Medici Chapel. A photograph of Ward's studio (fig. 38) shows that he owned plaster casts of those figures, as well as of Michelangelo's *Moses*. The derivation is most evident when Ward's *Warrior* is compared with Michelangelo's *Day:* the figures are reclining in a similar position, each head turned looking over the shoulder—elements that create a powerful reversed moment in the torso and give the overall figure a sweeping S curve.

Erastus Dow Palmer acknowledged this influence in a letter to Ward when he wrote:

> How I would like to step into your studio about three days. The Garfield must be nearly or quite ready for the plaster, and also the student into which you have infused so much of the true Angelo *swing* and force.[21]

RELATED WORKS:

There are ten drawings related to the *Garfield* in the Hunt papers.[22] A death mask of Garfield was included in the Ward Memorial Collection given by the sculptor's widow to New York University in 1922.[23] Its present location is unknown.

NOTES

1. Ward's first Washington commission from the Society of the Army of the Cumberland was the equestrian statue of Major General George H. Thomas, which was unveiled in 1879. In 1889 the society commissioned Ward to erect a third statue, the equestrian statue of General Philip H. Sheridan, but because of delays and complications it eventually was erected in Albany, New York, rather than in Washington.
2. *DAB*, s.v. "James Abram Garfield."
3. SAC 1887, pp. 55–56.
4. Ibid., p. 56.
5. SAC 1882, p. 46.
6. Ibid., p. 17.

7. SAC 1887, pp. 56–57.

8. SAC 1882, pp. 46–47.

9. SAC 1883, p. 52.

10. Memorandum from R. T. Lincoln, November 20, 1884, *Garfield Monument*, Record Group 42, Public Buildings and Grounds, National Archives, Washington, D.C.

11. SAC 1887, p. 57.

12. Memorandum from R. T. Lincoln, see n. 10.

13. Letter from JQAW to R. T. Lincoln, February 11, 1885, "Ground Plan and Elevation for the Garfield Monument," stamped Richard Morris Hunt, and letter from RMH to JQAW, March 22, 1887, Garfield Monument, Record Group 42, Public Buildings and Grounds, National Archives, Washington, D.C. See also Baker 1980, pp. 308–310, 545.

14. Letter from JQAW to Lincoln, see n. 13.

15. SAC 1887, p. 57.

16. Letter from JQAW to T. L. Casey, February 6, 1886, Garfield Monument, Record Group 42, Public Buildings and Grounds, National Archives, Washington, D.C.

17. SAC 1887, p. 57.

18. Letter from JQAW to J. M. Wilson, April 14, 1887, Garfield Monument, Record Group 42, Public Buildings and Grounds, National Archives, Washington, D.C.

19. *New York Times*, May 13, 1887, p. 1.

20. Letter from JQAW to Lincoln, see n. 13 above.

21. Letter from E. D. Palmer to JQAW, June 24, [1886] (AIHA).

22. "The Garfield Monument," AIAF.

23. Memorandum from H. O. Voorhis, October 10, 1922 (WMC).

79. DAVID HUNTER McALPIN
Bust, 1887

Marble, h. 27 in.
Signed: J.Q.A. WARD/1887
Union Theological Seminary, New York City

David Hunter McAlpin (November 8, 1816–February 8, 1901) was one of the nineteenth-century's leading tobacco producers. Of modest background, through his own business sagacity he built a small firm into one of the most prosperous in the country. He was the first to introduce to New York Virginia tobacco, which with great originality he called "Virgin Leaf." His business so expanded that in 1868 he had to purchase two entire blocks around Avenue D and Tenth Street to accommodate it. In addition to his tobacco trade he owned vast tracts of real estate in New York City. He was also a member of the board of directors of numerous banks, insurance companies, and other large corporations.[1] A devoted churchgoer, McAlpin was a director of the Union Theological Seminary from 1872 until 1901. The McAlpin collection of books on English history and theology is one of the largest and finest outside England today.[2]

Surprisingly, there are no records related to the bust at the seminary, nor are there any references to it either in Ward's correspondence or in any of the secondary material pertaining to the sculptor. McAlpin,

Cat. no. 79 *David Hunter McAlpin*

like William H. Fogg, whose portrait is also at the seminary, is shown with bushy muttonchops and clad in a contemporary business suit. His bust, on its original oak pedestal, still rests just outside the library that he supported so generously.

NOTES

1. *NCAB*, s.v. "David Hunter McAlpin."

2. H. S. Coffin, *A Half Century of Union Theological Seminary, 1896–1945* (New York: Charles Scribner's Sons, 1954), pp. 203–204.

80. SOLDIERS AND SAILORS MONUMENT, INDIANAPOLIS
Proposed design, 1887

In 1887 the Indiana legislature granted $200,000 for a Soldiers and Sailors Monument, to be built on the ground commonly known as Circle Park in Indianapolis. A commission was appointed, and an advisory board consisting of the Indiana architect Professor John P. Campbell, of Wabash College; General Thomas A. Morris; and Professor William R. Ware, a nationally known architect who taught at Columbia

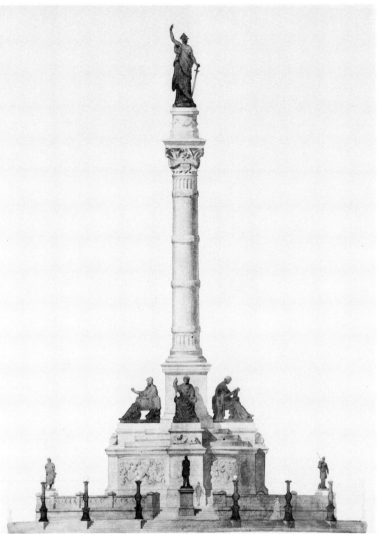

Cat. no. 80 Studio of Richard Morris Hunt, *Soldiers and Sailors Monument*, Indianapolis. Watercolor. The American Institute of Architects Foundation, Washington, D.C.

College, New York, was selected.[1] Shortly after assuming his responsibilities Ware, who had worked with Ward on the *Ether* and the *Yorktown* monuments, wrote the sculptor regarding the Indianapolis project:

> At present I want information, for myself and my committee, and my competing architects, as to the cost of single figures & groups, in stone marble or bronze. Any information you can give me I shall be very grateful for.[2]

The commission solicited designs from ten American architects, paying each of them $200,[3] and placed an advertisement in newspapers in the major cities of the United States, Canada, England, France, Germany, and Italy. Seventy architects responded, and each was sent a set of guidelines, a short history of Indiana, a map of the state, and a diagram of Circle

Park. January 12, 1888, was set as the last day the entries would be accepted.[4]

Two weeks before the deadline, Richard Morris Hunt wrote Ward a detailed letter (which Ward annotated in the margin with estimates) concerning the cost for sculpture for the monument:

> At last I have finished my design in competition for the Soldiers and Sailors Monument for Indianapolis—and am now preparing estimates of cost. . . . As there is no time to spare, would you call here within a day or two when I could explain. What is wanted in sculpture [is] as follows.

Crowning statue of "Indiana" in bronze			
		20 ft high	($20,000)
Statue representative of Army	8	″	
″ ″ Navy	8	″	(25,000)
″ ″ Sanitary Commission	8	″	
12 bas reliefs		8′ × 12′	(42,000)
1 ″ Lion in bronze		8′ × 12′	(3,000)
			($90,000).[5]

After reviewing the seventy entries, the commission unanimously chose number 4, titled "Symbol of Indiana," submitted by Bruno Schmitz, of Germany.[6] As with the Washington Monument (cat. no. 62) competition, to which Ward had supplied estimates in 1877, the Indianapolis Soldiers and Sailors Monument did not concern the sculptor beyond his initial designs and his cost estimates.

NOTES

1. E. B. Rose, "Soldiers' and Sailors' Monument," *Indiana Historical Society Publication* 18 [1957], p. 398.
2. Letter from W. R. Ware to JQAW, August 17, 1887 (N-YHS).
3. Rose, p. 399. (The ten American architects were: Richard Morris Hunt and George B. Post, New York; Van Brunt & Howe, Kansas City; Cabot & Chandler, Boston; T. P. Chandler, Philadelphia; Frederick Baumann and Burnham & Root, Chicago; James W. McLaughlin, Cinciannati; Adolph Scherrer, Indianapolis; and Peabody & Stearnes, St. Louis.)
4. Ibid., pp. 399–400.
5. Letter from RMH to JQAW, December 28, 1887 (N-YHS).
6. Rose, p. 400.

81. MR. CHASE
Bust, before 1888

Location unknown

A newspaper account of the unveiling in September 1888 of the *Goodale* memorial (cat. no. 83) in Columbus, Ohio, reports: "The hand [Ward's] that fashioned the busts of Dennison and Chase now in our State Capitol . . . is the same cunning hand that has framed this bust of Lincoln Goodale."[1] The bust of Chase, like the Dennison (cat. no. 17), could have been done when Ward was in Ohio between 1860 and 1861.

There are no additional references to the bust, and its present location is unknown. Howells reports that the Ohio sculptor Thomas D. Jones modeled "a bust of Chase, admirable as a likeness, and of a very dignified simplicity."[2] That was possibly the bust referred to in the *Columbus Daily Press.*

NOTES

1. *Columbus Daily Press* September 27, 1888, p. 1.
2. Howells 1916, p. 216.

Cat. no. 82.1 *William Earl Dodge*

82. WILLIAM EARL DODGE
Bust, 1888
(Plate XXII)

82.1. Marble, h. 25 in.
Signed: J.Q.A. WARD/1888.
The New-York Historical Society, New York City

82.2. Marble, h. 25 in.
Signed: J.Q.A. WARD/1888

The Chamber of Commerce of the State of New York, New York City

Though an undated newspaper clipping reported that "a portrait of the late William E. Dodge is being modeled for the family . . . preliminary to a bronze statue of heroic size" (cat. no. 73),[1] the family portrait was not completed until three years after the statue had been cast and dedicated. In November 1886, William, one of Dodge's sons, wrote Ward:

I find my mother was greatly pleased with the bust to which you have given such patient care, one side is quite perfect. On the other side she thinks a few touches would make the likeness more perfect.[2]

A little more than a year later William again wrote to Ward, saying, "Before you complete the final bust of my father I will be glad if you will let me see it, so as to arrange with you as to a pedestal which will give it the right height and angle."[3]

The first bust was given to the Historical Society in 1918 by D. Stuart, also a Dodge son.[4] The second bust is identical to the Historical Society portrait, but there is no record of it in the Chamber of Commerce's files. Since Dodge was a past president of the Chamber of Commerce, it would seem likely that the portrait was commissioned for that institution.

NOTES

1. Unidentified and undated newspaper clipping in Ward, "Scrapbook," N-YHS, p. 26.
2. Letter from W. E. Dodge to JQAW, November 4, 1886 (AIHA).
3. Ibid., December 26, 1887 (N-YHS).
4. N-YHS 1974, 1, pp. 221–222.

83. MEMORIAL TO LINCOLN GOODALE, M.D.
Bust, 1888

Bronze, over life-size
Signed: J.Q.A. WARD/sculptor
Founder's mark: CAST BY THE HENRY-BONNARD BRONZE CO. NEW YORK. 1888
Architect of base: Richard Morris Hunt
Inscription on base: LINCOLN/GOODALE
Unveiled: September 26, 1888[1]
Goodale Park, Columbus, Ohio

On May 29, 1882, the city council of Columbus, Ohio, and the executors of Lincoln Goodale's estate agreed to pay $5,000 jointly for a memorial to the doctor.[2] The office of the city clerk of Columbus notified Ward in June 1887 that the council had approved his "plans specifications and designs" for the monument on June 13, and would pay him the $5,470

Cat. no. 83 *Memorial to Lincoln Goodale, M.D.*

3. Letter from H. E. Bryan to J. W. Andrews, June 16, 1887 (N-YHS). Prugh 1951, pp. 7–8. *Columbus Daily Press,* September 27, 1888, p. 1.

4. Prugh 1951, pp. 7–8.

5. In 1914 a replica of *The Indian Hunter* (cat. no. 38.2) was placed in Oak Dale Cemetery in Urbana, Ohio, to mark Ward's grave.

6. Prugh 1951, p. 6.

7. Bill from RMH to JQAW, October 3, 1888 (N-YHS). See also Baker 1980, pp. 517, 546.

84. JULIUS AUGUSTUS DURKEE
Bust, 1888

Marble
Location unknown

Florence E. Durkee and her sister Martha Prudence Park,[1] both from New York, had Ward make a marble bust of their father, Julius A. Durkee (February 4, 1820–February 18, 1869).[2] In January 1888 Miss Durkee wrote Ward that she was coming to New York and was eager to see the nearly finished portrait.[3] On February 8, Mrs. Park wrote the sculptor to say that the bust had arrived safely in Buffalo.[4] Later that month she wrote Ward a letter that contains the most information known regarding the Durkee bust:

> Your letter of the Seventh lies before me and I take great pleasure in enclosing a check for $76. I am also very glad of the opportunity to again express my appreciation and thanks for your kindness and the personal attention you have given the marble. I can never thank you enough, and it is almost impossible to express the entire satisfaction we feel when looking at the bust. It is so much more beautiful in the marble, and its possession will ever be a constant source of happiness. There is a great deal of pleasure in the thought that you knew my father and we feel sure that the likeness is all the more perfect for your finishing touches.[5]

The letter does not make clear whether Ward was responsible for the execution of the entire bust or whether he had merely supervised or finished another sculptor's work. It does seem unlikely that Ward, in 1888 an illustrious name in American sculpture, would have taken such a secondary role.

NOTES

1. *DAB,* s.v. "Roswell Park" (a highly respected Buffalo surgeon and husband of Martha Prudence Durkee).

2. Letter from M. P. Koekkoek, Mrs. Park's granddaughter, to author, November 29, 1983.

3. Letter from F. Durkee to JQAW, January 4, 1888 (N-YHS). Mrs. Park enclosed two hundred dollars in her sister's letter.

4. Letter from M. P. Park to JQAW, February 8, 1888 (AIHA).

5. Ibid., February 19, 1888 (AIHA).

fee he had named.[3] Goodale (February 25, 1782–April 30, 1868), a Columbus land owner, merchant, and physician, was to be honored because in 1851 he had donated a large tract of woodland called Goodale Park to the city. The area was fenced in, the underbrush cleared away, and, in 1872, a lake was excavated and drives were laid out throughout the park.[4]

There is scant information in Ward's correspondence pertaining to the monument, and city records related to it were destroyed in a fire. The *Goodale* memorial was Ward's only statue to be erected during his lifetime in his native Ohio.[5] The portrait, represented in contemporary dress, was acclaimed as a "striking likeness of the community's first physician."[6] It is set on an eclectic, Beaux-Arts-style pedestal designed by Richard Morris Hunt.[7] The *Goodale,* similar to the memorial to Alexander Lyman Holley (cat. no. 85) in New York City, further exemplifies the strong influence that French art was exerting on Ward's public monuments during the 1880s.

NOTES

1. *Columbus Daily Press,* September 27, 1888, p. 1.

2. Ibid.

Cat. no. 85 *Memorial to Alexander Lyman Holley*

85. MEMORIAL TO ALEXANDER LYMAN
 HOLLEY
 Bust, 1889

Bronze, over life-size
Signed: J.Q.A. WARd/sculptor/N.Y. 1889.
Founder's mark: CAST BY THE HENRY-BONNARD
 BRONZE C⁰·/New York. 1889.
Architect of base: Thomas Hastings
Inscription on base [front]: HOLLEY/BORN IN
 LAKEVILLE/CONN. JULY 20TH, 1832/DIED IN
 BROOKLYN, N.Y./JANUARY 29TH, 1882/IN
 HONOR OF/ALEXANDER LYMAN
 HOLLEY/FOREMOST AMONG THOSE/WHOSE
 GENIUS AND ENERGY/ESTABLISHED IN
 AMERICA/AND IMPROVED/THROUGHOUT THE
 WORLD/THE MANUFACTURE OF/BESSEMER
 STEEL/THIS MEMORIAL IS ERECTED/BY
 ENGINEERS/OF TWO HEMISPHERES [back]:
 ALEXANDER LYMAN HOLLEY/BORN JULY 20,
 1832/DIED JANUARY 29, 1882
Unveiled: October 2, 1890
Washington Square Park, New York City

Alexander Holley (July 20, 1832–January 29, 1882)
is regarded as the father of modern American steel
manufacturing. In 1863 Holley acquired the American
rights to the English Bessemer steel process. He com-
bined the Bessemer patents with American steel-
processing patents, and in 1865, at Troy, New York, he
built the first steel plant of commercial significance in
the United States. From that time on Holley's career
was essentially the history of the manufacture of steel
in this country–an industry nurtured to full growth by
Andrew Carnegie.[1]

Following Holley's death, a committee was formed
by the Institute of Mining Engineers to erect a memo-
rial in his honor. R. W. Raymond, chairman of the
committee, wrote Ward in March 1886 asking the
sculptor to undertake the project.[2] On May 4 Ray-
mond informed Ward:

> The Committee on the Holley Memorial has unanimously
> voted to accept your proposal to furnish the bronze bust
> for the memorial and put it in place for two thousand
> dollars, the bust to be finished within one year.[3]

Ward's work on the bust did not progress as rapidly
as the committee had hoped, for it was not until Octo-
ber 1888 that committee member Charles MacDonald
wrote that Ward should consider the bust accepted.[4]
(Presumably, the finished model had only then been
submitted for their approval.) Ward nevertheless con-
tinued to rework the bust, and did not inscribe the
finished bronze until 1889.

While Ward labored on the portrait of Holley, the
committee seemed to be wavering as to the choice of
architect to design the pedestal. It had initially sug-
gested Leopold Eidlitz of New York;[5] why Eidlitz did
not do the work is not recorded. MacDonald, in his
1888 letter to Ward, suggested that the sculptor him-
self design a suitable pedestal.[6] The commission ulti-
mately went to Thomas Hastings, one of the country's
principal Beaux-Arts architects.[7] The finished memo-
rial was unveiled October 2, 1890[8]—a full two years
after the committee's original contracted date.

Ward has given the likeness of Holley a lively, spon-
taneous quality by his rich texturing of the surface. He
has increased the lifelike illusion by turning the head
slightly to the left, portraying the wavy hair gently
blown by the wind, and by suggesting a pleasant smile
in the crinkled corners of Holley's eyes and in his
upturned mouth. A wreath circling the base of the
bust produces a subtle transition from the bronze por-
trait to Hasting's white marble pedestal, which is
composed of a central pillar with a richly ornamented
capital flanked by two smaller connected pillars
capped with oval palmette motifs. Both sculpture and
pedestal are badly weathered, yet the portrait re-
mains one of the most sensitive Ward ever did; the
monument, one of his most successful public essays in
the Beaux-Arts style.

NOTES

1. *DAB*, s.v. "Alexander Lyman Holley."

2. Letter from R. W. Raymond to JQAW, March 27, 1886 (N-YHS).
3. Ibid., May 4, 1886.
4. Letter from C. MacDonald to JQAW, October 15, 1888 (N-YHS).
5. Letter from R. W. Raymond to JQAW, September 10, 1886 (N-YHS).
6. MacDonald to JQAW, see n. 4.
7. Walton 1910, p. LXXXIV.
8. Ibid.

86. JOSEPH WILLIAM DREXEL
Bust, 1889
(Plate XXIII)

Marble, life-size
Signed: J.Q.A.WARD./1889
Inscribed: Joseph W. Drexel
Courtesy The New York Public Library, Special
 Collections: Music, New York City

Joseph W. Drexel (January 24, 1833–March 25, 1888), son of the Philadelphia financier Francis Drexel, represented his father's interest in Europe. In 1871 Joseph moved to New York City and, with J. Pierpont Morgan, established the firm of Drexel, Morgan and Company. Drexel was associated with a large number of financial institutions, and was a major link between the large banking houses of America and Europe. In 1876 he retired from business and devoted his time to philanthropic and artistic enterprises. He was much concerned with the plight of the poor and the unemployed, and he underwrote a number of relief programs. He was president of the Philharmonic Society of New York and a Trustee of The Metropolitan Museum of Art. He bequeathed to the museum an important collection of musical instruments and, to the New York Public Library, an extensive music library.[1]

On July 2, 1888, about three months after Drexel's death, his widow, Lucy Wharton Drexel, wrote Ward:

I am happy to hear that you would be pleased to undertake the portrait bust which I wrote of and note the cost eighteen hundred dollars and the time in which you propose to finish it, next January. It is to be of the late Joseph W. Drexel—I have a large oil painting, a cameo and various photos and an etching of him all very satisfactory to work from.[2]

The deep folds of the "à l'antique" toga in which the *Drexel* figure is draped and the chiseled texture of the surface in general have an agitated quality highly unusual in Ward's marble work. The finely focused likeness reproduces Drexel's features in a lifelike fashion; Ward has once again displayed his genius for drawing out of an inanimate substance the psychological essence of a man.

RELATED WORKS:

A plaster cast of the *Drexel* was included in the Ward Memorial Collection that Mrs. Ward gave to New York University in 1922.[3] Its present location is unknown.

NOTES

1. *DAB*, s.v. "Joseph William Drexel."
2. Letter from L. W. Drexel to JQAW, July 2 [1888] (N-YHS).
3. Memorandum from H. O. Voorhis, October 10, 1922 (WMC).

87. PROFESSOR REICHARD
Bust, before 1890

The only reference to this bust is in the catalogue of the Second Special Exhibition of the Art Club of Philadelphia, 1890.[1] There is no information regarding the identity of Professor Reichard.

NOTES

1. *Art Club of Philadelphia: Second Special Exhibition, November 3, 1890–December 7, 1890* (Philadelphia: Press of Globe Printing House, 1890), p. 54, no. 159.

88. SILAS SADLER PACKARD
Bust, 1890

Bronze, h. 27 in.
Signed: J.Q.A. WARd/sculptor 1890
Founder's mark: Cast by the Henry-Bonnard
 Cº./N.Y. 1890
The New-York Historical Society, New York City

Silas Packard (April 28, 1826–October 27, 1898) was a pioneer in the field of business education. In 1858, in New York City, he founded Packard's Business College, which became one of the leading vocational schools in America. Packard was one of the first to recognize such technical innovations as the typewriter, and he successfully trained women for office work and promoted their clerical skills.[1]

In 1889 the Packard College Alumni Association commissioned Ward to execute a bronze bust of Packard for a niche in the college's reception room.[2] The portrait, which was modeled from life, was completed within a year—an unusually short working time for Ward. It was cast by the Henry-Bonnard foundry in New York City. At the presentation ceremony at the college on June 26, 1890, Packard, in a jocose mood, remarked:

When the Alumni Association announced to me its fell purpose, and asked me to meet this truthful man; this

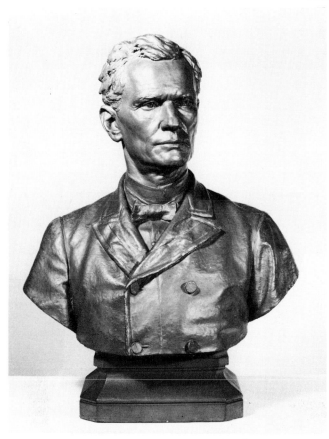

Cat. no. 88 *Silas Sadler Packard*

second Washington, who cannot tell a lie in clay and bronze, I knew that my goose was cooked, and that I should go down to posterity with all my sins of ugliness upon me. I didn't care about it on my own account, but I felt very bad for the family. . . . So I sent my wife to the artist, and she besought him in those specious arguments that a woman can wield so well, to grant her the favor of a few softened wrinkles, to grade down a few of the hills and level up some of the valleys, and thus remodel the topography, so to speak. He said, with that graceful suavity which characterizes him, that he would do almost anything to please a lady, but here he was quite helpless; his work was before him, and he must do it. He said, moreover, that he sympathized with her very deeply . . . and that he could see her point, without a microscope; but if she really wanted a comely bust she must either get some other man to sit for it or some other artist to model it. That ended the interview. But after all, I have a great interest in that bust, and I feel called upon to stand up for it. In fact, as the artist knows, I have stood up for it from the beginning. I have seen it grow, inch by inch, from the smallest pinch of clay to its present magnificent proportiions. And I have sympathized with the artist, and tried to encourage him in his dreary task. I have assured him that the Alumni Association was a well-meaning body of young people, who would eventually pay their just debts; and I have spoken of their respectable connections, and the prospect that other jobs might grow out of this, if he ever got it done. And I have assured him that when the Indian Hunter, and Shakespeare, and Washington, and

Garfield, and Thomas, and Greeley, and Beecher are forgotten, he can go on this bust, and still live.[3]

Although Packard's comments are couched in humor, he well understood that the essence of Ward's portraiture was his uncompromising fidelity to nature in the rendering of his subjects. Packard's bust is more than a mere likeness of a nineteenth-century gentleman in contemporary dress. There is, as Wayne Craven perceptively wrote, "an alertness about the eyes, an animation around the mouth, and a liveliness in the tilt of the head that endow the portrait with spirit and verve—a composite of the humor, temperament, energy, and intrepidity of the man himself."[4]

In 1954 the Trustees of Packard Junior College gave the bust to The New-York Historical Society.[5]

RELATED WORKS:

88.1. Working model
Plaster, h. 27 in.
The New-York Historical Society, New York City

The model was given to the society in 1942 by Arthur Vinton Lyall, Silas Packard's son-in-law.[6]

NOTES

1. *DAB*, s.v. "Silas Sadler Packard."
2. *Exercises Attendant Upon the Unveiling and Presentation of the Bust of S. S. Packard to the Packard College on the Evening of Thursday, June 26, 1890*, foreword (AIHA, where there is also a series of letters from S. S. Packard to JQAW).
3. Ibid., pp. 12–13.
4. Craven 1968, p. 253.
5. N-YHS 1974, 2, p. 592.
6. Ibid.

89. HORACE GREELEY
Statue, 1890
(Plates XXIV, XXV)

Bronze, over life-size
Signed: J.Q.A. WARd/sculptor 1890
Founder's mark: CAST BY THE HENRY-BONNARD BRONZE CO./NEW YORK 1890
Architect of base: Richard Morris Hunt
Inscription on base: HORACE GREELEY/FOUNDER OF/THE NEW YORK TRIBUNE
Unveiled: September 20, 1890
City Hall Park, New York City

Horace Greeley (February 3, 1811–November 29, 1872) was one of America's best-known newspaper editors and an influential political leader. In 1841

Greeley began publication of the *New York Tribune,* which, under his guidance in the next thirty years, set a new standard in American journalism through its combination of thorough news coverage, good taste, high moral standards, and intellectual appeal. Greeley's editorials brought him to national prominence as a popular public educator and moral leader who spoke out spiritedly on all social and political issues. An egalitarian, he was opposed to all kinds of monopoly, landlordism, and class distinction; he persistently championed the cause of workers, farmers, and the underprivileged. His odd appearance—a small, pink face fringed by throat whiskers; the white overcoat, shapeless trousers, and white socks he invariably wore; his shambling gait and absent-minded manner—was seized on by every caricaturist. His emotional stands on issues and his eccentricities were acceptable in an owner and editor of a newspaper, but they were apparently not suitable in an elected public official. On numerous occasions he sought public office, unsuccessfully, and when in 1872 he was nominated for president of the United States by the Democrats and Liberal Republicans, he retired from the *Tribune* and threw himself into the campaign. Shortly before the election his wife died, and that, along with the crushing defeat he suffered and the realization that the editorship of the *Tribune* was lost to him, drove him within weeks to insanity and death.[1]

It was not until nine years later that Whitelaw Reid, Greeley's business partner and a subsequent editor of the *Tribune,* wrote Ward asking if the sculptor would undertake a statue of Greeley.[2] An article in the *Tribune* suggested that no previous move in that direction had been made because of the lack of public support for Greeley at the time of his death.[3] No contracts exist that date or outline the final agreement of the commission, but a contemporary newspaper article reported that Ward began the portrait in 1883 and was paid $15,000 for it, and that Richard Morris Hunt received $3,000 for designing the base.[4] Ward's final model for the statue was completed by May 1890,[5] and on July 26 it was cast in four pieces—the head and body, the hand holding the paper, the chair, and the base—at the Henry-Bonnard foundry.[6] The statue, in a niche in front of the Tribune Building on Printing House Square (now Franklin Square) in New York (fig. 58), was unveiled on September 20.[7] The *Greeley* remained at that site for twenty-six years, after which it was moved to City Hall Park, where it still stands.[8]

From the beginning of the work Ward was confronted with two basic problems: how to create a monumental portrait statue of a peculiar looking man,

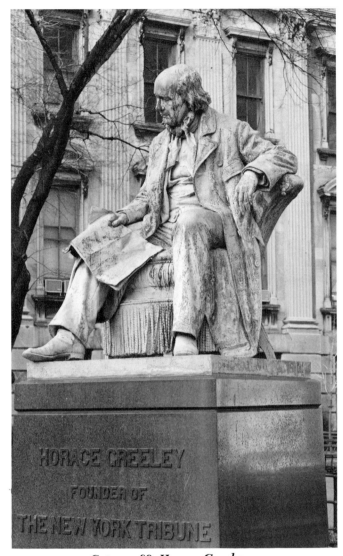

Cat. no. 89 *Horace Greeley*

and how to fit a seated figure into a sidewalk niche in front of the Tribune Building. In resolving the problems Ward may have been influenced to some degree by French sculpture, where there was a tradition (though by no means an ironclad rule) that seated poses were used for writers.[9] One of the most influential figures in that tradition was David d'Angers's *Ludwig Tieck* (fig. 7).[10] The *Greeley* bears a striking similarity to the *Tieck,* which was a figure Ward might well have known from the numerous replicas made after the statuette. In an interview, Ward recalled the problems and his solution of them:

Mr. Greeley's face was a very difficult one to deal with . . . but I was greatly helped by having made a mask of it soon after he died. By means of this I was enabled to reproduce the peculiar structure of his head that photographs would never have shown. The great difficulty was in giving the features the expression of childlike simplicity, together with the strength of a philosopher, which was peculiar to

him. After that expression had been caught in the clay the remainder of my task was comparatively easy. . . . Mr. Greeley is represented sitting on an upholstered lounge chair, which has one arm higher than the other. The left arm of the statue rests on the higher arm of the lounge, the hand dropping gracefully toward the front. Mr. Greeley's habitual attitude when at his desk was with his head bent down to his desk or his newspaper. When a visitor claimed his attention he scarcely moved his body, but turned his head slightly to the visitor in a listening attitude. This attitude I have tried to reproduce, without giving too much of a stoop to the back and shoulders. In the right hand is a newspaper that he has dropped upon his knee on the entrance of the visitor. The attire is in the fashion of the time of the war. A cravat loosely and somewhat negligently tied protrudes from under his neck whiskers and falls upon his broadly plaited shirt bosom. The vest is cut low, and the whole suit is rough cloth.[11]

The *Greeley* exemplifies the type of portrait statuary that made Ward one of the foremost sculptors of his time. While the portraiture of his mature years reveals a strong French influence, his work does not have the brilliance, technical virtuosity, or dramatic action of the American Beaux-Arts-trained sculptors. His statues are nevertheless unfailingly of unique integrity; his subjects and their stations in life realized with penetrating insight and fidelity. The *Greeley*, though not seen today in its original context, still remains a successful and sensitive monument to an important figure in American history.

RELATED WORKS:

A plaster death mask and a study of Greeley's hand were included in the Ward Memorial Collection that the sculptor's widow gave to New York University in 1922.[12] The present location of that material is unknown.

89.1. Preliminary sketch model
 Bronze, h. 16 in.
 Signed: JQA Ward/Sc
 Founder's mark: ROMAN BRONZE WORKS INC
 American Academy of Arts and Letters, New
 York City

Mrs. Ward gave the original plaster model of the *Greeley* to the American Academy in 1923. Because of its fragile condition the academy had it cast in bronze.[12] The sketch relates very closely to the finished statue, though there the seated figure is slightly more erect and the heavily tasseled chair was a later adaptation.

NOTES

1. *DAB*, s.v. "Horace Greeley."
2. Letter from W. Reid to JQAW, July 23 and October 3, 1881 (AIHA).

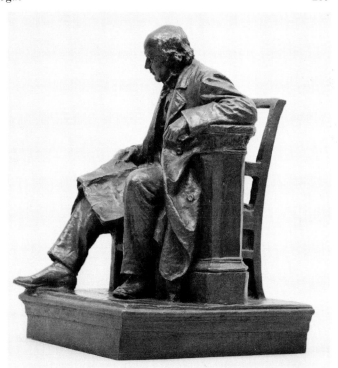

Cat. no. 89.1 *Horace Greeley*

3. *New York Tribune*, September 21, 1890, pp. 1–2.
4. *New York Sun*, May 10, 1890, p. 3. (See also Baker 1980, pp. 310–311, 544.)
5. Ibid. See also "American Notes," *The Studio* 5 (May 17, 1890), p. 242.
6. *New York Tribune*, September 2, 1890, p. 2.
7. Ibid., pp. 1–2. A particularly harsh review of the unveiling ceremony, of the Tribune building, of the site of the statue, and of the statue itself appeared in *The Studio* 5 (October 11, 1890), pp. 445–446.
8. Files 873–D, E. The Art Commission of the City of New York, has records showing that the Tribune Association gave the *Greeley* to the city on October 30, 1915, and that a proposal to move it to Battery Park was approved on November 8. Following public protest, City Hall Park was recommended on May 4, 1916, and was approved on May 22. The statue was relocated on June 9, 1916.
9. Hargrove 1980, p. 31.
10. Holderbaum 1980, pp. 221–222.
11. Ibid., p. 221.
12. Memorandum from H. O. Voorhis, October 10, 1922 (WMC).
13. Accession card, AAAL.

90. AUGUST BELMONT
 Bust, 1891

 Bronze, h. 22 in.
 Signed: J.Q.A. WARd/sculptor.
 Founder's mark [cursive]: Cast by the
 Henry-Bonnard Bronze Cº·/New York. 1891.
 The Museum of the City of New York

August Belmont (December 8, 1816–November 24,

1890) was a renowned banker, diplomat, and patron of the arts. Born in Germany, he worked as a boy in the office of the Rothschilds. At the age of twenty-one he moved to New York City, where, with the Rothschilds' backing, he established the firm of August Belmont & Company, which was to become one of the great banking houses of North America. Belmont became a force within the Democratic party and held several diplomatic posts. His official position, charming personality, and great wealth made him a highly conspicuous figure in New York social circles. In 1849, Belmont married Caroline Slidell Perry, daughter of Commodore Matthew Calbraith Perry.[1] Sixteen years later Belmont gave Ward his first major commission, a standing bronze statue of his father-in-law (cat. no. 46) for the city of Newport, Rhode Island.

A warm friendship developed between Belmont and Ward, and when the financier died on November 24, 1890, Ward was asked by the family to make a death mask that could serve "for future use."[2] Ward modeled this portrait bust of Belmont during the next year, and in September 1891 the Henry-Bonnard foundry billed him $180 for casting it.[3] The bust, given to the Museum of the City of New York in 1953 by Morgan Belmont,[4] was not dated either by the sculptor or by the foundry, but that it is the 1891 Henry-Bonnard casting seems indeed likely.

The *Belmont* is a vital and realistic portrait in which the abbreviated treatment of the figure's shoulders and breast produces an informality entirely appropriate to a family portrait. A lifelike quality is evinced by Belmont's contemporary dress, the deeply undercut pupils of his eyes, his muttonchop whiskers and the wiry hair surrounding his bald head, and the wrinkles present in the broad planes of his forehead and around his eyes and cheeks. The quality is further enhanced by Ward's treatment of the bronze surface, which he has textured so as to produce a vibrant play of tiny lights and shadows. The bust is more than just a likeness: it conveys a profound sense of the financier's actual strength and determination.

RELATED WORKS:

Between 1893 and 1894 Ward executed a marble bust of Belmont,[5] but the location of that portrait is not known. The death mask and the 1891 bust were the sources for the seated statue of Belmont that Ward completed in 1910 (cat. no. 116). A plaster cast of the *Belmont* was included in the Ward Memorial Collection that Mrs. Ward gave to New York University in 1922.[6] Its present location is unknown.

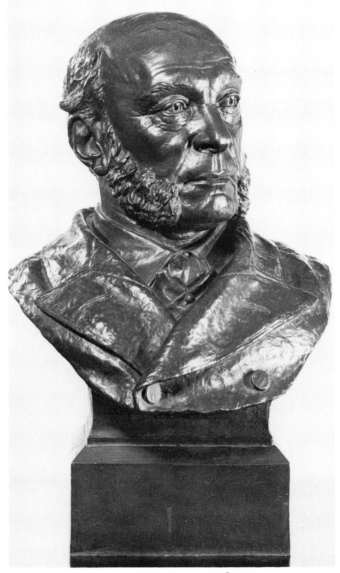

Cat. no. 90.1 *August Belmont*

90.1. Bust
 Bronze, 22¼ in.
 Signed: J.Q.A. WARd/sculptor
 Founder's mark: Cast by Henry-Bonnard
 c°./New York. 1892.
 National Portrait Gallery, Washington, D.C.

Undoubtedly this was the bust that August Belmont, Jr., was referring to when he wrote Ward in July 1892:

I have been daily expecting the delivery of the bust and pedestal which it was decided between us we would have at the office. I am anxious to get it in place and will thank you to have the matter attended to as soon as possible. I hand you herewith check for $1500.—and will remit you whatever further amount is necessary for the pedestal.[7]

The bust, reportedly kept at the Belmont summer

residence at Newport, Rhode Island, was sold by Perry Belmont to the Gropper Art Gallery in about 1970. The bust was later acquired by Victor Spark, a New York art dealer, who sold it to the National Portrait Gallery in 1978.[8]

NOTES

1. *DAB*, s.v. "August Belmont."
2. Letter from J. Hone to JQAW, November 24 [1890] (AIHA).
3. Bill from the Henry-Bonnard Co. to JQAW, September 26, 1891 (AIHA.).
4. Accession file, The Museum of the City of New York.
5. Letters from A. Belmont [Jr.] to JQAW, May 23, 1893; December 24, 1894 (N-YHS).
6. Memorandum from H. O. Voorhis, October 10, 1922 (WMC).
7. Ibid., July 26, 1892 (AIHA).
8. Accession file, National Portrait Gallery, Washington, D.C.

91. HENRY WARD BEECHER MONUMENT
1891
(Plates XXVI, XXVII, XXVIII, XXIX)

Bronze statue of Beecher, over life-size
Signed: J.Q.A. WARD/sculptor.
Founder's mark: CAST BY THE HENRY-BONNARD BRONZE CO./NEW YORK. 1891.

Bronze statue of a Young Black Girl with Palm Branch, life-size

Bronze statue of a Young Boy and Girl with a Garland of Flowers, life-size

Architect of base: Richard Morris Hunt
Inscription on base [front]: HENRY WARD BEECHER/1813 ⊕ 1887 [back]: THE GRATEFUL GIFT/OF MULTITUDES OF/ALL CLASSES CREEDS/AND CONDITIONS/AT HOME AND ABROAD/TO HONOR THE GREAT/APOSTLE OF THE/BROTHERHOOD OF MAN
Unveiled: June 24, 1891
Cadman Plaza, Brooklyn, New York

The unveiling of the *Beecher* monument marked the culmination of Ward's career. Although the sculptor lived for almost another twenty years, failing health and the burden of administrative responsibilities curtailed his production, and younger sculptors such as Augustus Saint-Gaudens, Daniel Chester French, and Frederick MacMonnies received the large, important commissions with increasing frequency.

Henry Ward Beecher (June 24, 1813–March 8, 1887) was one of America's most popular and inspiring preachers and orators of the nineteenth century. His father was Lyman Beecher, a well-known Presbyterian clergyman whose remarkable family of eleven children included Henry, Catherine, and author Harriet Beecher Stowe. Henry, after graduating from Amherst College in 1834, entered Lane Theological Seminary in Cincinnati, where his father was then director. In 1837, licensed to preach, Henry accepted a call to a church of twenty members in Lawrence, Indiana. Two years later he became pastor of the Second Presbyterian Church of Indianapolis, a position he held for eight years before taking charge of the newly organized Plymouth (Congregational) Church of Brooklyn. A man of moods and impulse, he spoke out with conviction and emotion on political and social issues as well as on religious subjects. His moral crusades had a poetic quality, and for over forty years attracted a weekly congregation of more than 2,500 people to his church. He strongly opposed slavery and supported the woman's suffrage movement; a modernist, he embraced the theory of evolution. In 1863 Beecher visited England, where his lectures were instrumental in gaining a more sympathetic understanding of the Union cause in the Civil War. Though unconventional in his dealings with people, he possessed great charm and warmth, and took a genuine interest in his fellowman. His enthusiasm, imaginative insight, ready wit, and easy command of language produced a convincing eloquence. A sensational charge of adultery brought against him by Theodore Tilton, a New York journalist and lecturer, tarnished Beecher's reputation, but he remained popular and influential until his death.[1]

Ward's involvement in the *Beecher* monument began during the last days of the preacher's life, when arrangements were made for him to make the death mask. On March 8, 1887, Ward received a telegram saying, "Beecher died nine-thirty. Dr. Seale says mask should be taken within four hours. Come as soon as possible."[2] As Fred W. Hinrichs, who was to become the prime mover and vice chairman of the Beecher Statue Fund, wrote Ward, a movement to erect a statue to Beecher was under way only three days after the preacher's death:

Citizens of Brooklyn have started an independent movement to raise a bronze statue to Henry Ward Beecher which we desire to have stand in the very heart of the city. We propose doing this by public subscription so that the humblest admirer of Mr. Beecher can have a share in the work. I have discussed the matter with the editors of the Brooklyn Eagle and they are ready to respond, and would like some idea of the probable expense, also some suggestions as to the character of the statue and pedestal. My personal wish is to have a simple, substantial pedestal.

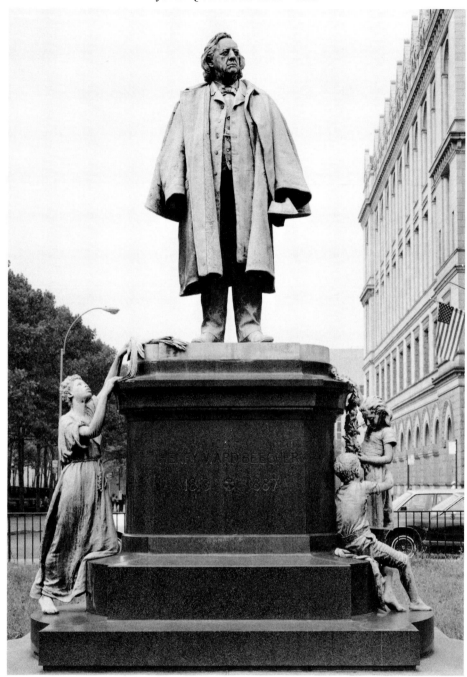

Cat. no. 91 *Henry Ward Beecher Monument*

The statue must be *the* thing, a perfect likeness, characteristic of Mr. Beecher in his best mood.

This is to be a public monument quite apart from what the family or intimate friends may do. Beecher's fame belongs to every citizen of Brooklyn.[3]

Because he had taken the death mask and had Hinrichs's support, Ward was advised in September 1887 that the executive committee of the Beecher Statue Fund had recommended him for the commission.[4] He was assured in the next month that the citizen committee would also approve his selection.[5] After another six months, on April 6, 1888, he signed a

$35,000 contract with the Beecher Statue Fund to "design, model, execute and complete in fine bronze a statue . . . eight feet in height" as well as two or three figures "representing some phase of . . . Beecher's character or public career."[6]

Working from the death mask and photographs of the preacher, Ward had his final plaster model completed by the winter of 1889 (fig. 92);[7] by the following year, the pedestal figures were also finished.[8] Despite criticism by Beecher's family and close friends of the accuracy of the subject's likeness,[9] the statue was widely acclaimed as one of the finest public monu-

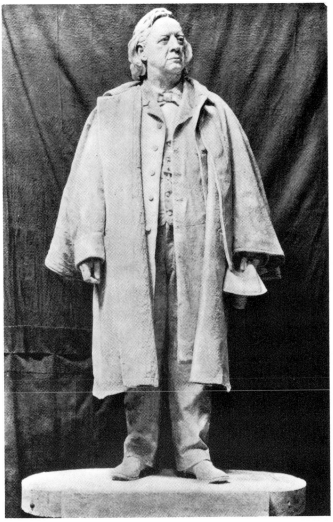

Fig. 92 John Quincy Adams Ward, *Henry Ward Beecher,* 1891. Full-scale plaster model. Reproduced from Adeline Adams, *John Quincy Adams Ward: An Appreciation,* 1912.

ments in the country. The press ran almost daily reports on its progress, and when the *Beecher* was cast, on May 9, 1890, at the Henry-Bonnard foundry, the event was attended by two hundred elegantly dressed men and women.[10] When the finished monument was unveiled a year later, on June 24, 1891, it was a major civic event that attracted more than fifteen thousand people to Borough Hall Park. Although there were repeated efforts to move the *Beecher* to Prospect Park,[11] it remained at Borough Hall until 1959 (fig. 59), when the statue, on its black granite pedestal designed by Richard Morris Hunt, was relocated to its present site in Cadman Plaza.[12]

The *Beecher* monument is the epitome of nineteenth-century public sculpture at its best. In it the sculptor's method of dealing with both portraiture and fundamental sculptural problems can be seen. While Ward has modeled a convincing, realistic image

of Beecher standing before the crowd he is to address, the statue is one of enormous monumentality. Ward has reduced surface details by clothing the figure in a knee-length Inverness cape; he has arranged the broadly treated volumes of the statue into a simple but massive triangular shape. In contrast to this almost austere monumentality are the small, intimately represented genre figures on the base. At the left, a young boy helps a girl climb the base to lay a garland of flowers on the pedestal—an expression of Beecher's devotion to children (fig. 60). At the right, a young black girl places a palm branch at Beecher's feet in gratitude for the role he played in the abolitionist movement. The figure of the girl has a striking similarity to Henri Chapu's 1876 *Youth* for his *Monument to Regnault* at the École des Beaux-Arts in Paris (fig. 61).

RELATED WORKS:

To date, four replicas of the working model are known; it seems likely that all of these are posthumous casts. In 1910 Charles Lamb thanked Mrs. Ward for a statuette of the *Beecher,*[13] but to determine whether that was one of the four pieces now known is not possible. There are also three sketches of the *Beecher* at The New-York Historical Society,[14] and one in a Ward sketchbook at the Albany Institute of History and Art.[15] A replica of the *Beecher* working model was exhibited in the colonnade at the Panama-Pacific Exposition in 1915.[16]

91.1. Working model
 Bronze, h. 14½ in.
 Signed: JQA Ward/sc
 American Academy of Arts and Letters, New
 York City

Ward resolved the basic composition and general treatment of the statue in the working model, but the statuette lacks the details and fineness of modeling of the finished statue. The model, in plaster, was given in 1923 by Mrs. Ward to the academy; they had it cast in bronze at a later date.[17] The signature appears to have been added when it was cast.

91.2. Working model
 Bronze, h. 14½ in.
 Signed: J.Q.A. Ward Sc.
 Founder's mark: GORHAM C⁰· FOUNDERS
 Bowdoin College Museum of Art, Brunswick,
 Maine

This piece was given to the American sculptor Charles Parks in 1968. It was sold to Hirschl & Adler

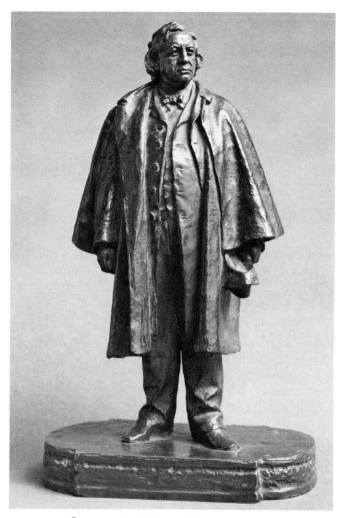

Cat. no. 91.3 *Henry Ward Beecher*

in 1982,[18] and was acquired by Bowdoin College in 1983.[19]

91.3. Working model
 Bronze, h. 14½ in.
 Signed [cursive]: J.Q.A. Ward Sc.
 Founder's mark: GORHAM C⁰· FOUNDERS
 The Metropolitan Museum of Art, New York
 City

The statuette was purchased by the museum from Mrs. Ward in 1917.[20]

91.4. Working model
 Bronze, h. 14½ in.
 Signed: JQA Ward/Sc
 Founder's mark: ROMAN BRON WORKS
 Amherst College, Amherst, Massachusetts.

The college purchased this piece from the Roman Bronze Works, New York City.[21]

91.5. Statue of Henry Ward Beecher
 Bronze, over life-size
 Signed: J.Q.A. WARD SCULPTOR
 Founder's mark: JNO WILLIAMS.
 INC./FOUNDERS. NEW YORK/1914.
 Architect of base: McKim Mead & White
 Inscription on base: HENRY/WARD/BEECHER/
 CLASS • OF • 1834
 Amherst College, Amherst, Massachusetts

The statue was erected by the Amherst Class of 1834 in tribute to one of the college's most famous graduates. Mrs. Ward was consulted in 1913 about the recasting of the statue, excluding the base figures.[22] Supervision of the casting and erecting of the statue, which was unveiled on June 14, 1915,[23] was carried out by Daniel Chester French.[24]

NOTES

1. *DAB*, s.v. "Henry Ward Beecher."
2. Telegram from H. C. King to JQAW, March 8, 188[7] (N-YHS).
3. Letter from F. W. Hinrichs to JQAW, March 11, 1887 (N-YHS). The letter must have been written at Ward's studio, as it is on the sculptor's letterhead. Hinrichs's reference that it was to be a "public monument quite apart from what the family or intimate friends may do" anticipates the conflict that was to develop between the Beecher family and the Statue Fund and Ward regarding the likeness of Beecher and the location of the monument.
4. Ibid., September 20, 1887.
5. Ibid., October 8, 1887.
6. Contract between the executive committee of the Beecher Statue Committee and JQAW, April 6, 1888 (N-YHS).
7. Letter from F. W. Hinrichs to JQAW, December 31, 1889 (N-YHS).
8. Letter from R. B. Moffat to JQAW, December 8, 1890 (N-YHS).
9. *Brooklyn Daily Eagle*, December 19, 1889. Beecher's doctor, W. S. Searle, stated that the likeness was not accurate and that Ward had never consulted with the family or with the preacher's intimate friends. F. W. Hinrichs, in the *Brooklyn Daily Eagle* of December 26, 1889, refuted Searle's criticism, saying that Ward had consulted hundreds of photographs of the preacher and that Ward and the committee had sought the advice of everyone. See also letter from F. W. Hinrichs to JQAW, December 31, 1889 (N-YHS).
10. *New York Times*, May 10, 1890, p. 1. "American Notes," *The Studio* 5 (May 10, 1890), p. 233.
11. *Brooklyn Daily Eagle*, January 27, 1893, p. 6.
12. File 2739-P, The Art Commission of the City of New York. Baker 1980, pp. 311–312, 546.
13. Letter from C. Lamb to Mrs. JQAW, December 28, 1910 (N-YHS).
14. In Ward material.
15. JQAW Sketchbook no. 3 (AIHA).
16. PPIE 1915, p. 246.
17. Accession card, AAAL. The model was probably cast by the Roman Bronze works in 1951 at the same time that they cast Ward's relief of *A Horse*, which is also owned by the academy.

18. Letter from S. E. Menconi to author, November 12, 1982.
19. Letter from J. Coffey to author, December 13, 1983.
20. Archives, MMA.
21. Letter from M. C. Toole to author, November 30, 1970. See also Lewis T. Shepard and David Paley, *American Art at Amherst: A Summary Catalogue of the Collection at the Mead Art Gallery, Amherst College* (Middletown, Connecticut: Wesleyan University Press, 1978), p. 206. The catalogue erroneously reports that the statuette was cast from the original plaster at the National Academy of Design rather than from the one at the American Academy of Arts and Letters.
22. Letter from Mrs. JQAW to G. A. Plimpton, May 8, 1913, Amherst College Library, Amherst, Massachusetts.
23. *Springfield Republican*, June 15, 1915, p. 1.
24. Unsigned letter to F. L. Babbott, April 9, 1914, Amherst College Library, Amherst, Massachusetts.

92. CHARLES L. BRACE
Bust, about 1891

Location unknown

In May 1891 a Georgiana Schuyler wrote to Ward:

I heard the other day to my great pleasure that you are to make a bust of our dear friend Charles L. Brace—I remember so well, the first work of yours I ever saw, (the kneeling Negro slave, with his fetters just broken,) was in Mr. Brace's house. . . .[1]

There is no further information pertaining to this portrait, to Mr. Brace, or to his statuette of *The Freedman*.

NOTES

1. Letter from G. Schuyler to JQAW, May 18, 1891 (AIHA).

93. ROSCOE CONKLING
Bust, 1892
(Plates XXX, XXXI)

Bronze, h. 23½ in.
Signed: J.Q.A. WARD/Sculptor.
Founder's mark [cursive]: Cast by the Henry-Bonnard Co./New York 1892.
The New-York Historical Society, New York City

Roscoe Conkling (October 30, 1829–April 18, 1888) was one of the most powerful and controversial political figures of the post-Civil War period. As United States congressman (1859–63 and 1865–67) and senator (1867–81), he was the unchallenged leader of the Republican party in New York. During Grant's administration he controlled federal patronage, but a dispute with President Garfield over political appointments caused him to resign his Senate seat in 1881. He returned to New York, expecting to be reelected, only to find that his political base had diminished. He

spent the remainder of his life outside of politics, devoting his last years to a successful law practice in New York City.[1]

The *Conkling* reveals the facility of Ward's modeling technique in the 1890s. The depth of the dark patina and the fluent, highly waxed surface, glimmering with light, produce an invigorated realism that justifies the work's rank as perhaps the finest of the sculptor's portraits. Wayne Craven writes that the naturalism of the Conkling bust

. . . rivals Italian Renaissance portraiture of the 15th century in its incisive portrayal, its feeling for sculptural form, and its exquisite sense of design. The last is especially evident in the wiry hair and beard, which are splendidly contrasted to the solid structure of the head and flesh. But Ward was not imitating the style of Verrocchio or of Donatello, as some of his fellow sculptors had already begun to do; he had not made the pilgrimage to Italy as Augustus Saint-Gaudens had done, and if there is any trace of a foreign style in his work, it is in the enlivened surfaces that come from contemporary French sculpture. No longer were the planes smooth, flat, and dull as Ward's surfaces became vibrant with a myriad of tiny lights and shadows that gave it a luster unknown to America's earliest bronze images. This feeling for the life-quality of the flesh is especially noticeable around Conkling's eyes and cheeks, and is also present on the broader planes of the forehead, neck and chest. In this portrait, which actually went beyond naturalism to what one may call realism, in the best sense of the term, Ward created a sensitive yet objective image of the gentlemanly, astute, and controversial senator from New York.[2]

The bust, which Ward used for the head of the Conkling statue unveiled the following year (cat. no. 94), was given to the Historical Society in 1956 by Walter Oakman, the subject's grandson.[3]

NOTES

1. *DAB*, s.v. "Roscoe Conkling."
2. Craven 1968, p. 254.
3. N-YHS 1974, 1, p. 161.

94. ROSCOE CONKLING
Statue, 1893

Bronze, over life-size
Signed: J.Q.A. WARD/Sculptor.
Founder's mark: CAST BY THE HENRY-BONNARD BRONZE CO./NEW YORK. 1893.
Inscription on base [front]: ROSCOE CONKLING
No unveiling ceremony; erected December 1, 1893
Madison Square Park, New York City

There is suprisingly scant information related to the *Conkling* (for biographical information see cat. no.

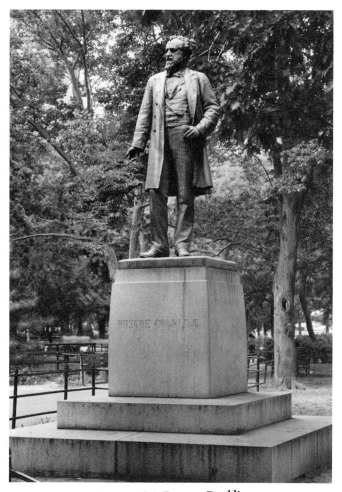

Cat. no. 94 *Roscoe Conkling*

93). In April 1893 the *New York Times* reported:

Ex-Vice President Levi P. Morton and Clarence A. Se-
ward recently sent the following letter to Mayor Gilroy:
"Certain of the friends of the late Roscoe Conkling have
procured his statue to be made in bronze by Mr. J. Q. A.
Ward. They desire to present it as a gift to the city and, if
proper, to have it placed in permanent position in Union
Square opposite the southwest corner of Sixteenth Street
at its junction with Broadway. This location is selected
because it was the scene of Mr. Conkling's last struggle
with the elements on the memorable night of March 12,
1888 [Conkling died of overexertion as a result of being
caught in the famous blizzard].
"As the Chief Magistrate of this city, will you kindly advise
us whether the gift will be accepted and permission ac-
corded for the placing of the statue in the designated
locality."[1]

Several park commissioners objected to the Union
Square location, contending that the corners of the
park were intended for statues of "four great Ameri-
cans," and though Conkling had been a distinguished
man, his stature was not great enough to warrant such
a place.[2] In June, the park commissioners decided on

a site in Madison Square Park for the work.[3] When the
Conkling was completed, it was quietly set in place
without ceremony, as reported in the *Times:*

No official notice of the placing of Roscoe Conkling's
monument in Madison Square Park had been received at
the Park Department yesterday. . . . [The statue] commit-
tee looked upon this as unnecessary, as it was now an-
nounced that it was Mrs. Conkling's wish that no cere-
monies should be held in connection with the unveiling.
The statue was lifted upon the pedestal on Friday
afternoon.
 It is a bronze statue and the work of J. Q. A. Ward, the
sculptor. It is 8 feet high, weights 1,200 pounds and cost
$16,000. It was cast at the foundry of Henry Bonnard. The
pedestal, which is of granite, will be inscribed with Ros-
coe Conkling's name in bronze letters. The design con-
forms to Mrs. Conkling's desire that her husband appear
as when delivering one of his great forensic efforts in the
United States Senate. Mr. Ward was three years at work
on the statue, Mrs. Conkling frequently supervising it in
the sculptor's studio. Before her death she wrote express-
ing herself as entirely satisfied with it.[4]

The bust (cat. no. 93) that Ward did for the family
was made prior to the statue. Alfred Conkling, a
cousin of the subject, posed for the portrait,[5] but Ward
seems to have had in mind a clear image of Conkling
and the eventual statue. As he told a reporter:

I am sure I have found the real Conkling. I received my
inspiration from a speech I heard him deliver but a few
days after he had returned from that famous visit to
Garfield at Mentor. In the middle of a sentence, while he
was speaking most eloquently, he suddenly stopped, took
a step or two toward the audience, and raising his hand
and throwing back his head, exclaimed in a low voice, that
penetrated every part of the hall: "The die is cast. Garfield
will be elected." He waited a moment, and then went on
to speak. I shall never forget the occasion. It seemed like
the words of a prophet who was a true prophet. I often
heard him in the Senate, but never was he so eloquent as
on that day when he was delivering an extempore speech
to a mixed audience.[6]

A characteristic late Ward portrait, Conkling, in the
midst of a speech, is posed candidly. His features and
dress are rendered with an unflinching realism that is
enlivened by the kaleidoscopic effect of light emanat-
ing from the subtly modeled surface of the bronze.
The bold and lifelike portrait captures Conkling's
charisma at the height of his political career.

NOTES

1. *New York Times*, April 8, 1893, p. 9.
2. Ibid.
3. Ibid., June 1, 1893, p. 9; June 4, 1893, p. 20.
4. Ibid., December 5, 1893, p. 12.
5. Letter from J. C. Conkling to JQAW, n.d. (N-YHS).
6. Unidentified and undated newspaper clipping, Ward,
"Scrapbook," opp. p. 156, N-YHS.

Cat. no. 95 *Horace Fairbanks*

Cat. no. 95 *Horace Fairbanks*, detail.

95. HORACE FAIRBANKS
Bust, 1893
(Plate XXXII)

Marble, life-size
Signed: J.Q.A. WARD./1893
St. Johnsbury Athenaeum, St. Johnsbury,
 Vermont

Horace Fairbanks (March 21, 1820–March 18, 1888) succeeded his father, Erastus, as manager of the family's platform scale company and, in 1874, as its president. Horace, like his father, was influential in Vermont politics, serving first as a state senator and elected governor in 1876. A generous philanthropist, in 1868 he commissioned New York architect John David Hatch to build the St. Johnsbury Athenaeum. The library of the institution housed over ten thousand volumes, and the art gallery, which was added to the building in 1873, boasted more than fifty paintings and works of sculpture, including *Domes of Yosemite*, Albert Bierstadt's famous canvas.[1]

It was for the Athenaeum's art collection that Mrs. Fairbanks commissioned a portrait of her late husband. Twenty years earlier the Fairbankses had asked Ward to execute a marble bust of Horace's father, Erastus (cat. no. 51), and Ward was the natural choice to do the portrait of the son. Writing for Mrs. Fairbanks in September 1892, Albert Farwell told the sculptor:

I send you four interior views of the Art Gallery which will give you an idea of where the bust of Governor Fairbanks is to be placed.
 The bust will probably take the place of the statue of Pandora at the right side of the large painting [Bierstadt's *Domes of Yosemite*].
 Mrs. Fairbanks wishes you to have a pedestal made according to the design which you sent or . . as your

judgment decides the bust will require.

Mrs. Fairbanks would like it in antique oak that would harmonize with the furnishings of the gallery . . . unless you think another wood would be better.[2]

By February 1893, a model of the bust was completed and Mr. Farwell again wrote Ward:

As to the coat Mrs. Fairbanks thinks you must have modeled [it] from the old coat sent you rather than from the photograph in which the coat [is as] Governor Fairbanks was accustomed to have it. The coat seems much too low at the back of the neck a point which you can easily change. It may be that in marble it should not be as close as in the photograph. This must be left much to your judgement.

Mrs. Willard [a friend of Mrs. Fairbanks] will return the photographs to you & they are marked No 1 & 2.

In No 1, the . . . criticism which Mrs. Fairbanks would make is that the corners of the mouth seem a little too much drawn down giving a more stern expression than Governor Fairbanks was accustomed to wear. . . .

In No 2, the . . . criticism is much more marked & Mrs. Fairbanks would add . . . that the face seems shorter & broader. . . .

Mrs. Fairbanks notices your remarks about the photographs being poor & she makes allowance for that but she understands that you wish her to express herself with entire freedom.[3]

Ward summarized these criticisms in penciled notes on the back of the letter, and undoubtedly incorporated the suggestions into the finished bust, which he shipped to St. Johnsbury in January 1894.[4] The realistic, bearded portrait of the founder of the Athenaeum still stands today just to the right of the *Domes of Yosemite.*

NOTES

1. *ACAB*, s.v. "Horace Fairbanks." See also *The St. Johnsbury Athenaeum and Art Gallery: A Catalogue of the Collection* (Lunenburg, Vermont: The Stinehour Press, n.d.).
2. Letter from A. Farwell to JQAW, September 19, 1892 (AIHA).
3. Ibid., February 28, 1893 (AIHA).
4. Receipt from M. E. Fairbanks to JQAW, January 10, 1894 (N-YHS).

96. STEPHEN WILCOX
Bust, 1894
(Plate XXXIII)

96.1. Bronze, h. 27 in.
Signed: J.Q.A. WARD.SC
Founder's mark: CAST BY THE
HENRY-BONNARD BRONZE CO N-Y. 1894.
Westerly Public Library, Westerly, Rhode Island

Cat. no. 96.1 *Stephen Wilcox*

96.2. Bronze, h. 27 in.
Signed: J.Q.A. WARD.SC
Founder's mark: CAST BY THE
HENRY-BONNARD BRONZE CO N-Y. 1894.
Babcock & Wilcox, New Orleans, Louisiana

Stephen Wilcox (February 12, 1830–November 27, 1893), an inventor and engineer, developed a steam generator in 1868 and, with his boyhood friend George Herman Babcock, established the firm of Babcock & Wilcox in New York City. The company's products were distributed around the world, yet Wilcox continued to work as an inventor. By the time of his death he held, alone or with others, forty-seven patents.[1] A philanthropist in the last years of his life, he gave, among other things, a park and a high school to his hometown of Westerly, Rhode Island, as well as $25,000 for the construction of a stately Memorial Building (Public Library) on Dixon House Square.

Shortly after Wilcox's death Ward was commissioned to execute two bronze busts of the inventor—one for the Memorial Building in Westerly and the second for the firm of Babcock & Wilcox. The portrait

was to be modeled from photographs and from a death mask, and it was specified that Wilcox was to be represented full shoulder in a modern coat and with a small necktie. Mrs. Wilcox and Nathaniel Pratt, president of Babcock & Wilcox, were to approve the portrait, and Ward was to receive two thousand dollars for each bust.[2] In May, after inspecting the model, Pratt wrote Ward that Mrs. Wilcox was very anxious to have the bust completed for the dedication of the Memorial Building on July 4.[3] Ward was not able to meet that deadline,[4] but he did complete the portrait by mid-July, and had it shipped by the Henry-Bonnard foundry to Pratt on July 24.[5] (The dedication of the Memorial Building had been delayed until August 15.) As a contemporary newspaper reported the scene, "In the reading room the tables were covered with magazines and newspapers. In the northwest corner was a bronze bust of Mr. Stephen Wilcox, made by J. Q. A. Ward, the sculptor."[6] The second bust was sent to the firm, and stands today in its offices, which are now in New Orleans.

Cat. no. 97.2 *Elliot Fitch Shepard*

The textured surface of the bust, the subject's intense gaze and wavy hair produce a spirited likeness. The contemporary dress is not a distraction but, rather, adds to the character of Wilcox, who was an unpretentious and pragmatic man. The high conceptual quality of the bust and its casting, finishing, and patina are characteristic of the work of both Ward and the Henry-Bonnard foundry. The rapidity with which Ward produced the bust was not typical of his working method; he usually labored over such a commission for at least a year, and often longer.

RELATED WORKS:

The Babcock & Wilcox company requested the "original clay" model,[7] but there is no record of it at the firm, and its present location is unknown.

NOTES

1. *DAB*, s.v. "Stephen Wilcox."
2. Letter from A. Pearsall to JQAW, February 9, 1894 (N-YHS).
3. Letter from N. W. Pratt to JQAW, May 29, 1894 (AIHA).
4. Ibid., May 31, 1894.
5. Letter from E. F. Aucaigne to JQAW, July 24, 1894 (AIHA).
6. Unidentified newspaper clipping, Westerly Public Library, Westerly, Rhode Island.
7. Letter from A. Pearsall to JQAW, July 25, 1894 (N-YHS).

97. ELLIOT FITCH SHEPARD
Bust, 1894

97.1. Marble, h. 27 in.
Signed: J.Q.A. WARD/1894
Scarborough Presbyterian Church,
Scarborough-on-Hudson, New York

97.2. Bronze, h. 26½ in.
Signed: J.Q.A. WARD/Sculptor.
Founder's mark: CAST BY THE
HENRY-BONNARD BRONZE CO. N-Y. 1894
Collection of Erving and Joyce Wolf, New York City

Colonel Elliot F. Shepard (July 25, 1833–1893) was a prominent New York lawyer, military officer, and newspaper editor. During the Civil War he helped to organize and equip fifty thousand troops for the field, and he was instrumental in forming the Fifty-first Regiment, which was named the "Shepard Rifles" in his honor. He was a founder of the New York Bar Association in 1876, but he abandoned his law prac-

tice in 1888 when he purchased the *Mail and Express,* which he edited until his death.[1]

Colonel Shepard married Margaret Louisa Vanderbilt, daughter of the William H. Vanderbilt whose portrait Ward executed in 1886 (cat. no. 75). The Shepards lived in Scarborough, New York, in Woodlea, an imposing house designed by Stanford White that is now the Sleepy Hollow Country Club.

Today, the marble bust of Shepard stands in the foyer of the Scarborough Presbyterian Church, which the Shepards commissioned the New York architectural firm of Haydel & Shepard to build in 1893.[2] The bronze bust, an exact replica of the marble, was acquired at auction in 1980.[3] It was formerly in the possession of Samuel Feldman, a New York art dealer, but there is no further record of its provenance.

The bust of Shepard shows Ward's characteristic richly textured surface, used to great effect in the subject's full beard and in the fur collar of his overcoat. Shepard's head is slightly tilted, and the deeply undercut pupils of his eyes, which gaze off to the left, lend to the bust an alert and spontaneous quality. The only references to the portrait occur in Walton[4] and in Adams.[5]

NOTES

1. *ACAB,* s.v. "Elliot Fitch Shepard."
2. In "To all Visitors: A Welcome from the Minister and Congregation of the Scarborough Presbyterian Church" (a printed pamphlet distributed at the entrance to the church).
3. *American Paintings, Drawings and Sculpture of the 19th and 20th Centuries,* Christie, Manson and Woods International, Inc. (May 22, 1980), lot no. 301.
4. Walton 1910, pp. LXXXVI, LXXXVIII.
5. Adams, 1912, p. XV, and JQAW entry in *DAB.*

98. FRANCIS LIEBER
Bust, 1895

Location unknown

Francis Lieber (March 18, 1800–October 2, 1872) was a German-born political philosopher who emigrated to America in 1827. He originated the *Encyclopaedia Americana* in 1829, and edited it until 1833. Between 1835 and 1856 he was a highly respected professor of history and political economy at South Carolina College. His abolitionist sympathies and ardent opposition to secession placed him at odds with many Southerners, and in 1857 he accepted a chair at Columbia College in New York. His book, *A Code for the Government of Armies* (1863), which glorified the unity of the United States, became a standard international book on military law and on the conduct of war.[1]

In March 1895, Lieber's wife wrote Ward that she

had decided to accept the bust of her husband, as it would never get any better.[2] There is no other reference to the work. A bust of Lieber was destroyed at South Carolina College as a protest to his political positions,[3] but there is no evidence to support that that bust and Ward's were one and the same.

NOTES

1. *DAB,* s.v. "Francis Lieber."
2. Letter from M. Lieber to JQAW, March 11, 1895 (N-YHS).
3. *The Clariosophic and Eurphradian Societies of the University of South Carolina, 125th Anniversary Celebration, November 6–7, 1931* (Columbia, S.C.: Epworth Orphanage Press, n.d.), p. 46.

99. JAMES HAZEN HYDE
Relief, 1895

Bronze, 24 × 17½ in. (oval)
Signed: J.Q.A. WARD./SCULPTOR.
Founder's mark: Cast by The Henry-Bonnard Bronze Co. N.Y. 1895

Inscribed: 6th/June/1876 [and] J. H./Hyde
The New-York Historical Society, New York City

James Hazen Hyde (June 6, 1876–July 26, 1959) was the heir apparent to the presidency of the Equitable Life Assurance Society that was founded in 1859 by his father, Henry B. Hyde (cat. no. 110). (The senior Hyde had engaged Ward in 1868 to execute the large marble statue group, *The Protector* [cat. no. 54], for the pediment of the Equitable Building in New York City.) After his father's death in 1899, James was made first vice president of the company, but his naiveté about the complexities of big business, together with a government investigation of the Equitable, forced him to resign his post in 1905. He remained active in numerous cultural institutions and was an outspoken Francophile, spending much of his time in France and promoting French cultural activities in this country.[1]

Henry B. Hyde, "a fond and sentimental father," commissioned Ward to model this portrait of the son, who was then attending Harvard University.[2] A profile of the right side of the subject's head, the relief is a realistic image whose subtly modeled surface produces a complex play of light and shadow to articulate the life-size features of the nineteen-year-old youth. Ward's adding an inscription onto the face of the plaque was undoubtedly influenced by the decorative calligraphy that Augustus Saint-Gaudens employed on his relief portraits. While Ward integrated the

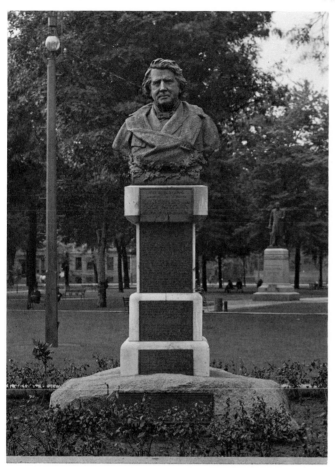

Cat. no. 104 *Memorial to Abraham Coles*

THEIR GOD REJOICE!/FOR HIS MERCY STANDETH FAST,/AND FROM AGE TO AGE DOTH LAST./HE ACROSS UNTRAVERSED SEAS,/GUIDED FIRST THE GENOESE:/HERE PREPARED A DWELLING PLACE,/FOR A FREEDOM-LOVING RACE:/FOR HIS MERCY STANDETH FAST,/AND FROM AGE TO AGE DOTH LAST./FILLED THE LAND, THE RED MAN TROD,/WITH THE WORSHIPPERS OF GOD:/WHEN OPPRESSION FORGED THE CHAIN/NERVED THEIR HANDS TO REND IN TWAIN:/FOR HIS MERCY STANDETH FAST,/AND FROM AGE TO AGE DOTH LAST./GAVE THEM COURAGE TO DECLARE,/WHAT TO DO AND WHAT TO DARE:/MADE THEM VICTORS OVER WRONG,/IN THE BATTLE WITH THE STRONG:/FOR HIS MERCY STANDETH FAST,/AND FROM AGE TO AGE DOTH LAST./MIDST THE TERROR OF THE FIGHT,/KEPT THEM STEADFAST IN THE RIGHT:/TAUGHT THEIR STATESMEN HOW TO PLAN,/TO CONSERVE THE RIGHTS OF MAN:/FOR HIS MERCY STANDETH FAST,/AND FROM AGE TO AGE DOTH LAST./NEEDFUL

SKILL AND WISDOM LENT/TO ESTABLISH GOVERNMENT:/LAID FOUNDATIONS, RESTING STILL/ON THE GRANITE OF HIS WILL:/FOR HIS MERCY STANDETH FAST,/AND FROM AGE TO AGE DOTH LAST./WIPED THE SCANDAL AND THE SIN/FROM THE COLOR OF THE SKIN:/NOW O'ER ALL, FROM SEA TO SEA/FLOATS THE BANNER OF THE FREE:/FOR HIS MERCY STANDETH FAST,/AND FROM AGE TO AGE DOTH LAST./PRAISE THE LORD FOR FREEDOM WON./AND THE GOSPEL OF HIS SON:/PRAISE THE LORD, HIS NAME ADORE, ALL YE PEOPLE, EVERMORE!/FOR HIS MERCY STANDETH FAST,/AND FROM AGE TO AGE DOTH LAST./ABRAHAM COLES, JULY 4, 1876 [carved in the base of the pedestal]: ABRAHAM COLES [bronze plaque set into the sub-base of the pedestal]: THE STATE, ALTHOUGH IT DOES NOT FORMULATE ITS FAITH, IS DISTINCTIVE CHRISTIAN./CHRISTIANITY, GENERAL, TOLERANT CHRISTIANITY IS A PART OF THE LAW OF THE LAND. REVERENCE/FOR THE LAW IS INDISSOLUBLY INTERWOVEN WITH REVERENCE FOR GOD. THE STATE ACCEPTS THE/DECALOGUE AND BUILDS UPON IT. AS RIGHT PRESUPPOSES A STANDARD, IT ASSUMES THAT THIS/IS SUCH A STANDARD, DIVINELY GIVEN, AND ACCEPTED BY ALL CHRISTENDOM; THAT IT UNDERLIES/ALL CIVIL SOCIETY, IS THE FOUNDATION OF THE FOUNDATION, IS LOWER THAN ALL AND HIGHER/THAN ALL; COMMENDS ITSELF TO REASON, SPEAKS WITH AUTHORITY TO THE CONSCIENCE, VINDICATES/ITSELF IN ALL GOVERNMENT, GIVING IT STABILITY AND EXALTING IT IN RIGHTEOUSNESS./ABRAHAM COLES./MEMORIAL VOLUME, P. XXVI.

Unveiled: July 5, 1897
Washington Park, Newark, New Jersey

Abraham Coles (December 26, 1813–1891), a prominent New Jersey physician and writer, was president of the New Jersey Medical Society and wrote extensively on scientific and medical subjects. He was also an avid poet who wrote a number of hymns, including "The Rock of Ages," a national song of praise, which is inscribed on the bronze plaque mounted on the pedestal of his monument.[1]

Three years after Abraham Coles's death, his son, J. Ackerman Coles, sounded Ward out about modeling his father's bust. In October 1894, Ward wrote to Coles:

As requested I give below a list of prices for a portrait bust as discussesd during your last visit at my studio.

For a portrait bust in marble life size	$2,000
For the same in bronze	$1,800
For the same in bronze Colossal	$3,500
Colossal bronze with life size	$4,000[2]

Coles must have decided on the last, because he commissioned the sculptor to execute a colossal bronze for a public monument in Washington Park and a life-size marble for himself.[3]

In March 1895 J. Ackerman Coles wrote Ward:

> Like yourself, I am very desirous that the bust you are modeling of my father shall be a perfect likeness. I have, therefore, engaged Mr. Edward Bierstadt to enlarge to life size the two photographs (profile & three quarters) you are using.[4]

The following year, Coles advised Ward that he had asked Bierstadt to go to his studio to photograph the bust of his father.[5] Although the last digit of the date of the Henry-Bonnard foundry mark is obliterated on the bronze bust, it was probably cast in 1897—the same date inscribed on the marble version.

The monument to Abraham Coles was unveiled on July 5, 1897,[6] on an eclectic pedestal that was described in a newspaper article:

> The foundation is broken stone from Jersey quarries mixed with American and Egyptian cement. Upon this foundation is laid an immense boulder, weighing seven tons, brought from Plymouth, Mass. A portion of one of the monoliths of Cheops, the great pyramid of Egypt, forms a part of the foundation. . . . The capstone . . . is a monolith from the Mount of Olives. The capstone is in turn set upon a monolith from Jerusalem, set upon two from Nazareth of Galilee. Beneath these are two stones from Bethlehem of Judea. The stones are polished upon three sides and are very beautiful, especially the monolith from Solomon's quarry under Jerusalem. This stone is believed to be like unto those used in the temple at Jerusalem. One side of the stones are left rough as they came from the hands of the Judean or Galilean workmen. These rare stones are set upon the huge Plymouth Rock. Upon the front of the stones are fastened bronze [plaques] in which is cast a copy of Dr. Coles's great national song of praise, "The Rock of Ages," below which, riveted to the Plymouth Rock, is a solid bronze tablet containing an extract from Dr. Coles's treatise on law in its relation to Christianity. The whole monument is surrounded by fourteen-foot monoliths of Quincy (Mass.) granite, which are bolted into corner posts, quarried not far from Mt. Tabor, near Tiberias and the Sea of Galilee.[7]

The pedestal weathered badly, and the makeshift assortment of stones became subject to scornful criticism. The pedestal was replaced in 1913 with a new one consisting of a square base and a tall, square, tapering shaft constructed of granite from Westerly,

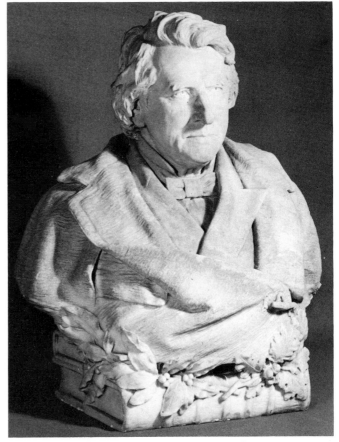

Cat. no. 104.1 *Abraham Coles*

Rhode Island. Both the original base and its replacement were designed by John L. Meeker and William Passmore Meeker of Newark, New Jersey.[8]

A vibrancy of light is refracted from the richly modeled surface of both busts, and each of the invigorated, realistic portraits rests on two closed books inscribed with titles of works by Coles.[9] Both bases, like those of the busts of Alexander Lyman Holley, done in 1889 (cat. no. 85), and of George William Curtis, executed in 1899 (cat. no. 107), include a foliated wreath.

RELATED WORKS:

104.1. Bust
> Marble, h. 28¾ in.
> Signed: J.Q.A. Ward/1897
> Inscribed on bust [back]: ABRAHAM
> COLES/A.M., M.D., PH.D., LL.D./1813–1891
> Inscribed on spine of books that make up the base of the bust: THE MICROCOSM/AND/
> OTHER POEMS [and] LATIN HYMNS/
> AND/PSALMS
> The Collection of The Newark Museum, Newark, New Jersey

Coles gave the marble portrait of his father to The Newark Museum in 1919.[10]

NOTES

1. *ACAB*, s.v. "Abraham Coles."
2. Letter from JQAW to J. A. Coles, October 12, 1894 (AIHA).
3. For a brief discussion on the monument to Abraham Coles see F. Thurlow, "Newark's Sculpture: A Survey of Public Monuments and Memorial Statuary," *The Newark Museum Quarterly* 26 (Winter 1975), p. 31. Thurlow suggests that the Newark Museum marble was carved by the Piccirilli brothers.
4. Letter from J. A. Coles to JQAW, March 4, 1895 (AIHA).
5. Letter from [J. A.] Coles to JQAW, September 14, 1896 (N-YHS).
6. *Newark Evening News*, July 6, 1897, p. 2.
7. "The Man and the Monument: Abraham Coles," *Newark Evening Star*, November 22, 1912. Newspaper clipping, inscribed November 22, 1912, from "Newark Sculpture" folder, Art Department, Newark Public Library, Newark, New Jersey.
8. "To Provide New Shaft for Abraham Coles Monument." Unidentified newspaper clipping, inscribed February 16, 1913, "Newark Sculpture" folder, Art Department, Newark Public Library, Newark, New Jersey.
9. In a letter from [J. A.] Coles, September 14, 1896 (N-YHS), Ward was asked to place the following titles on the spines of the pedestal books: "On the largest book imprint—The Life of Our Lord/The Psalms in English Verse/Latin Hymn/Dies Irae in 18 Versions/and on the back of the smaller volumes—The Microcosm and Other Poems/Prose Writings."
10. W. H. Gerdts, "Sculpture by 19th-Century American Artists in the Collection of the Newark Museum," *The Museum* n.s. 14 (Fall 1962), p. 15. See also *American Art in the Newark Museum* (Newark, New Jersey: The Newark Museum, 1981), p. 420.

105. ELIZABETH MORGAN
Hands, about 1898

Marble; bronze
Location unknown

Elizabeth Morgan was the mother of Bessie Hamilton Morgan Belmont, who married August Belmont, Jr., on November 29, 1881.[1] Bessie's father, Edward Morgan, had been a successful New York banker with a large house at 328 Fifth Avenue, but he was financially ruined in the Wall Street Panic of 1884.[2] Although the Belmonts tried to distance themselves from the Morgans after that sad event, Bessie maintained a close relationship with her family.[3] In 1897 she wrote Ward:

I wish to order in bronze and white marble, 2 of each, from the plaster cast that was made of my mother's hands. Will you advise me as to when I may come to see the first modeling for the above orders, also the length of time required for their completion, the cost of each work—I

ask this as my father Mr. Edward Morgan has requested me to order two of the hands one in bronze and one in marble for him, and I would like to arrange ahead to meet the payment of these.[4]

No further references to the Elizabeth Morgan hands exist, but because of the family association, as in the case of the relief of Jeannie Belmont (cat. no. 57), Ward probably executed the small commission. The sculpting of hands was a popular neoclassical tradition, but this is the only instance of Ward's doing any.[5]

NOTES

1. Black 1981, p. 607.
2. Ibid., pp. 601, 607, 670. (The Morgans were living at 190 Madison Avenue when the casts of Elizabeth's hands were taken. Letter from B. M. Belmont to JQAW, December 11, 1897 [N-YHS].)
3. Ibid., pp. 670–671.
4. Letter from B. M. Belmont to JQAW, December 11, 1897 (N-YHS).
5. It is interesting that a "Plaster cast of right hand of J. Q. A. Ward" is listed in Gifts from the JQAW Estate, April 18, 1934 (AAAL).

106. *HEAD OF A BLACK MAN*
Relief, 1898

Cat. no. 106.1 *Head of a Black Man*

Bronze
Multiple edition

There is no information relating to this naturalistic relief portrait. The choice of subject reveals Ward's continuing interest in and sensitive representation of the American black.

RELATED WORKS:

106.1. Relief
 Bronze mounted on marble, h. 4 in., w. 3 in.
 Signed: JQAWARD/SC/COPYRIGHTED 1898
 Collection of Hirschl & Adler Galleries, New
 York

This relief, the head bronze, the background marble, was acquired in 1982.[1]

106.2. Relief
 Bronze, h. 5 in., w. 3⅝ in.
 Signed: J.Q.A. Ward Sc.
 Founder's mark: #2 CAST BY THE
 HENRY-BONNARD C⁰.
 Private collection, Rochester, New York

The head and the oval background in this relief are cast in one piece. The portrait has the distinction of having been a gift from Ward to his good friend Montgomery Schuyler, the noted art critic. The relief descended in the Schuyler family to Robert Livingston Schuyler; to Mrs. Virginia S. Halstead, who in 1980 sold it to the present owner.[2]

NOTES

 1. Letter from S. E. Menconi to author, September 1, 1982.
 2. Letter from V. S. Halstead to author, April 10, 1980.

107. GEORGE WILLIAM CURTIS
 Bust, 1899

 Bronze, h. 27½ in.
 Signed: J.Q.A. Ward/Sculp
 Founder's mark: The Henry-Bonnard
 Co./Founders. N-Y. 1899
 Courtesy of The New York Public Library,
 Astor, Lenox and Tilden Foundations

George W. Curtis (February 24, 1824–August 31, 1892) was one of America's leading mid-nineteenth century journalists and orators. At the age of eighteen he went to spend two years at Brook Farm, where he was profoundly influenced by the Transcendentalist Movement. In 1854 he became the associate editor of *Putnam's Monthly,* and between 1863 and 1892 he was the editor of *Harper's Weekly.* Curtis, a leading spirit in the Republican party, became one of the most influential Independents in national affairs after the election of Grover Cleveland. Through his writing and lecturing he championed corruption-free politics and liberal social causes, and came somewhat to occupy the position formerly held by Horace Greeley. During the last two years of Curtis's life he served as chancellor of the University of the State of New York.[1] He was the keynote speaker at the 1883 ceremony dedicating Ward's *Washington* (cat. no. 69).

In December 1893, the Curtis Memorial Committee wrote Ward that they were pleased that the sculptor had agreed to execute the bronze bust of Curtis.[2] The bust was cast by the Henry-Bonnard foundry in 1899, but another two years passed before William Potts wrote to the New York Public Library:

On behalf of the George William Curtis Memorial Committee, it gives me pleasure to tender to the Trustees of the New York Public Library the bronze bust of Mr. Curtis recently made . . . and now at [Ward's] studio at 119 West 52nd St, the same to be ultimately placed in the Library Building on 5th Avenue.

As it must of necessity be some years before this building is completed, I would suggest (in the event of acceptance of this tender by the Trustees) that the bust be temporarily housed where it may be seen by the public in the Lenox Library building, and that . . . at some date to be agreed upon, the Committee be afforded an opportunity to hold an open meeting there for the purpose of effecting the transfer, with appropriate exercises, including a formal address.[3]

Events connected with the bust ceremonies were again delayed, and the portrait was not formally unveiled at the Lenox Library until December 7, 1903.[4] The bust was transferred to the Main Branch at Fifth Avenue and Forty-second Street when the Lenox Library was demolished in 1913.

Curtis, one of the period's leading men of letters, is represented in a pensive mood. The realistic portrait, proficiently modeled and cast, is displayed on a base encircled with a foliated wreath, as are the *Holley* (cat. no. 85) and the *Coles* (cat. no. 104).

RELATED WORKS:

107.1. Bust
 Plaster painted bronze color, h. 27½ in.
 Signed: J.Q.A. Ward/Sculp[obliterated]
 American Academy of Arts and Letters, New
 York City

The bust was given to the academy by Mrs. Ward in 1923.[5] That the sculptor retained it suggests that it was probably his original working model.

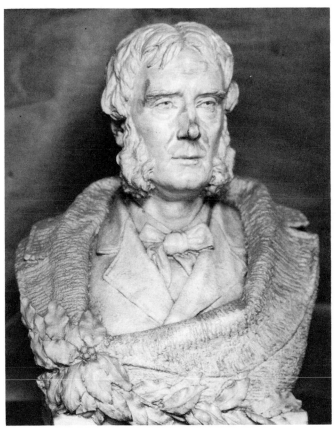

Cat. no. 107.2 *George William Curtis*

107.2. Bust
 Plaster painted white, h. 27½ in.
 Signed: J.Q.A. Ward Sculptor
 The New-York Historical Society, New York
 City

This plaster cast was given to the Historical Society in 1917 by Bridgham Curtis, the subject's son.[6] It varies from the bronze original and the preceding plaster in that the word "sculptor" is completely spelled out in the inscription.

NOTES

1. *DAB*, s.v. "George William Curtis."
2. Letter from W. Potts to JQAW, December 27, 1893 (N-YHS).
3. Letter from W. Potts to G. L. Rives, December 2, 1901, Minutes, Executive Committee, December 6, 1901, p. 316, NYPL.
4. Minutes, Board of Trustees 4, December 9, 1903, NYPL.
5. Accession card, AAAL.
6. N-YHS 1974, 1, p. 181.

108. THE DEWEY ARCH
 1899

 Staff statue of *Victory Upon the Sea*, over
 life-size

Fifth Avenue and 23rd Street, New York City
Unveiled: September 29, 1899; destroyed, 1900

Two years after successfully decorating the Reading Room of the Library of Congress (cat. no. 103), the National Sculpture Society turned its energies toward erecting a memorial to celebrate Admiral George Dewey's victory over the Spanish at Manila Bay. One of the society's objectives was to promote the decoration of public "squares and parks with sculpture of a high class."[1] Dewey's overwhelming victory in the Philippines in 1898, in which the Pacific squadron under his command destroyed eight Spanish ships at the cost of only eight wounded Americans, established the United States as a major power in the Pacific, and gave the society a suitable event and hero to honor with a civic monument.

With Dewey's fleet steaming toward New York in the summer of 1899, the National Sculpture Society appointed a special committee to interest the city in erecting a triumphal arch in celebration of Dewey's visit to New York. The committee, chaired by Ward, was composed of Karl Bitter, Charles R. Lamb, John De Witt Warner, and Frederick W. Ruckstull.[2] Lamb, a prominent architect and one of the chief advocates of the City Beautiful movement, and Ruckstull, the secretary of the special committee, were the principal promoters and organizers of the project. On the basis of plans hastily drawn up by Lamb (Dewey's visit was only six weeks away), the city appropriated $30,000 for the project, and members of the society agreed to contribute the sculpture for the memorial without reimbursement.[3]

A triumphal arch founded upon the design of the Arch of Titus[4] was selected as the architectural prototype of the memorial, not only for its association with the ancient Romans' commemoration of victories but also because it offered abundant space for sculptural adornment. In the same vein, it was decided to have the triumphal procession move up the Appian Way of New York—Fifth Avenue—to the arch, which was to be located at the avenue's juncture with Twenty-third Street (Madison Square).[5] The sculptural decoration on the arch and the colonnade that flanked Fifth Avenue north and south of it lauded the naval attributes of a peaceful nation capable of heroic military deeds when challenged. Twenty-eight sculptors in all contributed to the elaborate project. The decorating scheme and the sculptors' assignments for each section follow:

Crowning the Arch
 1. Victory Upon the Sea J.Q.A. Ward

Cat. no. 108 *Victory Upon the Sea.* Reproduced from Charles H. Caffin, *The Dewey Arch,* 1899.

Eight Figures on the Attic of the Arch

2.	Commodore Paul Jones	E.C. Potter
3.	Commodore Hull	H.K. Bush-Brown
4.	Commodore Mac-Donough	T.S. Clark
5.	Commodore Decatur	G.T. Brewster
6.	Commodore Perry	J.S. Hartley
7.	Lieut. Cushing	H.A. Lukeman
8.	Admiral Porter	J.J. Boyle
9.	Admiral Farragut	W.O. Partridge

Four Spandrels on the Arch

10.	Atlantic and Pacific Oceans	R.H. Perry
11.	North and East Rivers	I. Konti

Four Sculpture Groups on the Piers of the Arch

12.	The Call to Arms	P. Martiny
13.	The Combat	K. Bitter
14.	The Triumphal Return	C.H. Niehaus
15.	Peace	D.C. French

Two Reliefs on the Sides of the Arch

16.	Protection of Country	W. Couper
17.	Progress of Civilization	J. Gellert

Eight Medallions on the Sides of the Arch

18.	Captain Lawrence	H. Baerer
19.	Commodore Preble	D.F. Hamann
20.	Admiral Foote	F. Moynihan
21.	Admiral Worden	F. Moynihan

Fig. 93 Charles H. Lamb, model for *The Dewey Triumphal Arch,* 1899. Photograph. Reproduced from Charles H. Caffin, *The Dewey Arch,* 1899.

22.	Commodore Bainbridge	R. Goddard
23.	Admiral Dahlgren	C. Buberl
24.	Commodore Barry	F.W. Kaldenberg
25.	Admiral Davis	F.W. Kaldenberg

Single Figure Repeated on the Eight Double Columns Flanking Fifth Avenue North and South of the Arch

| 26. | Victory | H. Adams |

Four Sculpture Groups on the Four Triple Columns Flanking Fifth Avenue at the North and South Ends of the Colonnade Leading to the Arch

27.	The Army	F.W. Ruckstuhl
28.	The Navy	G.E. Bissell
29.	East Indies	C.A. Lopez
30.	West Indies	I. Konti.[6]

It was fitting that Ward, dean of American sculpture and president of the National Sculpture Society, model the sculpture group crowning the arch. There, his *Victory Upon the Sea* created a stunning silhouette that could be seen up and down Fifth Avenue; it was the keynote of the sculpture decoration for the whole celebration. Ward's winged *Victory* stood nobly in the bow of a barge borne through the water by five spirited sea-horses ridden by Tritons and mermans. In her raised right hand she held a laurel wreath, symbolic of her victories; in her lowered left hand she held a branch of palm leaves. The dramatic image, derived from the *Victory of Samothrace* (fig. 70), is another example of Ward's ability to adapt an antique sculpture into a modern idiom. Commenting on *Victory Upon the Sea*, the noted critic Russell Sturgis wrote:

> It will offend no one of the good men and good artists who worked upon the Arch to have it said here that the whole structure seems like a monument to the artistic and personal dignity of the President of the Sculpture Society. This man has been, for the third of a century, a successful sculptor; much found fault with by the public, who want their fine art well mixed with delicate sentiment; more admired by his fellow-sculptors than by the outside world, which has yet conspired to make him rich. The times have not been favorable. Had Ward been a Frenchman, he would have been great and famous forever, for in him there has been concealed a sculptor of the truest decorative power. "No man can model a better body in a coat or better legs in trousers; no man can model modern men and women as moderns require it, better than Ward—for it is impossible to do it better; if you want him to do ideally fine things, you must give him ideally fine subjects." This was the dictum of one of the sculptors who has worked for the Dewey celebration—of him who has designed and executed the group, "The Army" [Ruckstuhl]. At last, the ideally fine subject was given him, and Ward in his sixty-eighth year has produced a work of decorative

and expressional sculpture which the century may boast of, and which the community will not readily forget.[7]

The arch was completed for Dewey's visit to New York from September 28 to 30, 1899 (figs. 67–69). The work was constructed of staff (a material consisting of plaster mixed with fiber), but it was the hope of the Sculpture Society and especially of Lamb and Ruckstull that it would be put into a permanent material at a later date. The necessary funds were not forthcoming, however, and a year later, on November 13, 1900, it was ordered dismantled.[8] Though destroyed, *The Dewey Triumphal Arch* was a testimonial to the ideas and capabilities of the National Sculpture Society and of Ward as its president. In a six-week period, one of the most lavish Beaux-Arts memorials of the nineteenth century was designed and constructed.

NOTES

1. *New York Times*, May 31, 1893, p. 7.
2. Caffin 1899, p. 2.
3. Ruckstull 1925, p. 529–530. In a letter from D. Butterfield to JQAW, July 12, 1899 (AIHA), the Chairman of the Reception of Admiral Dewey by the City of New York informed Ward: "At a Meeting of the Plan and Scope Committee today, I was authorized by the Committee to take advantage of your generous and magnificent proposal, to have prepared or submitted from those already prepared for that purpose, sketches and designs for a Triumphal Arch to be erected of staff in temporary construction for Dewey Day. These designs and sketches to be prepared without expense to our Committee, or Fund, and in case of their adoption, such that we should be able to erect them at an expenditure not much over $10,000."
4. Sturgis 1899, p. 765.
5. Caffin 1899, pp. 6–7.
6. Ibid., pp. 6–15. Note variation in the spelling of Frederick W. Ruckstull's name.
7. Sturgis 1899, p. 768.
8. Stokes Iconography, 5, p. 2042.

109. JOHN QUINCY ADAMS WARD
Bust, about 1899

Bronze, h. 15 in.
Signed: J.Q.A. Ward Sc.
Founder's mark: GORHAM CO. FOUNDERS
Inscription on base: J.Q.A. WARD/SELF
 PORTRAIT/1830–1910
Ex coll.: Mrs. R. Ostrander Smith, Bronx, New
 York

No documentation relating to Ward's self-portrait is known. Being portrayed in costume was traditional in the nineteenth century, as evidenced by Emanuel Leutze's portrait of Worthington Whittridge in a seventeenth-century cavalier's costume[1] and by Eastman Johnson's self-portrait, in which he is dressed for the Twelfth Night party at the Century Club in 1899.[2]

Cat. no. 109 *John Quincy Adams Ward*

Ward was one of the "several gentlemen" who gave the Leutze painting to the Metropolitan Museum in 1903.[3] A dedicated Centurian, he too undoubtedly attended the 1899 Twelfth Night party, which was "the most elaborate in the nineteenth century history of the Club."[4] It seems plausible that the Ward self-portrait represents the sixty-nine-year-old sculptor in the cavalier costume that he wore to that gala event.

Stylistically, the richly textured surface of the bust, the deeply undercut pupils of the eyes, and the dramatic turn of the head produce the lifelike naturalism characteristic of Ward's portraiture of 1880s and 1890s. The bust was probably cast posthumously, for it has the Gorham Foundry mark, the firm Mrs. Ward employed regularly after her husband's death to cast his works.[5]

Mrs. Ward left the portrait to her daughter-in-law, Mrs. R. Ostrander Smith. The bust was dispersed with the rest of Mrs. Smith's effects after her death in 1971. Its present location is unknown.

RELATED WORKS:

109.1. Working model
 Plaster, h. 15 in.
 American Academy of Arts and Letters, New
 York City

The model was bequeathed to the academy by Mrs. Ward in 1933.[6]

NOTES

1. Collection of MMA.
2. Collection of Mr. and Mrs. Patrick Coffey. See also P. Hills, *Eastman Johnson* (New York: The American Federation of Arts, 1972), p. 116.
3. Archives, MMA. The gentlemen were James W. Pinchot, Daniel Huntington, J. Q. A. Ward, William T. Evans, Samuel P. Avery, and Samuel P. Avery, Jr.
4. H. S. Commager, "The Century, 1887–1906," in *The Century, 1847–1946* (New York, The Century Association, 1947), p. 72.
5. The posthomous-cast theory is supported by the inscription "1830–1910" on the base, though it could as well have been added at a later date.
6. Accession card, AAAL.

110. HENRY BALDWIN HYDE
 Statue, 1901
 (Plates XXXIV, XXXV)

 Bronze, over life-size
 Signed: J.Q.A. WARd/sculptor/ • 1901 •
 Founder's mark: THE • HENRY-BONNARD
 BRONZE C⁰/FOUNDERS./N.Y. 1901.
 Unveiled: May 2, 1901
 Equitable Life Assurance Building, New York
 City

Henry B. Hyde (February 15, 1834–May 2, 1899) was the founder of the Equitable Life Assurance Society. In 1852, at the age of eighteen, Hyde obtained a minor clerkship with the Mutual Life Insurance Company. Only seven years later, with a hundred thousand dollars he had raised, office furniture he had borrowed, and in a room he had rented above the Mutual Life Insurance Company, he established the Equitable company. By the time of his death, the Equitable had become one of the largest insurance companies in the world, with assets of over two hundred and fifty million dollars, a surplus of over sixty million, and outstanding insurance of over a billion dollars.[1] Hyde was one of Ward's important patrons. In 1867 he commissioned the sculptor, then a young man, to execute *The Protector* (cat. no. 54), a large marble statue

Cat. no. 110 *Henry Baldwin Hyde*

mit himself to "make every effort to have the bronze statue ready by the 15th of Feb.(next)."[2] In June, with George B. Post, the building's architect, Ward inspected the Equitable building for a site for the statue,[3] but it was not until the following September that he had a model of the statue ready for young Hyde's inspection (figs. 64, 65). The sculptor and the patron must both have been pleased with the model: the only noticeable change in the finished work was the elongation of the figure, which made Hyde a slimmer and more attractive man and the statue more imposing. Cast by the Henry-Bonnard foundry in 1901, the work was unveiled in the arcade of the Equitable building at 120 Broadway on May 2, the second anniversary of Hyde's death.[4]

To this day the *Hyde* stands in the lobby of the Equitable building overlooking the comings and goings of his company's employees. A characteristic Ward portrait statue, the likeness is vigorous, bold, and acutely realistic. While the figure is classical, it is garbed in modern dress and imbued with such naturalistic force that one can sense the energy and determined will of the man who founded the Equitable and built it into one of the largest insurance companies in the world. Hyde, pausing in his stride, is shown in a thoughtful mood, resting his weight on his left leg and bending his right leg slightly at the knee in graceful contrapposto. He holds a pair of gloves in one hand, and his left thumb is thrust into his trousers pocket, causing his overcoat and jacket to be turned back. The image, conceived in broad, richly textured planes from which the light shifts dramatically, is an imposing one.

RELATED WORKS:

One plaster and fourteen bronze statuettes of Hyde have been located to date out of a total of approximately eighty-one that were cast by the Henry-Bonnard foundry. In March 1901, Ward wrote to James Hazen Hyde:

I promised some weeks ago to give you an estimate for six bronze statuettes of H. B. Hyde from the model made some time ago. I have just now had an opportunity to carefully look the figure over and make an estimate of the cost. I find it will be necessary to remodel the plaster figure almost entirely—as I should be unwilling to have it published . . . in its present form.

Therefore to prepare the model and finish six copies in bronze, I should charge twenty-four hundred dollars $2,400. The bronzes might be finished by September next.[5]

In July, Ward informed Hyde that the statuettes were going to the foundry and that the first should be ready September 20 or 25.[6] On September 28 he wrote

group for the pediment over the entrance of the Equitable building in New York City, and in 1895 he engaged Ward to model a relief of his nineteen-year-old son, James Hazen Hyde (cat. no. 99).

It was probably shortly after the insurance magnate's death that Ward was approached to execute his statue, for Ward wrote James Hazen Hyde on May 22, 1899, to acknowledge a check for $5,000 and to com-

Hyde, "At last after many experiments with color I have the first copy of the statuette in bronze and would like you to see it here at as early a moment as convenient to yourself."[7] Two years later, in February, the Equitable ordered fifty more statuettes at two hundred dollars each,[8] and on July 18 Hyde ordered an additional twenty-five copies.[9] Besides these three orders, several of the located statuettes have a 1902 foundry date, indicating that figures were cast between the six statuettes ordered in 1901 and the seventy-five figures requested in 1903. In 1970 a Ward statuette that fits the description of the *Hyde* was sold at Parke-Bernet,[10] though the catalogue lists it merely as "Figure of a Man" and makes no reference to Henry B. Hyde, whose name is inscribed on the front of all the known works. The 1903 castings appear to have been numbered on the bottom. In 1975 the Office of Historical Resources at the Equitable Life Assurance Society reported:

> To my knowledge there are seventeen statues in the home office. These are in the possession of the following: yourself, Dr. Fey, Messrs. Smith, Hageman, Keehn, Sexton, Bryant (at home), Malley, Duff, Berube, Herzog, T. Esposito (Agcy), and the Secretary's Department. I have four in the Archives, one of which is being donated to the Smithsonian Institute; Dr. Buley was given one in 1955. In May 1972, R. Enochs presented a statue to the Metropolitan Museum of Art's American Paintings and Sculpture Department.[11]

110.1. Statuette
 Plaster, h. 20½ in.
 Signed: J.Q.A. WARD/sculptor
 Inscribed: HENRY B. HYDE/FOUNDER
 OF/THE EQUITABLE LIFE ASSURANCE
 SOCIETY
 American Academy of Arts and Letters,
 New York City

Possibly the original 1901 working model, this was given to the academy in 1923 by Mrs. Ward.[12]

110.2. Statuette
 Bronze, h. 20⅞ in.
 Signed: J.Q.A. WARD/sculptor
 Founder's mark: THE HENRY-BONNARD
 C⁰·/FOUNDERS. NEW-YORK. 1901.
 Inscribed: HENRY B. HYDE/FOUNDER OF/THE
 EQUITABLE LIFE ASSURANCE SOCIETY
 The Metropolitan Museum of Art, New York
 City

This, one of the original six bronze statuettes, was given to the Metropolitan Museum in 1972 by the Equitable Life Assurance Society.[13]

Cat. no. 110.2 *Henry Baldwin Hyde*

110.3. Statuette
 Bronze, h. 20¾ in.
 Signed: J.Q.A. WARD/sculptor
 Founder's mark: THE HENRY-BONNARD
 BRONZE C⁰./FOUNDERS. N.Y. 1901
 Inscribed: HENRY B. HYDE/FOUNDER OF/THE
 EQUITABLE LIFE ASSURANCE SOCIETY
 The New-York Historical Society, New York
 City

James Hazen Hyde gave this statuette to the Historical Society in 1945.[14]

110.4. Statuette
Bronze, h. 20⅞ in.
Signed: J.Q.A. WARD/sculptor
Founder's mark: THE HENRY-BONNARD
 BRONZE CO./FOUNDERS N.Y. 1901
Inscribed: HENRY B. HYDE/FOUNDER OF/THE
 EQUITABLE LIFE ASSURANCE SOCIETY.
Collection of Erving and Joyce Wolf, New
 York City

The statuette was acquired at auction in 1979.[15]

110.5. Statuette
Bronze, h. 21 in.
Signed: J.Q.A. WARD/sculptor
Founder's mark: THE HENRY-BONNARD
 BRONZE CO./FOUNDERS N.Y. 1901
Inscribed: HENRY B. HYDE/FOUNDER OF/THE
 EQUITABLE LIFE ASSURANCE SOCIETY
Collection of Henry B. Hyde, New York City

Mr. Hyde is a grandson of the Equitable's founder.[16]

110.6. Statuette
Bronze, size not recorded
Signed: J.Q.A. WARD/sculptor
Founder's mark: THE HENRY-BONNARD
 BRONZE CO./FOUNDERS N.Y. 1901
Inscribed: HENRY B. HYDE/FOUNDER OF/THE
 EQUITABLE LIFE ASSURANCE SOCIETY
Collection of Henry B. H. Ripley, Isle of
 Palms, South Carolina

Mr. Ripley is a great-grandson of the Equitable's
founder.[17]

110.7. Statuette
Bronze, h. 21 in.
Signed: J.Q.A. WARD/sculptor
Founder's mark: THE HENRY-BONNARD
 BRONZE CO./FOUNDERS N.Y. 1902
Inscribed: HENRY B. HYDE/FOUNDER OF/THE
 EQUITABLE LIFE ASSURANCE SOCIETY
Collection of Mrs. Isabel Hyde Jasinowski,
 Washington, D.C.

Mrs. Jasinowski is a great-granddaughter of the first
Henry B. Hyde.[18]

110.8. Statuette
Bronze, h. 20¾ in.
Signed: J.Q.A. WARD/sculptor
Founder's mark: THE HENRY-BONNARD
 BRONZE CO./FOUNDERS N.Y. 1902
Inscribed: HENRY B. HYDE/FOUNDER OF/THE

EQUITABLE LIFE ASSURANCE SOCIETY
Collection of Paul Windels, Jr., New York
 City

Mr. Windels's wife, Patricia R. Windels, is a great-
granddaughter of the Equitable's founder.[19]

110.9. Statuette
Bronze, h. 20¾ in.
Signed: J.Q.A. WARD/sculptor
Founder's mark: THE HENRY-BONNARD
 BRONZE CO./FOUNDERS N.Y. 1903
Inscribed: HENRY B. HYDE/FOUNDER OF/THE
 EQUITABLE LIFE ASSURANCE SOCIETY
Collection of Henry B. Hyde, New York City

Mr. Hyde, a grandson of the Equitable's founder,
also owns a 1901 casting of the statuette (cat.
no. 110.5).[20]

110.10. Statuette
Bronze, h. 20¾ in.
Signed: J.Q.A. WARD/sculptor
Founder's mark: THE HENRY-BONNARD
 BRONZE CO./FOUNDERS N.Y. 1903
Inscribed: HENRY B. HYDE/FOUNDER
 OF/THE EQUITABLE LIFE ASSURANCE
 SOCIETY
Collection of Mrs. Paul Windels, Jr., New
 York City

Mrs. Windels is a great-granddaughter of the Equi-
table's founder.[21] Her statuette is stamped on the bot-
tom "4#24."[22]

110.11. Statuette
Bronze, h. 21 in.
Signed: J.Q.A. WARD/sculptor
Founder's mark: THE HENRY-BONNARD
 BRONZE CO./FOUNDERS N.Y. 1903
Inscribed: HENRY B. HYDE/FOUNDER
 OF/THE EQUITABLE LIFE ASSURANCE
 SOCIETY
Collection of Malcolm P. Ripley, La Quinta,
 California

Mr. Ripley is a great-grandson of the first Henry B.
Hyde.[23] This piece is stamped on the bottom "#86."[24]

110.12. Statuette
Bronze, h. 20½ in.
Signed: J.Q.A. WARD/sculptor
Founder's mark: THE HENRY-BONNARD
 BRONZE Cº./FOUNDERS. N.Y. 1903
Inscribed: HENRY B. HYDE/FOUNDER

OF/THE EQUITABLE LIFE ASSURANCE
SOCIETY
Albany Institute of History and Art, Albany,
New York

This piece was given to the institute in 1952 by
Mrs. R. Ostrander Smith, Ward's stepdaughter-in-
law.[25]

110.13. Statuette
Bronze, h. 20½ in.
Signed: J.Q.A. WARD/sculptor
Founder's mark: THE HENRY BONNARD
BRNZE C/FOUNDERS NY 1903.
Inscribed: HENRY B. HYDE/FOUNDER
OF/THE EQUITABLE LIFE ASSURANCE
SOCIETY
The Equitable Life Assurance Society of the
United States, New York City

Stamped "70" on the bottom, this statuette has
been in the Equitable collection since it was cast in
1903.[26]

110.14. Statuette
Bronze, h. 20 in.
Signed: J.Q.A. WARD/sculptor
Founder's mark: THE HENRY-BONNARD
BRONZE CO./FOUNDERS NY 1903.
Inscribed: HENRY B. HYDE/FOUNDER
OF/THE EQUITABLE LIFE ASSURANCE
SOCIETY
National Portrait Gallery, Washington, D.C.

This statuette was given to the gallery in 1975 by
the Equitable company.[27]

110.15. Statuette
Bronze, h. 20 in.
Signed: J.Q.A. WARD/sculptor
Founder's mark: THE HENRY-BONNARD
BRONZE CO./FOUNDERS N.Y. 1903
Inscribed: HENRY B. HYDE/FOUNDER
OF/THE EQUITABLE LIFE ASSURANCE
SOCIETY
Collection of Rita LaBarre, New York City

NOTES

1. *DAB*, s.v. "Henry Baldwin Hyde." For a complete
discussion of Henry B. Hyde's association with the
Equitable Life Assurance Society, see Buley 1967.
2. Letter from JQAW to J. H. Hyde, May 22, 1899,
James Hazen Hyde Papers, N-YHS.
3. Ibid., June 1, 1899.
4. Buley 1967, 1, p. 567; 2, pp. 941, 1074, 1300. The
statue survived the fire of 1912 that destroyed the

Equitable building, and was reinstalled in the new
building constructed on the same site in 1915. The
headquarters were moved to 393 Seventh Avenue in 1924,
but the statue of Hyde was put in storage until 1934, when
it was formally dedicated at the new building. The
Equitable home office was moved to 1285 Avenue of the
Americas in 1961, and the *Hyde* was moved again.
5. Letter from JQAW to J. H. Hyde, March 28, 1901,
James Hazen Hyde Papers, N-YHS.
6. Ibid., July 31, 1901.
7. Ibid., September 28, 1901.
8. Letter from the vice president's office to JQAW,
February 24, 1903 (N-YHS).
9. Letter from JQAW to J. H. Hyde, July 18, 1903,
James Hazen Hyde Papers, N-YHS.
10. *Nineteenth Century Works of Art*, Parke-Bernet
Galleries, Inc. (October 16, 1970), lot no. 14.
11. Memorandum from I. Calnek to C. G. Eklund,
October 7, 1975, Statue Group Folder, ELAS.
12. Accession card, AAAL.
13. Archives, MMA.
14. N-YHS 1974, 1, pp. 377–378.
15. *American Paintings, Drawings and Sculpture of the
18th, 19th and 20th Centuries*, Christie, Manson and
Woods International, Inc. (October 24, 1979), lot. no. 130.
16. Letter from P. Windels to author, n.d.
17. Ibid.
18. Ibid.
19. Ibid.
20. Ibid.
21. Ibid.
22. Ibid., November 7, 1983.
23. Ibid., n.d.
24. Ibid., November 7, 1983.
25. Accession file, AIHA.
26. Archives, ELAS.
27. Accession file, National Portrait Gallery,
Washington, D.C.

111. JAMES ORMSBEE MURRAY
Relief, about 1901

Destroyed

Scant information exists on this relief of James O.
Murray (November 27, 1827–March 27, 1899), a
popular dean of the faculty at Princeton College for
sixteen years. Murray's father, though born in South
Carolina, was opposed to slavery. In 1835 he freed his
slaves and moved to Springfield, Ohio, a neighboring
town of Urbana, where Ward was reared. Murray was
educated at Brown University and Andover Theolog-
ical Seminary. For more than twenty years he served
as pastor of various Congregational and Presbyterian
churches. In 1867 he was elected to the board of
trustees of the Princeton Seminary, and eight years
later he returned to Princeton as Holmes Professor of
Belles-Lettres and English Language and Literature.
In 1883 he was made dean of the faculty, and though
his duties included student discipline and the enforce-
ment of scholarship standards he became one of the
most beloved officers of the college. A professorship of

English literature was founded there in his name.[1]

The only reference to the relief is in *Princeton Portraits:* "A marble tablet in memory of Dean Murray with a portrait medallion in relief by John Quincy Adams Ward, unveiled in the fall of 1901, was lost when the old Marquand Chapel burned in 1920, and no adequate photograph has been found."[2]

NOTES

1. D. D. Egbert, *Princeton Portraits* (Princeton, N.J.: Princeton University Press, 1947), pp. 122–123. (See also *DAB,* s.v. "James Ormsbee Murray.")
2. Ibid., p. 123.

112. THE NEW YORK STOCK EXCHANGE
Pediment statuary, 1903

Marble, over life-size, replaced in 1936 with lead over copper
Signed: not visible from the ground

Architect of the building: George B. Post
Wall and Broad streets, New York City

When Ward undertook the sculpture decoration for the pediment of the New York Stock Exchange, he was seventy-one years old and struggling to complete the models for the equestrian statues of Generals Sheridan and Hancock. Ward was assisted in the Stock Exchange project by Paul Wayland Bartlett,[1] but there is no way to know to what degree the younger sculptor contributed either to the planning or to the execution of the work.

Ward agreed in June 1901 to execute the pediment for $57,000.[2] The following spring the building committee reported that Ward had completed a substantial amount of the work on the models, which were then in the hands of Mr. "Pinchorelli."[3] A monograph on the Piccirillis—a family of Italian stonecutters consisting of a father and his six sons—reveals that the carving was done by Getulio Piccirilli, the youngest of the sons, who was:

Cat. no. 112 *New York Stock Exchange,* pediment. Reproduced from *Year Book of the Architectural League and Catalogue of the Twenty-fourth Annual Exhibition,* 1909.

. . . only eighteen years old when John Quincy Adams Ward . . . entrusted him with the carving of the great pedimental group of the New York Stock Exchange Building. Its execution was the biggest thrill of his life. The central figure is twenty-two feet high and executed from a model only one-fifth its size—a daring undertaking for a youth of eighteen and a tribute to his ability as a master stone cutter.[4]

Getulio's work was completed by the spring of 1903, but serious flaws were discovered in the marble to be used for both the construction of the building and the sculpture. On June 26, according to a building committe report on the findings of the architect, George B. Post:

. . . the time has come for beginning the setting of the sculpture, that [Post] had the occasion recently to examine carefully large surfaces of the marble from which the statuary is cut and found it full of grave defects, that he had become apprehensive . . . lest after the statuary has been placed on the marble shelf some of the stones supporting the figures develop rotten spots, break off, and allow one of the figures to fall.[5]

A steel support was devised for the sculpture,[6] and in December 1903 the building committee guardedly reported:

Regarding the possibility of pieces of the Statuary falling, Mr. Post said there is no unusual danger; all pieces were with the center of gravity & would be anchored and doweled; he thought the arms and legs could not drop off; he thought all flaws had been discovered. . . . He suggested an examination once in 5 or 6 years, as sufficient.[7]

The technical problems overcome, the statuary was set in place the following spring.[8]

The theme of the pedimental sculpture is "Integrity Protecting the Works of Man." The statuary is composed of eleven figures. At the center, with outstretched arms, stands *Integrity,* with two small children at her feet receiving and recording the products being brought by other groups in the pediment. Flanking *Integrity* are representations of wealth-producing sources: on one side, the products of the earth; on the other, the means of invention. At the right are figures representing Scientific and Mechanical Power, and, at the corner, the Designer and the Mechanic. To the left are Primitive Agriculture and the Products of the Soil; male figures at the corner represent Mining. The theme apparently originated with the architect, for during discussions about the flaws in the marble and the projected cost overruns in the setting of the sculpture, he pointed out that there were "differences in the Architect's sketches, and the Sculptor's actual work."[9] The liberties that Ward had taken, however, did not prevent Post from writing enthusiastically to the sculptor, when the groups had

been set in place, to congratulate him "upon the result of your work."[10]

Ward's classically posed and draped figures are arranged in a balanced, harmonic composition that effectively complements Post's severe classical facade. The weight of the statuary—ninety tons—together with the flaws in its marble, caused the Stock Exchange in 1936 to replace the marble figures with lead-coated copper replicas weighing only ten tons.[11] The original marble statuary was not preserved, and there is no record of any surviving fragments.

NOTES

1. M. Schuyler, "The New Stock Exchange," *The Architectural Record* 12 (September 1902), p. 413.
2. Minute Book of the Building Committee, June 14, 1901, p. 56, NYSE.
3. Building Committee Transcripts, March 12, 1902, p. 23, NYSE.
4. Lombardo 1944, p. 292.
5. Minute Book of the Building Committee, June 26, 1903, p. 353, NYSE.
6. Ibid.
7. Ibid., December 7, 1903, p. 391.
8. Letter from G. B. Post to JQAW, May 20, 1904 (N-YHS).
9. Building Committee Transcripts, June 26, 1903, pp. 4–5, NYSE.
10. Letter from G. B. Post to JQAW, May 20, 1904 (N-YHS).
11. "Stock Exchange Statuary of Copper—Masterpieces of Craftsmanship," *Bulletin of the Copper and Brass Research Association* 93 (August 1937), pp. 4–5.

113. CORNELIUS VANDERBILT
 Bust, 1903

113.1 Marble, h. 24 in.
 Signed: J. Q. A. Ward/1903/Sc.
 Inscribed [front]: Vanderbilt's monogram
 [right side]: 1843 [left side]: 1899
 The Breakers, Newport, Rhode Island

113.2 Bronze, h. 24 in.
 Signed: J. Q. A. Ward/Sc
 Founder's mark: THE HENRY-BONNARD
 BRONZE CO. FOUNDERS NY 1903
 Inscribed [front]: Vanderbilt's monogram
 [right side]: 1843 [left side]: 1899
 The Breakers, Newport, Rhode Island

Surprisingly, there are no references to these busts of the second Cornelius Vanderbilt (November 27, 1843–September 12, 1899) either in Ward's correspondence or in any of the essays on his sculpture. The subject was named after the "Commodore," his grandfather, who had established the family fortune. The young Cornelius was regarded as the hardest

worker in the family, though far more conservative than any of the others in all his business dealings. After his father's death in 1883, he became the chief director of the family's investments. He was chairman of the New York Central & Hudson River and the Michigan Central railroads, president of the Canada Southern Railway, and the director of many corporations. His activities, philanthropic and otherwise, were multitudinous. He had little time for going out in society, but he built a palatial house on Fifth Avenue in New York; he also built The Breakers, at Newport, Rhode Island—one of the great nineteenth-century American mansions.[1] In addition to doing these portraits of Cornelius, Ward also did busts of his father, William H. Vanderbilt (cat. no. 75), in 1886, and of his son William Henry (cat. no. 101) in 1895.

Made four years after his death, in 1899, the portrait of Cornelius is uncharacteristic of Ward's busts of the period in that the subject is represented, à l'antique, with a narrow drapery over his right shoulder. The work has a noble, patrician quality that has a closer affinity to an ancient Roman general then to a self-assured, nineteenth-century American businessman.

RELATED WORKS:

See cat. no. 75, "Related works."

NOTES

1. *DAB*, s.v. "Cornelius Vanderbilt."

114. GENERAL PHILIP HENRY SHERIDAN
Equestrian statue, 1906
(Plate XXXVI)

Bronze, over life-size
Signed: J • Q • A • WARD • S^c.
Founder's mark: JNO. WILLIAMS,
 INC./FOUNDERS N.Y./1916.
Architect of base: Henry Bacon
Inscription on base: SHERIDAN
Unveiled: October 7, 1916
Capitol Hill Park, Albany, New York

"Little Phil" Sheridan (March 6, 1831–August 5, 1888) was born in Albany, New York, but grew up on the Ohio frontier. After attending the United States Military Academy, from which he was graduated in 1853, he served at various frontier posts. He was appointed a colonel of the Second Michigan Cavalry following the outbreak of the Civil War and distinguished himself at Booneville and Perryville in 1862. Promoted to major general, he took a prominent part

in the Chattanooga Campaign of 1863. In 1864 he commanded the cavalry corps of the Army of the Potomac. His decisive victory at Cedar Creek, in which he made an epic twenty-one-mile-ride on horseback to rally his men and win the battle, made him a national hero and the inspiration for Thomas Buchanan Reed's laudatory poem, "Sheridan's Ride." In 1865 Sheridan successfully blocked Robert E. Lee's retreat and brought about the Confederate surrender at Appomattox. Sheridan's charismatic personality and restless energy, combined with his military prowess, made him one of the most popular and daring officers of the Civil War.[1] After the war, he was elected governor of Louisiana and Texas, and, in 1884, succeeded William T. Sherman as commander of the United States Army.

Sheridan was an influential member of the Society of the Army of the Cumberland, which had commissioned Ward's *Thomas* (cat. no. 61) and *Garfield* (cat. no. 78). Owing to the success of these projects, the general and the sculptor had developed a friendship, and even discussed between themselves a possible statue of Sheridan.[2] Following Sheridan's death in 1888, the Society of the Army of the Cumberland appointed a committee to see to the commissioning of a statue to his memory. The committee members were Generals J. S. Fullerton, Russel A. Alger, James Barnett, A. C. Ducat, and C. F. Manderson; Colonels Henry Stone and H. C. Corbin; and Major W. H. Lambert.[3] The following year General Fullerton reported that General Barnett had met in Washington with members of Congress, and that a bill, prepared and approved, provided:

> . . . for the preparation of a site and the erection of a pedestal for a statue of the late GENERAL PHILIP H. SHERIDAN in the city of Washington, forty thousand dollars; said site to be selected by and said pedestal to be erected under the supervision of the Secretary of War, the Chairman of the Joint Committee on the Library, and the Chairman of the SHERIDAN Equestrian Statue Committee of the Society of the Army of the Cumberland.[4]

General Fullerton further noted to the society that the committee:

> . . . expressed a preference for MR. J.Q.A. WARD. MR. WARD is the artist who made for our Society the THOMAS and GARFIELD statues. In appreciation of his excellent work on these statues, he was made an honorary member of our Society. MR. WARD has been informed that the work would be given to him, and he was asked to prepare sketches and give estimates of cost to this Committee to be presented by it to our Society. But no work on the statue is to be undertaken by him till after a model therefor be presented to and accepted by your Committee, and unless the cost shall come within the amount of our prob-

Cat. no. 114 *General Philip Henry Sheridan*

in the sketch model, but that Ward had assured him, "Now-a-days artists can not put in any fancy work, but have got to confine themselves as nearly as possible to science." Fullerton continued:

> He showed me a half a dozen figures, and in every picture where there was a horse the position of the leg was almost exactly that position. He stated that those positions were obtained by instantaneous photographs taken of a horse trotting and suddenly pulled up. This is the position of a horse that has been run up there and suddenly stopped.[10]

The model now accepted, the sculptor was paid $2,500.[11]

Three years later, at the society's 1895 reunion in Chattanooga, General Fullerton reported that Ward had not completed a working model for the *Sheridan.* He read the following extract from a letter from Ward:

> In view of the fact that I have already been a long while engaged upon the statue of SHERIDAN, and feeling that your Committee and the members of your Society will probably magnify this lapse of time, it becomes difficult for me to make a report upon the progress of the work which may be entirely acceptable and agreeable to all.
>
> I can not, at present, name a date when the statue will be finished. All that I can say is, I have devoted the past two years exclusively to it and shall continue to give all my time to the work until it is completed. This, of course, involves considerable pecuniary loss to myself, as I have refused other important commissions in order to give all my time to this one.
>
> The statue has absorbed all my interest for the present and the development of the studies has been so encouraging that I feel quite confident of being able to produce a work of art creditable both to your Society and myself.
>
> This is the last of a series of important works that the Society of the Army of the Cumberland has honored me with, and my ambition is to make it the best work of my life.
>
> I trust that your Committee will sympathize with my earnestness and ambition in this matter, and not urge me into a state of anxiety. When the thing is once in bronze it cannot be changed. Future generations will not ask how long or how short a time it took to make the statue, but will only remark on its quality.[12]

In the next few years there was apparently little progress on the work, nor was there much communication between the sculptor and the society. In November 1898, in response to an inquiry from General Corbin, Ward wrote:

> Your telegram inquiring "what is the condition of the Statue of Sheridan" is something that I have expected and dreaded to receive at any time during the past six months - it puts me on the defensive. A year ago I had the large model well advanced but found that it would never satisfy me - that I should never be happy with it - so pulled it down and made new studies entirely - these are now all completed and I have made all preparations for setting up the large model again which *I do not propose ever to change* except in detail study.

able collections. MR. WARD informed your Chairman that the probable cost would be thirty-five thousand dollars.[5]

At the society's 1891 reunion, held in Columbus, Ohio, General Fullerton was discouraged because funds raised for the statue were meager and because Ward did not have a sketch model ready for the society to inspect.[6] Ward had nearly completed a model, but wished to make several revisions. He hoped shortly to finish two versions "in order that there might be a selection between the two."[7] Fullerton had visited Ward's studio in New York to see the model the sculptor was working on, and felt it was "going to be the handsomest statue in America." He informed the members of Ward's resolutions, saying, "He intends this to be his life work. It is the last work of the kind he expects to do, and he has given his whole mind and attention to it."[8]

The sketch model, once completed, was approved, and on April 23, 1892, Ward signed a $35,000 contract calling for the statue to be finished by July 1, 1898.[9] Fullerton reported at the society's 1892 reunion that he had criticized the position of one of the horse's legs

This report will no doubt be a shock to you and it will be difficult for the members of the Society of the Army of the Cumberland to understand how any sculptor should require so many years for such a work. I did not myself expect to occupy so much time with it but it has been an honest occupation of my time for I have not lost a month in idling or in working on other commissions - in fact my studio for the past three years has been practically closed to all offers of statues. If however I can peacefully complete this statue and work happily on it I shall not regret my sacrifice of time or money - but I do sincerely regret the disappointment that the delay will bring to the members of your Society - and I regret what may seem to them the appearance of a very unbusinesslike performance on my part.[13]

Ward's embarrassment and his commitment to finish the statue had little effect, for it was not until 1903, nearly five years later, that he had completed a clay model and a life-size study of the head (fig. 71).[14] By the time he had completed the working model, in 1904, the Sheridan family was thoroughly disenchanted with him. After fifteen frustrating years, the merits of Ward's model were not enough to overcome the hostility Ward had engendered in them. The general's wife, Irene Sheridan, was particularly critical, and refused to lend General Sheridan's army badges, stirrups, sabre, belt, and spurs that the sculptor had requested to aid him in modeling the full-size model for the statue.[15] In addition to the ill feeling that had arisen over the delays, conflicts developed between Mrs. Sheridan and Ward regarding the portrayal of Sheridan. Ward's concept of the statue, established during his several meetings with the general, had been reaffirmed with the officers of the society. His *Sheridan* represented the general as a senior officer in the final years of his life. Mrs. Sheridan wanted the statue idealized, showing her husband as a dashing young officer on his horse "Rienze" in the course of his famous ride. While a compromise at this early stage might have halted the widening rift between Ward and Mrs. Sheridan, it would have caused factual inaccuracies that Ward could not accept. He could reduce the general's girth, but he could not represent a youthful Sheridan as a general arrayed in all the medals that were bestowed upon him during his long career. The points of view of those two strong-willed individuals gradually polarized, and in the end their differences could not be resolved.

At its 1905 annual reunion, the society approved a resolution canceling Ward's contract,[16] and Colonel Sheridan [the general's brother, Michael V. Sheridan] bluntly reported to the members that Ward was "too old and has made too many of these statues so there is no more originality in him."[17]

Despite the society's and Mrs. Sheridan's criticisms, Ward continued to work on the full-size model, and by the summer of 1905 had completed it (fig. 72).[18] In the hope of softening Mrs. Sheridan's opposition—she had become the final arbiter on the matter—Ward invited her and her son, a lieutenant, to inspect the work. Mrs. Sheridan at first refused,[19] but finally visited Ward's studio in December 1905. She rejected the model. In a joint letter to William H. Taft, then secretary of war and a member of the Congressional Committee on the Sheridan Statue, she and her son voiced many objections, among which were, "the torso is not good," "the pose of the figure on the horse is very objectionable, as it sadly lacks the impulse and action which were the General's prominent characteristics," and "the horse . . . lacks the action with which the General always inspired his horse."[20] Trying still to find a compromise and probably also thinking to justify their termination of the contract, the War Department encouraged Mrs. Sheridan in May 1906 to review the changes Ward had made in the model. Again she rejected it.[21] George B. Davis, on behalf of Secretary Taft, wrote to Ward:

Upon the occasion of my recent visit to your studio to talk over with you the matter of the Sheridan Statue, you will recall that your conclusion was that if Mrs. Sheridan would make another examination of the statue, and if, after such examination, she was still dissatisfied with the work, you would relieve the Commission from further embarrassment in the matter.

I am advised that Mrs. Sheridan, accompanied by her son, Lieutenant Sheridan, visited your studio on Friday the 11th instant and examined the statue. Upon her return to this city she formally advised the Secretary of War, in writing, that she is still not satisfied with the work and is unable, after a careful consideration of the matter, to change the opinion already expressed to you and to the Commission.[22]

The issue was not so easily settled, for Ward refused to abandon the project. A special review committee composed of several artists[23] and members of the society inspected the model and confirmed Mrs. Sheridan's objections, and Ward's statue was officially rejected by the Congressional Committee in March 1907.[24] Ward brought suit against the society for breach of contract,[25] but at the time of the sculptor's death, in 1910, the case was still in litigation. The memorial to Sheridan was awarded to Gutzon Borglum, whose equestrian figure was unveiled in the capital at the intersection of Massachusetts Avenue and Twenty-third Street on November 25, 1908.[26]

Probably in preparation for his lawsuit, Ward wrote in pencil an extensive memorandum recounting the

details of the entire Sheridan commission. The document not only gives the sole record of Ward's participation in the project, which began even before Sheridan's death in 1888, but offers a rare insight into the sculptor's working method and aesthetic judgments concerning his own sculpture. (Some punctuation has been added for clarity.)

The first time that I met with any members of the S. of the A. of C. occurred in Washington either on the afternoon or evening following the inauguration of the Garfield monument. Some one of the officers gathered there said "there is one more statue to be erected by our Society—and that is, said two or three voices—Sheridan, Sheridan." Gen. Fullerton remarked then we will stop—and Ward we want you to make it and do your best—Gen. Barnett adding but we want you to do this as reasonably as you can, for the Society has been severely taxed for the Thomas & Garfield monuments and as our numbers diminish we shall find it more and more difficult to raise the necessary money. So inasmuch as they had already given me two important commissions I named as reasonable a sum as I thought would compensate me for the serious work it would involve. It was then arranged that I should have an interview with Gen. S. and if possible make some studies of his head and make memoranda of his characteristics. The [general's] engagements precluded any idea of modeling his head at that time so I had to content myself with some pencil sketches and measurements and arranged to have his head photographed in 4 different views. Our interview lasted a couple of hours during which I found that he laid more stress upon his career after his first activities in the war than I supposed he would—speaking lightly of the famous ride at Winchester and other incidents in his campaigns—so that I was impressed with the idea that it would be agreeable to him to be represented in his mature years. This view coincided with my own, especially as I looked at his head—a perfect type of the military commander—and thought how much it expressed the possibilities of his earlier fighting age, at the same time giving a larger view of his mature character as a great commander with indications of a capacity for statesmanship.

It was then determined in my own mind to take this larger view of the man as a better and more comprehensive representation of the character in sculpture than to limit it to any one incident of his earlier life. This view of the case I presented to some of the officers still remaining in Washington and they agreed with me in my view of the case—the only names of these gentlemen that I can now recall are Gen Alger, Fullerton, Barnett and I think Gen Corbin—as I had already executed two works for the Society of the army of the C.

It was some time after this when the commission to make the statue was approaching the form of a contract that I met Mrs. Sheridan who at first seemed inclined to retain in her mind the image of her younger husband. But as she wished to have the General represented in his highest rank with all his decorations displayed, it was pointed out that this would not be sufficiently consistent with the facts in his history. It was understood then with her that I would represent him in the full dress of General

of the Army so far as such costume had been prescribed in that time.

The treatment of the horse was discussed very thoroughly in the interview with Gen. Sheridan at his office referred to above—he had his orderly bring up two or three horses as specimens of the type he preferred—I readily agreed with his selection. He was an excellent judge of horses and subsequently I purchased for my working model a horse of that type. In selecting the action or pose of the horse I elected to represent a horse that had been in spirited action suddenly reined up—endeavoring to support one that had been in action and capable of further activity if called upon—at the same time to secure that element of repose so necessary for the lasting qualities of monumental sculpture.

In preparing my sketches I passed through many phases of treatment of the subject—always adhering to my chief "motif"—but endeavoring to make all details conform to this one expression and at the same time make a composition that would express this motif from the chief points of view and also make a harmonious composition.

Many members of the society from time to time saw these sketches and studies in progress. I cannot now recall the names of any of them except those of Gen Fullerton Alger and Barnett who were I believe members of a committee or [subcommittee] to further the work. These gentlemen agreed with my idea of the treatment of the subject and, as some of them said, were disposed to leave the artistic treatment of the subject to my own judgement.

One of my sketches represented Gen Sheridan in military cloak—this I abandoned for the reason that while it might present a good effect from one or two points of view too many other views were sacrificed for this effect, and it was leading into the picturesque rather than the sculpturesque quality. *One of these models which was accepted by the committee as the basis of our contract I still have—but as will be seen much modified in my last study. Still the general idea of a horse suddenly reined up and the rider giving an informal salute is in "substantial accordance" with my first motif. *This design now exists only in a photograph, the figure of Sheridan having been destroyed.

Encouraged by the approval of the [committee] to progress with the studies in my own way and never for a moment anticipating any trouble in this matter, I carelessly allowed several of my sketches to be destroyed—but they would only illustrate the evolution that takes place in developing any serious production in sculpture. Believing that any hasty completion of a work . . . far from exhibiting the quality of genius [is] more an exhibition of conceit and limited perception, it may be understood how time is not considered while working out a scheme or design. Considering it important for the preparation of myself for a criticism of my own work I often covered it up and took up other work in progress in my studio for many days or weeks—coming back to the Sheridan with a fresh eye and judgement—all this consumes time. I was very anxious that this should be one of my best efforts in my life.

About this time Mrs. Sheridan visited my studio—but unfortunately at a time when I had dismounted the figure of the Gen. to facilitate a more detailed study of the horse. But as she said she did not know much about a horse and

was more interested in the figure of the General. The visit was not very satisfactory to her. Later when the larger model was well advanced she again saw it in company with her son—Lieut. Sheridan. While on this visit, I believe, Mrs. S. furnished me with copies of the various orders and medals awarded the Gen. here and in Europe [and] showed me how to adjust the sash etc. etc. Mrs. Sheridan expressed herself pleased with the head as a likeness but reverted to her wish for a younger condition of the body—slimmer in the waist. The son expressed himself very much pleased with the horse, the seat of the rider and the general treatment of the statue. But before leaving he acquiesced in his mothers opinion that the body below the belt should be reduced. So, anxious to please Mrs. Sheridan I did reduce the corpulency of the Gen. as much as I dared to do and preserve the characteristics of the mature General as we had agreed upon. After this change I again invited her to visit my studio with her son. The reduction of the body was not yet sufficient to please her but she still expressed herself satisfied with the head of the Gen. She seemed a little more determined not to be satisfied and the son had changed his opinion of the horse very materially notwithstanding his former expressed opinion of it. I then felt that there was a determination on their part or her part not to like any study for the statue. In meantime Gen. Clouse [and] Gen. Wade with some of his brother officers from Governors Island saw the work and were not only pleased with it but very enthusiastic over it. Gen Corbin about this time saw it and found no fault with [it] but seemed perfectly satisfied, lending me his sash and volunteering to procure for me any accessories & further material that I might require. There were many visitors to see the model—some members of the Society of the A. of C. some sculptors and some laymen—and their general verdict encouraged me to feel that my treatment of the subject had been successful. In the meantime Gen. Michael V. Sheridan the brother had seen it on two or three occasions but his observations [on] the first visit were not very clear and on his last appearance his remarks led me to believe that for some reason he had been instructed to speak unfavorably of the model.

Just before Gen. M. V. S. made his last visit I received a communication from him enclosing a copy of the action of the S. of the A.C. in which it had turned over to the U.S. Government the whole matter. It was some months after this action of the Society before I was informed of it. In the meantime I was at work on my model—and I think Gen Corbin's last visit occurred after the date of this action of the Society.

After the communication from the War Dept. also informing me of the action of the Society—I supposed this transfer to the Government carried with it the conditions of my contract with the Society—[I] answered their letters with that understanding, never waiving the idea that I had a safe contract with the Society. Matters went along for a while until I had a visit from the Sec. of War who while protesting his inexperience as an expert in art matters said the work seemed beautiful to him and he expressed himself as agreeing with my view of its treatment.

The next message from the War Dept. came in a personal visit from the Judge Advocate who in the course of a visit tried very hard to persuade me to sign a release from any claim that I might have against the Society of the A of C. He also looked at my model and exclaimed "beautiful" and found no fault with it, but the object of his visit was to have me sign that release, to which I always replied in about the same language. I cannot afford either morally, professionally or pecuniarily to do it. Amongst the chief arguments he used was that [I] would continue to delay the completion of the work beyond any reasonable time. As I had my studies all made I told him I would give bond to complete the work in bronze in 18 months from that date. He did not use that argument any more. After much pleasant diplomatic argument on his part I finally told him to send Mrs. Sheridan once more to look at the model and if she still maintained her attitude I would then make it easy for the War Dept. This I have done not having had any correspondence or communication with it since.

Mrs. Sheridan with determination on her face . . . scarcely looked at the model and gave no sign of approval except to express some satisfaction. I did not discuss the matter with her or use any arguments in my favor. My contract was with the S. of the A. of C. not with Mrs. Sheridan.

It was I think after this that I made an appointment with the Sec to meet him at his office in Washington. Very much the same talk occurred there that I had had with the Judge Advocate. He wished me to sign a release. I declined to do this in almost exactly the same words that I used in reply to the Judge Advocate. He seemed very much worried and perplexed about the whole matter. I left the office. Not long after I received a letter from the War Dept. advising me that a committee or jury to decide upon the acceptance of my model would visit my studio at a certain date. To this I believe I made no reply or if I did it was to say that I would be happy to see the gentlemen at the appointed time. They came so far as I was concerned [as] other visitors might have come. There was not an expert amongst them, not even one sculptor of any description amongst them. I was quiet and listened. It did not take me long to make up my mind that these gentlemen had received their instructions before visiting my studio. A few perfunctory remarks from its diplomatic members did not deceive me, their verdict had been given them, as it was the same as that of Mrs. Sheridan. I had already taken advice of [counsel] and had been careful not to recognize their authority to go back on my understanding with the S. of the A. of C.[27]

Ward did not live long enough to see his statue of General Sheridan given new life on the lawn in front of the New York State Capitol in Albany. In 1914, Governor Martin H. Glynn of New York urged that the statue be erected to perpetuate the memory of the city's famous son.[28] On February 11, in a rousing address before the members of The Philip H. Sheridan Camp No. 200, Sons of Veterans, Governor Glynn pledged that if they raised $10,000 for the erection of the statue of Sheridan, he would see that the state appropriated $20,000.[29]

A general committee was formed, and a more influential subcommittee, composed of J. Harris Loucks (chairman), Rollin B. Sanford, Edgar A. VanderVee,

Ben V. Smith, and John Farnsworth, was appointed to oversee the project.[30] On April 4, 1914—only two months later—the subcommittee reported that an equestrian statue by a nationally respected sculptor would cost between $50,000 and $100,000. The subcommittee, however,

> . . . became aware of the existence in plaster ready for enlargement of a completed model of an equestrian statue of General Sheridan by John Quincy Adams Ward, which had been made upon the order of the Society of the Army of the Cumberland, for erection in Washington, and which could be procured and erected in the City of Albany under the direction and supervision of Daniel C. French, America's most eminent sculptor, at the mere cost of erection, plus a small honorarium to the widow of Mr. Ward.[31]

In support of Ward's model the subcommittee presented a letter signed by Herbert Adams, A. A. Weinman, Kenyon Cox, Edwin H. Blashfield, William H. Low, Arnold W. Brunner, H. A. MacNeill, and Walter L. Palmer, who expressed their "high appreciation of this statue as a work of art," and pointed out Mr. Ward's "most eminent position as a sculptor." The letter concluded, "The Equestrian statue of Sheridan is the latest work of his full maturity, and in truth of portraiture and spirit of its conception would make a notable monument for the birth city of the great general."[32]

The offer of Daniel Chester French to erect the *Sheridan* for $25,000 within a two-year period was accepted by the committee.[33] The *Sheridan* was Ward's third statue whose casting French supervised, an undertaking that attested to the respect and gratitude he felt for his onetime teacher.[34] French employed the sculptor F. H. Packer to enlarge the working model, which was still in Mrs. Ward's possession.[35] The figure's enlargement was completed by March 1915,[36] and the statue was sent to New York to be cast by the Jno. Williams Foundry. The *Sheridan*, on a simple rectangular pedestal designed by French's close friend Henry Bacon,[37] was unveiled on the lawn in front of the Capitol in Albany on October 7, 1916.

The unveiling of the *Sheridan* brought to successful completion Ward's artistic legacy. The statue represents the triumphant Sheridan in full military dress, possibly at the moment he passes the reviewing stand in a parade. He pauses, pulling up his horse, and greets the crowd, his hat held in his outstretched hand. He is at once commanding and acknowledging the adulation of the nation his courage helped to preserve. In his design, Ward returned to a composition he and F. O. C. Darley had devised in 1864 for the equestrian relief portrait of General George B.

McClellan (cat. no. 32). The conception and realization of the work are brilliant. There is a dichotomy in the composition of the statue—a tension between the poised, heroic image of the general and the energy-packed image of the horse he effortlessly holds in check. In recognizing the juxtaposition between the simple, monumental portrait of Sheridan and the galvanized horse one can appreciate the painstaking efforts Ward repeatedly made to perfect the relationship between the two figures. The result is a dramatic and ennobling work, a statue in a timeless parade.

RELATED WORKS:

A plaster model incorrectly referred to as "the General Sherman" was included in the Ward Memorial Collection given by the sculptor's widow to New York University in 1922.[38] Its present location is unknown. A plaster model was also bequeathed by Mrs. Ward to the American Academy in 1933.[39] It was reportedly badly damaged when it arrived at the academy, and its present location is also unknown.[40]

114.1. Sketch model
 Plaster, h. 14 in.
 Albany Institute of History and Art, Albany,
 New York

This sketch model was given to the institute by Mrs. R. Ostrander Smith, Ward's stepdaughter-in-law.[41]

NOTES

1. *DAB*, s.v. "Philip Henry Sheridan."
2. Memorandum JQAW [1907] (AIHA).
3. SAC 1905, p. 21.
4. SAC 1889, p. 51.
5. Ibid., p. 52.
6. SAC 1891, pp. 44–46.
7. Ibid., p. 45.
8. Ibid., pp. 45–46.
9. SAC 1892, p. 42; SAC 1905, p. 21–22. In the two accounts is a discrepancy in the amount Ward was to be paid. The 1892 minutes erroneously put the figure at $30,000 instead of $35,000.
10. SAC 1892, pp. 42–43.
11. Ibid., p. 49.
12. SAC 1895, p. 107.
13. Letter from JQAW to General H. C. Corbin, November 16, 1898 (AIHA).
14. Letter from JQAW to M. O. Chance, June 5, 1903, Sheridan Statue, Record Group 42, Public Buildings and Grounds, National Archives, Washington, D.C.
15. Letter from M. V. Sheridan to JQAW, June 2, 1904 (AIHA).
16. SAC 1905, pp. 23–24.
17. Ibid., p. 25.
18. Ibid., p. 22.
19. Letter from M. V. Sheridan to JQAW, December 11, 1905 (AIHA).
20. Letter from I. Sheridan to W. H. Taft, December 28,

1905, Sheridan Statue, Record Group 42, Public Buildings and Grounds, National Archives, Washington, D.C.

21. Ibid., May 13, 1906.

22. Letter from G. B. Davis to JQAW, May 15, 1906 (AIHA).

23. SAC 1906, pp. 9–10. The committee was made up of three artists: Charles F. McKim, Francis Millet, and Guy Lowell. SAC 1906 incorrectly lists Augustus Saint-Gaudens as being on the committee.

24. *New York Times*, March 14, 1907, p. 5.

25. SAC 1909, p. 12.

26. J. M. Goode, *The Outdoor Sculpture of Washington, D.C.: A Comprehensive Historical Guide* (Washington, D.C.: Smithsonian Institution Press, 1974), p. 300.

27. Memorandum JQAW [1907] (AIHA).

28. Sheridan 1916, p. 22.

29. Ibid., p. 24.

30. Ibid., p. 30.

31. Ibid., pp. 32–33.

32. Ibid., pp. 35–36.

33. Ibid., pp. 37–39.

34. In 1910 French had supervised the casting of Ward's equestrian statue of General Winfield Scott Hancock, and in 1915 he oversaw the casting of a replica of Ward's statue of Henry Ward Beecher for Amherst College.

35. For a complete financial record of French's cost for enlarging and casting of the *Sheridan* see DCF Account book, pp. 158–159, Archives, Chesterwood, Stockbridge, Massachusetts.

36. Ibid., p. 159.

37. Ibid., p. 158.

38. Memorandum from H. O. Voorhis, October 10, 1922 (WMC).

39. Accession card, AAAL, and Gifts from the JQAW Estate, April 18, 1934 (AAAL).

40. Ibid.

41. Accession file, AIHA.

115. THE SMITH MEMORIAL
1910

Bronze equestrian statue of General Winfield
 Scott Hancock, over life-size
Signed: J.Q.A. WARD SCULPTOR 1910
Founder's mark: not recorded
Architects of base: James H. Windrim and
 John T. Windrim
Fairmount Park, Philadelphia, Pennsylvania

The Smith Memorial, the gateway to West Fairmount Park in Philadelphia, was one of the most ambitious permanent sculpture projects undertaken at the turn of the century. The semicircular memorial contains fifteen individual pieces of sculpture executed by some of the most eminent artists of the day. Considering Ward's esteemed position in the field of American sculpture, it is not surprising that he was commissioned to do one of the arch's most important portraits, the equestrian statue of General Winfield Scott Hancock (February 14, 1824–February 9, 1886).

Named for Winfield Scott, one of America's out-

standing military minds in the first half of the nineteenth century, Hancock acquired his own reputation as the greatest fighting general in the Army of the Potomac. He was born and reared in Pennsylvania, and graduated from West Point. He served in the Mexican War, and was made a brigadier general of volunteers at the outbreak of the Civil War. Hancock's lasting fame came from his effective command of his troops at the Battle of Gettysburg. It was he who selected Gettysburg as the place upon which to fight, and it was his strong field position that dissuaded Lee from immediate attack. On the second day of the battle, it was Hancock again who prevented Lee's troops from circling behind the Union army lines. During the last two days of the battle, Hancock was largely responsible for turning back the final Confederate attack. Wounded during the battle, he returned to Washington, where he received the thanks of Congress for his conspicuous role in the victory at Gettysburg. Because of his outstanding military record, the Democratic party nominated Hancock for president in 1880. He lost the election to James A. Garfield by

Cat. no. 115 *General Winfield Scott Hancock*. Reproduced from *Year Book of the Architectural League and Catalogue of the Twenty-sixth Annual Exhibition*, 1911.

fewer than ten thousand popular votes; in the electoral college, by fifty-nine.[1]

The Smith Memorial, commemorating Pennsylvania's military and naval heroes of the Civil War, was commissioned by Richard Smith (1821–1894), a Philadelphia owner of a prosperous electroplate and type foundry. Instructions concerning the $500,000 monument were explicitly outlined in Smith's will, drawn up in 1891—the year an approved model and designs for the arch were deposited at the Fidelity Insurance Trust and Safe Deposit Company in Philadelphia. Smith left the financial responsibility to John B. Gest, president of the Fidelity Insurance Trust; the design and construction, to the Philadelphia architect James H. Windrim; and the selection and supervision of sculptors for the specified statues, to the Fairmount Park Art Association. With the death of Smith's wife in 1895, the terms relating to the memorial went into effect, but it was not until 1897 that the association's committee on *The Smith Memorial* met at the Philadelphia Art Club to begin the task of selecting the sculptors for the statuary of the arch.[2] Over the next fifteen years the committee met regularly to carry out the responsibilities entrusted to them.

The first order of business was to prepare a letter, which was dated December 23, 1897, to be sent to seventy-three sculptors to notify them of the statuary required and to request photographs of their work and their cost estimates for specific works listed.[3] Fifty-nine sculptors responded within two months, and the bids submitted were printed and presented for consideration to the full committee on February 21, 1898.[4] During the next three months the committee reviewed the bids and portfolios of the artists, and traveled to Washington and to New York to inspect the sculptors' existing monuments.

Because the committee was disappointed that John Quincy Adams Ward and Daniel Chester French, two of the country's foremost sculptors, had not responded, committee member Edward A. Coates visited them in their New York studios.[5] Following his interviews, both artists consented to participate in the project, and on May 6, 1898, the subcommittee on fine arts unanimously recommended that the following commissions be awarded:

John Quincy Adams Ward	Equestrian statue, Major General Winfield Scott Hancock
Paul Wayland Bartlett	Equestrian statue, Major General George B. McClellan
Daniel Chester French	Colossal figure, Major General George Gordon Meade
William Ordway Partridge	Colossal figure, Major General John Fulton Reynolds
Herbert Adams	Colossal figure, Richard Smith
Charles Grafly	Bust of Admiral David Dixon Porter
A. Stirling Calder	Bust of Major General John Frederick Hartranft
George E. Bissell	Bust of Admiral John A. B. Dahlgren
Samuel Murray	Bust of James H. Windrim, Esq.
Bessie O. Potter Vonnoh	Bust of Major General S. W. Crawford
Moses Ezekiel	Bust of Governor Andrew Gregg Curtin
Katherine M. Cohen	Bust of General James A. Beaver
John J. Boyle	Bust of John B. Gest, Esq.
Paul Wayland Bartlett	Two eagles and globes.[6]

Work on the busts and the standing colossal figures proceeded relatively smoothly, with the exception of William Ordway Partridge's statue of Reynolds. Three of Partridge's preliminary models were rejected by the committee,[7] and, pressed by other obligations, he retired from the project in February 1901.[8] The committee hurriedly selected Charles Grafly to execute the *Reynolds*.[9] By September 1902 it was cast in bronze,[10] the last of the three colossal statues to be placed in the memorial.

The equestrian statues of Generals Hancock and McClellan, the principal statuary on the arch, were not completed until 1912, a full twelve years after the projected date. Ward and Paul Wayland Bartlett, commissioned to model the figures, were to be paid $32,000 and $35,000, respectively, but Ward was in

his late sixties when he accepted the *Hancock* commission and was plagued by poor health, and the project was repeatedly delayed. Bartlett was a close friend and associate of Ward's. Though a leading Beaux-Arts sculptor, he was a notoriously slow worker. To make matters worse, at the time he accepted the *McClellan* commission, he was beginning work on an equestrian statue of Lafayette—gift from the United States to the French nation to reciprocate for the Statue of Liberty.

At first Bartlett's work on the memorial progressed well. By May 1899 he had finished a preparatory sketch,[11] and six months later had completed an enlarged figure to be placed on the staff mock-up of the arch erected in the park.[12] Satisfied with the enlargement, the committee paid him the ten percent of his total fee that he was to receive by contract upon completion of the staff figure.[13] But then, absorbed in his statue of Lafayette, Bartlett spent almost all his time in his Paris studio, and all but ignored the Philadelphia commission.

During the next two years there was almost no contact between the association and either of the two artists, and in October 1901 the association passed a resolution to ascertain their progress.[14] Four months later, representatives of the committee met with the sculptors in Ward's studio. After they had inspected Ward's model of the *Hancock* they wrote: "It had progressed very much further than we had anticipated, and met with our enthusiastic approval, the whole design being serious, dignified, and most interesting."[15] In their conversation with Bartlett, the committee representatives were assured that his full-size model was nearing completion and could soon be brought from Paris to be cast in bronze. Bartlet also told them that he and Ward had worked closely together on their statues in order to make them harmonious.[16]

The committee, aware that the selection of new sculptors would only further delay the project, decided to retain Ward and Bartlett. In March 1902, Ward signed a new contract calling for the figure of Hancock to be finished and in place within fifteen months.[17] At the same time, Bartlett, who had also agreed to model a pair of eagles and globes for the arch, relinquished that commission.[18] The association cast about with dispatch for a sculptor to execute these works and, two months later, in May 1902, the eagles and globes were awarded to J. Massey Rhind, who had already been employed to execute the architectural reliefs on the arch.[19]

By July 1903, the contracted date, neither Ward nor Bartlett had presented anything new to the committee. The association debated constantly over whether or not to solicit new artists to execute the equestrian figures, but delayed a final decision in hopes that the statuary would soon be completed. After further delay the committee finally met in New York in January 1906 to inspect Bartlett's full-size plaster model. Whether frustrated by Bartlett's tardiness or by his absence because of work on the *Lafayette* in Paris, or simply because they were dissatisfied with the model, the committee criticized his work, contending that important details had been neglected and that the entire figure was insufficiently completed.[20] Mystified by their reaction, Bartlett wrote the committee:

I am sorry you had a bad impression of the statue—you saw it under the worst possible circumstances, bad light, too near, and you probably climbed up to the loft and looked at it from above. I hoped you would make allowances. This statue is made to be seen at a distance and from below, and there are many rough places which at a distance will scintillate and give it more life than pretty polished pleats. I do not deny there is still something to do to it, but it is very little in comparison to its qualities—you cannot deny that there is power there and that the horse has a fine poise and a great deal of nobility in its simple pose.[21]

Their disappointment with Bartlett's model prompted the association to take action. Ward and Bartlett were notified in May 1906 that their contracts were annulled, and a court suit was initiated against Bartlett to recover the money he had received for his staff model.[22] Even though their contracts had been terminated, the sculptors continued to work on the statues; the association itself seemed to hold out some hope that the works could be completed, since they made no effort to select new artists to execute the equestrian figures. After two years, however, when Bartlett had still not come forward with a new model and Ward, because of poor health, had had to give up his studio, the association made the inevitable decision to recommission the statues and to try to bring the project to an end.[23]

Daniel Chester French, who as a youth had studied briefly with Ward, was sympathetic to Ward's position and admired his model. French wrote compassionately but logically to John M. Gest, the trustee's son who had assumed his father's duties:

Mr. Ward has completed a model which, in the eyes of his fellow artists, is a work of unusual merit, admirably suited to the place, dignified and impressive, so that the success of the finished statue is practically assured. It is possible to finish the statue and erect it in bronze so that it can be put in place by June 1, 1910.[24]

Ward must have been distressed to have French act as intermediary in the project, but the two men

seemed to have discussed the best way to handle the committee: on March 22, 1909, only a month later, French wrote to Ward:

> I have just had a personal letter from Mr. Gest saying that it looks as if they would permit us to finish the Hancock statue from your model, adjusting the business relations in the way you authorized me to suggest to Mr. Gest.[25]

In mid-May, French wrote: "The model arrived in good order yesterday. I told your man that I should like to give a wash of wax and turpentine to bring the rider and horse into relation. I shall wait to hear from you about this."[26] He wrote elatedly three days later: "The Hancock Committee met in my studio today in full force and approved your model."[27] With conviction and diplomacy French had pieced together a welcome compromise for everyone, and on June 4, 1909, he signed a contract with the Fairmount Park Art Association that called for the statue to be completed and in place on the memorial by October 1910.[28] While Ward participated intellectually in the completion of the Hancock, his failing health prevented his working in the studio. French and Edward C. Potter oversaw all the work, while Carl A. Heber, who had signed a contract with Ward for $2,5000,[29] did the actual enlarging of the statue. Work progressed quickly, and by the end of July, Heber informed Ward that the full-size staff model would be completed by August 3 or 4.[30] The finished model of the *Hancock* was put in place on the arch, but there were still delays before the memorial was completed. The committee could not meet until the fall to approve it, and they also wished to have the *McClellan* statue in place:[31] it had been given to Potter, on French's recommendation, in September, and he had not had enough time to finish his work.[32] The delay enabled the committee to grant French an extension of four months on his final date for completion of the Hancock.[33] Finally, on November 27, French wrote to the aging sculptor:

> I met Potter and the Committee at the monument in Philadelphia yesterday. Both statues were in place and both heartily approved. Potter and I were empowered to go ahead and finish them without any further inspection by the Committee. After all there seems to be some virtue in this body.[34]

After receiving bids from several foundries French, with Ward's concurrence, had the Gorham Foundry cast the statue for $6,200.[35] The chemical makeup of the bronze for the statue had been discussed by architect Windrim in 1900, when he suggested that the patina should be "the greenish cast which copper takes after exposure to the weather."[36] In December 1910 the *Hancock* was set in place,[37] six months after the sculptor's death. Potter's contract had called for the *McCellan* to be completed within a year and a half, and it was finished and in place according to schedule by June 1912 (fig. 73).[38]

Ward's *Hancock* is not only a powerful statue in its own right but also, more important, with it the sculptor has achieved an unprecedented effect in his coordination of the figure to the curve of the architecture: by arching the neck of Hancock's horse and turning it, he directs the viewer's eye back and around the arch of the memorial. In comparison, though Potter's *McClellan* is professionally modeled and executed, his completed equestrian in no way harmonizes either with Ward's figure or with the architecture itself. In spite of the talk of balancing the two statues, the work lacks any realization of Ward and Bartlett's vision that the statues be the memorial's climactic figures, complementary in size and spirit while corresponding to the sweep of the baroque arch. The absence of Bartlett's balancing equestrian creates a lasting flaw in what would have been a glorious achievement.

RELATED WORKS:

A figure of General Hancock was exhibited in Gallery 35 at the Panama-Pacific International Exposition in 1915.[39] The present location of this piece is not known, and it is not possible to determine if it was a working model or a reduction of the final statue.

115.1. Working model
 Plaster, h. 39 in.
 American Academy of Arts and Letters, New
 York City

This piece, mislabeled as "the *Sheridan*," was bequeathed to the academy in 1933 by Mrs. Ward.[40]

NOTES

1. This entry is a condensed version of L. Sharp, "The Smith Memorial," *Sculpture of a City: Philadelphia's Treasures in Bronze and Stone*, ed. N. B. Wainwright. (New York: Walker Publishing Co. for the Fairmount Park Association, 1974), pp. 168–179. See also *DAB*, s.v. "Winfield Scott Hancock."
2. Smith Memorial 1, pp. 5–7, minutes, October 26, 1897.
3. Ibid., pp. 55–67, printed circular letter, December 23, 1897.
4. Ibid., pp. 75–81, minutes, February 21, 1898.
5. Ibid., pp. 111–113, minutes of subcommittee, April 30, 1898. (See also letter from E. H. Coates to JQAW, April 30, 1898, and letter from JQAW to E. H. Coates, n.d. [AIHA].)
6. Ibid., pp. 129–130, May 6, 1898. (See also contract between Fidelity Insurance and JQAW, November 2, 1898 [AIHA].)

7. Ibid., 2, p. 301, subcommittee report, February 12, 1900.

8. Ibid., 3, p. 385, letter from W. O. Partridge, February 1, 1901.

9. Ibid., p. 413, minutes, April 11, 1901.

10. Ibid., 5, p. 606, letter from C. J. Cohen to committee members, September 15, 1902.

11. Ibid., 2, p. 264, minutes, May 9, 1899.

12. Ibid., p. 271, letter from C. J. Cohen to committee members, October 3, 1899.

13. Ibid., p. 294C, letter from C. J. Cohen to J. M. Gest, November 10, 1899; p. 294A, letter from J. M. Gest to C. J. Cohen, November 6, 1899.

14. Ibid., 3, p. 453, minutes, October 15, 1901.

15. Ibid., 4, pp. 526–530, report from L. W. Miller and C. J. Cohen, February 14, 1902.

16. Ibid.

17. Ibid., pp. 574–576, contract Fidelity Insurance and JQAW, March 24, 1902. (See also contract between Fidelity Insurance and JQAW, March 24, 1902 [AIHA].)

18. Ibid., pp. 591–592, contract release between Fidelity Insurance and P. W. Bartlett, March 31, 1902.

19. Ibid., pp. 594–596, contract between Fidelity Insurance and J. M. Rhind, May 12, 1902.

20. Ibid., 5, pp. 660–663, minutes, January 25, 1906.

21. Ibid., pp. 667–668, letter from P. W. Bartlett to C. J. Cohen, February 15, 1906.

22. Ibid., p. 673, letter from W. P. Gest to JQAW, May 7, 1906; p. 674, letter from W. P. Gest to P. W. Bartlett, May 7, 1906.

23. Ibid., pp. 713–714, minutes, December 14, 1908.

24. Ibid., 6, p. 724, letter from DCF to J. M. Gest, February 19, 1909.

25. Letter from DCF to JQAW, March 22, 1909 (N-YHS).

26. Ibid., May 14, 1909.

27. Ibid., May 17, 1909.

28. Smith Memorial 6, pp. 735–756, contract between Fidelity Insurance and DCF, June 4, 1909.

29. Contract between JQAW and C. A. Heber, May 27, 1909 (AIHA).

30. Letter from C. A. Heber to JQAW, July 27, 1909 (N-YHS).

31. Smith Memorial 6, pp. 766–768, minutes, September 1, 1909. (See also letter from DCF to JQAW, August 23, 1909 [N-YHS].)

32. Ibid., pp. 769–772, contract between Fidelity Insurance and E. C. Potter, September 1, 1909. In outrage, Bartlett wrote to JQAW, November 26, 1909, "It seems that Potter has acted much worse than I imagined. He took a provisional contract for this *statue last spring!* and signed the definite one the first of September. He can give pointers to Borglum. I wrote to him at once and told him I could not believe that he should have done such a thing. But have had no answer." (AIHA).

33. Letter from DCF to JQAW, October 7, 1909 (N-YHS).

34. Ibid., November 27, 1909.

35. Ibid., June 8, 1909.

36. Letter from J. H. Windrim to JQAW, May 4, 1900 (AIHA).

37. Smith Memorial 6, p. 791, letter from J. M. Gest to C. J. Cohen, December 6, 1910. (See also *New York Sun,* December 4, 1910.)

38. Ibid., pp. [803–804], minutes, June 4, 1912.

39. PPIE 1915, p. 246.

40. Gifts from the JQAW Estate, April 18, 1934 (AAAL).

116. AUGUST BELMONT
Statue, 1910
(Plates XXXVII, XXXVIII, XXIX, XL)

Bronze, over life-size
Signed: J • Q • A • WARD SC.
Founder's mark: GORHAM CO. FOUNDERS
Island Cemetery, Newport, Rhode Island

Financier August Belmont's association with Ward spanned the artist's long career. After seeing the enlarged plaster of *The Indian Hunter* in Snedicor's gallery in New York in 1865, Belmont commissioned Ward to execute a standing bronze statue of his father-in-law, Commodore Matthew C. Perry (cat. no. 46), for the city of Newport. When Belmont died twenty-five years later, Ward was asked to make his death mask,[1] which he then used in executing the bronze and marble busts of Belmont (cat. no. 90) for the family.

Which of the family asked Ward to model the statue of Belmont or when it was commissioned is not recorded, although in January 1903 August Belmont, Jr., did write Ward to say that he would stop by the sculptor's studio "to see the study for the statue."[2] Ward's administrative duties in a number of art societies and the increasing pressure on him to complete the equestrian statues of Generals Sheridan and Hancock probably account for his putting aside the *Belmont.* In 1908 Ward sold his studio to Charles Niehaus,[3] and his frustration at not being able to complete the *Sheridan* and the *Hancock,* combined with increasing health problems, prevented further work on the statue of Belmont. In October 1909, Ward, then bedridden, hired F. Herman Packer to enlarge and finish the seated statue within five months for $1,500.[4] Packer consulted regularly with Ward and brought photographs of the work in progress to him. Packer's dependence on Ward's sketch model and his advice is evident in a note he wrote to Ward:

Your letter of today received, perhaps it would be well for me to make preparations to adjust a compass for the pointing of the portrait bust, which I brought from Mr. [Charles] Lamb's studio over a week ago. I have the small sketch enlarged very carefully and copied very exactly, and . . . the size of the head looks right, only I would feel safer if you could see the statue now.[5]

By April 1910 Ward's health no longer allowed him to deal with the progress of the statue, as a letter Packer wrote to Mrs. Ward indicates:

Thank you very kindly for today's check regarding work on statue. I have made slow progress since your last visit, but . . .succeeded in getting a few good folds [in the

trousers] and Monday Mr. Melville posed for shoe and gaiter again which also is very much improved. . . .

Today Mr. MacNeil called and expressed himself very much pleased with the progress I have made since he saw the figure last.

I fully realize how constantly you must be at Mr. Ward's side at these trying times, and often wondered why I did not have the sense to tell you before this, that in case you wish me to run any errand or tend to any matters about the city I am at your disposal at any time just by dropping me a line.

With best wishes for Mr. Ward's health and kindest regards.[6]

Ward died on May 1, 1910, two months before the statue was completed. It was probably shortly after the sculptor's death that Packer wrote Mrs. Ward, "Mr Belmont called today, and his visit was a complete success, he was delighted with the work. I cannot explain how happy I feel that all was so successful."[7] The finished model was cast by the Gorham Foundry.

The siting of the *Belmont* is from an artistic viewpoint a most unhappy tale. Montgomery Schuyler, the art critic who was a close friend of Ward's, had written to the sculptor in March 1910 regarding the placement of the statue:

I have been looking up the Belmont tomb at Newport. Dick Hunt made it. It is very classic, and about Dick's best in that way, I think. It is an exedra, with a canopied niche in the centre, but nothing under the niche. It strikes me that in that niche is the place for your statue. The layout is much like that of the Dodge monument, in which I believe Dick assisted you.[8]

Hunt's sons, who had inherited their father's architectural firm, rejected Schuyler's suggestion,[9] and the Belmont family kept the statue at Belcourt, their house at Newport.[10] On May 31, 1941, they presented the *Belmont* to the city of Newport at a ceremony held in Washington Square.[11] At a later date the statue was moved to its present location on a low pedestal in front of the Belmont family chapel in Newport's Island Cemetery.

Belmont, shown wearing a heavy, fur-lined overcoat and holding his chin with his left thumb and forefinger, sits in a corner chair, apparently lost in reverie. The simple massiveness of the figure and the subtly textured surface of the work reveal that Ward's creative powers had in no way diminished in the last years of his life.

RELATED WORKS:

In March 1911 August Belmont, Jr., wrote to Mrs. Ward to thank her for the statuette of his father.[12] The present location of this model is not known.

NOTES

1. Letter from J. Hone to JQAW, November 24 [1890] (AIHA).
2. Letter from A. Belmont [Jr.] to JQAW, January 13, 1903.
3. *New York Times*, November 30, 1908, p. 1.
4. Letter from H. Packer to JQAW, October 22, 1909 (AIHA). Packer's legal name was Frank Herman Packer, but he signed himself "Herman Packer" in all the Ward material.
5. Ibid., January 11, 1910.
6. Letter from H. Packer to Mrs. JQAW, April 19, 1910 (AIHA).
7. Ibid., n.d. Though this letter is undated, an accounting of Packer's time and charges reveals that he was working on the statue through June 13, 1910. Receipt from H. Packer to the Estate of JQAW, n.d. (AIHA).
8. Letter from M. Schuyler to JQAW, March 29, 1910 (AIHA).
9. Letter from the architectural firm of Hunt & Hunt to M. Schuyler, April 8, 1910 (AIHA).
10. Letter from A. Belmont to author, December 2, 1983.
11. Reed 1947, p. 333.
12. Letter from A. Belmont [Jr.] to Mrs. JQAW, March 14, 1911 (AIHA).

117. BAPTISMAL FONT
Model, undated

Plaster, h. 12¼ in.
American Academy of Arts and Letters, New
 York City

There is no information relating to this piece. It was bequeathed to the academy in Mrs. Ward's will of 1933.[1]

NOTES

1. Accession card and Gifts from the JQAW Estate, May 16, 1934 (AAAL).

118. FOUNTAIN FIGURE
Model, undated

Plaster, h. 13¾ in., w. 4¾ in.
American Academy of Arts and Letters, New
 York City

The small decorative panel is listed as a "Fountain Figure" at the academy.[1] When it was received as part of Mrs. Ward's bequest, it was recorded as a "plaster model of a decoration."[2]

NOTES

1. Accession card, AAAL.
2. Gifts from the JQAW Estate, May 16, 1934 (AAAL).

119. RELIEF, GOSHEN
Design, undated

Cat. no. 117 *Baptismal Font*

Location unknown

The memorial exhibition of Ward's work included a "Design for relief. Goshen, N.Y."[1] There is no further reference to the piece and it has not been located in the Goshen area.

NOTES

1. Memorial Exhibition 1911, no. 13. Gifts from the JQAW Estate, April 18, 1934 (AAAL) lists "Designs for Reliefs."

120. DR. JONES
 Bust, undated

Location unknown

Cat. no. 118 *Fountain Figure*

William Walton[1] and Adeline Adams[2] both list a marble bust of a "Dr. Jones, Washington, D.C.," as part of Ward's oeuvre, but no other references to the bust are known. A Dr. John Davies Jones of Washington, D.C., died on January 5, 1903.[3] An influential official in the Bureau of Forestry, he may have been the subject of a Ward bust. It is also possible that Walton and Adams might have mistaken Ward's portrait of Dr. Joseph M. Toner at the Library of Congress in Washington, D.C. (cat. no. 71), for what they call the bust of "Dr. Jones."

NOTES

1. W. Walton 1910, pp. LXXXVI and LXXXVIII.
2. Adams, 1912, p. XV, and JQAW entry in *DAB*.
3. *New York Times*, January 6, 1903, p. 9.

121. *SILENUS*
Newel post, undated

Oak, h. 27 in.
American Academy of Arts and Letters, New York City

This small cherublike figure holding a basket or a vessel above his head was listed in the inventory of objects from Mrs. Ward's 1933 bequest to the academy as a "Carved wooden newel post—Silenus."[1] It may have come from either of the houses designed by Richard Morris Hunt for Ward—the first in 1868, the second in 1882.[2]

NOTES

1. Gifts from the JQAW Estate, April 18, 1934 (AAAL).
2. Baker 1980, p. 300.

122. *HEAD OF A YOUNG BLACK BOY*
Relief, undated

Bronze, 5 × 5 in.
Ex coll.: Mrs. R. Ostrander Smith, Bronx, New York

This relief is the companion to the plaque discussed in the following entry (cat. no. 123). As in *Head of a Young Indian Girl*, Ward's choice of subject, his use of hard-edged lines to delineate the head, and the smooth surface of the bronze lead to the assumption that the portrait was done in the 1860s.

123. *HEAD OF A YOUNG INDIAN GIRL*
Relief, undated

Bronze, 5 × 5 in.
Ex coll.: Mrs. R. Ostrander Smith, Bronx, New York

Cat. no. 121 *Silenus*

Cat. no. 122 *Head of a Young Black Boy*

Cat. no. 123 *Head of a Young Indian Girl*

This relief and the preceding *Head of a Young Black Boy* (cat. no. 122) were done to decorate the doors of an English court cupboard that once belonged to Ward. It was inherited by Mrs. R. Ostrander Smith, the sculptor's stepdaughter-in-law, and was sold after her death in 1971.

The work is a highly naturalistic portrait of a young girl whose hair is pulled into a twist on top of her head. Although the piece is not dated and there are no references to it, the choice of an Indian as subject, the hard lines delineating the physiognomy of the head, and the untextured surface of the plaque lead to the conclusion that Ward probably executed the relief in the 1860s.

124. GEORGE HANSON HITE
Bust, undated

Location unknown

A portrait by Ward of a George Hanson Hite is recorded at Woodlawn Cemetery, Bronx, New York.[1] There is no other information related to the piece, and it is now missing from the designated plot.

NOTES

1. Letter from M. Shapiro to author, January 6, 1984.

125. MARGARET LEUPP
Bust, undated

Marble, h. 20 in.
Cooper-Hewitt Museum, New York City; on
 loan to the National Museum of American
 Art, Washington, D.C.

There is no information to substantiate that this portrait is in fact of Margaret Leupp or when it was done or whether it was executed by Ward.[1] Stylistically, the bust corresponds to the classicized portraits that Ward did before his first trip to Europe, in 1872. The subject is reportedly the daughter of Charles M. Leupp (1808–1859), a well-to-do New York art patron.[2] Leupp had a long and close friendship with Henry Kirke Brown, and "became one of his [Brown's] staunchest supporters."[3] He owned Brown's bust of "A Young Girl," and lent it to the National Academy's 1850 exhibition,[4] causing one to suspect that this bust, if of Margaret Leupp, could have been the one exhibited by Brown.

NOTES

1. Accession file, Cooper-Hewitt Museum, New York City. There is no additional information in the files of the

Cooper-Hewitt except that the bust is of Margaret Leupp and is by JQAW.

 2. J. T. Callow, "American Art in the Collection of Charles M. Leupp," *Antiques* 118 (November 1980), pp. 998–1009. See also "Our Private Collections," *The Crayon* 3 (June 1856), p. 186.

 3. Craven 1972, p. 47, n. 6.

 4. NAD 1850, p. 22, no. 9.

Cat. no. 125 *Margaret Leupp*

Abbreviations

The major repositories of Ward's papers are: In Albany, New York, the Albany Institute of History and Art; in New York City, the American Academy of Arts and Letters, The Metropolitan Museum of Art, Department of American Paintings and Sculpture, and The New-York Historical Society; and in Newburgh, New York, Mr. and Mrs. Oliver E. Shipp. Parentheses around the abbreviation (see below) for any of those institutions or persons indicate that the document cited is in that collection of Ward material. See also Bibliography, section 1: "Manuscripts."

Little personal material exists in any Ward material at the various institutions. The information pertaining to his private life that appears in these pages has been derived from his contemporaries' papers or from personal recollection supplied by members of his family, particularly the late Mrs. R. Ostrander Smith, the sculptor's stepdaughter-in-law, and Mrs. Oliver E. Shipp, great-granddaughter of Ward's eldest sister, Eliza Thomas.

"Accession file" or "Accession card" in a footnote refers to the subject of the entry.

Annotated sources have been deleted wherever possible in the essay, since they appear in the entry of the work under discussion.

AAAL American Academy of Arts and Letters, New York City

ACAB
Appleton's Cyclopaedia of American Biography. Edited by James Grant Wilson and John Fiske. 6 vols. Rev. ed. New York: D. Appleton and Co., 1900.

Adams 1912
Adeline Adams. *John Quincy Adams Ward: An Appreciation.* New York: National Sculpture Society, 1912.

AIAF The American Institute of Architects Foundation, Washington, D.C., repository of Richard Morris Hunt papers.

AIHA Albany Institute of History and Art, Albany, New York

APS Department of American Paintings and Sculpture, The Metropolitan Museum of Art, New York City

Baker 1980
Paul R. Baker. *Richard Morris Hunt.* Cambridge: MIT Press, 1980.

Bartlett 1886
Truman H. Bartlett. "Early Settler Memorials . . . I: The Pilgrim." *American Architect and Building News* 20 (September 4, 1886), pp. 107–109.

Black 1981
David Black. *The King of Fifth Avenue: The Fortunes of August Belmont.* New York: The Dial Press, 1981.

Buley 1967
R. Carlyle Buley. *The Equitable Life Assurance Society of the United States, 1859–1964.* 2 vols. New York: Appleton-Century-Crofts, 1967.

Caffin 1899
Charles H. Caffin. *The Dewey Triumphal Arch.* New York: Copyright by Charles H. Caffin, 1899.

CAM 1970
Cincinnati Art Museum. *Sculpture Collection of the Cincinnati Art Museum.* Cincinnati: Cincinnati Art Museum, 1970.

Clark 1954
Eliot Clark. *History of the National Academy of Design, 1825–1953.* New York: Columbia University Press, 1954.

COC 1882
New York Chamber of Commerce. *Twenty-fourth Annual Report of the Corporation of the Chamber of Commerce of the State of New York, For the Year 1881–82.* New York: Press of the Chamber of Commerce, 1882.

COC 1880
New York Chamber of Commerce. *Twenty-second Annual Report of the Corporation of the Chamber of Commerce of the State of New York, For the Year 1879–80.* New York: Press of the Chamber of Commerce, 1880.

Cowpens 1896
1781–1881. Proceedings At the Unveiling of the Battle Monument in Spartanburg, S.C., In Commemoration of the Centennial of the Battle of Cowpens. Spartanburg, South Carolina: The Cowpens Centennial Committee, 1896.

CPC 1868
Twelfth Annual Report of the Board of Commissioners of the Central Park for the Year Ending December 31, 1868. New York: Evening Post Steam Presses [1869].

CPC 1867
Minutes of Proceedings of the Board of Commissioners of The Central Park, for the Year Ending April 30, 1867. New York: W. C. Bryant & Co., 1867.

Craven 1972
Wayne Craven. "Henry Kirke Brown: His Search for an American Art in the 1840's." *American Art Journal* 4 (November 1972), pp. 44–58.

Craven 1969
Wayne Craven. "Henry Kirke Brown in Italy, 1842–1846." *American Art Journal* 1 (Spring 1969), pp. 65–77.

Craven 1968
Wayne Craven. *Sculpture in America.* New York: Thomas Y. Crowell Co., 1968.

Cresson 1947
Margaret French Cresson. *Journey into Fame: The Life of Daniel Chester French.* Cambridge: Harvard University Press, 1947.

Curtis 1883
George William Curtis. *An Address at the Unveiling of the Statue of Washington upon the spot where he took the oath as first President of the United States. Delivered on the 26th November, 1883, the One Hundred Anniversary of the evacuation of the City of New York by the British Army.* New York: Harper Brothers, 1883.

DAB
Dictionary of American Biography. Edited by Allen Johnson. 22 vols. New York: Charles Scribner's Sons, 1927–1957.

Daley 1873
Charles P. Daley. "Presentation Address." In *Shakespeare: Ward's Statue in The Central Park, New York.* New York: T. H. Morrell, 1873.

DCF Daniel Chester French, American sculptor, friend and pupil of JQAW.

Dodge 1886
Proceedings at the Unveiling of the Statue of William E. Dodge. New York: The De Vinne Press, 1886.

Dreiser 1899
Theodore Dreiser. "The Foremost of American Sculptors." *The New Voice* 16 (June 17, 1899), pp. 4, 5, 13.

Dryfhout 1982
John H. Dryfhout. *The Work of Augustus Saint-Gaudens.* Hanover, New Hampshire: University Press of New England, 1982.

ELAS Archives, Equitable Life Assurance Society, New York City

Fairman 1927
Charles E. Fairman. *Art and Artists of the Capitol of the United States of America.* Washington, D.C.: United States Government Printing Office, 1927.

Galt 1820
John Galt. *The Life, Studies and Works of Benjamin West, Esq.* London: T. Cadell and W. Davies, Strand, 1820.

Gifts from the JQAW Estate
Two separate lots of objects received from Mrs. JQAW's bequest (1933) to the American Academy of Arts and Letters: the first, "Listed on April 18, 1934"; the second, "Delivered on May 16, 1934."

Hargrove 1980
June E. Hargrove. "The Public Monument." In *The Romantics to Rodin.* Edited by Peter Fusco and Horst W. Janson. Los Angeles and New York: The Los Angeles County Museum of Art in association with George Braziller, Inc., 1980.

HKB Henry Kirke Brown, American sculptor, JQAW's teacher and mentor.

Holderbaum 1980
James Holderbaum. "Portrait Sculpture," essay; "Ludwig Tieck," entry. In *The Romantics to Rodin.* Edited by Peter Fusco and Horst W. Janson. Los Angeles and New York: The Los Angeles County Museum of Art in association with George Braziller, Inc., 1980.

Howe 1890
Henry Howe. *Historical Collections of Ohio.* 2 vols. Columbus: Henry Howe & Son, 1890.

Howe 1913
Winifred E. Howe. *A History of The Metropolitan Museum of Art.* New York: The Metropolitan Museum of Art, 1913.

Howells 1916
William D. Howells. *Years of My Youth.* New York: Harper and Bros., 1916.

Howells 1886
William D. Howells. "Sketch of George Fuller's Life." In *George Fuller: His Life and Works.* Edited by J. B. Millet. Boston and New York: Houghton, Mifflin & Co., 1886, pp. 1–52.

Jarves 1960
James Jackson Jarves. *The Art-Idea.* New York: Hurd and Houghton, 1864. Reprint. Edited by Benjamin Rowland, Jr. Cambridge: The Belknap Press of Harvard University Press, 1960.

JQAW John Quincy Adams Ward

JQAW Scrapbook
In Ward material at the Albany Institute of History and Art, Albany, New York.

JQAW Sketchbooks
In Ward material at the Albany Institute of History and Art, Albany, New York.

Leslie 1868
Frank Leslie. *Report on the Fine Arts, Paris Universal Exposition, 1867. Reports of the United States Commissioners.* Washington, D.C.: Government Printing Office, 1868.

Lombardo 1944
Josef Vincent Lombardo. *Attilio Piccirilli: Life of an American Sculptor.* New York and Chicago: Pitman Publishing Corporation, 1944.

MacKaye 1927
Percy MacKaye. *Epoch: The Life of Steele MacKaye.* 2 vols. New York: Boni and Liveright, 1927.

Memorial Exhibition 1911
Memorial Exhibition of Works by the Late John Quincy Adams Ward, N.A. New York: National Sculpture Society, 1911.

Middleton 1917
Evan P. Middleton, ed. *History of Champaign County Ohio.* 2 vols. Indianapolis, Indiana: B. F. Brown & Co., 1917.

Miller 1957
Agnes Miller. "Centenary of a New York Statue." *New York History* 38 (April 1957), pp. 167–176.

MMA The Metropolitan Museum of Art, New York City

MOMA The Museum of Modern Art, New York City

MOMA 1932
American Painting and Sculpture, 1862–1932. New York: The Museum of Modern Art, 1932.

Morgan 1968
Theodore Morgan. "Seventy-five Years of American Sculpture," *National Sculpture Review* 17 (Summer 1968), pp. 6–15, 28–32.

NAD National Academy of Design, New York, New York.

NAD 1874
Catalogue of the Forty-ninth Annual Exhibition of the National Academy of Design, 1874. New York: E. Wells Sackett & Bro., 1874.

NAD 1868
Catalogue of the Forty-third Annual Exhibition of the National Academy of Design, 1868. New York: Sackett & Mackay, 1868.

NAD 1867–8
Catalogue of the First Winter Exhibition of the National Academy of Design, 1867–8. New York: Sackett & Mackay, 1868.

NAD 1867
Catalogue of the Forty-second Annual Exhibition of the National Academy of Design, 1867. New York: Sackett & Mackay, 1867.

NAD 1863
Catalogue of the Thirty-eighth Annual Exhibition of the National Academy of Design, 1863. New York: Sackett & Cobb, 1863.

NAD 1862
Catalogue of the Thirty-seventh Annual Exhibition of the National Academy of Design, 1862. New York: Sackett & Cobb, 1862.

NCAB
The National Cyclopaedia of American Biography. New York: James T. White & Co., 1892–.

N-YHS The New-York Historical Society, New York City

N-YHS 1974
Catalogue of American Portraits in The New-York Historical Society. 2 vols. New Haven: Yale University Press, 1974.

NYPL New York Public Library, New York City

NYSE New York Stock Exchange building, Wall and Broad streets, New York City

OES Mr. and Mrs. Oliver E. Shipp, Newburgh, New York. Mrs. Shipp is the great-granddaughter of Eliza Thomas, JQAW's eldest sister.

PAFA Pennsylvania Academy of the Fine Arts, Philadelphia, Pennsylvania

PAFA 1863
Catalogue of the Fortieth Annual Exhibition of the Pennsylvania Academy of the Fine Arts. Philadelphia: Collins, Printer, 1863.

PAFA 1859
Catalogue of the Thirty-sixth Annual Exhibition of the Pennsylvania Academy of the Fine Arts. Philadelphia: Collins, 1859.

Pilgrim 1885
Unveiling of the Pilgrim Statue by the New-England Society in the City of New York at Central Park, June 6, 1885. New York: privately printed, 1885.

PPIE 1915
Official Catalogue of the Department of Fine Arts: Panama-Pacific International Exposition.
San Francisco: The Wahlgreen Company, 1915.

Prugh 1951
Donald F. Prugh, ed. *Goodale Park Centennial, 1851–1951.* Columbus, Ohio: The Franklin
County Historical Society for the Division of Parks and Forestry, 1951.

Reed 1947
Thomas Lloyd Reed. "J. Q. A. Ward, Sculptor." Ph. D. dissertation, Harvard University,
1947.

Richman 1974
Michael T. Richman. "The Early Career of Daniel Chester French, 1869–1891." Ph. D.
dissertation, University of Delaware, 1974.

RMH Richard Morris Hunt, architect, JQAW's principal collaborator.

ROS The late Mrs. R. Ostrander Smith, JQAW's stepdaughter-in-law.

Roseberry 1964
Cecil R. Roseberry. *Capitol Story.* Albany: The State of New York, 1964.

Ruckstull 1925
Frederic W. Ruckstull. *Great Works of Art and What Makes Them Great.* New York: Garden
City Publishing Co., 1925.

SAC The Society of the Army of the Cumberland

The minutes of the society's annual reunions from 1906 to 1909 were published in the
same year or in the year after by MacGowen-Cooke Printing Company, Chattanooga,
Tennessee.

SAC 1909
The Society of the Army of the Cumberland, Thirty-seventh Reunion, Chattanooga, Tennessee, 1909. Chattanooga: MacGowen-Cooke Printing Company, 1910.

SAC 1906
Thirty-fourth Reunion, Chattanooga, Tennessee.

The minutes of the society's annual reunions from 1895 to 1905 were published in the
same year or in the year after by The Robert Clarke Company, Cincinnati, Ohio.

SAC 1905
The Society of the Army of the Cumberland, Thirty-third Reunion, Chattanooga, Tennessee, 1905. Cincinnati: The Robert Clarke Company, 1906.

SAC 1904
Thirty-second Reunion, Indianapolis, Indiana.

SAC 1903
Thirty-first Reunion, Washington, D.C.

SAC 1901
Thirtieth Reunion, Louisville, Kentucky.

SAC 1900
Twenty-ninth Reunion, Chattanooga, Tennessee

SAC 1899
Twenty-eighth Reunion, Detroit, Michigan.

SAC 1898
Twenty-seventh Reunion, Columbus, Ohio.

SAC 1896
Twenty-sixth Reunion, Rockford, Illinois.

SAC 1895
Twenty-fifth Reunion, Chattanooga, Tennessee.

The minutes of the society's annual meetings from 1870 to 1893 were published in Cincinnati in the same year or in the year after by Robert Clarke & Co.

SAC 1893
The Society of the Army of the Cumberland, Twenty-fourth Reunion, Cleveland, Ohio, 1893.
Cincinnati: Robert Clarke & Co., 1894.

SAC 1892
Twenty-third Reunion, Chickamauga, Georgia.

SAC 1891
Twenty-second Reunion, Columbus, Ohio.

SAC 1890
Twenty-first Reunion, Toledo, Ohio.

SAC 1889
Twentieth Reunion, Chattanooga, Tennessee.

SAC 1887
Eighteenth Reunion, Washington, D.C.

SAC 1885
Seventeenth Reunion, Grand Rapids, Michigan.

SAC 1884
Sixteenth Reunion, Rochester, New York.

SAC 1883
Fifteenth Reunion, Cincinnati, Ohio.

SAC 1882
Fourteenth Reunion, Milwaukee, Wisconsin.

SAC 1879
Eleventh Reunion, Washington City, D.C.

SAC 1876
Tenth Reunion, Philadelphia, Pennsylvania.

SAC 1875
Ninth Reunion, 1868–1875, Utica, New York.

SAC 1874
Eighth Reunion, Columbus, Ohio.

SAC 1873
Seventh Reunion, Pittsburgh, Pennsylvania.

SAC 1872
Sixth Reunion, Dayton, Ohio.

SAC 1871
Fifth Reunion, Detroit, Michigan.

SAC 1870
Fourth Reunion, Cleveland, Ohio.

Saint-Gaudens 1913
Augustus Saint-Gaudens. *The Reminiscences of Augustus Saint-Gaudens.* Edited by Homer Saint Gaudens. 2 vols. New York: The Century Co., 1913.

SCC 1878
Report of the State Capitol Commissioners to the General Assembly of the State of Connecticut, for the Year Ending November 30, 1878. Hartford: Case, Lockwood & Brainard Co., 1879.

Schuyler 1909
Montgomery Schuyler. "John Quincy Adams Ward: The Work of a Veteran Sculptor." *Putnam's Magazine* 6 (September 1909), pp. 642–656.

Schuyler 1908
Montgomery Schuyler. "The Work of Leopold Eidlitz." *The Architectural Record* 24 (November 1908), pp. 365–378.

Sheldon 1878
G. W. Sheldon. "An American Sculptor." *Harper's New Monthly Magazine* 57 (June 1878), pp. 62–68.

Sheridan 1916
Unveiling of the Equestrian Statue of General Philip H. Sheridan, Capitol Park, Albany, New York, October 7, 1916. Albany: Sheridan Monument Commission, 1916.

Simms 1879
Ceremonies at the Unveiling of the Bronze Bust of William Gilmore Simms at White Point Garden, Charleston, S. C., June 11th, 1879. Charleston: The News and Courier Book Presses, 1879.

Small 1897
Herbert Small. *Handbook of the New Library of Congress in Washington.* Boston: Curtis & Cameron, 1897. Reprint. Washington, D. C.: Library of Congress, 1980.

Smith Memorial
The Fairmount Park Art Association. "The Minute Books of the Smith Memorial." 6 bound vols. typescript. (804 pp.) October 26, 1897–June 4, 1912. The Pennsylvania Historical Society, library.

Stokes Iconography
Isaac N. Phelps Stokes, comp. *The Iconography of Manhattan Island, 1498–1909.* 6 vols. New York: Robert H. Dodd, 1915–28.

Sturgis 1902
Russell Sturgis. "The Work of J. Q. A. Ward." *Scribner's Magazine* 32 (October 1902), pp. 385–399.

Sturgis 1899
Russell Sturgis. "The Sculpture of the Dewey Reception in New York." *Scribner's Magazine* 26 (December 1899), pp. 765–768.

Taft 1921
Lorado Taft. *Modern Tendencies in Sculpture.* Chicago: University of Chicago Press, 1921.

Thieme-Becker
Allgemeines Lexikon der Bildenden Künstler von der Antike bis zur Gegenwart. Edited by Ulrich Thieme and Felix Becker. 37 vols. Leipzig: E. A. Seemann, 1907–1950.

Tomkins 1970
Calvin Tomkins. *Merchants and Masterpieces: The Story of The Metropolitan Museum of Art.* New York: E. P. Dutton & Co., 1970.

Townley 1871
D[aniel] O'C. Townley. "J. Q. Adams Ward." *Scribner's Monthly* 2 (August 1871), pp. 403–408.

Tuckerman 1867
Henry T. Tuckerman. *Book of the Artists: American Artist Life.* New York: G. P. Putman & Son, 1867.

WAA 1860
Catalogue of the Fourth Annual Exhibition of the Washington Art Association. Washington, D. C.: Henry Polkinhorn, 1860.

WAA 1859
Catalogue of the Third Annual Exhibition of the Washington Art Association. Washington, D. C.: William H. Moore, 1859.

Walton 1910
William Walton. "The Work of John Quincy Adams Ward, 1830–1910." *International Studio* 40 (June 1910), pp. LXXXI–LXXXVIII.

Ward, "Scrapbook."
A collection of clippings in the library at The New-York Historical Society, New York City.

WMC Ward Memorial Collection, Elmer Ellsworth Brown Papers, Archives, New York University, New York City

Young 1960
Dorothy Weir Young. *The Life and Letters of J. Alden Weir.* Edited by Lawrence W. Chisolm. New Haven: Yale University Press, 1960.

BIBLIOGRAPHY

Throughout the bibliography, an asterisk next to a book, an article, or an institution denotes that it contains a large body of information on Ward or on his work.

1. *Manuscripts.*

*The Albany Institute of History and Art, Albany, New York. John Quincy Adams Ward correspondence, Sketchbooks, and Scrapbook (Ward material).

*The American Academy of Arts and Letters, New York City. John Quincy Adams Ward correspondence; photographic collection; "Reminiscent Sketch of a Boyhood Friend" [1908], reprinted privately from May 1908 *Times-Citizen*, Urbana, Ohio; Lists of Gifts from the John Quincy Adams Ward Estate, April 18, May 16, 1934 (Ward material).

Amherst College Library, Amherst, Massachusetts. The Henry Ward Beecher statue, correspondence.

The Art Commission of the City of New York. Record folders for public sculpture; sculpture card index.

Chamber of Commerce of the State of New York, New York City. Account book for the statue of George Washington; minutes of the Chamber of Commerce meetings (see Abbreviations, COC, p. 281).

Connecticut State Library, Hartford. Architectural drawings of the Connecticut State Capitol.

The Equitable Life Assurance Society of the United States, New York City. "Equitable Statue Group: History" (*The Protector;* Henry B. Hyde); Record Group B, Audio-Visual Material, Buildings and Facilities.

Fairmount Park Art Association, Philadelphia, Pennsylvania. "Minute Books of the Smith Memorial." Six bound volumes, typescript, October 26, 1897–June 4, 1912 (804 pp.).

Federal Hall National Memorial Library, New York City. The statue of George Washington, correspondence.

Library of Congress, Washington, D. C. Typescript letters of Henry Kirke Brown, edited by Henry Kirke Bush-Brown; Daniel Chester French Family Papers.

The Metropolitan Museum of Art, New York City. Archives.

*The Metropolitan Museum of Art, New York City. Department of American Paintings and Sculpture. Transcripts of John Quincy Adams Ward correspondence.

National Archives, Washington, D. C. Monument Record Group 42, Public Buildings and Grounds, "Garfield" and "Sheridan." General Record Division, Boxes 32–50, Old Army and Navy, "Yorktown."

Newark Public Library, Newark, New Jersey. Art Department, "Newark Sculpture" folder.

*The New-York Historical Society, New York City. James Hazen Hyde correspondence; John Quincy Adams Ward correspondence (Ward material). Ward, "Scrapbook," library.

The New York Public Library, New York City. Minutes, Board of Trustees; Minutes, Executive Committee.

The New York Stock Exchange, New York City. Archives, Building Committee Transcripts; Minute Book of the Building Committee.

*New York University, New York City. Archives, Ward Memorial Collection, Elmer Ellsworth Brown Papers.

University of Maine at Orono, Raymond H. Fogler Library. Hamlin Family Papers.

University of Vermont, Burlington, Billings Library. The statue of the Marquis de Lafayette, correspondence.

Upjohn, Richard M. "Architectural Drawings of the Connecticut State Capitol." Connecticut State Library, Hartford, Connecticut.

Weaver, Eleanor. Presentation paper [1900]. Collection of Mr. and Mrs. Oliver E. Shipp, Newburgh, New York.

Winterthur Museum, Joseph Downs Manuscript and Microfilm Collection, Winterthur, Delaware. J. Q. A. Ward, "Reminiscent Sketch of a Boyhood Friend" [1908], reprinted privately from May 1908 *Times-Citizen*, Urbana, Ohio.

2. *Dissertations.*

Gurney, George. "Olin Levi Warner (1844–1896): A Catalogue Raisonné of His Sculpture and Graphic Works." Ph. D. dissertation, University of Delaware, 1978.

*Reed, Thomas L. "J. Q. A. Ward, Sculptor." Ph. D. dissertation, Harvard University, 1947.

Richman, Michael T. "The Early Career of Daniel Chester French, 1869–1891." Ph. D. dissertation, University of Delaware, 1974.

*Sharp, Lewis I. "A Catalogue of the Works of the American Sculptor John Quincy Adams Ward, 1830–1910." Ph. D. dissertation, University of Delaware, 1980.

3. *Dictionaries and Encyclopedias.*

Allgemeines Lexikon der Bildenden Künstler von der Antike bis zur Gegenwart. Edited by Ulrich Thieme and Felix Becker. 37 vols. Leipzig: E. A. Seemann, 1907–1950.

Appleton's Cyclopaedia of American Biography. Edited by James Grant Wilson and John Fiske. 6 vols. Rev. ed. New York: D. Appleton and Co., 1900.

Biographical Dictionary of American Architects. Edited by H. F. Withey and E. R. Withey. Los Angeles: Hennessy & Ingalls, 1970.

Dictionary of American Biography. Edited by Allen Johnson. 22 vols. New York: Charles Scribner's Sons, 1927–1957.

King's Dictionary of Boston. Edited by Edwin M. Bacon. Cambridge: Moses King, Publisher, 1883.

The National Cyclopaedia of American Biography. New York: James T. White & Co., 1892–.

4. *Books.*

*Adams, Adeline, *John Quincy Adams Ward: An Appreciation.* New York: National Sculpture Society, 1912.

———. *The Spirit of American Sculpture.* Rev. ed. New York: National Sculpture Society, 1929.

Baker, Paul R. *Richard Morris Hunt.* Cambridge: The MIT Press, 1980.

Black, Alexander. *The Story of Ohio.* Boston: D. Lothrop Company, 1888.

Black, David. *The King of Fifth Avenue: The Fortunes of August Belmont.* New York: The Dial Press, 1981.

Buley, R. Carlyle. *The Equitable Life Assurance Society of the United States, 1859–1964.* 2 vols. New York: Appleton-Century-Crofts, 1967.

Caffin, Charles H. *American Masters of Sculpture.* New York: Doubleday, Page & Co., 1903.

———. *The Dewey Triumphal Arch.* New York: Copyright by Charles H. Caffin, 1899.

Art Commission of the City of New York. *Catalogue of the Works of Art Belonging to the City of New York.* New York: The City of New York, 1909.

*The Century Association. *John Quincy Adams Ward: Memorial Addresses . . . November 5, 1910.* New York: The Century Association, 1911.

Cincinnati Art Museum. *Sculpture Collection of the Cincinnati Art Museum.* Ohio: Cincinnati Art Museum, 1970.

Clark, Edna M. *Ohio Art and Artists.* Richmond, Virginia: Garrett and Massie, Publishers, 1932.

Clark, Eliot. *History of the National Academy of Design, 1825–1953.* New York: Columbia University Press, 1954.

Coffin, Henry S. *A Half Century of Union Theological Seminary, 1896–1945.* New York: Charles Scribner's Sons, 1954.

Commager, Henry Steele. "The Century, 1887–1906." In *The Century, 1847–1946.* New York: The Century Association, 1947.

Commager, Henry Steele, and Morris, Richard B., eds. *The Spirit of 'Seventy-Six; The Story of the American Revolution As Told by Participants.* 2 vols. Indianapolis, Indiana: Bobbs-Merrill Co., 1958.

Cooper, Jeremy. *Nineteenth-Century Romantic Bronzes: French, English and American Bronzes 1830–1915.* London: David & Charles, 1975.

Cortissoz, Royal. *American Artists.* New York: Charles Scribner's Sons, 1923.

Craven, Wayne. *Sculpture in America.* New York: Thomas Y. Crowell Co., 1968.

Cresson, Margaret French. *Journey into Fame: The Life of Daniel Chester French.* Cambridge: Harvard University Press, 1947.

Dimock, Anthony Weston. *Wall Street and the Wilds.* New York: Outing Publishing Co., 1951.

Dryfhout, John H. *The Work of Augustus Saint-Gaudens.* Hanover, New Hampshire: University Press of New England, 1982.

Egbert, Donald D. *Princeton Portraits.* Princeton, New Jersey: Princeton University Press, 1947.

Fairman, Charles E. *Art and Artists of the Capitol of the United States of America.* Washington, D.C.: United States Government Printing Office, 1927.

Friedman, B. H. *Gertrude Vanderbilt Whitney.* Garden City, New York: Doubleday & Co., 1978.

Galt, John. *The Life, Studies and Works of Benjamin West, Esq.* London: T. Cadell and W. Davies, Strand, 1820.

Gardner, Albert T. *American Sculpture: A Catalogue of the Collection of the Metropolitan Museum of Art.* New York: The Metropolitan Museum of Art, 1965.

Goode, James M. *The Outdoor Sculpture of Washington, D. C.: A Comprehensive Historical Guide.* Washington, D.C.: Smithsonian Institution Press, 1974.

Hargrove, June E. "The Public Monument." In *The Romantics to Rodin.* Edited by Peter Fusco and Horst W. Janson. Los Angeles and New York: The Los Angeles County Museum of Art in association with George Braziller, Inc., 1980.

Haskell, Francis, and Penny, Nicholas. *Taste and the Antique: The Lure of Classical Sculpture, 1500–1900.* New Haven: Yale University Press, 1981.

Hills, Patricia. *Eastman Johnson.* New York: Clarkson N. Potter, Inc., in association with the Whitney Museum of American Art, 1972.

Holderbaum, James. "Portrait Sculpture," essay; "Ludwig Tieck," entry. In *The Romantics to Rodin.* Edited by Peter Fusco and Horst W. Janson. Los Angeles and New York: The Los Angeles County Museum of Art in association with George Braziller, Inc., 1980.

*Howe, Henry. *Historical Collections of Ohio.* 2 vols. Columbus: Henry Howe & Son, 1890.

Howells, William D. *Years of My Youth*. New York: Harper and Bros., 1916.

———. *Stories of Ohio*. New York: American Book Co., 1897.

———. "Sketch of George Fuller's Life." In *George Fuller: His Life and Works*. Edited by J. B. Millet. Boston and New York: Houghton, Mifflin & Co., 1886.

Jarves, James Jackson. *The Art-Idea*. New York: Hurd and Houghton, 1864. Reprint. Edited by Benjamin Rowland, Jr. Cambridge: The Belknap Press of Harvard University Press, 1960.

Johnson, Thomas H. *The Oxford Companion to American History*. New York: Oxford University Press, 1966.

Lombardo, Josef Vincent. *Attilio Piccirilli: Life of an American Sculptor*. New York and Chicago: Pitman Publishing Corporation, 1944.

MacKaye, Percy. *Epoch: The Life of Steele MacKaye*. 2 vols. New York: Boni and Liveright, 1927.

Matthews, T. *The Biography of John Gibson, R.A., Sculptor, Rome*. London: William Heinemann, 1911.

Mayor, A. Hyatt, and Davis, Mark. *American Art at the Century*. New York: The Century Association, 1977.

*Middleton, Evan P., ed. *History of Champaign County Ohio*. 2 vols. Indianapolis, Indiana: B. F. Brown & Co., 1917.

The New-York Historical Society. *Catalogue of American Portraits in The New-York Historical Society*. 2 vols. New Haven: Yale University Press, 1974.

Pilgrim, Dianne H. "Decorative Art: The Domestic Environment." In *The American Renaissance, 1876–1917*. New York: The Brooklyn Museum, 1979.

Proske, Beatrice. *Brookgreen Gardens, Sculpture*. Brookgreen, South Carolina: Brookgreen Gardens, 1943.

Prugh, Donald F., ed. *Goodale Park Centennial, 1851–1951*. Columbus, Ohio: The Franklin County Historical Society for the Division of Parks and Forestry, 1951.

Richman, Michael. *Daniel Chester French: An American Sculptor*. New York: The Metropolitan Museum of Art for the National Trust for Historic Preservation, 1976.

Roseberry, Cecil R. *Capitol Story*. Albany: The State of New York, 1964.

Ruckstull, Frederick W. *Great Works of Art and What Makes Them Great*. New York: Garden City Publishing Co., 1925.

Rutledge, Anna W., ed. *Cumulative Record of Exhibition Catalogues: The Pennsylvania Academy of the Fine Arts, 1807–1870: The Society of Artists, 1800–1814; The Artists' Fund Society, 1835–1845*. Philadelphia: American Philosophical Society, 1955.

Saint-Gaudens, Augustus. *The Reminiscences of Augustus Saint-Gaudens*. Edited by Homer Saint-Gaudens. 2 vols. New York: The Century Co., 1913.

St. Johnsbury Athenaeum and Art Gallery. *A Catalogue of the Collection*. Lunenburg, Vermont: The Stinehour Press, n.d.

Sharp, Lewis. "The Smith Memorial." In *Sculpture of a City: Philadelphia's Treasures in Bronze and Stone*. Edited by Nicholas B. Wainwright. New York: Walker Publishing Co. for the Fairmount Art Association, 1974.

Shepard, Lewis A., and Paley, David. *American Art at Amherst: A Summary Catalogue of the Collection at the Mead Art Gallery, Amherst College*. Middletown, Connecticut: Wesleyan University Press, 1978.

Small, Herbert. *Handbook of the New Library of Congress in Washington*. Boston: Curtis & Cameron, 1901. Reprint. Washington, D.C.: Library of Congress, 1980.

Stokes, Isaac N. Phelps, comp. *The Iconography of Manhattan Island, 1498–1909*. 6 vols. New York: Robert H. Dodd, 1915–1928.

*Taft, Lorado. *The History of American Sculpture*. New York: Macmillan Co., 1903. Revised edition, 1924.

———. *Modern Tendencies in Sculpture*. Chicago: University of Chicago Press, 1921.

Tenney, Martha Jane. *Tenney Family; or, the Descendants of Thomas Tenney, of Rowley, Mass. 1638–1890*. Boston: American Printing and Engraving Co., 1891.

*Tuckerman, Henry T. *Book of the Artists: American Artist Life*. New York: G. P. Putnam & Son, 1867.

Van Nimmen, Jane, and Mirolli, Ruth. *Nineteenth Century French Sculpture: Monuments for the Middle Class*. Louisville: J. B. Speed Art Museum, 1971.

Webster, J. Carson. *Erastus Dow Palmer*. Newark, Delaware: University of Delaware Press. London and Toronto: Associated University Presses, 1983.

Wennberg, Bo. *French and Scandinavian Sculpture in the Nineteenth Century: A Study of Trends and Innovations*. Stockholm: Almqvist & Wiksell International, 1978.

Wittkower, Rudolf. *Gian Lorenzo Bernini: The Sculptor of the Roman Baroque*. London: Phaidon Press, 1966.

Young, Dorothy Weir. *The Life & Letters of J. Alden Weir*. Edited by Lawrence W. Chisolm. New Haven: Yale University Press, 1960.

5. *Unveiling Ceremonies.*

Ceremonies at the Unveiling of the Bronze Bust of William Gilmore Simms at White Point Garden, Charleston, S.C., June 11th, 1879. Charleston: The News and Courier Book Presses, 1879.

Curtis, George W. *An Address at the Unveiling of the Statue of Washington upon the spot where he took oath as first President of the United States. Delivered on the 26th November, 1883, the One Hundred Anniversary of the evacuation of the City of New York by the British Army*. New York: Harper Brothers, 1883.

Daley, Charles P. "Presentation Address." In *Shakespeare: Ward's Statue in The Central Park, New York*. New York: T. H. Morrell, 1873.

Exercises Attendant Upon the Unveiling and Presentation of the Bust of S. S. Packard to the Packard College on the Evening of Thursday, June 26, 1890. New York: [1890].

Presentation of the Statue of Washington to the City of Newburyport. Newburyport, Massachusetts: William H. Huse & Co., 1879.

Proceedings at the Unveiling of the Statue of William E. Dodge. New York: The De Vinne Press, 1886.

1781–1881. Proceedings At the Unveiling of the Battle Monument in Spartanburg, S.C., In Commemoration of the Centennial of The Battle of Cowpens. Spartanburg, South Carolina: The Cowpens Centennial Committee, 1896.

Unveiling of the Equestrian Statue of General Philip H. Sheridan, Capitol Park, Albany, New York, October 7, 1916. Albany: Sheridan Monument Commission, 1916.

Unveiling of the Pilgrim Statue by the New-England Society in the City of New York at Central Park, June 6, 1885. New York: privately printed, 1885.

6. *Minutes and Reports.*

Central Park, New York. *Minutes of Proceedings of the Board of Commissioners of The Central Park, for the Year Ending April 20, 1870*. New York: Evening Post Steam Presses, 1870.

————. *Minutes of Proceedings of the Board of Commissioners of The Central Park, for the Year Ending April 30, 1868*. New York: Wm. C. Bryant & Co., 1868.

————. *Minutes of Proceedings of the Board of Commissioners of The Central Park, for the Year Ending April 30, 1867*. New York: W. C. Bryant & Co., 1867.

————. *Twelfth Annual Report of the Board of Commissioners of The Central Park for the Year Ending December 31, 1868*. New York: Evening Post Steam Presses [1869].

Connecticut State Capitol. *Report of the State Capitol Commissioners to the General Assembly of the State of Connecticut, for the Year Ending November 30, 1878*. Hartford: Case, Lockwood & Brainard Co., 1879.

Leslie, Frank. *Report on the Fine Arts, Paris Universal Exposition, 1867. Reports of the United States Commissioners.* Washington, D.C.: Government Printing Office, 1868.

New York Chamber of Commerce. *Twenty-fourth Annual Report of the Corporation of the Chamber of Commerce of the State of New York, For the Year 1881–82.* New York: Press of the Chamber of Commerce, 1882.

————. *Twenty-second Annual Report of the Corporation of the Chamber of Commerce of the State of New York, For the Year 1879–80.* New York: Press of the Chamber of Commerce, 1880.

Library of Congress. *Annual Report of the Librarian of Congress for the Fiscal Year Ending June 30, 1946.* Washington, D.C.: United States Government Printing Office, 1947.

Society of the Army of the Cumberland. For minutes of annual meetings, see Abbreviations, SAC, pp. 285–87.

United States Government. *Index to the Executive Documents of the House of Representatives 1882–83; 1883–84; 1884–85.* Washington, D.C.: Government Printing Office, 1883; 1884; 1885.

7. *Articles in Periodicals.*

"American Sculpture." *The World* [New York], December 29, 1895, p. 33.

Bartlett, Truman H. "Early Settler Memorials . . . I: The Pilgrim." *American Architect and Building News* 20 (September 4, 1886), pp. 107–109.

Belote, T. T. "American and European Swords in the Historical Collections of the United States National Museum." *Smithsonian Bulletin* 163 [1970].

Callow, James T. "American Art in the collection of Charles M. Leupp." *Antiques* 118 (November 1980), pp. 998–1009.

Craven, Wayne. "Henry Kirke Brown: His Search for an American Art in the 1840's." *American Art Journal* 4 (November 1972), pp. 44–58.

————. "Henry Kirke Brown in Italy, 1842–1846." *American Art Journal* 1 (Spring 1969), pp. 65–77.

Crawford, John S. "Physiognomy in Classical and American Portrait Busts." *The American Art Journal* 9 (May 1977), pp. 49–60.

————. "The Classical Orator in Nineteenth Century American Sculpture." *The American Art Journal* 6 (November 1974), pp. 56–72.

*Dreiser, Theodore. "The Foremost of American Sculptors." *The New Voice* 16 (June 17, 1899), pp. 4–5, 13.

*"The First of American Sculptors." *Current Literature* 48 (June 1910), pp. 667–670.

Gerdts, William H. "Sculpture by Nineteenth-Century American Artists in the Collection of the Newark Museum." *The Museum* n.s. 14 (Fall 1962), pp. 1–25.

Knaufft, Ernest. "Ward, the American Sculptor." *American Review of Reviews* 41 (June 1910), pp. 694–696.

Miller, Agnes. "Centenary of a New York Statue." *New York History* 38 (April 1957), pp. 167–176.

Morgan, Theodora. "Seventy-five Years of American Sculpture." *National Sculpture Review* 17 (Summer 1968), pp. 6–15; 28–32.

Rose, Ernestine Bradford. "Soldiers' and Sailors' Monument." *Indiana Historical Society Publications* 18 (1957), p. 398.

*Schuyler, Montgomery. "John Quincy Adams Ward: The Work of a Veteran Sculptor." *Putnam's Magazine* 6 (September 1909), pp. 642–656.

————. "The Work of Leopold Eidlitz." *The Architectural Record* 24 (November 1908), pp. 365–378.

————. "The New York Stock Exchange." *The Architectural Record* 12 (September 1902), pp. 413–420.

*Sharp, Lewis I. "John Quincy Adams Ward: Historical and Contemporary Influences." *The American Art Journal* 4 (November 1972), pp. 71–83.

*Sheldon, G. W. "An American Sculptor." *Harper's New Monthly Magazine* 57 (June 1878), pp. 62–68.

Sturgis, Russell. "Facade of the New York Stock Exchange." *The Architectural Record* 16 (November 1904), pp. 465–482.

*———. "The Work of J. Q. A. Ward." *Scribner's Magazine* 32 (October 1902), pp. 385–399.

———. "The Sculpture of the Dewey Reception in New York." *Scribner's Magazine* 26 (December 1899), pp. 765–768.

Thurlow, Fearn. "Newark's Sculpture: A Survey of Public Monuments and Memorial Statuary." *The Newark Museum Quarterly* 26 (Winter 1975), pp. 1–32.

*Townley, D[aniel] O'C. "J. Q. Adams Ward." *Scribner's Monthly* 2 (August 1871), pp. 403–408.

Van Brunt, Henry. "The New Architecture At Albany." *American Architect and Building News* 5 (January 25, 1879), pp. 28–29.

*Walton, William. "The Work of John Quincy Adams Ward, 1830–1910." *International Studio* 40 (June 1910), pp. LXXXI–LXXXVIII.

Ward, John Quincy Adams. "Sculpture in America," *Ainslee's Magazine* 4 (October 1899), pp. 285–288.

8. *Exhibitions and Sales Catalogues.*

The largest numbers of Ward's works were shown at the Memorial Exhibition of the Works of the Late John Quincy Adams Ward, N.A., National Sculpture Society, New York, 1911; and at the Panama-Pacific International Exposition, San Francisco, 1915 (see Abbreviations, pp. 283, 285: "Memorial Exhibition 1911"; "PPIE 1915"; see also NAD; PAFA). Other exhibitions and sales catalogues listing Ward's work are cited at the appropriate catalogue entry.

9. *Magazines and Newspapers.*

Passing references to Ward or to his work are noted at the individual entries; any major reports are listed under *Articles in Periodicals,* no. 7.

INDEX

Figures in heavy type denote illustrations. The plates referred to can be found in the Album of photographs, pp. 97–136. Unless otherwise noted, the works of art are by John Quincy Adams Ward.